Design and Political Dissent

This book examines, through an interdisciplinary lens, the relationship between political dissent and processes of designing.

In the past twenty years, theorists of social movements have noted a diversity of visual and performative manifestations taking place in protest, while the fields of design, broadly defined, have been characterized by a growing interest in activism. The book's premise stems from the recognition that material engagement and artifacts have the capacity to articulate political arguments or establish positions of disagreement. Its contributors look at a wide array of material practices generated by both professional and nonprofessional design actors around the globe, exploring case studies that vary from street protests and encampments to design pedagogy and community-empowerment projects.

For students and scholars of design studies, urbanism, visual culture, politics, and social movements, this book opens up new perspectives on design and its place in contemporary politics.

Jilly Traganou is an architect, and Professor of Architecture and Urbanism at Parsons School of Design, The New School. She is co-editor-in-chief of *Design and Culture*, and author of *Designing the Olympics: Representation, Participation, Contestation* (Routledge, 2016).

Routledge Research in Design Studies

Routledge Research in Design Studies is a new series focusing on the study of design and its effects using analytical and practical methods of inquiry. Proposals for monographs and edited collections on this topic are welcomed.

Thinking Design Through Literature
Susan Yelavich

Labor and Creativity in New York's Global Fashion Industry
Christina H. Moon

Wayfinding, Consumption, and Air Terminal Design
Menno Hubregtse

Narrative Environments and Experience Design
Space as a Medium of Communication
Tricia Austin

Contemporary Processes of Text Typeface Design
Michael Harkins

Design and Political Dissent
Spaces, Visuals, Materialities
Edited by Jilly Traganou

The Ontology of Design Research
Miguel Ángel Herrera Batista

For more information about this series, please visit: https://www.routledge.com/Routledge-Research-in-Design-Studies/book-series/RRDS

Design and Political Dissent
Spaces, Visuals, Materialities

Edited by Jilly Traganou

Routledge
Taylor & Francis Group
NEW YORK AND LONDON

First published 2021
by Routledge
52 Vanderbilt Avenue, New York, NY 10017

and by Routledge
2 Park Square, Milton Park, Abingdon, Oxon, OX14 4RN

Routledge is an imprint of the Taylor & Francis Group, an informa business

© 2021 Taylor & Francis

The right of Jilly Traganou to be identified as the author of the editorial material, and of the authors for their individual chapters, has been asserted in accordance with sections 77 and 78 of the Copyright, Designs and Patents Act 1988.

All rights reserved. No part of this book may be reprinted or reproduced or utilized in any form or by any electronic, mechanical, or other means, now known or hereafter invented, including photocopying and recording, or in any information storage or retrieval system, without permission in writing from the publishers.

Trademark notice: Product or corporate names may be trademarks or registered trademarks, and are used only for identification and explanation without intent to infringe.

Library of Congress Cataloging in Publication Data
Names: Traganou, Jilly, 1966- editor.
Title: Design and political dissent : spaces, visuals, materialities / edited by Jilly Traganou.
Description: New York : Routledge, 2021. | Includes bibliographical references and index.
Identifiers: LCCN 2020025274 (print) | LCCN 2020025275 (ebook) | ISBN 9780815374220 (hardback) | ISBN 9781351187992 (ebook)
Subjects: LCSH: Communication in design. | Art and social action.
Classification: LCC NK1510 .D47225 2021 (print) | LCC NK1510 (ebook) | DDC 701/.03–dc23
LC record available at https://lccn.loc.gov/2020025274
LC ebook record available at https://lccn.loc.gov/2020025275

ISBN: 978-0-815-37422-0 (hbk)
ISBN: 978-1-351-18799-2 (ebk)

Typeset in Sabon
by River Editorial Ltd, Devon, UK

For Maya and Miki

Contents

List of Figures x
List of Plates xiv
Notes on Contributors xv

1 Introduction 1
JILLY TRAGANOU

SECTION 1
Social Movements as Design Agents 23

PART 1
Visuals and Objects of Protest 25

2 The Green Stripe: The Color of Identification 27
VICTORIA HATTAM

3 Strategies of Creative Dissent under the People's Republic of China's "One China Policy" 38
KYLE KWOK

4 The Slovene Zombie Uprising 52
KSENIJA BERK

5 The Distribution of Abilities: Disability, Dissent, and Design Activism by the Gothenburg Cooperative for Independent Living 65
OTTO VON BUSCH AND HANNA AF EKSTRÖM

PART 2
Artifacts in the Afterlife of Protest 79

6 Art of the March: Archiving Aesthetics of the Women's March—Interviews with Alessandra Renzi, Dietmar Offenhuber, Siqi Zhu, Christopher Pietsch and Navarjun Singh 81
GRACE VAN NESS AND PRAKASH KRISHNAN

7 Dissent, Design of Territory, and Design of Memory: The Museum of Slavery and Freedom at the Valongo Wharf, Rio de Janeiro 95
ANA HELENA DA FONSECA AND BARBARA SZANIECKI

8 Beautiful Trouble: A Pattern Language of Creative Resistance—An Interview with Nadine Bloch 110
EVREN UZER

RESPONSE TO SECTION 1
Social Movements as Design Agents 121

9 The Objects of Political Creativity 123
JAMES M. JASPER

SECTION 2
Dissenting through Material Engagement 131

PART 1
Political Contention by Design 133

10 Vulnerable Critical Makings: Migrant Smuggling by Boats and Border Transgression 135
MAHMOUD KESHAVARZ

11 The Madrid Hologram Protest and the Democratic Potential of Visuality 147
KSENIJA BERK

12 Data Acquisition, Data Analytics, and Data Articulations: DIY Accountability Tools and Resistance in Indonesia—An Interview with Irendira Radjawali of Drone Academy, Indonesia 161
ALESSANDRA RENZI

13 Politics of Design Activism: From Impure Politics to Parapolitics 171
THOMAS MARKUSSEN

PART 2
Spaces of Contestation and Prefiguration 185

14 The Agonistic Design of Conflict Kitchen 187
VERÓNICA URIBE DEL ÁGUILA

15 Events and Ecologies of Design and Urban Activism: From
 Downtown São Paulo to the Peripheries 202
 KRISTINE SAMSON

16 Temporarily Open: A Brazilian Design School's Experimental
 Approaches against the Dismantling of Public Education—A
 Conversation on Design Pedagogy as Dissent 217
 ZOY ANASTASSAKIS, MARCOS MARTINS, LUCAS NONNO, JULIANA PAOLUCCI, AND
 JILLY TRAGANOU

17 Designing Post-carbon Futures: The Prefigurative Politics of the
 Transition Movement 226
 EMILY HARDT

18 Occupied Theater Embros: Designing and Maintaining the
 Commons in Athens under Crisis—An Interview with Eleni
 Tzirtzilaki 241
 URSULA (ORSALIA) DIMITRIOU

RESPONSE TO SECTION 2
Dissenting through Material Engagement 257

19 Designing While Dissenting While Dissenting While Designing:
 A Response in Counterpoint 259
 ZOY ANASTASSAKIS

Bibliography 265
Index 287

Figures

2.1	Hundreds of thousands of Iranian supporters of defeated reformist presidential candidate Mir Hossein Mousavi demonstrate in Tehran on June 15, 2009	28
2.2	A massive demonstration in support of reformist candidate Mir Hossein Mousavi is formed as supporters gather on the streets of Tehran, June 15, 2009	30
2.3	Iranian election protest. June 2009. Photo from Green Movement demonstration	31
3.1	The TriForce of Occupy Hongkong, motion graphics, DDED HK, 2014	40
3.2	Online naming contest for the two panda cubs, Tam Tam (貪貪) and Wu Wu (污污)	43
3.3	"Democracy at 4 a.m." Full-page advertisement on March 29 and 30, 2014, *New York Times*. Design: Aaron Yung-Chen Nieh (聶永真)	47
3.4	"Stand with Hong Kong at G20" global advertising campaign Full-page advertisement, *New York Times*, June 28, 2019	49
4.1	Paper zombie masks, "Protestival" at the second All-Slovenian People's Uprising (ASPU), Ljubljana, December 22, 2012	56
4.2	Two different types of zombies acting together in front of the Slovenian Central Bank building. Third ASPU, Ljubljana, February 8, 2013	58
5.1	CP doll, created by Gothenburg Cooperative for Independent Living (GIL), 2012	71
5.2	CP Truck with team, created by GIL, 2015	74
5.3	Converted parking spaces in Gothenburg	74
6.1	Signs of the Women's March in Boston arranged along the fence on Boston Common, 2017	82
6.2	Aerial mosaic of rescued signs from the Women's March in Boston, 2017	83
6.3	Images from "Art of the March" (http://artofthemarch.boston)	84
6.4	Images from "Art of the March"	85
6.5	Immersive interface image from "Art of the March"	86
6.6	Image from Vikus Viewer (https://vikusviewer.fh-potsdam.de/)	87
7.1	The Museum of Tomorrow, Rio de Janeiro, 2017	96

7.2	*Afoxé Filhos de Gandhi*, carnival group rooted in Candomblé practices at the Valongo Wharf, Rio de Janeiro, 2017	97
7.3	Valongo Wharf (*Cais do Valongo*) in Rio de Janeiro, declared in 2017 a World Heritage Site	98
7.4	"What Place is This?" an image-game by designer Philippe Leon Anastassakis, Bar Dellas Bar at Harmonia Square, Rio de Janeiro, 2018	106
8.1	Two huge photographic cutouts of hands—generated during the creative imagery section of Beautiful Trouble's training in Budapest in 2014. They culminated on the streets in a 1,000-person demonstration against the raiding of liberal NGOs by the right-wing government who saw them as "fronts for leftist influence from abroad." The hands became the main symbolic image of the protest, appearing on Hungarian news and television, and were picked up internationally by the news agency AFP	111
8.2	Theory cards from the Beautiful Trouble Strategic Creativity Deck presented at Busboys and Poets in Takoma Park, MD, February 16, 2020	113
8.3	"Blanket Game," Beautiful Trouble Strategic Creative Actions planning workshop with United We Dream organizers, Denver, CO, August 2016	115
11.1	Hologram protest in front of the Spanish Parliament against the "gag law," Madrid, 2015	149
11.2	Hologram protest	151
13.1	*DENNIS Design Center*, an urban installation by Bureau Detours. Transforming a site on Prague Boulevard. Delivery of freight containers, Copenhagen, August 2011	177
13.2	*DENNIS Design Center*. Preparing the site on Prague Boulevard	177
13.3	*DENNIS Design Center*. Folk kitchen and public dialogue	178
14.1	*Conflict Kitchen Iran*, Pittsburgh, 2010. The design elements of the wrapper sparked the customers' curiosity and speculation, while staff members engaged them in horizontal dialogues about the project and its current iteration	193
14.2	*Conflict Kitchen Afghanistan*, 2014. Wrapper reads: "People doubt the reality of this war. Of course, after the Taliban falling, the ordinary people's lives changed in a good direction. But these changes are more prominent in the lives of those Afghans who work in NGOs"	194
14.3	*Conflict Kitchen Venezuela, 2014*. Common table. Commensal practices such as those deployed by CK constituted a space for the emergence of the political, by fostering a space for both critique (or de-identification) and re-identification	196
14.4	*Conflict Kitchen Palestine*, 2014. On November 7, CK closed its doors for five days due to a death threat. On November 10, 2014, 200 people gathered in front of CK to show their support for CK	198
15.1	Spatial production and interventions on *Minhocão*, São Paulo: *Muda Coletivo*'s *Bolha Imobiliária* (The Real Estate Bubble), December 2012	207
15.2	*Cooper Glicério*, São Paulo. Entrance to the recycling station and boxing academy, 2012	209
15.3	Batiste gives a guided tour of *Cooper Glicério*, 2012	209
15.4	Regular users of the boxing academy share dinner at *Cooper Glicério*, 2012	210

xii *Figures*

16.1 "Open ESDI, UERJ resists." Banners made by students for the inauguration of ESDI's new gate and entryway, during the period of the *ESDI Aberta* (Open ESDI) occupation, Rio de Janeiro, February 2017 218
16.2 Collective lunch during the occupation 219
16.3 Sleeping room during students' occupation at *ESDI Aberta*, Rio de Janeiro, February, 2017 220
16.4 Student's occupation manifesto affixed on a wall in the main School's entrance. Manifesto excerpt: "Occupy ESDI. We, an ESDI student group, decided to initiate an occupation movement, today, on March 14, 2017. Due to systematic delays, and lack of payment of employees' salaries, student scholarships, and UERJ maintenance fees, we agree with the position of the board of directors that have declared the impossibility to return to normal university operation. In the meantime, emptying the university puts its very existence in danger. With the community fragmenting, looking for specific solutions, the collectivity is lost. With this in mind, we understand that the occupation is an alternative that can foster activities of creativity and learning in response to this reality. This, which is the essence of the university, is our real tool to reintegrate the community in defense of public and popular education" 221
16.5 The "Box *ESDI Aberta*" used to collect money for community support 222
16.6 Students working at the vegetable garden of Green Space, an experimental research lab at *ESDI Aberta* 223
16.7 Students working at the Colaboratório, a graphic experimentation laboratory of *ESDI Aberta* 223
16.8 *ESDI Aberta* organizing meeting in January 2017 224
17.1 Transition Pasadena's gardens serve to bring people together and demonstrate permaculture principles. Shown here is the Free-Food Garden, which during its three-year existence was located outside of the Arroyo Food Co-op. The group has also maintained the Throop Learning Garden since 2011, growing apricots, blueberries, figs, corn, squash, olives, beans, tomatoes, okra, and more, Pasadena, CA, 2015 232
17.2 Since 2014, the Transition Media Free Store has sought to meet people's needs through gift-giving, sharing, and community rather than the exchange of money and increased consumption. With dozens of volunteers, the Free Store is open five days per week and sees an average of more than 100 visitors per day, Media, PA, 2016 233
17.3 The Village Building Convergence, organized by a working group of Transition Montpelier, was held each summer from 2009 to 2016 in central Vermont. The VBC focused on increasing resilience through building skills and community connections with potlucks, music, and workshops on topics ranging from medicinal plants and timber frame construction to art and social justice, Brookfield, VT, 2011 234
18.1 First day of Occupied Theater Embros's activation, Athens, November 11, 2011 243
18.2 A communal Christmas meal in 2013 taking place on the stage of the Embros Theater 244

18.3	The police threatened to evacuate the state-owned building of Embros several times. Symbolic wrapping of Embros in protest of its imminent closure on November 25, 2012	245
18.4	Assembly in the main theater space of Embros	246
18.5	Performance by a resident of Psiri district using as stage the foyer of the theatre and featuring the table of Embros. Nomadic Architecture and the Stories of People, February 4, 2013	250

Plates

1 Hundreds of thousands of Iranian supporters, June 15, 2009
2 Iranian election protest, June 2009
3 The TriForce of Occupy Hongkong, motion graphics, DDED HK, 2014
4 CP Doll, created by Gothenburg Cooperative for Independent Living, 2012
5 Signs of the Women's March in Boston arranged along the fence on the Boston Common, 2017
6 Aerial mosaic of rescued signs from Women's March in Boston, 2017
7 "What Place is This?" an image-game by designer Philippe Leon Anastassakis, Bar Dellas Bar at Harmonia Square, Rio de Janeiro, 2018
8 "Blanket Game," Beautiful Trouble Strategic Creative Actions planning workshop with *United We Dream* organizers, Denver, CO, August 2016
9 *DENNIS Design Center*. Preparing the site on Prague Boulevard, Copenhagen, 2011
10 *Conflict Kitchen Iran*, Pittsburgh, 2010
11 Spatial production and interventions on Minhocão, São Paulo: *Muda Coletivo*'s *Bolha Imobiliária* (The Real Estate Bubble), December 2012
12 Sleeping room during students' occupation at *ESDI Aberta* (Open ESDI), Rio de Janeiro, February, 2017
13 Students working at the vegetable garden of Green Space, an experimental research lab at *ESDI Aberta*, 2017
14 Transition Pasadena's Free-Food Garden, Pasadena, CA, 2015
15 First day of Occupied Theater Embros's activation, Athens, November 11, 2011
16 A communal Christmas meal in 2013 taking place on the stage of the Embros Theater

Contributors

Zoy Anastassakis is a Brazilian designer and anthropologist. She was the director at *Escola Superior de Desenho Industrial, Universidade do Estado do Rio de Janeiro* (ESDI/UERJ) (2016–18), where she works as Associate Professor, coordinating the research group *Laboratório de Design e Antropologia*. Since 2020, she is also an associated researcher at the Center for Research in Anthropology (CRIA), in Lisbon, Portugal. Together with Marcos Martins, she is co-author of a book on ESDI's radical pedagogy during the period 2016–17, to be published by Bloomsbury in their series "Design in Dark Times."

Ksenija Berk is an independent scholar and critic from Ljubljana (Slovenia). She holds a PhD in Aesthetics and MA in Historical Anthropology of Visual Arts. Her research focuses on the intersection of design, aesthetics and politics, history of design in the Balkans, the de-hegemonization of design and design history, social design, visual and material culture of dissent, activist design, power relations, and politics of the street. Her work explores how design works as an agent of social and political change, empowers the marginalized, and builds platforms for a critical re-thinking of values, ideas, and processes.

Otto von Busch is Associate Professor of Integrated Design at Parsons School of Design. His artistic and academic work focuses on the topics of design, agency, and empowerment, exploring how design, and especially fashion, can mobilize community capabilities through collaborative craft and social activism. He has previously published chapters on design activism as part of *The Routledge Handbook of Sustainable Product Design* (2017), *The Routledge Companion to Design Research* (2015), *The Routledge Handbook of Sustainability and Fashion* (2014), as well as other design anthologies.

Ursula (Orsalia) Dimitriou (Dipl. Arch. Eng., MA, PhD) is a practicing architect and a researcher. Her research interests include design as a political tool, commons and public space, urban insurgencies, grassroots practices, theatrical and ephemeral interventions in urban space, participatory design, and social sustainability. Ursula is leading design studios at the University of Westminster and Central Saint Martins, and is co-director of SYN (https://studiosyn.co.uk/), an interdisciplinary design studio in London.

Hanna af Ekström is a disability activist and PhD candidate in design at HDK-Valand, the Academy of Art and Design at Gothenburg University, Sweden. In her

research, she uses a theoretical framework of critical disability studies, crip theory, and queer phenomenology to expand the current concept of accessibility within city planning and urban development by including emotions, cognition, and the senses.

Ana Helena da Fonseca (MA) is a practicing designer and a researcher. Her research interests include design in society, city branding and its symbolic and imagistic constructions, mega-events as a tool for broadcasting city image, and branding and digital platforms. She currently works as a UX/UI designer at IBM, in Rio de Janeiro.

Emily Hardt is a political scientist and scholar-activist whose primary interests are collective action, alternative economies, climate justice, and feminist theory and politics. Emily earned her PhD in Political Science from the University of Massachusetts Amherst in 2013. She teaches in the Gender, Leadership and Public Policy graduate program at the University of Massachusetts Boston.

Victoria Hattam is a professor in the Politics Department at The New School for Social Research, in New York City. Over the last decade, Hattam has co-taught a series of critical studios on visual and spatial politics with faculty from the Parsons School of Design. Hattam's current research examines shifting relations between design and production in the global economy. She is a member of the Multiple Mobilities Research Cluster—www.multiplemobilities.org—and a faculty fellow at the Graduate Institute for Design, Ethnography, and Social Thought at the New School in 2020–21.

James M. Jasper is a sociologist who writes about culture and politics. His most recent books include *The Emotions of Protest* (University of Chicago Press, 2018), *Public Characters: The Politics of Reputation and Blame* (Oxford University Press, 2020), and *Protestors and Their Targets* (Temple University Press, 2020).

Mahmoud Keshavarz is a Senior Lecturer in Design Studies at HDK-Valand, University of Gothenburg and affiliated researcher at the Engaging Vulnerability research project, Uppsala University, Sweden. His work focuses on the material politics of borders and im/mobility and has been published in journals such as *Design Issues*, *Design Philosophy Papers*, *Borderlands*, and *Law Text Culture*. He is author of *The Design Politics of the Passport: Materiality, Immobility, and Dissent* (Bloomsbury, 2019), co-editor of *Seeing Like a Smuggler: Borders from Below* (Pluto Press, forthcoming), founding member of Decolonizing Design, and co-editor-in-chief of the journal *Design and Culture*.

Prakash Krishnan is an artist-researcher, educator, community worker, and Media Studies graduate student at Concordia University in Tio'tia:ke (Montréal). He employs mixed media methods including writing, podcasting, film-making, and curating as pedagogical tools to engage in public scholarship. His research is particularly attentive to the relationship between media artifacts and marginalization via colonial, community, and social media archives. Prakash's research has been published in the *Canadian Journal of Communication*, *PUBLIC*, and *PLOT(S) Journal of Design Studies*.

Kyle Kwok is a visual designer and an independent researcher from Hong Kong. He is currently working on a research project on exploring how actors in the

2019 Hong Kong Protests are using graphic design as a medium and a resistance tactic.

Thomas Markussen is Associate Professor and co-founder of the Social Design Research Unit, at the University of Southern Denmark. In his work, Markussen focuses on how design can be used as a political and critical aesthetic practice, notably in the fields of social design, design activism, and design fiction. His publications include journal articles such as "The Disruptive Aesthetics of Design Activism: Enacting Design between Art and Politics" (Design Issues 2013) and "Disentangling the 'Social' in Social Design's Engagement with the Public Realm" (*CoDesign* 2017).

Marcos Martins has been a tenured professor at *Escola Superior de Desenho Industrial* (ESDI), Rio de Janeiro, since 2010. He conducted postdoctoral research at Princeton University, in New Jersey (2018), received a PhD in Communications from Universidade Federal do Rio de Janeiro (2009), and an M.F.A. from the School of Visual Arts, in New York (1992). As a professor and researcher, he explores the links between interaction and graphic design with art, philosophy, and media studies.

Grace Van Ness is a multimedia artist and graduate student in Communications Studies. Both her research and art practice investigate alternative and co-constructive documentary production, activist media, and the radical potential of nonfiction narrative as regards pornography and the sex workers' rights movement. Grace's video and installation work has been recognized at numerous film festivals and was included in the SOMArts exhibition, "We're Still Working: The Art of Sex Work," as well as the *Cultures du témoignage* program, "*Témoigner pour Agir.*" Her latest research on sex worker organizing post-FOSTA-SESTA appears in *The Critical Makers Reader: (Un)learning Technology* (Institute of Network Cultures, 2019). Currently, Grace is editing the forthcoming documentary, *Under the Red Umbrella*—a modern account of sex worker rights and activism in the United States.

Lucas Nonno is a design student at the Escola Superior de Desenho Industrial, Universidade do Estado do Rio de Janeiro (ESDI/UERJ), since 2014. He was elected representative of the student body from 2015 to 2017 and the departmental council in 2017. Since 2017, he has been working as a design intern developing sustainable projects at Matérial Brazil.

Juliana Paolucci holds BA and MA degrees in Design from *Escola Superior de Desenho Industrial, Universidade do Estado do Rio de Janeiro* (ESDI/UERJ) (2013/2018). After specializing in Design Thinking at HPI D-School in Germany, she carried out innovation projects for a diverse range of industries in Europe, Asia, and Latin America. She is currently Partner-director of Innovation at the innovation consultancy Laje, and invited lecturer at Brazilian business schools COPPEAD/UFRJ and FIA/USP.

Alessandra Renzi is Associate Professor in Communication Studies at Concordia University, in Tio'tia:ke (Montréal) where she explores the relays between media, art, and activism through militant research and media co-production. Alessandra's work has been featured in journals like *Theory, Culture & Society* as well as venues like the Transmediale Festival in Berlin and the Queens

Museum of Art in New York. She is the author of *Infrastructure Critical: Sacrifice at Toronto's G8/G20 Summit* (with Greg Elmer, ARP, 2012), and *Hacked Transmissions: Technology and Connective Activism in Italy* (University of Minnesota Press, 2020).

Kristine Samson is an urbanist and Associate Professor at the Department of Communication and Arts, Roskilde University, Denmark. Her research interests cover art, design, and activism in urban space and in particular how activism, art, and citizens negotiate urban space and its publics. She has published articles on DIY and tactical Urbanism (*Journal of Urbanism*) and is a co-editor of *Situated Design Methods* (MIT Press, 2014). In her recent research project, "Evental Urbanism," she explores how design, activism, and citizens affect one another and create pluralization or a series of minor instituting events.

Barbara Szaniecki is a researcher at the research group *Laboratório de Design e Antropologia* and Adjunct Professor at the *Escola Superior de Desenho Industrial, Universidade do Estado do Rio de Janeiro* (ESDI/UERJ). Her research focuses on the relationships between design and political concepts such as multitude, power, and protests. Her current work is about how collaborative design processes produce citizenship possibilities in a context of global cities. She co-edited with Giuseppe Cocco the book *Creative Capitalism, Multitudinous Creativity: Radicalities and Alterities* (Lexington, 2015).

Jilly Traganou (Dipl. Arch. Eng., PhD) is an architect, and Professor of Architecture and Urbanism at Parsons School of Design, The New School, in New York. Her publications include *Designing the Olympics: Representation, Participation, Contestation* (Routledge, 2016); *Travel, Space, Architecture*, co-edited with Miodrag Mitrašinović (Ashgate, 2009); and *The Tokaido Road: Traveling and Representation in Edo and Meiji Japan* (RoutledgeCurzon, 2004). She is also co-editor-in-chief of the *Design and Culture* journal. Her current work focuses on the role of space, maintenance, and materiality in prefigurative politics.

Verónica Uribe del Águila is a PhD student in Communication and Science Studies at the University of California San Diego. She holds an MA in Design Studies from Parsons School of Design and a BA in Philosophy by PUCP (*Pontificia Universidad Católica del Perú*). Her current research analyzes the political economy of DIY making and digital manufacturing as well as the different ways in which DIY making is imagined, produced, and valued as a global empowering technology especially in Latin America. Uribe's work explores the intersection between geography, design, labor, and feminist science and technology (Feminist STS).

Evren Uzer is a New York City-based educator, urban planner, and community practitioner working on civic engagement in planning and design. Her current research focuses on activism, critical heritage studies, and feminist spatial practices. She is Assistant Professor of Urban Planning at the Parsons School of Design. Evren's practice is currently split between community engagement, planning, and design work at the Collective for Community, Culture and Environment, and her artistic practice at roomservices.

1 Introduction

Jilly Traganou

I vividly recall the moment when it all clicked: that afternoon in the spring of 2014, when Quizayra arrived at my office to discuss her thesis on the materiality of bodegas. Typical of students in New York, who leave home in the morning with plans for a day full of action, she always carried a lot of stuff. But that particular day, I noticed something strange spilling out of Quizayra's bag—something unusually soft and fluffy. A stuffed animal, I thought as she started unpacking, taking out her notebook and placing the blobby thing on the table. I couldn't stop myself from asking, of course.

"I brought my pillow," she said, "because my mattress was too heavy."

This answer was both surprising and confusing. Our brief exchange on the matter, however, soon led to my "aha" moment. A protest was taking place in the city that day against universities' refusal to act appropriately after allegations of on-campus sexual assault.[1] The act of protest was realized by carrying one's own mattress—or, in Quizayra's case, her pillow—into the streets. Even though I didn't properly understand the specific cause and mechanics of this protest, I suddenly recognized the power of protesting with things, not words, that act in support of our grievances.

This confirmed an insight stemming from my research at the time, although it was on a very different subject: the abysmal worlds created by the Olympic Games. I had come to understand that design and creativity are not tools merely in the hands of those authorized to create the impactful projects that accompany a mega-event. Despite having disproportionately less power, counter-Olympics activists also display an abundance of creativity, which in their hands is mobilized toward dissenting rather than enabling the Olympics. And that day in my office, Quizayra and her pillow assured me that protesting with things was in fact a thing! Here on my table was an object of creative resistance. It was nothing but a pillow, a trivial, passive object—and yet it was everything but that.

How is design associated with a pillow protest? one might ask. Or in other words, what are we talking about when we talk about "design and dissent"? Here, in this book, we are referring not only to the specific processes of creating objects that are meant to participate in dissent. The essays and discussions that follow consider acts of material engagement as much more than just producing design; these acts also include assembling, appropriating, and collecting artifacts, from objects and spaces to images and imaginaries. We also include material practices that happen in various spaces, from the street and the square to a school or a theater, and the remaking of these spaces to enable dissent.

To put it differently, this book examines nonverbal repertoires of political contention that are anchored in the physical world: disobedient objects, insurgent practices in occupied spaces, archives of material artifacts that embody dissent, and various creative assemblages that enact disagreement. We look at how they are made and used in protest or in spearheading dissent at various sites, the ways they are archived or commemorated, the methods used by activists and designers to extract lessons from them as agents of new political affiliations. We do this in order to shed light on the materialities involved in dissent, and to understand their trajectories, their potential, and their limits.

In the second decade of the 21st century, the world witnessed a rise in dissent due to the expansion of inequality, oppression, and discrimination.[2] It also saw an increase in the diversity of protest tactics, including creative, performative, and materially established forms of dissent.[3] Images of encampments from the Arab Spring and Occupy movements, performative action from the World Trade Organization protests, and "disobedient objects" from the student uprising in Hong Kong circulated extensively in social media and spread virally around the globe. These protests coalesced a multitude of causes, and even though some were critiqued as "strategies of withdrawal,"[4] they are of particular interest because they evoked a multivocality in the articulation of dissent that far exceeded the activists' verbal demands or speech actions.

Reflecting on the proliferation of "repertoires of contention"[5] in the 21st century so far, this book examines the relationship between political dissent and acts of design. Its premise stems from the recognition that dissent often happens through things—that material practices and artifacts have the capacity to articulate political arguments and act politically.[6] The word "things" here stands for a broader nexus of materiality that includes not only objects but also visual culture and spaces. Our attention is focused on both the realm of production (the acts of conceiving and creating such things) and the realm of use, appropriation, and dissemination—the effects, diffusion, preservation, and afterlives of these things. Even beyond that, things appear in this book as having their own active capacity, as artifacts with politics, to echo an influential piece by Langdon Winner.[7]

Bracketing the notion of *design* as an actor in political dissent is where our contribution to the burgeoning field of protest culture and social movement studies lies. In this book, we are motivated by a dual question: *what* in design might be conducive to dissent, and *where* is design in dissent? "Design" might not be the most obvious word to use in contexts of dissent. Here, we do not talk simply about form-giving or about work by professional designers, but rather about an epistemological category. Designing is considered by design theorist Nigel Cross as the core figurative capability and knowledge employed in actions that have to do with change, expanding Herbert Simon's proposition that design is an interdisciplinary component "accessible to all those involved in the creative activity of making the artificial world,"[8] and the "core of all professional training ... architecture, business, education, law, and medicine."[9]

Thus, this volume recognizes design as a capacity that expands from the work of professional designers to encompass practices of "diffuse design" by non-experts, such as grassroots organizations, cultural activists, and everyday practitioners.[10] It considers acts of dissent that use methods of design (such as "planning, inventing, making, and doing"[11]), even when realized by non-designers, to achieve goals that are inherently

political and that stem from—or more often, establish—a position of disagreement. We present design as the central experience of the creative process, at the core of a wider array of intentional practices of material or performative figuration that evoke political disagreement, ranging from street protests and encampments to design activism and community empowerment. And we explore the affective domains of relationality between human and non-human actors before, during, and after acts of designing.

While designers are not typically perceived as radical or revolutionary,[12] the core of design offers a potentiality akin to change. One might argue that design oscillates between two ways of producing change: first, masking compliance with novelty, which is typical in the design of commodities, and second, subverting the norm by articulating new courses of action, and processes of becoming. In this book, we examine mostly the latter: dissenting designers (or non-experts who tap into their "designerly"[13] capacity) using methods and tropes of design to oppose a political decision, reveal new information, demand change, disrupt the status quo, propose alternatives, or prototype desirable futures. Yet we do not present design as a liberating force per se. Given the clear systemic problems and reactionary politics within the design establishment, we do not claim designers are by definition self-sacrificing idealists who strive only for the public good. In fact, we also look at design activists who change allegiance depending on circumstances, including personal and political opportunity. And we look at designers' acts of dissent that are coopted by or siding with entities which they initially opposed.

Our approach comprises multiple disciplinary perspectives, including design studies, visual studies, urbanism, architecture, aesthetics, communication, media and technology studies, political science, anthropology, and sociology; assumes qualitative research methodologies based on the analysis of case studies from around the globe, and offers responses by two scholars: US-based sociologist James Jasper, whose work has focused on the cultural and emotional aspects of social movements, and Brazil-based Zoy Anastassakis, who is trained in both anthropology and design. Through these frameworks, we investigate the relationship in recent decades between design and dissent from two different but converging trajectories.

A Converging Two-Directional Inquiry

The first trajectory through which we will analyze the relationship between design and dissent is that of social movements. Since entering a pivotal new era beginning with the WTO protests ("Battle of Seattle"), theorists of social movements have noted a "diversity of tactics"[14] and "new languages" taking place in protest.[15] This trajectory includes imaginative and creative forms of protest, such as street performance, puppet theater, and encampments, while revealing a new type of political organizing that differs from hierarchical structures of the past, which had emerged out of contention toward state politics.

The second trajectory comes from the domain of design. In the new millennium, interest in activism has been revitalized among designers, who are not only active participants in social movements but also developing their own designerly responses to the sociopolitical realities of our era, from anti-consumption and sustainability efforts to various causes both integral and exogenic to design.

Of course, these two types of creative political praxis merge in that they are mostly collective, participatory, relational, process-oriented, and open-ended; finished artifacts

are not always the primary goal. Most important, these approaches to design are happening not in studios but on the streets, in public squares or communal places often reclaimed through direct action, connected with practices of solidarity and generating new forms of citizenship. Numerous books show the creative aspects of political dissent and rightfully blur the boundaries between these two areas of dissenting practice.[16] Austerity measures, for instance, are fought both by going into the streets to demand fiscal policy change and by developing self-managed platforms of solidarity; gentrification is challenged through both opposition to zoning regulations and communal action at reclaimed sites. Designers, architects, and urbanists—whether through community boards, transnational organizations (such as the World Social Forum), or participation in urban activism— play significant roles in both domains of dissent.

Yet one cannot overlook a division in the scholarly analysis: social movements are scrutinized mainly by political and social theorists, while design activism falls within the purview of design or, when dealing with the city specifically, of architecture and urbanism. In contrast, this book—although written mostly by design scholars—grapples with both domains, offering discourses on social movements; political design, architecture, and urbanism: and the productive intersections of the two fields.

Design Discourse on Activism and Dissent

Design scholars provide crucial insights on design activism, taking into account broader sociopolitical frameworks. In examining "the work of designers, sometimes with their clients, to frame and act on the need for change through their design work,"[17] Ann Thorpe has emphasized the difference between generative and conventional repertoires of political action, particularly in anti-growth and sustainability movements. She has made insightful analogies between sociological concepts such as the notion of events and "repertoires of action" (developed by Charles Tilly and Sidney Tarrow) and the activist tactics of designers, focusing in particular on what designers "know how to do," such as "competitions, visualizations and design services."[18] Guy Julier, meanwhile, sees design activism emerging in response to the recent crisis of neoliberalism and views it through the prism of political economy and value creation. Based on Marxist geographer David Harvey's assertion that in the condition of neoliberalism, capital chases sources of value caused by "surplus liquidity,"[19] Julier finds that not only design but also design activism seeks "to mobilize underused assets, leverage enthusiasms, and generally look for future sources of value."[20] To Julier, unconventional political behaviors such as occupations and boycotts are descended from the postmaterial ethic of the 1970s[21] while also akin to the Zapatistas' declaration that "another world must be made."[22]

Inspired by Chantal Mouffe's ideas on agonism and her distinction between politics and the political, Carl DiSalvo has presented the concept of "adversarial design," elaborating an analysis of interactive design and mapping projects that "prompt recognition of political issues and relations, express dissensus, and enable contestations claims and arguments,"[23] instead of directly proposing solutions or political messaging. Thomas Markussen has discussed design activism through Ranciere's distinction between politics and the police, and his notion of aesthetic disruption,

exploring how design "lends its power of resistance by being precisely a *designerly* way of intervening in people's lives."[24] Markussen sees urban activism as a disruption of socioculturally entrenched forms of belonging in and inhabiting the everyday world.[25] Asking similar questions, my own work on anti-Olympics action also found a wide array of designerly modes of dissenting, although with greater emphasis on non-expert designers and "material actions that might not be conventionally understood as design."[26] I investigated not only the making but also the un-making of the Olympics, including "embodied sociotechnical practices" of dissent, especially public disruption and "prefigurative habitus."[27] Mahmoud Keshavarz, too, examines non-professional designers' work, in his work on "forged passports as material dissent,"[28] which reveals that the world not only is "articulated through a series of material making" but also can "be disarticulated or rearticulated through the same capacity."[29]

Several other thinkers address resistance born of material action by looking at the production of space, urbanity, and territory in the world's capitals and peripheries alike. The anthropologist Arturo Escobar recently addressed the role of design in "world making," advocating for the type of autonomy and pluralism in design he saw in the decolonializing efforts of Afro-descendants in Latin America.[30] In the tangential field of critical urbanism, Margit Mayer, David Harvey, Neil Brenner, and Erik Swyngedouw have assessed the impact of "right to the city" movements (which often unite a wide array of practitioners from DIY urbanists to green guerrilla activists), focusing on the surrounding capitalist conditions and the limited potential for change amid the regurgitated forms and operations of neoliberal governance.[31]

While institutions are slow to recognize non-professional domains of desgn, an extraordinary institutional recognition of the relationship between design and social movements was by the Victoria and Albert Museum. Its 2014 exhibition *Disobedient Objects* displayed art and design artifacts produced mainly by social movement activists from around the world, rather than by professional designers.[32] Bringing forth the untold story of objects that participate in protest revealed them as instruments of empowerment rather than simply as props, thus deconstructing the stereotype of social movements as violent or, from an aesthetic perspective, naive. Most of the disobedient objects were repurposed everyday objects: pans used to make noise during street protests in Argentina, plastic water bottles used as makeshift gas masks by activists from Istanbul to Ferguson, Missouri. By coalescing contributors from across the domains of design and social studies, the exhibit catalogue bridged the two disciplines an aim that the present book shares.[33]

Social Science/Political Philosophy Discourse on the Material

As design scholars became more interested in the convergence between design and dissent, scholars of social movements were paying increasing attention to the material and emotional dimensions of protest. Early work by sociologist and historian Tilly, for example, focused on contentious politics in 18th- and 19th-century Britain and France, identifying historically appropriate repertoires such as "breaking windows, attacking pilloried prisoners, tearing down dishonored houses, staging public marches, petition, holding formal meetings, organizing special-interest associations."[34] For Tilly,

> the word *repertoire* identifies a limited set of routines that are learned, shared, and acted out through a relatively deliberate process of choice. Repertoires are learned cultural creations, but they do not descend from abstract philosophy or take shape as a result of political propaganda; they emerge from struggle ... At any particular point in history, however, [people] learn only a rather small number of alternative ways to act collectively.[35]

Tilly proposed systematic ways of viewing such actions as repertoires, and later focused on the spatial aspects of dissent—in particular, the geography of policing, the notion of safe spaces, spatial claim making, and control of places as stakes of contention.[36]

Jasper continues Tilly's legacy, shifting scholarly attention from the structural and historical paradigms of protest toward notions of creativity and agency, culture and meaning. For Jasper, culture "consists of shared mental worlds and their perceived embodiments": words, rituals, events, artifacts, and artworks that carry "symbolic meaning."[37] He is particularly interested in how artifacts arouse "cognition, morality, and emotion"[38] that—overlooked by the earlier sociologist's work—function as "micro-foundations" of political action. These notions are particularly pertinent in "post-citizenship movements" created by constituencies who already have basic political rights, unlike the citizenship movements (mainly national) formed in the era of industrial expansion "by and on behalf of people who were excluded in some way from full human rights, political participation, or basic economic protections."[39] Post-citizenship movements are extended by "people already integrated in their society's political, economic, and educational systems,"[40] who pursue "'post-industrial' or 'post-material' aims like protection of the environment, peace, and disarmament" or even "lifestyle protections and animal rights"—seeking justice for others and "changing their society's cultural sensibilities."[41]

Global Justice Movements and Beyond

The late 1990s saw the rise of "the movement of movements": the global justice movement (GJM), which developed "to contest the nexus between global economic and global political elites in fostering capitalist globalization and the negative effects of these processes on communities around the world and the environment."[42] Collective action became transnational, intensified, and diffused. Along with "a new propensity for 'taking people to the street,'" sociologists Tarrow and Donatella Della Porta soon saw new forms of civil disobedience "produc[ing] major innovations in the existing repertoire"—a combination of "educational campaigns, comic presentations, and attention to the mass media, stressing not only the power in numbers but also the importance of the presentation and diffusion of the message."[43] Anthropologist David Graeber identified a "link between the actual experience of first imagining things and then bringing them into being" and "the ability to envision social alternatives"[44]—an essential anti-alienating condition inherent in these new repertoires of dissent. Yet social science research has not provided in-depth analyses neither of the origins, modalities, and expressive languages of these repertoires, nor the agency and affordances they provided.

In the 21st century, new forces of oppression and modes of opposition have yielded a new generation of social movement research. This is an era of new wars,

austerity measures, totalitarianism, populism, racism, and near-complete ecological disaster. The world also sees the return of what Giorgio Agamben has called "bare life," marked by increasing housing and work insecurity, labor exploitation, climate and war refugees, and aggressive nationalist and ultra-right groups' on vulnerable populations. At the same time, an expanded consciousness of rights and demand for legal and symbolic recognition has propelled movements by marginalized communities—people who identify as indigenous, black, sex workers, women, transgender, or ethnic or religious minorities—that can now connect globally and transnationally. Renewed interest in political organizing has become a force even in nations where labor unions, and strikes had become all but obsolete. One key difference of these recent movements, such as the Spanish 15-M, "is a re-engagement with the state and the direct appeal to state institutions and laws as the basis of claims and demands (as opposed to abstract principles or ideologies)."[45] Unlike the early GJM, political action is becoming more direct, dealing with ordinary citizens, local issues, and neighborhood assemblies.[46]

From the "Movement of the Squares" to Commoning and Municipalism

Whether or not the various public space occupations that spread globally starting in 2011 comprised a single "movement of the squares," these protest camps did express solidarity and referred to each other as important sources of inspiration,[47] creating a historical moment that captured the attention of both designers and social scientists. Employing creative forms of contentious action at sites of experimentation for new forms of governance and social imagination, the camps drew a lot of scholarly attention, including from disciplines that do not traditionally deal with materiality. Political scientists, media theorists, and cultural anthropologists—recognizing a genealogy of dissent practices in protest camps[48]—have focused on the ways horizontality, transparency, and direct democracy are put into action though "popular assemblies" and task forces that work on the basis of alternation.[49] In a comprehensive study of the protest camp prototype as a distinct form of resistance, Anna Feigenbaum and colleagues explored the mutual formulation of material infrastructures of support and processes of collective identity formation and embodiment. Despite highlighting the processes of horizontality, their work also found formal and structural affinities between protest encampments and hierarchical social forms like military camping and the Scouts.[50]

In contrast to the "political process model" of US-based social scientists like Tilly, McAdam, Tarrow, and Jasper, Cristina Flesher Fominaya's genealogical approach debunks the myth of the squares' spontaneity, pointing to 1980s Spain and the evolution from the autonomous movement to the Indignados—the gradual introduction of new repertoires "of deliberation and consensus decision-making, such as the fishbowl method" introduced to the national assembly in 2003.[51] Eduardo Romanos and others highlight the irony and humor in handwritten placards and events like the aerobics assembly or the funeral for democracy, which "served to facilitate emotional union within the group [and] attract media attention," while also mitigating "the fatigue-related costs of activism [and] consolidat[ing] an alternative political identity."[52] Francesca Polletta reveals a genre of performative deliberation with roots in direct democracy's "formal roles in the process—timekeeper, stacker, facilitator, vibes watcher—and sophisticated hand signals."[53] The "people's

8 *Jilly Traganou*

mic" is another embodiment that became a hallmark of the movement—a "collective amplification of individual voices in public gatherings" that reflects on "the conditions of possibility of communication ... in an open, unscripted environment."[54]

Academics also have inquired about the distinct role of visuality in these protest sites, such as https://wearethe99percent.tumblr.com/, which constructed the 99% as a political constituency through both narrative and visual means. In addition to books uncovering how these movements developed via social media and digital platforms, edited volumes and journal special issues compiled dispatches, essays, blog posts, and images from the camps, examining these phenomena immediately after they erupted.[55] This "chorus of voices"—theorists, journalists, political analysts, writers, polemicists, photographers, organizers, activists—reflected the mix of disciplines and subjectivities within these new protest sites.

Alongside the squares, other occupied spaces proliferated as sites of protest, through processes of commoning and prefiguration, as with Embros Theater in Athens and *ESDI Aberta* (Open ESDI) in Rio de Janeiro (discussed in this book). By connecting the dots from these temporary occupations to the re-emergence of municipalism in Spain and the Transition Towns, this book captures some of the trajectory from squares to communal sites to forms of urban governance.

Putting the Imaginal and the Material into Action

It is no surprise that social scientists and political philosophers are renewing their tools as they examine these movements and propose action. *Feminism for the 99%*, a manifesto of anti-corporate feminism, advocates for established modes of political action (such as strikes) while also inquiring about notions of care in today's capitalism.[56] Feminist philosopher Chiara Botticci looks at the "imaginal" as a condition both individual and social, a capacity that offers freedom "when the mechanisms of domination break down and the new breaks in."[57] The primordial, prelinguistic dimension of Botticci's imaginal is not so different from the pre-signifying, affective dimensions of design, where also the "new breaks in" and the struggle for emancipation from "mechanisms of domination" occurs, whether against physical environments that exclude disabled bodies or top-down rezoning that displaces residents. From the perspective of materiality, according to feminist theorist Elizabeth Grosz, freedom is conceived not negatively "as the elimination of constraint, but in terms of a 'freedom to,' a positive understanding of freedom as the capacity for action."[58]

The Book's Two Sections: Dissent as/through Design

Reflecting this two-directional inquiry—but also challenging it—the book is divided into two sections. Section 1 looks at social movements as agents of design: how design is employed in processes of dissent. The chapters in Part 1 of this section focus on the production and use of design *during the protest*, and Part 2 looks at acts of archiving, commemorating, and learning from artifacts and material processes—the afterlife of protest.

The objects and visuals explored in Section 1 come from the green revolution of Iran (in the chapter by Victoria Hattam) ... anti-austerity protests in Slovenia (Ksenija Berk) ... opposition to the One China policy in Hong Kong, Macao, and

Taiwan (Kyle Kwok) ... Afro-Brazilian claims of recognition after the Rio de Janeiro Olympics (Barbara Szaniecki and Ana Helena da Fonseca) ... post-citizenship movements for women's rights in Trump's America (Grace Van Ness and Prakash Krishnan), and disability activism in Sweden (Otto Von Busch and Hanna af Ekström). The artifacts that emerge are exuberant: colorful flags and textiles, zombie masks, digital memes, full-page ads, "retarded dolls," beer bottles, subversive signs, hand-drawn posters, banners, archives, that coalesce memories and territorialize anew. These are not inanimate objects, but things and edifices that speak, commemorate, satirize, mock, and incite. They have the power not only to express but also to animate political passions. They spring to life in public spaces of high visibility or interaction, in digital domains, and in other public media. And they offer a glimpse of the "front end" of designing—as in the props used in workshops of creative resistance (Evren Uzer).

The protesters' ultimate goals vary, from political reform, independence, and regime change to new legislation and politics of recognition. While materiality is not necessarily at the root of the protest action, materialization often becomes indispensable in preparing the protest. As people go to the streets to call for change—or to embody their indignation, rage, or suffering—spaces, materials, and visuals become both allies and points of connection with others. And as these material entities and domains help protesters express emotions, obtain new power, become more than a crowd, and awaken audiences, they become actors on their own rights. These artifacts speak to each other, generating patterns and new emotions even when the protesters have left them behind. How many of us have picked up an abandoned political relic from the street?

Some Section 1 contributors talk with the makers of protest artifacts or attend their deliberations; they learn about the motivations, imaginaries, methods, tactics, and uses of space. Others concentrate on what happens during the protest or on the opportunities that open up when protest images are disseminated. Some chapters analyze how the dissenting artifacts embody tropes of dissent, from humor and satire to bluntness, melancholia, or monstrosity, as they theatrically and viscerally speak truth to power no less potently than verbal messages. And some contributions look at collections of protest artifacts or spaces of commemoration intended to mobilize further change—archival efforts that help us discern patterns of visual languages and tactics used in protest cultures, and build knowledge that inspires new forms of action.

Section 2 looks at dissent generated through acts of material engagement, mobilized directly by designerly inquiry and action—that is, at design's capacity to act politically, through a variety of design actors, from professional designers, architects, and urbanists to media makers, hackers, artists, urban farmers, and craftspeople.

This section, too, is divided into two parts. Part 1 scrutinizes political contention generated by acts of designing: from boats that transgress borders as populations flee across the Mediterranean (in the chapter by Mahmoud Keshavarz) and drones that collect data on the corporate deforestation of indigenous Indonesia (Alessandra Renzi), to a crowd-sourced hologrammatic protest against constitutional changes in Madrid (Ksenija Berk) and community-engaging urban actions in Denmark (Thomas Markussen). In each case, the process of designing—from conceiving and planning to realizing and using—fuels civil disobedience or contestation, in events that carefully navigate the line between legality and illegality.

Part 2 focuses on spatial agency, with various communities of designers, artists, and non-experts using space for ongoing processes of contestation or prefiguration (rather than one-off events). The authors describe how space is used tactically or strategically to afford specific opportunities and make certain claims, whether concerning that particular location (as with an occupation of São Paulo's Minhocão highway to oppose gentrification, discussed in Samson's chapter), or taking advantage of fissures in the urban fabric (as with new opportunities for disenfranchised communities in an abandoned São Paulo viaduct space, also in Samson's chapter). These are longer-term actions in spaces reclaimed as sites of free expression or alternative pedagogies—differential spaces that restore unity "to what abstract space breaks up"[59]—and activating them requires processes of commoning.[60] Their size and scale vary, from an ethnic restaurant in Pittsburgh (Verónica Uribe del Aguila) to the Embros Theater in Athens (Orsalia Dimitriou) to a school in Rio de Janeiro (Zoy Anastassakis et al.) to the self-reliant Transition Towns (Emily Hardt). Within these spaces, designerly acts unfold: the making of objects (menus, signs, bubbles), the assemblage of heterogeneous elements, or engaging in permaculture.

Some of these efforts belong to what Carl Boggs called "prefigurative politics": the embodiment, "within the ongoing political practice of a movement, of those forms of social relations, decision-making, culture, and human experience that are the ultimate goal."[61] What distinguishes prefigurative political processes from others that grow out of political disagreement is their aim to not just oppose a given condition, but also build a preferred one. To sociologist Wini Breines, strategic politics (such as those reflected in Section 1) display a "commit[ment] to building organization in order to achieve power so that structural changes in the political, economic, and social orders might be achieved,"[62] while prefigurative politics offer living examples of alternative social formations that have "embraced the 'concept of community'" and that "embody the desired society" of the future.[63] Conceived to produce change rather than merely demand it, most prefigurative projects are difficult or impossible to scale up, and do not manage—or even attempt—to achieve wider political change in the immediate future. Thus they are often criticized as micro-utopias or even acts of escapism.

What is important for this book, however, is that the action of design in prefigurative action is a "value-oriented" factor. The design produced in these realms has embedded value in striving toward a desirable situation, even if temporarily, or in small scale. Instead of a means to express a political message (e.g., a poster), an instrument of protest (e.g., a protective device), a specific solution (e.g., artifacts of survival), or something with no subsequent use, prefigurative politics employ the "politics of the act" (described below) in building "alternative cultures and societies."[64] In the context of the left, prefigurative political acts offer a glimpse of "what democracy looks like," creating "forms of the common different from the ones on offer from the state, the democratic consensus, and so on."[65]

*　*　*

By cross-fertilizing design, architectural, and urban discourse with sociological approaches to dissent, we strive to improve understanding of a topic that is currently understudied in examinations of social movements, while also expanding the scholarship of design that has focused primarily on design activism. In this book, we place a magnifying lens over the production of artifacts in dissent—what designers would

call ideation, prototyping, testing, and making—a process that in the production of dissenting design is not as orderly as in other types of design. We analyze the aesthetic languages and tropes that are employed in the artifacts and processes of design in dissent; shed light on the broader lifecycle of such artifacts; and we show how the agency of both space and materiality is activated and infused into acts of dissent. Most important, we demonstrate that this capacity for creative dissent is not limited to professional practice, but is evident also in the work of nonprofessional designers in acts of political activism. From community recyclers to refugee boat makers to disability activists to zombie protesters, these "invisible" designers display the same determination and resourcefulness as their trained counterparts. Although their products and actions may not be made with longevity in mind, they contain the seeds of a desirable future.

Public Spaces, Claims, Actions, and Programs

A broader note on the notion of the public, as both a physical and a conceptual realm of political deliberation, claim making and action, is warranted. The case studies presented here make it clear that different spaces of contention evoke different political claims—or vice versa, that different types of politics need different spatial settings to accomplish their goals. There is a major distinction between the type of politics that unfolds in public space, or the "'public sphere,' as an arena of political deliberation and participation"[66] that emerges between civil society and the state,[67] and the type activated in communal sites, or interstitial spaces of civil society that are not necessarily associated with the state. This could happen either because their claims might be labeled as pre-political or nonpolitical, or because the protesters are excluded from state politics and therefore have no opportunities for public recognition.

Section 1 describes social movements and protests that play out typically in public spaces, mostly as part of a category of "collective political struggle," which Tilly calls "transgressive contentious politics." For Tilly, such politics involve "newly self-identified political actors," and parties that "employ innovative means of collective action."[68] Transgressive contention "more often disrupts existing spatial routines in its setting, and more often involves deliberate occupation, reorganization, or dramatization of public space."[69] Indeed, all the protests described in Section 1 involve dramatization in the public realm, including in social media or traditional media platforms.[70]

Most case studies in Section 2, on the other hand, take place in communal or private settings, and their claims are typically not to the government of the land. Instead, grievances target multinational corporations (Indonesia), the real estate industry (Brazil), a public institution or subset of the state (Denmark, Brazil), or transnational politics and organizations (Africa and southern Europe). And in some cases, such as Conflict Kitchen (United States) and Embros Theater (Greece), there is even an absence of a claimant—no direct demand, no anticipated response from a power-holder, no sense of closure imparted by an outside authority. The work to be done is primarily internal. Only during a second stage might such projects expand into the *polis*, usually as the result of reflection or upon reaching a tipping point. Some of these projects might head to the periphery, reaching out to those who are left out of mainstream political conversations, as with the architectural pedagogy project Escola

sem Muros in São Paulo's suburbs. In that way, these events resonate with what anthropologist James Holston has called "sites of insurgent citizenship."[71]

It is important to note that the projects examined in the book were not commissioned by formal public institutions or governments as part of the "new culture of public sector innovation," considered by Julier as belonging to the field of design activism.[72] The work is, however, close to what Thorpe names more openly "public interest design."[73] The *ESDI Aberta* movement in Rio, despite being part of a state-owned university, developed when the school's faculty and administrators went on strike, and not through a governmental mandate. Yet the participants' outreach to newcomers through events and publications endeavored to elevate the pedagogy that was evoked in the process to a matter of public interest, while the activities within the movement could conceivably be incorporated into a future curriculum. In the same city, the substantive debates on the Museum of Slavery are also intended to result in the creation of a project of public interest.

Nevertheless, some of these projects are at times co-opted by the state, the market, or other claimants, and often those who participate or initiate them do not act for pure political reasons. The case of the Bureau Detours' DENNIS Design project illustrates the political limitations of design activism within the neoliberal context. Not only has the right to the city become more and more of a bourgeois prerogative,[74] but new forms of neoliberal governmentality are also "narrowing, if not suspending, the space of the properly political."[75] Thus, following objections expressed by critical urbanists, one might say the search for the interstitial and the communal (rather than the public stage) is also often a retreat from (or at least symptomatic of) the eroding public arena. This type of action, absent a broader view of undemocratic politics, renders dissenting movements or acts even more vulnerable to corruption by the constantly regenerated neoliberal forms of governance and operation. It often gives activists the illusion of participation in the decision-making process, without however resulting to other types of improvements.

The degree of participation by civil society and right to the city groups in the processes and institutions of "collective consumption," which was once the state's domain, has increased and been operationalized through what urbanist Margit Mayer has called a move "from protest to program"; "formerly alternative community-based organizations" have now become "professionalized" and inserted into "new strategies of neighborhood revitalization and activation,"[76] expressing a type of "neoliberalism with a human touch."[77] At the same time, groups whose aims are not satisfied by or included in such programs, or whose members are ideologically opposed to the state or a government, become more radicalized and refuse to take part in such forms of collaboration.

Politics of Demand, of Counterhegemony, and of the Act[78]

Three threads of political modality crisscross the book, and design occupies a different role in each modality.

The first thread, *politics of demand*, appears especially in Section 1: Protesters in Slovenia demand a new fiscal policy. Protesters in Madrid demand a change to the law. Disability activists demand a change in the policies that determine the space and materiality of their city. The role of the designer in the politics of demand is usually to communicate or articulate the demands in visual, digital, or material

forms. Although one might say this role is auxiliary, remember that artifacts (e.g., zombie masks, green fabric) carry and acquire agency when out in the open, while of course, communication—their main role in the protest—is crucial to the unity and visibility of any social movement.

The designer often also sets the stage where the claims will be expressed. According to Rancière, for whom dissensus is the only possibility in democracy, there is "conflict over the existence of a common stage and over the existence and status of those present on it."[79] Disrupting the "police order," and disputing who is included and excluded from the "polis," is a precondition for politics.[80] Creating the space for the stage is a significant contribution. Designers featured here open up new stages, using not only squares, streets, and social media (where public disagreement is ordinarily vocalized), but also newspaper ads that advertise revolution, restaurants, parking lots, and bars where contentious politics are not routinely anticipated and where unpredictable encounters and political dialogue are being seeded by design.

Politics of counterhegemony (the second thread) are also present, in chapters where design provides new symbols of identification that change the game. If hegemony is the creation of dominating systems of thinking and acting, counterhegemony is activated by ideas and discourses that challenge these beliefs and norms. This terrain is not always rational; for Mouffe, passion and affect are instrumental elements in the process of identification. By rearticulating symbolic resources and configuring new ones, designed artifacts both comprise and mobilize new counterhegemonic political practices and languages of communication. Counterhegemony emerges precisely because of the rearticulation of the "vast area of floating elements ... in opposing camps."[81]

Some groups we encounter in the book act intentionally in a counterhegemonic way, and even seek opportunities to seize political power. Thus, parties that are antagonistic to government policies and politics may stir up protests, like the anti-neoliberalism and anti-austerity demonstrations in Spain and Slovenia. But post-citizenship movements also rise up to become political actors in formal electorate politics, such as the disability activist group GIL that proposed a candidate for mayor of Gothenburg, Sweden.

Politics of the act are the third thread of political modality, carried by affinity groups that are characteristic of new social movements such as alterglobalization and Occupy. Skeptical of both liberalism and hegemony, affinity groups are founded on shared commitments and values rather than on duties that derive from notions of citizenship within the state. Formally, even though an internal dissensus is practically unavoidable, they appear to be the exact opposite of the dissensus-based social bodies advocated by Mouffe (who indeed has been critical of movements like Occupy and the Indignados for their refusal to engage with representative politics).[82] According to sociologist Richard Day, affinity groups are task-specific and consensus-driven, and are oriented toward achieving maximum effectiveness with a minimum of bureaucracy.[83] Such groups typically consist of between five and twenty individuals, though the model is extendable "to larger groups and non-statist federations."[84]

In this book, affinity groups are encountered in the Embros Theater, *ESDI Aberta*, and Transition Towns cases. Their value "lies not only in achieving political efficacy and organizational efficiency, but in building alternative cultures and

societies—alternative subjectivities and ways of being."[85] Affinity groups do not depend on concessions, and are not positioning themselves within a protectionist state or demanding improvements from it. Rather, they "break out of the loop" of a consistently unsatisfied fantasy of demand[86] to act for themselves. Where design plays an important role, even though the members of affinity groups may not be conscious of it, is in the enactment of an empirical social experimentation. Experiments of "radical empiricism" stress the capacity of the materiality of bodies and things in creating collective bonds beyond the symbolic. Affinity groups often begin designing alternative social formations in interstitial sites rather than public spaces and institutionalized forums.

Design truly occupies a separate role in each of these three modalities. It is employed in service to politics of demand by using its communicative capacity to express and unify, as in the green color of Iran's insurrection. It becomes a means of reconfiguring "floating elements" to producing new counterhegemonies—as in how the DENNIS Design Center undermined the authoritative Danish Design Center and mobilized a radical, and by now a new dominant idea of design as community engagement. Last, the "unseaworthy" boats carrying immigrants to safety, as well as the prefigurative socio-material practices in reclaimed spaces, are evocative of politics of the act.

Yet links and synergies between the three modalities are possible and might also happen by design. Against the odds, ideas that started as micro-utopias—Occupy, Indignados—can scale up to counterhegemonic configurations such as those of the municipalist parties in Spain (*Barcelona en Comú* and *Ganemos Madrid*), or political platforms such as the Green New Deal in the United States. Talking specifically about the civic politics of the squares, for instance—which are typically seen as emblematic of politics of the act and are criticized as failing to achieve counterhegemony—Alexandros Kioupkiolis found that in fact they "combined hegemony with horizontalism, and … turned the scales in favour of plurality, egalitarianism, and decentralisation through new modes of unification."[87] This is in agreement with various thinkers who envision politics of the act and counterhegemony as supportive of each other.[88]

By acknowledging the importance of materiality in dissent, we are also reminded that politics of the act create new political subjectivities. The 99%, a familiar protagonist of various movements today, emerged out of Occupy. The concept evolved through processes of identification (rather than through the resurrection of established identities) on many fronts, such as the feminist movement or the right to the city. Very often, the necessary unity coalesced through an emphasis on material practices (practices of care, homesteading, gardening). Bracketing these as practices of resistance has become a way to uphold many of these movements.

What This Book Proposes

This book is intended to spotlight processes of design that are inherent in contentious political action, in order to create a sharper picture of the potential role of materiality as an agent of dissent. As each chapter reveals, design is not simply crystallized in artifacts, but evolves through practices of material engagement, and expands from global epicenters of political action to myriad places of the everyday. Design manifests as a capacity of production, as much as a secondary production

in assemblages of things and non-things in the realms of use, appropriation, and artifacts' afterlives.

The framework below includes a set of twelve lenses that future researchers can use to better understand the expansive and distributed trajectory of design. Not all of these lenses are addressed in the book, and certainly this list is not exhaustive:

(1) Production and Process: Assume an inquiry on praxeology, and consider creative dissent by focusing on its process of production. Does the design of artifacts follow clear methods from the conception of a product to ideation, prototyping, testing, iterating, and crafting (as those found in professional design)? How are these processes different for nonprofessional designers or among designers with mixed expertise? What are the techniques, modalities, and technologies of production?

(2) Authorship: What happens when authorship shifts from the individual designer to the collective? How does work in creative resistance contribute to designers' or political subjects' careers?

(3) Organizations and Labor: Dissenting practices range from cooperative and communitarian to entrepreneurial and even professional. Is there a distinction between work for creative dissent and creative labor? What are the economies of creative labor? Would the labor of creative dissent defy the conditions of exploitation within which creativity has historically operated? How does dissenting design relate to patterns of work in the neoliberal context (speed/production, flexible accumulation, precariousness)?

(4) Tropes and Modalities: Understand the tropes and modalities through which materialized dissent is activated and evokes disagreement, including appropriation, hacking, subversion, humor, monstrosity, tactical responses to disciplinary apparatus, and reclaiming or occupying space.

(5) Spatialities and Geographies: Examine the spaces of dissent, either material or mediated—public, communal, or private. What are their geographies or network arrangements? Are border conditions or Global North/South divisions conducive to understanding dissent? How do different spaces allow for different types of dissenting practices (from public claims to community empowerment, insurgency, or claims to autonomy)? How do notions of differential space (Lefebvre), public sphere (Habermas), civil society (Marion Young[89]), and commoning (Federici, Caffentzis) contribute to the understanding of space in dissent?

(6) Assemblages, Networks, and Meshwork: Examine the connections and relationships between human and non-human agents, and among things themselves (Latour, Ingold[90]). How are morality and agency distributed among these actors (Bennett)?

(7) Practices and Habitus: Consider how material forms and practices of dissent are performed, disseminated, adopted, and adapted in various contexts. How do these practices travel across territories? What types of habitus support the materialization of protest (Bourdieu,[91] Crossley[92])?

(8) Afterlives: When and how do the objects of protest become commodified, trivialized, or commemorated? What do museums or collections do to disobedient objects? What are the new politics emerging after these objects are produced (Yaneva)?

(9) Affect and Emotion: What kind of affective domains are generated through material practices? How do objects "stick" during and after dissent (Ahmed,[93] Feigenbaum)?
(10) Political Regimes and Intent: Do political artifacts point toward specific technopolitical frameworks that might be system-centered or human-centered (Winner, Mumford[94]), strategic or prefigurative (Breines), radical or reformist (Young[95])?
(11) Time and Ecologies: What broader temporal frameworks and ecologies of practices (Stengers[96]) are evolving through and after material practices of dissent?
(12) Ontologies of Designing: What new ontologies are emerging from artifacts and material practices of dissent? How are these artifacts and practices in turn designing us, their subjects (Willis[97])?

This book is not meant to insist that all designers be politically minded or involved, even though the contributors do share a belief that all design acts politically. Yet a broader scaffolding of possibility in processes of contention—from demands to counterhegemony to politics of the act or prefiguration, from public spaces to interstitial sites, from protest to programming—can help generate questions about what else can be done, where energies could be channeled, and whom we might work with in continuation of any design process that has to do with change.

If this volume promotes any sense of advocacy, it is for greater acknowledgment of the unpredictable, uncontrollable agency of design and designing—for more convergence between designers and social movements, and for new multidisciplinary methods for understanding and acting through political creativity. And the areas for further research not addressed in this book, requiring multi-, inter-, and transdisciplinary approaches, are plentiful.

What does design bring to social movements? Specific crafts, techniques, methods, and a range of actions not routinely used by social movements … a propinquity to innovation that opens up new possibilities of mobilizing or bringing attention to dissent … an eagerness for direct action that goes beyond the symbolic to provide immediate, even if temporary, solutions … an understanding of the iterative aspect of change … an awareness that dissent need not happen only at moments and sites of protest, but in the everyday sphere or in sites of solidarity, insurgence, and prefiguration.

And what do social movements bring to design? The imperative of collectivity and embodiment … a suspicion of solutionism … a necessity to connect and assess methods, tactics, and objects of dissent in light of broader ethics and goals of change … an awareness that change requires work on multiple fronts that much exceed material needs and affordances … an understanding that one needs to see action in an array of efforts … a recognition of the value of organizing.

All the above are necessary to both do and undo, to create spaces of justice and fight against injustice, to generate glimpses of the imagined and set up conditions that will allow expansion of such visions on a larger scale.

Acknowledgments

I am indebted to Victoria Hattam, Miodrag Mitrasinovic, Barbara Adams, and Mahmoud Keshavarz for their feedback at various stages of this introduction's

writing; Amy Dorta McIlwaine and Anna Matthiesen for their thorough work in copyediting, and Blake Roberts for editing the images; all the book's contributors as well as Anna Feigenbaum, Mark Frazier, and Anooradha Iyer Siddiqi for peer reviewing; and Routledge's Isabella Vitti and her assistant, Katie Armstrong, for their encouragement and guidance. The book was supported by generous funding from Parsons School of Design, for which I am grateful.

Notes

1 This protest was related with the *Mattress Performance* (2014–15), an endurance project by Columbia University art student Emma Sulkowicz, demanding that the university expel a fellow student who allegedly raped her in her dorm room.
2 I am referring to a variety of movements, from the global justice movement in the 1990s that emerged with the rise of globalization, to the subsequent shift to local, autonomous movements in the 2000s.
3 Sociologists della Porta and Tarrow see "new targets, new frames, and new combinations of constituencies … producing major innovations in the existing repertoire" of protest after years of "more moderate tactics." Donatella della Porta and Sidney Tarrow, "Transnational Processes and Social Activism. An Introduction," in *Transnational Protest and Global Activism*, eds. della Porta and Tarrow (Lanham, MD: Rowman & Littlefield Publishers, 2004), 26. This is not to discount a genealogy of creative resistance, from the 1871 barricades of the Paris Commune; to anti-nuclear encampments from the mid-1950s to the 1980s; to the various creative acts of the 1960s (such as the May 1968 protests in France; the Students Movement in Mexico; the Civil Rights Movement, the Black Panthers breakfasts, the burning of Vietnam War draft cards, the feminists' Freedom Trash Can; and political theater in Europe and the US); to the Instant City at the International Council of Societies of Industrial Design (ICSID) Congress in Ibiza in 1971; to the squatters' movement starting in the mid-1970s in places like New York, London, Berlin, Turin, and Amsterdam; to Food Not Bombs, Guerrilla Girls, the AIDS Quilt, and ACT UP in the 1980s; etc. I am grateful to Barbara Adams for indicating a plethora of such earlier examples.
4 Chantal Mouffe, *Agonistics: Thinking the World Politically* (London: Verso, 2013), 66–71.
5 This term by Charles Tilly will be analyzed further below.
6 Such arguments have been made by a variety of thinkers, not always belonging to the same camp. Langdon Winner, "Do Artifacts Have Politics?" *Daedalus* 109, no. 1 (Winter 1980): 121–36; Jane Bennett, *Vibrant Matter: A Political Ecology of Things* (Durham, NC: Duke University Press, 2010); Bruno Latour, "From Realpolitik to Dingpolitik or How to Make Things Public," in *Making Things Public: Atmospheres of Democracy* (Cambridge, MA: The MIT Press, 2005); Albena Yaneva and Alejandro Zaera-Polo, *What is Cosmopolitical Design? Design, Nature and the Built Environment* (Farnham, UK: Ashgate Publishing, 2015).
7 Winner, "Do Artifacts Have Politics?"
8 Nigel Cross, "Designerly Ways of Knowing," *Design Issues* 3, no. 4 (1982): 54, referencing Herbert Simon, *The Science of the Artificial* (Cambridge, MA: The MIT Press, 1969).
9 Simon, *The Science of the Artificial*, 111.
10 Ezio Manzini, *Design, When Everybody Designs: An Introduction to Design for Social Innovation* (Cambridge, MA: The MIT Press, 2015), 37.
11 For Bruce Archer, design is "the collected body of experience, skill, and understanding embodied in the arts of planning, inventing, making, and doing." Bruce Archer, "The Three Rs," *Design Studies* 1, no. 1 (July 1979): 18–20.
12 Belief in the power of design to shape sociopolitical reality has been shared by various movements, from design reform in Victorian Britain, to the Bauhaus and Ulm in pre- and post-war Germany, to the Metabolists in 1970s Japan.
13 For Cross, there are "forms of knowledge special to the awareness and ability of a designer, independent of the different professional domains of design practice." Cross, "Designerly Ways of Knowing," 54.

14 Diversity of tactics includes "cultural work, popular education, and grassroots-community organizing," but also militant activities and property destruction. Janet Conway, "Civil Resistance and the Diversity of Tactics in the Anti-Globalization Movement: Problems of Violence, Silence, and Solidarity in Activist Politics," *Osgoode Hall Law Journal* 41, no. 2/3 (Summer/Fall 2003): 510, http://digitalcommons.osgoode.yorku.ca/cgi/viewcontent.cgi?article=1424&context=ohlj.
15 Graeber's "new language" of civil disobedience combines elements of street theater and festival, and originates from the Zapatistas and other movements of the Global South. David Graeber, "The New Anarchists," *New Left Review* 13 (2002): 66.
16 See, e.g., Pete Weibel, ed., *Global Activism: Art and Conflict in the 21st Century* (Cambridge, MA: The MIT Press, 2015), and Liz McQuiston, *Visual Impact: Creative Dissent in the 21st Century* (London: Phaidon Press Limited, 2015).
17 Ann Thorpe, "Applying Protest Event Analysis to Architecture and Design," *Social Movement Studies* 13, no. 2 (2014): 276.
18 Ibid., 283.
19 Guy Julier, "Introduction: Material Preference and Design Activism," *Design and Culture* (special issue) 5, no. 2 (2013): 146.
20 Guy Julier, "From Design Culture to Design Activism," *Design and Culture* (special issue) 5, no. 2 (2013): 232.
21 Julier, "Introduction," 147.
22 Ibid., 150, citing EZLN, "Ejército Zapatista de Liberación Nacional Communiqué," ("Zapatista Army of National Liberation Communiqué"), 2008, accessed March 10, 2020, www.elkilombo.org/communique-indigenous-revolutionary-clandestine-committee/.
23 Carl DiSalvo, *Adversarial Design* (Cambridge, MA and London: The MIT Press, 2012), 12.
24 Thomas Markussen, "The Disruptive Aesthetics of Design Activism: Enacting Design Between Art and Politics," *Design Issues* 29, no. 1 (Winter 2013): 38; original emphasis.
25 Ibid., 42.
26 Jilly Traganou, *Designing the Olympics: Representation, Participation, Contestation* (New York: Routledge, 2016), 6–7.
27 Ibid., 267–88.
28 Mahmoud Keshavarz, *The Design Politics of the Passport* (London: Bloomsbury, 2019), 87.
29 Ibid., 101.
30 Arturo Escobar, *Designs for the Pluriverse: Radical Interdependence, Autonomy, and the Making of Worlds* (Durham, NC and London: Duke University Press, 2018).
31 David Harvey, "The Right to the City," *New Left Review* 53 (2008); Erik Swyngedouw, *Designing the Post-Political City and the Insurgent Polis* (London: Bedford Press, 2011); Neil Brenner, Peter Marcuse, and Margit Mayer, eds., *Cities for People, Not for Profit: Critical Urban Theory and the Right to the City* (London and New York: Routledge, 2012). See also Margit Mayer, *Social Movements in the (Post)Neoliberal City* (London: Bedford Press, 2010); David Harvey, *Rebel Cities: From the Right to the City to the Urban Revolution* (New York and London: Verso, 2012).
32 Curated by Catherine Flood (July 26, 2014–February 1, 2015, V&A Museum).
33 The catalogue included, for instance, texts by art historian Julia Bryan-Wilson; anthropologist David Graeber; and interdisciplinary media theorist Anna Feigenbaum. Catherine Flood and Gavin Grindon, eds., *Disobedient Objects* (London: V&A Publishing, 2014).
34 Charles Tilly, "Contentious Repertoires in Great Britain, 1758–1834," in *Repertoires and Cycles of Collective Action*, ed. Mark Traugott (London and Durham, NC: Duke University Press, 1995), 26.
35 Ibid.
36 Charles Tilly, "Spaces of Contention," *Mobilization: An International Journal* 5, no. 2 (2000): 135.
37 James Jasper, "Cultural Approaches in the Sociology of Social Movements," in *Handbook of Social Movements across Disciplines*, eds. Bert Klandermans and Conny Roggeband (Berlin: Springer, 2010), 60.
38 Ibid.
39 James Jasper, *The Art of Moral Protest: Culture, Biography, and Creativity in Social Movements* (Chicago, IL: University of Chicago Press, 1997), 7.

40 Ibid., 7.
41 Ibid., 8.
42 Cristina Flesher Fominaya, "Debunking Spontaneity: Spain's 15-M/Indignados as Autonomous Movement," *Social Movement Studies* 14, no. 2 (2015): 149.
43 Della Porta and Tarrow, "Transnational Processes and Social Activism," 26.
44 Graeber, "The New Anarchists," 73.
45 Fominaya, "Debunking Spontaneity," 154; referencing Cristina Flesher Fominaya, *Social Movements and Globalization: How Protests, Occupations and Uprisings Are Changing the World* (London: Palgrave Macmillan, 2014).
46 For Della Porta and Tarrow ("Transnational Processes and Social Activism," 17), GJM were characterized by diffusion ("the spread of movement ideas, practices, and frames"), domestication ("the playing out on domestic territory of conflicts that have their origin externally"), and externalization ("the challenge to supranational institutions to intervene"). For Fominaya ("Debunking Spontaneity," 154), the European movements, on the other hand instead of "controlling the multinationals ... are concerned with controlling the politicians ... and reforming the democratic institutions."
47 Graeber, "The New Anarchists," 237.
48 Examples include the New Left sit-ins (1960s), Abalone Alliance's camps protesting the Diablo Canyon nuclear plant in California (1981), and Greenham Common Women's Peace Camp in Newbury, England (1982–85). For the last, see Anna Feigenbaum, "Written in the Mud," *Feminist Media Studies* 13, no. 1 (2013): 1–13.
49 See, e.g., Maria Kaika and Lazaros Karaliotas, "Spatialising Politics: Antagonistic Imaginaries of Indignant Squares," in *The Post-Political and its Discontents: Spaces of Depoliticisation, Spectres of Radical Politics*, eds. Japhy Wilson and Erik Swyngedouw (Edinburgh: Edinburgh University Press, 2014).
50 Anna Feigenbaum, Fabian Frenzel, and Patrick McCurdy, *Protest Camps* (London and New York: Zed Books, 2013), 161.
51 Fominaya, "Debunking Spontaneity," 148, 151.
52 Eduardo Romanos, "Collective Learning Processes within Social Movements: Some Insights into the Spanish 15M/Indignados Movement," in *Understanding European Movements: New Social Movements, Global Justice Struggles, Anti-Austerity Protests*, eds. C. Flesher Fominaya and L. Cox (London: Routledge, 2013), 214–16.
53 Francesca Polletta, *Freedom Is an Endless Meeting: Democracy in American Social Movements* (Chicago, IL: University of Chicago Press, 2002), 190.
54 Marco Deseriis, "The People's Mic as a Medium in Its Own Right: A Pharmacological Reading," *Communication and Critical/Cultural Studies* 11 (2014).
55 See Janet Byrne and Robin Wells, eds., *Occupy Handbook* (New York: Back Bay Books, 2012); Kate Khatib and Margaret Killjoy, eds., *We Are Many* (Oakland, CA: AK Press, 2012).
56 Cinzia Arruzza, Tithi Bhattacharya, and Nancy Fraser, *Feminism for the 99%* (London and New York: Verso, 2019).
57 Chiara Bottici and Rob Ritzen, "Imaginal Interventions: An Interview with Chiara Bottici," *Krisis* 2 (2017): 47, https://krisis.eu/wp-content/uploads/2017/11/Krisis-2017-02-Rob-Ritzen-Imaginal-Interventions.pdf. See also Chiara Bottici, *Imaginal Politics: Images beyond Imagination and the Imaginary* (New York: Columbia University Press, 2014).
58 Elizabeth Grosz, "Feminism, Materialism, and Freedom," in *Becoming Undone: Darwinian Reflections on Life, Politics, and Art* (Durham, NC: Duke University Press, 2011), 60.
59 Henri Lefebvre, *The Production of Space*, trans. D. Nicholson Smith (Oxford: Blackwell Publishers, 1991), 52.
60 George Caffentzis and Silvia Federici, "Commons Against and Beyond Capitalism," *Community Development Journal* 49, suppl. 1 (2014): i92–i105.
61 Carl Boggs, "Marxism, Prefigurative Communism and the Problem of Workers' Control," *Radical America* 11, no. 6 (Winter 1977): 99–122, 100.
62 Wini Breines, "Community and Organization: The New Left and Michels' 'Iron Law,'" *Social Problems* 27, no. 4 (1980): 422.
63 Wini Breines, *Community and Organization in the New Left, 1962–1968: The Great Refusal* (New Brunswick, NJ: Rutgers University Press, 1981), 6–7.

64 Richard J.E. Day, *Gramsci Is Dead: Anarchist Currents in the Newest Social Movements* (London and Ann Arbor, MI: Pluto Press, 2005), 35.
65 Jacques Rancière, "Democracies against Democracy," in Giorgio Agamben et al. (eds.), *Democracy in What State?* (New York: Columbia University Press, 2011), 80; cited in Kaika.
66 David Harvey, "The Political Economy of Public Space," in *The Politics of Public Space*, eds. Setha Low and Neil Smith (New York: Routledge, 2006), 17.
67 Jürgen Habermas, *The Structural Transformation of the Public Sphere: An Inquiry into a Category of Bourgeois Society (Studies in Contemporary German Social Thought)* (Cambridge, MA: The MIT Press, 2001), xi.
68 Charles Tilly, "Spaces of Contention," *Mobilization: An International Quarterly 5*, no. 1 (September 2000): 1, 137.
69 Ibid., 138.
70 Protests in public space may target private organizations. In fact, the high visibility of public spaces often makes them a preferred arena for contention in efforts to solicit consumer pressure—such as workers protesting against employers who infringe their rights, with parallel calls to the consuming public for boycotts (see, e.g., ongoing protests against fast-food chain Wendy's over working conditions and treatment of women).
71 According to Holston, "Citizenship changes as new members emerge to advance their claims, expanding its realm, and as new forms of segregation and violence counter these advances, eroding it. The sites of insurgent citizenship are found at the intersection of these processes of expansion and erosion." James Holston, "Spaces of Insurgent Citizenship," *Making the Invisible Visible: A Multicultural Planning History*, 1st ed. (Berkeley, CA: University of California Press, 1998), 48.
72 Guy Julier, "Political Economies of Design Activism and the Public Sector," *Nordic Design Research Conference 2011*, Helsinki, www.nordes.org, 4.
73 Thorpe, "Applying Protest Event Analysis to Architecture and Design," 275.
74 Richard Sennett, *The Fall of Public Man* (Cambridge: Cambridge University Press, 1977), 137.
75 Erik Swyngedouw, "Post-Democratic Cities: For Whom and for What?" Paper presented in Concluding Session, Regional Studies Association Annual Conference, Pécs, Budapest, May 26, 2010, 2, www.variant.org.uk/events/pubdiscus/Swyngedouw.pdf.
76 Margit Mayer, "The 'Right to the City' in Urban Social Movements," in *Cities for People, Not for Profit*, eds. Brenner, Marcuse, and Mayer, 68.
77 Ibid., 75.
78 This revisits the chapter "What If? A Speculative Topography of Potential Olympic Futures" (Traganou, *Designing the Olympics*, 309–28), which contemplates these three types of political action in relation to Olympics contestation. This political classification is based on Day, *Gramsci Is Dead*, 83.
79 Jacques Rancière, *Disagreement: Politics and Philosophy* (Minneapolis, MN and London: University of Minnesota Press, 1999), 26–7.
80 Jacques Rancière, *The Politics of Aesthetics: The Distribution of the Sensible* (London and New York: Continuum, 2013), 89.
81 Chantal Mouffe, "Politics and Passions: The Stakes of Democracy," *Ethical Perspectives* 7, no. 2–3 (2000): 148.
82 Mouffe, *Agonistics: Thinking the World Politically*, 77.
83 Day, *Gramsci Is Dead*, 35.
84 Ibid.
85 Ibid.
86 Ibid., 89.
87 Alexandros Kioupkiolis, "Counter-hegemony, the Commons, and New City Politics," *Transform Europe*, April 18, 2019, accessed February 24, 2020, www.transform-network.net/en/publications/yearbook/overview/article/yearbook-2019/counter-hegemony-the-commons-and-new-city-politics1/.
88 See Benjamin Arditi, "Post-Hegemony: Politics Outside the Usual Post-Marxist Paradigm," *Contemporary Politics* 13, no. 3 (2007): 220–21; Yannis Stavrakakis, "Post-Hegemonic Challenges: Discourse, Representation and the Revenge(s) of the Real," *Network of Analysis of Political Discourse, Working Papers*, no. 2 (2013): 19.

89 Iris Marion Young, *Inclusion and Democracy* (Oxford: Oxford University Press, 2000).
90 Tim Ingold, *Being Alive: Essays on Movement, Knowledge and Description* (London: Routledge, 2011).
91 Pierre Bourdieu, "The Politics of Protest: An Interview with K. Ovenden," *Socialist Review* 242 (June 2000).
92 Nick Crossley, "Repertoires of Contention and Tactical Diversity in the UK Psychiatric Survivors Movement: The Question of Appropriation," *Social Movement Studies: Journal of Social, Cultural and Political Protest* 1, no. 1 (2002).
93 Sarah Ahmed, *The Cultural Politics of Emotion* (Edinburgh: Edinburgh University Press, 2014)
94 Lewis Mumford, "Authoritarian and Democratic Technics," *Technology and Culture* 5 (1964): 1–8.
95 Iris Marion Young, *Inclusion and Democracy* (Oxford: Oxford University Press, 2000).
96 Isabelle Stengers, *Cosmopolitics* (Minneapolis, MN: University of Minnesota Press 2010).
97 Anne-Marie Willis, "Ontological Designing," *Design Philosophy Papers* 4, no. 2 (2006): 69–92.

Plate 1 Hundreds of thousands of Iranian supporters, June 15, 2009.

Plate 2 Iranian election protest, June 2009.

Plate 3 The TriForce of Occupy Hongkong, motion graphics, DDED HK, 2014.

Plate 4 CP Doll, created by Gothenburg Cooperative for Independent Living, 2012.

Plate 5 Signs of the Women's March in Boston arranged along the fence on the Boston Common, 2017.

Plate 6 Aerial mosaic of rescued signs from Women's March in Boston, 2017.

Plate 7 "What Place is This?" an image-game by designer Philippe Leon Anastassakis, Bar Dellas Bar at Harmonia Square, Rio de Janeiro, 2018.

Plate 8 "Blanket Game," Beautiful Trouble Strategic Creative Actions planning workshop with *United We Dream* organizers, Denver, CO, August 2016.

Plate 9 DENNIS Design Center. Preparing the site on Prague Boulevard, Copenhagen, 2011.

Plate 10 Conflict Kitchen Iran, Pittsburgh, 2010.

Plate 11 Spatial production and interventions on Minhocão, São Paulo: *Muda Coletivo*'s *Bolha Imobiliária* (The Real Estate Bubble), December 2012.

Plate 12 Sleeping room during students' occupation at *ESDI Aberta* (ESDI Open), Rio de Janeiro, February, 2017.

Plate 13 Students working at the vegetable garden of Green Space, an experimental research lab at *ESDI Aberta*, 2016.

Plate 14 Transition Pasadena's Free-Food Garden, Pasadena, CA, 2015.

Plate 15 First day of Occupied Theater Embros's activation, Athens, November 11, 2011.

Plate 16 A communal Christmas meal in 2013 taking place on the stage of the Embros Theater.

Section 1
Social Movements as Design Agents

Part 1

Visuals and Objects of Protest

2 The Green Stripe
The Color of Identification

Victoria Hattam

On June 16, 2009, while traveling in Boston, I pick up the *USA Today* that has been left outside my hotel door and head down to breakfast. Flipping through the paper between mouthfuls of oatmeal, a photograph catches my attention (Figure 2.1, Plate 1). Hundreds of thousands have gathered in the streets of Tehran to protest the declaration that Mahmoud Ahmadinejad has won the June 12th election. A photographer, Behrouz Mehri, captures the moment with a slightly elevated view of protesters packed into the streets, reaching as far as the eye can. A large green ribbon stretching above the crowd animates the image. Long after the Tehran protests have subsided, I find myself pondering the power of this image.

Why is this image so arresting? I am no specialist in Iranian politics, yet it speaks to me 6,000 miles away. The green stripe is crucial; it enacts a politics of identification through color identification that I want to explore. Images of large crowds often garner attention—there is something inherently political about masses of people challenging authority by appearing in public. And that is certainly evident here. But it is the splash of color that draws me in. The "color crowds," as I have come to think of them, capture something important about political identification. How does the Mehri image redirect existing accounts of political identification through color?

Moreover, I am not alone in my reaction to the green stripe; Mehri's image was selected by many news organizations as the photo of the day: the *Boston Globe*, *Washington Post*, and PBS all choose the Mehri photograph to run alongside their coverage of the Iranian election. A quick glance at Google images, flickr, and other websites reveals that Mehri's photograph, and other similar "green stripe" images continue to circulate in cyberspace as hallmarks of the election outpouring.[1] How might attending to the Mehri photograph shift the boundaries of the political?

My aim is *not* to subject the image to the life of the mind. On the contrary, I want to move things in the opposite direction. If we are lucky, the image might serve as a thread to the sensorium. Rather than discipline sight, I seek to undiscipline reason. Images can expand conceptions of the political in ways that are difficult to capture through text and word. The power of the image in general, and the color crowd photographs in particular, rests, I argue, on the ways in which visuals open up political analysis to questions of affect and time. It is here, in engaging the affective and temporal dimensions of politics, that images can help us move beyond the hegemony of the word.

Figure 2.1 Hundreds of thousands of Iranian supporters of defeated reformist presidential candidate Mir Hossein Mousavi demonstrate in Tehran on June 15, 2009.
Photo: Behrouz Mehri, AFP/Getty Images.

Image, Affect, Time

There are ways in which sight seems to bypass the critical, rational processes that dominate intellectual life, allowing images to captivate viscerally, hence the frequent references to the "gut" reaction many have to images.[2] Do we react viscerally to images because the brain actually processes images differently than words? Might the current revolution in brain research speak to the viscerality of the image? I leave the neuroscience to others.[3] What is clear is that the centuries-old designation of text-based literacy as the cornerstone of critical thinking inadvertently links affect and image through the relentless twinning of reason and word. Print, newspapers, public education, and the flowering of liberal arts education throughout the nineteenth and twentieth centuries have made text the focal point of thought and reason, thereby relegating vision and the other senses to the unruly life domain of the gut reaction (emotional, intuitive, and unspoken). In some sense, the viscerality of the image is produced through long-standing equations of reading and writing with analytical thinking.

Even a quick glance at the Mehri image activates what Daniel Stern calls a "feeling voyage." Although writing in a very different context, the idea that change is enacted intersubjectively through a myriad micro-exchanges in which we begin to affectively reimagine the possibilities of (political) identification.[4] Roland Barthes' notion of "advenience" similarly captures the affective provocation that images initiate, although importantly for Barthes not all images have the capacity to move: "This picture advenes, that one doesn't."[5] The question, for Barthes, is to figure out which image

"sets me off" and why? Stern is not so interested in identifying particular provocations as he is in attending to everyday encounters of various kinds. For Stern, even inadvertent exchanges among people and objects carry with them feeling exchanges: watching a patient sit in a chair, pouring a glass of orange juice, or a glance all serve as affective encounters through which we both repeat and rework our intersubjective repertoires. The small scale and pervasiveness of the feeling journeys makes them powerful agents of change. For Stern, the task is to become attuned to these everyday encounters as a way of remaining open to change.

Rather than asking which images advene and which don't, I want to follow Stern in assuming that the capacity to animate a voyage is not so narrowly cast. I want to ask how, and in what ways, looking at the Mehri image initiated an affective exchange without presuming the encounter to be a tightly scripted one. Many images might set us off, thereby opening up the shifting and contested terrain of affective states. As such, explorations of affect do not resolve or settle matters; turning to the affective will not resolve disagreements. But our encounters with images can expand our conception of the political into its dynamic nonverbal domains. Catching sight of the Mehri photograph while sitting in Boston provoked a micro-voyage for me. A collective project is clearly underway, and we are invited in—invited to go along—even if only for a few seconds, to a moment of collective identification. It is this process of affective engagement through the image that I want to explore. The image invites us in, not to a settled political project, nor to a blank screen; rather the image prompts an open-ended exchange—an ongoing interaction between image and viewer that will unfold over time. The green stripe's power lies precisely in the ways in which it is simultaneously affectively engaging and semiotically open. It calls forth identifications in public while keeping open the sign of political mobilization.

The contours of my project might become clearer when contrasted with alternative lines of work linking aesthetics and politics that are currently in vogue. On several occasions, I have been lured into talks that seemed, from their titles, to be nested in the same issues that I am after. Aesthetics and politics is often the frame; visions of images dance in my head. But once underway, I quickly learn that I have made a mistake. Within minutes, we are back to Emmanuel Kant, Gilles Deleuze, or some other philosopher with never an image to be seen. Time and again, discussions of visuality quickly return to questions of philosophy in ways that ignore the political promise I see in the image.

Rather than philosophize about the image, or extend literacy from texts to photographs, I turn to visuality in order to open up the political in different ways than we can with words.[6] Visual essays, visual arguments, and looking groups shift the relative weight of text and image and in so doing ask us to look rather than talk. Nor does the looking need to be serious, careful, disciplined, or trained. I focus on everyday visuality, on the inadvertent, on the photo that catches your attention when you are eating oatmeal. Some wonderful work is already being done in the domain of visual politics; for example, see the work of Chris Killip, Irit Rogoff, Jane Fulton Suri, and Camilo Jose Vergara.[7] All have changed how I look. It is with this work in mind that I contemplate the green stripe.

What is the affective pull of color? How does the green stripe enact a micro-image journey that allows me to reimagine politics while sitting in Boston?

The Color of Identification

The practice of coding political movements by color is long-standing: communist red, white Russians, anarchist black, and regal purple have swirled through politics for centuries. The color revolutions of the last decade continue the practice with the Orange Revolution in the Ukraine in 2004–5, the Green Revolution in Iran, and the use of red and yellow to signify different political positions in the Thai protests of 2009. In all of these instances, sight, as much as text and word, have been used to create political connections—identifications have been generated quickly and contagiously through color.

Some might approach the Iran color crowd through the various meanings of green both within Islamic cultures in general and Iranian politics more specifically,[8] or by considering the ways in which the green stripe serves as a generative provocation to visual rhetorics of flesh and flag currently shaping the American political landscape—especially those associated with ethnicity and race.[9] While the cultural content of color take us part way in understanding the green stripe, it does not capture what I am after.

The affective pull of the Mehri image can be gauged more effectively by considering the image within visual fields swirling around the Iranian election protests of 2009. The green stripe was only one of many images in play; contrasting it with other photographs helps clarify what it is about the Mehri image that captures me so. Consider Figure 2.2 below, taken in the same street during the same election protests in Tehran. The long gray roof is still clearly in view, only now more of the building can be seen than in the Mehri image. The distance and frame have shifted,

Figure 2.2 A massive demonstration in support of reformist candidate Mir Hossein Mousavi is formed as supporters gather on the streets of Tehran, June 15, 2009.

Photo: Mohammad Kheirkhah, UPI/Newscom.

and the green color stripe can no longer be seen. Crowds *without* color—they seem pale by comparison—flat and disappointing compared to the color crowds.

While Figure 2.2 also is dramatic, when placed alongside Mehri's photograph, it fades; it becomes a generic protest photograph that might have been taken in many times and places. The Mehri image, by comparison, lingers because of the play of color. The swath of green creates a sense of linked fate among those holding the ribbon—immediately one senses an act of collective identification in public. The pinging of red and green across the image, most noticeably between the red-shirted man standing above the crowd and the green stripe, but also among the smaller flecks of red and green scattered across the photo, draw otherwise disparate elements into conversation. The interaction of color animates the visual field and the photo begins to sing.[10]

Not just any old splash of green will do. A quite particular scale is needed to trigger the identificationary pull of Mehri's image. Other images, such as Figure 2.3 (Plate 2), generate quite different reactions. This image is powerful too, but differently so. The dramatic green sail (an image that has been reproduced in many places) foregrounds a singular figure in ways that diminish the horizontality of the crowd seen in the middle distance. After all, the man holding the sail stands above the crowd, looking down on others—prominent and singular in ways that contrast with the use of color and form in the green ribbon. Although dramatic in its own right, it shifts the identifications in play in the Mehri photograph. The green stripe

Figure 2.3 Iranian election protest, June 2009. Photo from Green Movement demonstration.
Photo: Jeff McNeill (CC BY-SA 2.0). www.flickr.com/photos/jeffmcneill/3629090335/, accessed November 19, 2010. Creative Commons Attribution Share Alike 2.0 generic license.

sits in the middle distance, embedded within a horizontal plane, holding both individuation and hierarchy at bay. The green stripe, in Mehri's hands, serves as a very particular sign; at once distinctive, yet not particular. Importantly, the splash of color signifies powerfully at the scale of the crowd.

The green stripe animates the moment of collective identification providing a dramatic visual display of the pleasures of connection. The sense of opposition that drew the crowds into the street is left implicit and tensions among those who have mobilized are not yet on view. Comparing the Mehri photograph with those above makes clear that many powerful images were in circulation; the green stripe is not the only photo to garner attention. The task is not so much to defend the green stripe as the definitive image of the election protests, nor to claim that it had a singular capacity of advening. Rather I am suggesting that visuality more generally opens the door to the affective and in so doing expands our conception of the political

Image Journeys

The force of the green stripe, then, is the capacity to animate affective encounters, or image journeys, of an open-ended kind. Rather than anchoring the power of green in the meaning of color, I am suggesting that the image's power lies in the capacity of the green ribbon to animate an exchange in which the image is at once striking and yet open. After all, it is not entirely clear what the green ribbon signifies in Tehran, let alone Boston. The splash of color serves as an invitation—if one takes up the call, either via the image or the street, one embarks upon what Uday Mehta rightly specifies as a necessarily provisional encounter.[11] There are no guarantees where the journey is heading, nor where it will end. The moment of green invites us in; it is precisely the open-ended quality of the encounter that is crucial to being alive to change.

Looking at the Mehri photo in Boston prompted just such an image-journey for me. The green stripe drew me in, initiating an engagement without end. The play between viewer and viewed is the thing. In that dynamic relation, affective circuits begin to move in ways that unsettle and reconfigure. The exchange is at once personal and political—traversing the boundary between the internal and external with ease. Movement is in the air. Journeys, after all, are about change. Seen this way, images provide an important link to the projectivity of politics through which we expand, reimagine, and enact new possibilities. Everyday looking affords innumerable opportunities for us to tune into the affective circulations through which we might re-imagine the contours of politics.

Most often, image journeys are short and frequent—a series of inadvertent glances and fleeting feelings. On any given day, we embark on many such visual encounters— a sign, a glance, a visual assemblage, a wall. The possibilities are infinite, yet generally go unnoticed. But if you are attentive, you might detect a shift through a smile or lightness of step as a particular image urges you to embark on a small trip.

The identificatory exchanges that looking initiates can be illuminated via Christopher Bollas' work rethinking Freud's legacy through psychoanalytic practice rather than theories of psychic development.[12] It is the therapeutic encounter, the attentiveness to micro-affective exchange, that Bollas claims that we should hold on to, not Freud's theories of childhood sexuality. While attention to the clinical has long

been a key component of psychoanalytic training, the centrality of practice has not been carried over to engagements between psychoanalysis and the social sciences. Instead, all too often the most reductive accounts of childhood development are used to generate rather stilted explanations of a range of social phenomena. Bollas opens up an interesting way to think affect and politics through psychoanalytic practice—a rethinking that has interesting ramifications for considering the affective dimension of image journeys.[13]

What matters most for Bollas is the intersubjective exchange, and what he has at times referred to as the "unthought known."[14] I do not follow Bollas literally in his account of the transferential analytic space but want to hold onto the notion of a semiotically powerful nonverbal communication. Nor do I consider the unthought known a transhistorical unconscious, since historic and cultural specificities pervade affective states as well as discursive practices. I am trying to capture something else—I am interested in the sensory domains of politics in which disagreements, differences, and identifications are explored, expressed, and changed without words.[15] Perhaps we might think of this as the *unspoken political*. For Bollas, Stern, and many psychoanalysts, the therapeutic setting, specifically the transference, helps to make affective states visible. Images, I am suggesting, offer everyday access to the dynamic life of nonverbal encounters in which the circulation of affect takes center stage.[16]

Images not only act as screens for our projective identifications; they also actively solicit engagements that makes possible the micro-politics of change. The feeling journeys that accompany looking are never fully of our own making.[17] Images have generative capacities to move us and thereby initiate the emergent into being. Exactly what balance will be struck between old and new, viewer and viewed remains in question. That is the nature of open engagement through looking.

Visual Disagreements

Affects do not travel alone, nor even in pairs, but are multiple and labile, shifting quickly both within and among subjects—so much so that tracking them requires a deftness and subtlety more often associated with poetry than social science. Rather than assuming that the Mehri image invokes a particular reaction—that image and affect are tightly paired—we might more usefully think of the image as providing an opening to the worlds of nonverbal communication in which affects are constantly on the move. Seen this way, moments of looking are neither singular nor simple things; looking provides a portal through which we can engage the shifting and contested terrain of the nonverbal. The task is not simply to read affect from image, but rather to track the interplay of affective states through visual encounters in order to access the unspoken political.

What affects, then, does the green stripe animate? There is an infectious sociability in the densely packed streets; there is an exhilaration to collective action—to being the part that is no part laying claim to the whole. Such bold acts of collective identification require the heady courage garnered through collective action. The image emboldens; the excitement is contagious; the luminous green conveys a lightness of sprit. The contrast with the reds, oranges, grays, and blacks that fill images of fists, rocks, flames, and blood that pervade other protest images is striking. The green stripe emphasizes connection over conflict and division.

Yet, at the very moment that I am drawn to the image, I am also acutely aware of what I do not know. The image is at once familiar and foreign; it both draws me in as well as prompting me to question: what streets are these? Why green? What are the lines of affiliation and contention here? Is this a difference of a different kind? *All of this happens without words.* The whole process takes a matter of seconds. There is a shift in the unspoken political through which the landscape moves. Taken-for-granted associations begin to wiggle loose and might be rearranged. This unsettling, this shift in the presumptive associations, is precisely what enables change to occur. The millions of images we encounter each day afford countless opportunities for us to wriggle free of old habits and dispositions. The power of visually initiated change does not lie in the ah-ha! moments associated with any particular image, or in the power of images to inspire systemic transformation. More often, images inadvertently ungrout the old, thereby facilitating small-scale reconfiguration.[18]

While Daniel Stern's journey metaphor captures the sense of movement that I want to hold at the center of politics, it too easily elides the equally important place of disorientation as key to processes of reconfiguration. The notion of a journey conveys too strong a sense of destination—of traveling from here to there—that undercuts the open-endedness of the visual encounter that I consider crucial to personal and political change. Embracing the sense of wandering aimlessly, being lost, cast adrift is vital, since it is precisely the mix of pleasure *and* anxiety that comes with disorientation that gives journeys their affective charge and capacity to animate change. One of my early childhood memories is of setting off on bicycles with my siblings in the early hours of a weekend morning with the specific intent of getting lost. The attraction, the thrill of it, was to get off the grid to some unknown place that held notions of possibility through disorientation. I want to keep echoes of that sentiment at the heart of the political.

Too often, social scientists analyze affects in singular, stable, and uncontested terms: Tea Partiers are angry, Democrats are depressed. But political fields are never so easily reduced to singular affective lines. It is important to bring the affective into view without assuming the nonverbal will settle zones of discord and disagreement. The point is not to find agreement in the domain of the affective, but to consider the dynamic interplay of affects as we do other sites of political contestation. Affective circulations are politics by other means: always complex, shifting, and contested. The task is not to smooth them over, but to take them in.

But disorientation is different from discord. The latter still assumes a mapping of a kind, precisely as a way of attending to differences within. Disorientation involves something else: a not knowing, a sense of relinquishing, of giving oneself over to the journey itself, in order to catalyze a process of change. De Certeau has a wonderful appreciation for the generative capacity of wandering the city and for the importance of gaps as well as planks within the picket fence.[19] All too often moments of political mobilization are asked to specify their destination: where are you headed? Who is in charge? What do you stand for? Rushing too quickly to specify the demands inevitably forecloses the political opening at hand by moving to resolve the sense of disorientation that accompanies and facilitates change.

Finally, some have suggested that the affective turn is a disturbing one, since it opens the door to political appeals absent substantive rational consideration. History has shown on more than one occasion, that affective appeals can be mobilized for pernicious ends. The dangers are real; attending to the affective will not ensure

better outcomes. But avoiding the affective, shutting it out from view, is no less worrisome. Averting one's eyes only leaves affective circulations to work their magic hidden from view. The remedy, I have been arguing, is not to suppress the affective, nor to bring it into the realm of reason. Instead, I am suggesting that we open our conception of the political to include affective encounters through which disagreements and affiliations are explored and reimagined. Doing so expands and enlivens conceptions of the political.

Notes

1 The Behrouz Mahri photograph was included in the *Boston Globe*'s "The Big Picture: New Stories in Photographs," and in the *Washington Post*'s "Day in Photos" for June 15, 2009, and on PBS.org, June 16, 2009. *USA Today* estimates its online and print circulation at 5.9 million. Even allowing for some inflation of circulation figures, in part through the hotel distribution system through which I encountered the image, many have seen the image and many news organizations selected this particular photograph to reproduce in the aftermath of this election. *USA Today*'s circulation data are taken from Audit Bureau of Circulation FAS-FAX. As of September 13, 2010, the Behrouz Mehri photo above had 3,992 hits on flickr.
2 See Terry Smith, "Enervation, Viscerality: The Fate of the Image in Modernity," in *Impossible Presence: Surface and Screen in the Photographic Era*, ed. Terry Smith (Chicago, IL: University of Chicago Press, 2001); and Javier Sanjines, "Visceral Cholos: Desublimation and the Critique of Mestizaje in the Bolivian Andes," in *Impossible Presence*. For other interesting work opening up the senses, see David Howes, "Scent, Sound, and Synaesthesia: Intersensoriality and Material Culture theory," in *Handbook of Material Culture*, eds. Christopher Tilley, Webb Keane, Susanne Küchler, Michael Rowlands, and Patricia Spyer (Los Angeles, CA: SAGE Publications, 2013); Regina Bendix and Donald Brenneis, eds., "The Senses," *ETNOFOOR* XV111, no. 1 (2005); Alain Corbin, *The Foul and Fragrant: Odor and the French Social Imagination* (Cambridge, MA: Harvard University Press, 1988); Marita Sturken, "Absent Images of Memory: Remembering and Reenacting the Japanese Internment," *Positions* 5, no. 3 (1997): 687–707.
3 There is much interesting work being done on the neuroscience of vision. For introductions to some of this fascinating work, see Arien Mack and Irvin Rock, *Inattentional Blindness* (Cambridge, MA: The MIT Press, 1998); Semir Zeki, "Art in the Brain," *Daedalus* 127, no. 2 (March 1998): 71–104; Kanwisher, Nancy, "The Brain Basis of Human Vision," MIT World Special Events and Lectures, April 26, 2006. https://techtv.mit.edu/videos/16456-the-brain-basis-of-human-vision.; William Connolly, *Neuropolitics: Thinking, Culture, Speed* (Minneapolis: University of Minnesota Press, 2007); Randy Buckner, "Remembering the Past to Imagine the Future: The Prospective Brain," *Nature Reviews/Neuroscience* 8 (September 2007): 657–61.
4 Daniel N. Stern, *The Present Moment in Psychotherapy and Everyday Life* (New York: W.W. Norton, 2004). See especially Chapter 10, 172–73, for his discussion of "feeling voyages." See also Siri Hustvedt, "Freud's Playground: Some Thoughts on the Art and Science of Subjectivity and Intersubjectivity," *Salmagundi*, no. 174/175 (Spring 2012): 59–78, 222; and Siri Hustvedt, *A Woman Looking at Men Looking at Women: Essays on Art, Sex, and the Mind* (New York: Simon and Schuster Paperbacks, 2016), 367–81.
5 Roland Barthes, *Camera Lucida: Reflections on Photography* (New York: Hill and Wang, 1980), 19.
6 Some scholars have responded to the visual–literacy divide by advocating for an expansion of literacy from words to images. For example, see Michael Lesy, "Visual Literacy," *Journal of American History* 94, no. 1 (June 2007): 143–53. I move things in the opposite direction.
7 I am indebted to Clive Dilnot for introducing me to Chris Killip's work. See Christopher Killip, *Seacoal* (Gottingen, Germany: Steidl, 2011); Irit Rogoff, "Looking Away: Participations in Visual Culture," in *After Criticism—New Responses to Art and Performance*,

ed. Gavin Butt (London: Blackwell, 2005); Jane Fulton Suri and IDEO, *Thoughtless Acts? Observations on Intuitive Design* (San Francisco, CA: Chronicle Books, 2005); and Camilo Jose Vergara, *How the Other Half Worships* (New Brunswick, NJ: Rutgers University Press, 2005).

8 I am especially grateful to Neguin Yuvari for her assistance in reading the geographic and political specificities of the Mehri photograph and for recommending the following sources on the Green Movement in Iran: Nader Hashemi and Danny Postel, eds., *The People Reloaded: The Green Movement and Struggle for Iran's Future* (Brooklyn, NY: Melville House, 2010); James Harkin, "Cyber-Con," *London Review of Books* 32, no. 2 (December 2010): 19–21. See also Ruecian, "Colors of Religion: Islam," Color+ Design (blog), September 8, 2007, www.colourlovers.com/blog/2007/09/08/colors-of-religion-islam/blog. For classic works exploring the complex relations between culture and color, see Marshal Sahlins, "Colors and Cultures," *Semiotica* 16, no. 1 (1976): 1–22; John A. Lucy and Richard Shweder, "Whorf and His Critics: Linguistic and Nonlinguistic Influences on Color Memory," *American Anthropologist* 81, no. 3 (September 1979): 581–615; and more recently Diana Young, "The Smell of Greenness: Cultural Synaesthesia in the Western Desert," *Etnofoor* 18, no. 1 (2005): 61–77.

9 For elaboration of ethnic and racial representations via flesh and flag, see Victoria Hattam, "Asymmetries of Visuality and the Gift of Design," presentation prepared for conference, "The Gift of Design," Parsons School of Design, New York, December 17, 2010. See also the grotesque images of Al Sharpton discussed in Victoria Hattam, *In the Shadow of Race* (Chicago, IL: University of Chicago Press, 2007), 129–56, and Mark Rheinhardt, "The Art of Racial Profiling," in *Kara Walker: Narratives of a Negress*, eds. Ian Berry, Vivian Patterson, and Mark Reinhardt (Cambridge, MA: The MIT Press, 2003).

10 See Joseph Albers, *Interaction of Color* (New Haven, CT: Yale University Press, 2006/1963). I am grateful to a fascinating conversation with Andrew Lenaghan and Margaret Harris on Albers and these images.

11 See Uday Singh Mehta, *Liberalism and Empire: A Study of Nineteenth-Century British Liberal Thought* (Chicago, IL: University of Chicago Press, 1999), 1–46.

12 Christopher Bollas, *The Evocative Object World* (New York: Routledge, 2009); and Christopher Bollas, *The Freudian Moment* (London: Karnac, 2007).

13 Once you follow Bollas to practice, then much clinical work can serve as model for attending to the affective encounter with an image. For example, see Stern, *The Present Moment*; and Michael Feldman and Elizabeth Bott Spillius, eds., *Psychic Equilibrium and Psychic Change: Selected Papers of Betty Joseph* (New York: Routledge, 1989).

14 Christopher Bollas, *The Shadow of the Object: Psychoanalysis of the Unthought Known* (New York: Columbia University Press, 1989).

15 There is an exciting new field of work on the senses of various kinds. See Corbin, *The Foul and The Fragrant*; Howes, "Scent, Sound and Synaesthesia"; Barry Blesser and Linda-Ruth Salter, *Spaces Speak, Are You Listening?* (Cambridge, MA: The MIT Press, 2007); Bendix and Brenneis, eds. "The Senses"; Brandon Labelle, *Acoustic Territories: Sound Culture and Everyday Life* (New York: Continuum, 2010); "Symposium—A Return to the Senses," *Theory and Event* 13, no. 4 (2010); Margaret Schedel and Andrew V. Uroskie, eds., "Special Issue: Sonic Arts and Audio Cultures," *Journal of Visual Culture* 10, no. 2 (August 2011); and Kara Keeling and Josh Kun, eds., "Special Issue: Sound Clash: Listening in American Studies," *American Quarterly* 63, no. 3 (September 2011).

16 For an excellent account of the circulation of affect, see Sarah Ahmed, "Affective Economies," *Social Text* 22, no. 2 (79) (Summer 2004): 117–39. See also Ann Cvetkovich, "Public Feelings," *South Atlantic Quarterly* 106, no. 3 (Summer 2007): 459–68.

17 See especially, W.J.T. Mitchell, *What Do Pictures Want? The Lives and Loves of Images* (Chicago, IL: University of Chicago Press, 2005). See also Arjun Appadurai, ed., *The Social Life of Things: Commodities in Cultural Perspective* (New York: Cambridge University Press, 1986), 3–63; and Jane Bennett, *Vibrant Matter: A Political Ecology of Things* (Durham, NC: Duke University Press, 2010).

18 For work exploring related themes, see Introduction in Gerald Berk, Dennis Galvan, and Victoria Hattam, eds., *Political Creativity* (Philadelphia: University of Pennsylvania Press,

2014); and Victoria Hattam and Joseph Lowndes, "From Birmingham to Baghdad: The Micropolitics of Partisan Change," in *Political Creativity*, eds. Gerald Berk, Dennis Galvan, and Victoria Hattam (Philadelphia: University of Pennsylvania Press, 2014). For excellent work exploring the relation between visuality and macro political change, see John Elderfield, *Manet and the Execution of Maximilian* (New York: MOMA, 2006).

19 Michel de Certeau, *The Practice of Everyday Life*, trans. Steven Rendall (Berkeley: University of California Press, 1984), 127–29. See also Judith Butler's eloquent engagement with the question of demands when she spoke at Occupy Wall Street on October 25, 2011. J. Hagen Jamie, "And Then Judith Butler Showed up at Occupy Wall Street," *Autostraddle*, October 25, 2011, accessed November 12, 2011, www.autostraddle.com/and-then-judith-butler-showed-up-at-occupy-wall-street-in-solidarity-117911/.

3 Strategies of Creative Dissent under the People's Republic of China's "One China Policy"

Kyle Kwok

Through its "One China Policy" (OCP),[1] the People's Republic of China (PRC), with the Chinese Communist Party (CCP) at the helm, demands the world's acknowledgement of its overarching sovereignty over Hong Kong, Macao and Taiwan (Republic of China, ROC),[2] and respect for its territorial integrity. The OCP is rooted in the political belief of one unified nation of "China," an ideology which is critical for our understanding of the PRC's authoritarian behaviour in the contemporary context. Britain's colony of Hong Kong (1842–1997) and Macao (1557–1999), a Portuguese colony, were handed over to the PRC in 1997 and 1999 respectively, under the "one country, two systems" principle. Coupled with its rapid economic rise over the past two decades are the CCP's aggressive demands for international recognition of its sovereignty over Taiwan as the remaining territory (a colony of Japan from 1895 to 1945) to "rejoin" the mainland under the OCP.

For international affairs scholar and regional security expert Fei-ling Wang, the nature of the PRC's rising power is connected with the so-called "China Order," the Chinese world empire order. The China Order derives from the Qin-Han polity, an authoritarian Confucian-Legalist imperial state, and "justifies and defends its rule with the Mandate of Heaven to unite, order and govern the whole known world—the *tianxia* (all under heaven, 天下)."[3] This mindset, of a centralized sociopolitical order as heaven's way that has the mandate of political unification in its center, helps explain the PRC's hegemonic acts over Hong Kong, Macao and Taiwan, regardless of the latter's wishes not to unite under a single country, China. These include the PRC's 2018 demands that the international aviation industry adopt politically correct naming, and designate each locale in the Greater China Region with the "China" tag—"Taiwan, China," "Hong Kong, China," and "Macao, China"—despite their status as independent trading entities.

Several scholars and political activists have argued that after over a century of colonial rule and separation from the regime on the mainland, Hong Kong and Macao are victims of the OCP and its political ideology. Cultural studies scholar Wing-sang Law believes that Hongkongers returned to China unwillingly in 1997, and that the 1997 handover was a passive and ideological act, and culturally unsuccessful. Reunification was a political failure as British-PRC negotiations in the 1980s did not include consultations with Hongkongers about their future. The feeling of powerlessness continued post-handover, with the CCP's failure to deliver on its "one country, two systems" constitutional promise for political autonomy and democracy for Hong Kong.[4] Citizens in Macao are facing a similar situation to their neighbors.

The CCP intended to use Hong Kong and Macao in its efforts to showcase the "one country, two systems" as a viable option for Taiwan. However, witnessing the deterioration of individual freedoms and democracy in the two former colonies, there is a growing fear among the Taiwanese that they will face the same destiny if their "country" accepts the PRC's offer of reunification under the "one country, two systems" principle. On November 21, 2018, PRC President Xi Jinping stated that the people of Taiwan should seek reunification and accept the "one country, two systems" political arrangement with the PRC. Within 48 hours, Taiwan's President Tsai Ing-wen responded with her clear rejection of the idea and urged China to understand Taiwan.[5]

Political disagreements with the OCP were followed by forceful social movements that used a variety of protest methods. With the PRC's political beliefs at the forefront, I will offer a contextual analysis of how civil rights activists and dissidents in Hong Kong, Macao, and Taiwan have been using creative dissent strategies to express their disobedience to the OCP over the past decade, and will connect their forms of creative resistance with dissent strategies found in the mainland, claiming the rise of new forms of political identity across these Chinese-speaking territories.

The Parodic Protest Strategy of *Ngok Gaau* (惡攪) in Hong Kong

In the case of Hong Kong, I argue that the resistance to the political ideology of One China is manifested in the civil protests that have erupted since 1997. One of the most significant public demonstrations, the 79-day Umbrella Movement in 2014, began with a massive student-led civil sit-in street protest of citizens with various political and social concerns. The movement captured the world media's attention with its strong visual identity of a yellow umbrella, a common quotidian object transformed into a humble symbol of self-defense against tear gas, police pepper spray, and batons. Although it transpired as one of the most important global civil disobedience movements in recent history, protesters failed to gain any reassurances on the question of universal suffrage in the aftermath. In spite of this outcome, the Umbrella Movement experience continues to contribute to various intellectual disciplines including studies on social movements and civic education. In the area of visual communication, I will examine the creative strategy of *ngok gaau* (惡攪), the local slang term in Cantonese Chinese that refers to satirical humor, spoofs, and parodies, which was used in design work produced during the Umbrella Movement. I will analyze how designers tease out subconscious responses to the OCP concept from the Umbrella Movement experience.

The 46-second motion graphic video, "The TriForce of Occupy Hongkong" (學生攞你命三千) in a primer example of *ngok gaau*.[6] A mock news report of the happenings at the occupied protest sites, it was first posted to YouTube on October 7, 2014. The video was created by DDED HK, a newly established digital design company at the time, whose main creator was in his early 30s. The company's name has no significant meaning except to represent its humorous creative approach or its spoof design philosophy, a vernacular inspiration rooted in Hong Kong's transforming cultural, political, and social environment. The company's survival depends on self-initiated design projects for which social media is important

for publicizing its by-products, such as figurative toys, with millennials as its target audience. Within the first three months of the company's launch, it had 17,000 YouTube channel subscribers. During the Umbrella Movement, the company kept pace with developments on the ground, posting animated short videos in eight-bit-pixel visual style. Its designers also created a series of characters—students, public persons, police, and folklore figures—that expanded as the movement unfolded.

The English-subtitled "The TriForce of Occupy Hongkong" YouTube video opens with students holding yellow umbrellas with the Hong Kong cityscape in the background. The news anchorman for the *Qiangguo Xinwen* (A Powerful Country News, 強國新聞) flashes on to the screen to report that the student rally for the National Day celebration has been plunged into chaos due to the Evil West's support. He continues to give an account of students using weapons of mass destruction to destroy Hong Kong, such as umbrellas acting as parachutes and ray guns to kill police. Other weapons including cling film employed as shields to fight off the police and the evil strategy of singing the Happy Birthday song to calm down the angry tongue-lashing counter-protesters. In the video's closing scene, the anchorman declares that Hong Kong is now a dangerous place (Figure 3.1, Plate 3).

Figure 3.1 The TriForce of Occupy Hongkong, motion graphics, DDED HK, 2014.
Source: https://youtu.be/dHwWPXdtII4.

The video creator parodied how the pro-CCP Hong Kong news media were characterizing student protesters as an evil force. This work speaks for the young protesters who have felt helpless with the increasing misrepresentation of the truth in the media since Hong Kong's handover to the PRC. Hong Kong-based literary critic Wendy Gan alerts us to the Hong Kong protests' playful and witty aspects, where humor and parody are used as a strategy to wrench control from dominant discourses. This puckish protesting style is a reflection of an "increasing sense of powerlessness felt by Hong Kong citizens in defining their own political processes as well as their own physical space."[7] She observes that in the age of social media and the Iinternet, humor "registers an element of democratic plurality and freedom," as anyone can create and share in cyberspace as a "collectively disseminated process."[8] DDED HK's video works reflects many young Hongkongers' collective dislike for the current political reality, one where their space for individual freedom is shrinking daily under the OC ideology.

Most scholars view the Umbrella Movement as the rethinking of Hong Kong's relationship with the PRC, especially among millennials who, as Wing-sang Law comments, have transformed their formerly passive state of mind towards safeguarding the city's cultural and historical memories, and utilized the cultural differences between Hong Kong and the PRC as a tactic to defend the political autonomy and democracy promised under the principle of "one country, two systems."[9] In agreement, Patsiaouras, Veneti, and Green, from a marketing and media perspective, find that Umbrella Movement protest art works reflect the protesters' distinguished values and political beliefs, and reveal their resistance to PRC-imposed values.[10] Commenting on Hong Kong's political resistance rallies and the use of American superhero icons, political scientist Dan Garrett emphasizes Hong Kong's struggles for democracy, human rights and social justice alongside its citizens' resistance to the PRC's communist values and identity.[11]

While it did offer a glimmer of hope for Hongkongers to negotiate a space and materiality for democracy under the "one country, two systems" framework, the Umbrella Movement has entrenched the PRC government's enforcement of its "one country" vision, casting aside its commitment to the "two systems" framework in Hong Kong. In April 2019, a Hong Kong court convicted nine local democracy activists, known as the "Umbrella Nine," for inciting public nuisance in relation to their advocating roles in the Umbrella Movement.[12] A November 2018 tally by a Hong Kong writer shows that the government charged 266 protesters for their Umbrella Movement activities and convicted 118 individuals, including sentencing three students leaders—Joshua Wong, Alex Chow, and Nathan Law—and the Umbrella Nine to six-to-eight month jail terms.[13] These indictments testify that the government in Beijing is not supportive of democracy and the development of liberal values in the HKSAR,[14] which is possibly endangering the PRC's political ideology.

"Creative Concealment" through *Ngok Gaau* in Macao

When compared to Hong Kong's situation, most analysts agree that the PRC has more successfully implemented its "one country, two systems" formula in the Macao Special Administrative Region (MSAR).[15] Since its return to the PRC in 1999, Macao has evolved from serving as Hong Kong's casino to a destination of

the emerging capitalist class of the PRC; the latter promotes Macao globally as a Las Vegas-style gambling tourism destination. The city's population grew by more than 30 percent in the post-handover period (2000–17).[16] Many local people perceive this change as an intrusion on their local culture and as a recolonization, as the bulk of new migrants are Mainlanders.[17]

Anti-reform and conservative forces in support of the pro-Beijing position have a solid hold on almost all business sectors, from the gambling industry to publishing. Beneath the national "Socialist Harmonious Society" (社會主義和諧社會) strategy, social, political, and economic problems are simmering, amplified by the growing gap between the rich and the poor. Press freedom, as one might expect, is waning—most local media are adopting the PRC model of censorship and repression, which is in line with the local government's publicity.[18] There are few dissenting voices in the MSAR, and activists are hesitant to negotiate and resist the PRC's political power over the city. Macao is generally considered to have a weak civil society, as the majority of citizens prioritize materialistic advancement over democratic reform.[19]

Despite contemporary social and political realities, there are dissenting voices among the Macanese—journalists and citizens—who are challenging the cycle of censorship and repression that characterizes the OCP. The case study below focuses on the *ngok gaau* creative dissenting strategy that we saw before used in Hong Kong, specifically the work created for the *Macau Concealers* (formerly *Concealing Daily News*), a non-profit publication. This made its debut in November 2005 as a supplement in the newsletter of the New Macau Association (新澳門學社), a small pro-democracy political organization founded in 1992. In response to the selective reporting approach of contemporary journalism in the city and the mainstream media's practice of concealment, *Macau Concealers* (*Aiman Ribao*, 愛瞞日報) takes a puckish approach to express its dissenting voice.

The publication's Mandarin name, *Aiman Ribao*, is a play on the words *Aomen Ribao* (澳門日報), the city's main Chinese-language newspaper, the *Macao Daily News*. The concealing practices used in its reporting are well known, as is its reputation as the official voice of the pro-China elements in the MSAR. The majority of Macanese speak Cantonese and their pronunciation of Aomen (澳門) in Mandarin is often pronounced as aiman (愛瞞), which ironically means "love to conceal." This creative use of language represents the "existent and artificial links between language and norms; it also criticizes widely held presuppositions that an item always belongs to a certain language or mode, and that languages are discrete systems."[20] This publication uses word play as an act of ideological resistance to mock the PRC's model of censorship and repression in Macao.

The *Macau Concealers*' publishing goal is to disclose to the public, using a humor-based approach, the facts that are not being reported in the mainstream media. As Hong Kong popular culture has had a strong influence on Macao since the 1950s, the Macanese are very familiar with the satire and ludicrous-style parodies that the *Macau Concealers* employs. For example, in September 2016, the publication organized a naming contest for the two panda cubs born in Macao. Tam Tam (貪貪) and Wu Wu (污污) won the competition; when combined, the translation in English of the two Chinese names is "Cor-rupt" (Figure 3.2).[21] This is a parody of the combined meaning in English of the two cubs' official, government-proffered names—Jianjian (健健) and Kangkang (康康)—which is "healthy."

Figure 3.2 Online naming contest for the two panda cubs, Tam Tam (貪貪) and Wu Wu (污污).
Source: *Macau Concealers*, September 12, 2016.

Citizens' use of the *Macau Concealers* as a platform to express their views of their government is one way that they can convey their discontent.

George Orwell once said that "Every joke is a revolution" and that "a joke is a temporary rebellion against virtue."[22] The power of these protests lies on "the abundant capacity for homonyms and near-homonyms in Mandarin and Cantonese" which "raises the spectre of an endless play on words and a concomitant undermining of original intent."[23] With the witty combination of images and words, Hong Kong and Macao activists manage to evoke rebellion against the CCP's perceived idea of virtue, and thus make their audiences complicit in their acts of political messaging. This subversive capacity, which is inherent in the Chinese language, is found in creative resistance not only in the former colonies but also in the CCP-controlled and highly suppressed mainland. The linguistic and cultural continuity across the region possesses a potential for alliances between voices of resistance.

Egao (惡搞): A Creative Strategy to Challenge the Harmonious Society in the PRC

In 2004, CCP implemented a national policy entitled *hexie shehui* (Harmonious Society, 和諧社會), created to ensure that the regime remains stable and national security is ample enough to quash any real or imagined secessionism threats, including from independence movements in Tibet, South Mongolia, East Turkestan, and Taiwan. In the name of upholding *hexie shehui*, CCP censors language practices

using sophisticated technology and suppression methods. Jokes, word play, and puns that criticize the single-party government and its social policies are forbidden and offenders face persecution and arrest. In spite of the risk, online activists and netizens have been placing their freedom, and in some cases their lives, at stake to speak out via the Internet and social media platforms, which quickly became key communication tools after they were integrated into society in the 2010s.

Echoing the mocking laughter approach found in Hong Kong and Macao, the creative strategy of *egao* (惡搞) in Mandarin Chinese, a slang term for a parody, emerged through political and social satirists' works in the late 2000s as the naissance of online satire in social media in mainland China as well. It has since evolved into a form of disobedience and an expression of culture with observance functions.[24] Part of *egao*'s development is recorded in an English-language eBook, *Decoding the Chinese Internet: A Glossary of Political Slang*, first published in 2013 by China Digital Times (CDT), a California-based bilingual website providing news and original analysis on information that the PRC's state censors block, fabricate, or suppress.[25]

Academic research on humor and Internet censorship in the PRC is a growing field, appearing since the 2010s. Artist and researcher of Internet culture, An Xiao Mina looks at the visual and creative practices in Chinese Internet memes as political acts, in the context of the CCP's censorship environment, and finds that employing humor to reveal difficult truths and within the context of the Internet, where anyone can jam in a creative dialogue with posts to dodge censorship attempts, is a contribution to social change.[26] Media researcher Bingchun Meng points out that the *egao* creative approach has a transformative capability, and that the Internet has the distributive power to expand the communication space through entertainment discourses to challenge the dominant order.[27] Hongmei Li argues that "parodies offer important opportunities to erode hegemony through their destructive and sometimes revolutionary nature."[28] On the other hand, Siu-yau Lee, whose work is looking at institutional changes in Chinese politics, claims that political satires are never *just* a form of humor, and the author is optimistic that "if a satirical campaign can survive state suppression, it may gradually generate considerable oppositional forces."[29]

Parodic and satirical social and political expressions continue to spread in cyberspace despite the CCP's expansion in 2013 of the procuratorate law on *xunxin zishi* (picking quarrels and provoking trouble, 尋釁滋事) which now applies to online behavior.[30] Chinese language scholar Perry Link and technology and human rights activist Xiao Qiang posit that the new language of Chinese Internet memes leads to new thoughts, which rot the CCP's foundation and prepare the ground for significant change, including undermining the concept of *Tianchao* (Celestial Empire, 天朝), the ancient name for China, which netizens employ in an ironic way to describe the current government.[31] STOPPED The China Order—the concept of uniting the nation—remains a significant concept for the CCP regime, an ideological value that it imposes on the population with the ultimate goal of securing its domestic political power.[32] Link and Qing question whether an alternative world view and new political identity are evolving away from the ideology that "people are still trained to believe, for example, that *dang* (party) and *guo* (nation) are inseparable, or at least close enough that *ai guo* (patriotism) and *ai dang* (love of the party) need not be distinguished."[33] They believe that Chinese netizens are

increasingly placing ironic distance between themselves and the CCP, raising questions of national identity, including "what does it mean today to be 'Chinese'?"[34]

In response to the question of identity and citizenship, Link and Qing conclude that netizens are gradually able to produce political critiques on whether the "answer to the question 'What is to be Chinese' has to be the formula 'China equals the CCP,'" and that "there is a terrain upon which people can explore alternative answers to questions of identity."[35] Terms related to civic society such as *gongmin* (citizen), a new concept of identity—a person who has *quan* (rights)—alongside the ideas of "right to know," "right to express," and "right to monitor," have been growing in recent years.[36] If general public opinion in the PRC shifts, how would this impact on the concept of One China and its related policies in HKSAR, MSAR and Taiwan, or in Tibet and Xinjiang? The mass of critical netizens is growing but the constant pushback from censors and the fear of the consequences if one is caught does currently restrain these individuals.[37]

Creative Resistance Messaging from Taiwan and Hong Kong: "Colluding with External Forces"

While netizens in the PRC are increasingly questioning the various definitions of China, one scholarly survey reveals that the PRC's economic rise and new-found wealth has not generated the influence in Taiwan and Hong Kong that the PRC anticipated in terms of increased national pride and identification with "China."[38] In the case of Taiwan, the Kuomintang of China (KMT), also translated as the Chinese Nationalist Party, retreated to the islands in 1945, and imposed ideological suppression and material law until 1987. The island nation has moved away from its tight ideological and political history and there is a softening towards the development of a vernacular Taiwanese cultural identity. Also, the political environment changed, permitting the establishment of new political parties. Today, Taiwan is considered to be a self-ruled, fully democratic state with de facto independence, despite the PRC's desires for a united China.

The Taiwanese had their first opportunity to vote in a presidential election on March 23, 1996; the KMT's Lee Teng-hui (b. 1923) was elected as its ninth president. The KMT's major competitor, the Democratic Progressive Party, won the vote in the second open election in 2000 and its leader, Chen Shui-bian, became a symbol of the transition from the KMT's autocratic single-party rule to a multi-party system in a democratic Taiwan. Ironically, as the Taiwanese were relishing their new-found democracy in 1996, Hongkongers were contemplating their inevitable "return" to the "motherland" that would occur less than a year later.

Since the 1990s, Taiwan has faced constant threats from the PRC conceerning the issue of reunification, the "motherland" being keen to bring Taiwan back into the fold as part of the PRC's OCP. This pressure was coupled with a slowdown of the island's economy in the 2000s. The Taiwanese have used the experiences of post-handover Hong Kong as a reference point, very aware of the actions of pro-Beijing politicians and civil servants in Hong Kong who are betraying the locals' interests. Anti-mainland sentiment and resistance to OC ideology has been mounting in Taiwan, especially since 2000, and particularly among the young generations. This is exemplified by the student-led, 23-day civil disobedience movement that erupted in Taipei on March 18, 2014, leaving Taiwan's Legislative Yuan occupied by more than

200 students for the duration.[39] The protesters were opposing the Cross-Strait Service Trade Agreement between Taiwan and the PRC, condemning the ruling KMT party for putting the country's democracy and national security at risk for its economic revival and in doing so, making Taiwan more reliant on the PRC.[40]

Student activists chose the Sunflower Movement moniker as a homage to two important student-initiated civil movements for sociopolitical reforms in Taiwan's history: the 1990 Wild Lilies Movement and the 2008 Wild Strawberries Movement.[41] The Sunflower Movement used a representational image of a sunflower to symbolize protesters' "hope, defiance, and courage,"[42] and were supported by a large proportion of the population. The deadlock remained even after the police's forced evacuation of the occupied site, when unarmed and peaceful students and citizens were injured. In order to raise the profile of their resistance internationally, 11 netizens turned to virtual crowd fundraising through the placement of newspaper ads in *Apple Daily*, a local newspaper and the *New York Times*, on March 29 and 30, 2014.[43] Their efforts raised NT$ 6.7 million (approximately US$ 227,000) within three hours from 3,621 backers.[44]

The full-page *New York Times* advertisement had a black background and featured a small black-and-white photo of police using force on an unarmed citizen in the lower right-hand corner. A color photo of the evacuation scene taken outside the Legislative Yuan appeared in the bottom lower right-hand corner, echoing the content of the black-and-white photo. The two-column copy on the left side told the story of that night in Taipei (Figure 3.3). Aaron Yung-chen Nieh (聶永真, b. 1977), the first Taiwanese member of the Alliance Graphique Internationale, designed the advertisement. Entitled "Democracy at 4 a.m.," Nieh's creative approach in this work is more poetic than emotional, despite the situation's direness. It was inspired by "Four in the Morning," a poem by Nobel Laureate and Polish poet Wisława Szymborska (1923–2012). The advertisement's sub-heading—"Morning without YOU is a dwindled dawn"—is from American poet Emily Dickinson (1830–86). Both headings use a soft appeal to provoke readers' support for this struggle for democratic ideals through civil disobedience to wake up their government to the threat from across the Taiwan Strait.

When comparing the Sunflower Movement and Umbrella Movement, critics declare both to be acts of civil disobedience, with the PRC as the protesters' common target.[45] Hong Kong has retained its common puckish protesting style, backed by a media history that embraces the satirical and sarcastic in formats ranging from television variety shows to Stephen Chow movies. In contrast, the Taiwanese approach has been cerebral and scholarly, sustained by a conceptual philosophical rationale. Each strategy was designed to flourish in its specific environment, examples of diverse ways to take on a common opponent, albeit with different results. Hsiao and Wan argue that while Taiwan's Sunflower Movement can be viewed as a victory, Hong Kong's Umbrella Movement was destined to fail.[46]

In Taiwan, protesters faced off against a democratically elected government. None of the protesters have been convicted, unlike in Hong Kong as discussed earlier. "Today's Hong Kong, Tomorrow's Taiwan" (今日香港 明日臺灣) was one of the most popular slogans chanted during the Sunflower Movement, reflecting protesters' fears of a Taiwan under the "one country, two systems" framework. Clearly, the anti-CCP sentiments of the two movements have brought citizens closer together in resisting the assertions of this ideology.

Figure 3.3 "Democracy at 4 a.m." Full-page advertisement on March 29 and 30, 2014, *New York Times*. Design: Aaron Yung-Chen Nieh (聶永真).

Source: www.4am.tw.

After Hong Kong's Umbrella Movement ended in December 2014, civil movement in the HKSAR reached a low point, until over one million people peacefully took the streets on June 9, 2019 against the Fugitive Offenders and

Mutual Legal Assistance in Criminal Matters Legislation (Amendment) Bill 2019 (2019年逃犯及刑事事宜相互法律協助法例 [修訂 條例草案]), or the Anti-Extradition Law Amendment Bill (abbreviated as Anti-ELAB, 返送中) for short; this new disobedience movement was ongoing in the summer of 2019. The Umbrella Movement experience and social media advancements since 2015 have allowed protesters to adopt new resistance strategies instead of attempting the long-term occupation of public spaces. Among these new strategies is an approach similar to the Taiwan case study mentioned earlier. A group with diverse backgrounds initiated a crowdfunded project in late June 2019 to place an open letter as an advertisement in major newspapers of selected G20 member countries.[47] Along with a Twitter campaign using hashtag #FreedomHK and the official website—freedomhkg.net—the project asks people of the world to stand with Hongkongers in defending freedom and autonomy in Hong Kong.

The project raised over US$857,000 in nine hours, and 13 advertisements were placed in 19 newspapers during the June 2019 G20 summit, including Canada's *Globe and Mail*, the *New York Times* (Figure 3.4) and the *Washington Post*, France's *Le Monde*, the UK's *Guardian*, Germany's *Süddeutschen Zeitung*, Japan's *Asahi Shimbun*, Korea's *East Asia Daily*, and Sweden's *Dagens Nyheter*.[48] In a short four-day period, the project team completed the crowd fundraising, placement, copy writing, translation, and production of the advertisements. The design of each advertisement was localized based on the open letter copy and most used a similar headline in different languages. The overall design direction contained a bold san serif typeface headline "Stand with Hong Kong at G20," copy of the open letter, a QR code linked to the project website, and a black-and-white photo from the June 12, 2019 protest. Compared to the 2014 Sunflower Movement's "Democracy at 4 a.m." advertisement, though, the seriousness of the anti-extradition bill meant that bold and direct was a more appropriate approach than a poetic and emotional appeal.

It is unclear whether the Hong Kong team acknowledged the Taiwanese internationalizing strategy—the "Democracy at 4 a.m." advertisement placement. The Chinese Foreign Ministry has often accused Hong Kong civic disobedience protesters of "colluding with external forces" or "colluding with foreign forces" (勾結外國勢力), and this G20 project team decided to put the allegation into reality. When compared with the Umbrella Movement, the messages from Hongkongers around the PRC's actions to dishonor its promise of the "one country, two systems" agreement since the handover are louder and clearer than ever.

Postscript

Western powers and Japan have encouraged the PRC's rise for decades, hoping that economic success would usher in free expression, human rights, and civil society. However, these hopes have not yet materialized in the imagined way, even after four decades of China's Reform and Opening Policy. The examination of selected creative resistance strategies in Hong Kong, Macao, and Taiwan shows analogies and exchanges between citizens of the former colonies' resistance to the CCP's One China concept, as well as with internal dissent in the PRC. The case studies I highlight in this chapter indicate a variety of strategies, from the puckish and the parodic to the poetic and the factual. These strategies generate a dissenting collective through acts of visual and textual readership, evoking feelings that can vary from shared laughter and elation to anger and determination. They are acts of

Figure 3.4 "Stand with Hong Kong at G20" global advertising campaign. Full-page advertisement, *New York Times*, June 28, 2019.

Source: https://freedomhongkong.org/en/aboutus/.

disobedience via design in the effort to raise awareness and oppose CCP authoritarian rule. As current events in Hong Kong signal, while I am finishing this chapter in December 2019, this effort is ongoing, and such acts of resistance will characterize the region's politics for the foreseeable future.

Notes

1. "The National Unification Council's Definition of 'One China'" [August 1, 1992], *Chinese Law and Government* 35, no. 3 (2002): 60–61.
2. In its modern history, China was divided under different governments after the Qing dynasty's (1644–1912) fall. Its successor, the Republic of China (ROC), was established on October 1, 1912. ROC lost control of the mainland in the second phase of the Chinese Civil War (1946–49) to the Chinese Communist Party (CCP) and retreated to Taiwan. The People's Republic of China (PRC) was founded on October 1, 1949 under the command of the CCP. They controlled the mainland and eventually replaced the seat occupied by the ROC as "China" in the United Nations in 1971.
3. Fei-Ling Wang, *The China Order: Centralia, World Empire, and the Nature of Chinese Power* (Albany: State University of New York Press, 2017), 3.
4. Wing-sang Law, "Decolonisation Deferred: Hong Kong Identity in Historical Perspective," in *Citizenship, Identity and Social Movements in the New Hong Kong: Localism after the Umbrella Movement*, eds. Wai-man Lam and Luke Cooper (Abingdon: Routledge, 2018), 13–33.
5. Yimou Lee, "Taiwan President Defiant after China Calls for Reunification," *Reuters World News*, January 2, 2019, www.reuters.com/article/us-china-taiwan-president/taiwan-president-defiant-after-china-calls-for-reunification-idUSKCN1OW0FN.
6. DDED HK, "The TriForce of Occupy Hongkong," *YouTube*, October 7, 2014, www.youtube.com/watch?v=dHwWPXdtII4&feature=youtu.be.
7. Wendy Gan, "Puckish Protesting in the Umbrella Movement," *International Journal of Cultural Studies* 20, no. 2 (2017), 163.
8. Ibid., 164.
9. Law, "Decolonisation Deferred," 19.
10. Georgios Patsiaouras, Anastasia Veneti, and William Green, "Marketing, Art and Voices of Dissent: Promotional Methods of Protest Art by the 2014 Hong Kong's Umbrella Movement," *Marketing Theory* 18, no. 1 (2018), 84.
11. Dan Garrett, "Superheroes in Hong Kong's Political Resistance: Icons, Images, and Opposition," *PS: Political Science and Politics* 47, no. 1 (2014), 112.
12. Suzanne Sataline, "'Umbrella Nine' Hong Kong Pro-Democracy Leaders Sentenced to Jail," *The Guardian*, April 24, 2019, www.theguardian.com/world/2019/apr/24/umbrella-nine-hong-kong-pro-democracy-leaders-sentenced-to-jail.
13. Holmes Chan, "Hong Kong's Leading Umbrella Movement Activists Handed Jail Sentences," *Hong Kong Free Press*, April 24, 2019, www.hongkongfp.com/2019/04/24/breaking-hong-kongs-leading-umbrella-movement-activists-handed-jail-sentences/.
14. Sonny Shiu-Hin Lo, "One Formula, Two Experiences: Political Divergence of Hong Kong and Macao since Retrocession," *Journal of Contemporary China*, 16, no. 52 (2007): 362.
15. Ibid., 359.
16. Worldometers, "Macao Population (2019)—Worldometers," *Worldometers.Info*, April 29, 2019, www.worldometers.info/world-population/china-macao-sar-population/.
17. Carol Archer and Christopher Kelen, "Macao Monuments: In Art, in Poetry, and in Your Face," *Space and Culture* 14, no. 2 (2011): 141–46.
18. Niall Fraser, "Macau Journalists Concerned about Press Freedom, Survey Shows," *South China Morning Post*, September 29, 2017, www.scmp.com/news/hong-kong/politics/article/2113462/macau-journalists-are-concerned-about-press-freedom-and.
19. Lo, "One Formula, Two Experiences," 368.
20. Hong Zhang, and Brian Hok-Shing Chan, "Translanguaging in Multimodal Macao Posters: Flexible Versus Separate Multilingualism," *International Journal of Bilingualism* 21, no. 1 (2017): 50.
21. Jason Chao, "「貪貪」、「污污」勝出熊貓民間花名投票" ("Tam Tam and Wu Wu Won the Folk Naming Competition"), *Medium*, September 12, 2016, https://medium.com/庭-思-問/貪貪-污污-勝出熊貓民間花名投票-b46a76ccedaf.
22. "George Orwell: Funny, but Not Vulgar," *George Orwell's Library*, April 24, 2019, http://orwell.ru/library/articles/funny/english/e_funny.
23. Gan, "Puckish Protesting in the Umbrella Movement," 167.

24 Luwei Rose Luiqiu, "The Cost of Humour: Political Satire on Social Media and Censorship in China," *Global Media and Communication* 13, no. 2 (2017), 124.
25 The latest (2015) edition is free to download and the publisher hosts a regularly-updated wikipage with over 300 entries of subversive Chinese Internet language on resistance lexicon. For more on *egao*, see Luiqiu, "The Cost of Humour," 124; China Digital Times, ed., *Decoding the Chinese Internet: A Glossary of Political Slang* (Berkeley, CA: China Digital Times, 2015).
26 An Xiao Mina, "Batman, Pandaman and the Blind Man: A Case Study in Social Change Memes and Internet Censorship in China," *Journal of Visual Culture* 13, no. 3 (2014): 367–69.
27 Bingchun Meng, "From Steamed Bun to Grass Mud Horse: E Gao as Alternative Political Discourse on the Chinese Internet," *Global Media and Communication* 7, no. 1 (2011): 34–38.
28 Hongmei Li, "Parody and Resistance on the Chinese Internet," in *Online Society in China: Creating, Celebrating, and Instrumentalising the Online Carnival*, eds. David Kurt Herold and Peter Marolt (New York: Routledge, 2011), 72.
29 Siu-yau Lee, "Surviving Online Censorship in China: Three Satirical Tactics and Their Impact," *The China Quarterly* 228 (2016): 1062.
30 Jason P. Abbott, "Of Grass Mud Horses and Rice Bunnies: Chinese Internet Users Challenge Beijing's Censorship and Internet Controls," *Asian Politics & Policy* 11 (2019): 167.
31 Perry Link, and Xiao Qiang, "Introduction: China at the Tipping Point," in *Decoding the Chinese Internet: A Glossary of Political Slang*, ed. China Digital Times (Berkeley, CA: China Digital Times, 2015), 5.
32 Wang, *The China Order*, 102.
33 Link and Qian, "Introduction," 4.
34 Ibid.
35 Ibid., 8.
36 Ibid., 8–9.
37 Abbott, "Of Grass Mud Horses," 167.
38 For example, see Frank C.S. Liu, and Francis L.F. Lee, "Country, National, and Pan-national Identification in Taiwan and Hong Kong Standing Together as Chinese?" *Asian Survey*, 53, no. 6 (2013): 1112–34.
39 "Taiwan: Restraint Urged in Protests over China Trade Deal," *Amnesty.Org*, March 19, 2014, www.amnesty.org/en/press-releases/2014/03/taiwan-restraint-urged-protests-over-china-trade-deal/.
40 Chih-ming Wang, "'The Future that Belongs to Us': Affective Politics, Neoliberalism and the Sunflower Movement," *International Journal of Cultural Studies* 20, no. 2 (2017), 178; Fang-Yu Chen and Wei-Ting Yen, "Who Supports the Sunflower Movement? An Examination of Nationalist Sentiments," *Journal of Asian and African Studies* 52, no. 8 (2017), 1194.
41 Hsin-Huang Michael Hsiao and Po-San Wan, "The Student-Led Movements of 2014 and Public Opinion: A Comparison of Taiwan and Hong Kong," *Asian Journal of Comparative Politics* 3, no. 1 (2018), 62.
42 Wang, "'The Future that Belongs to Us'," 178.
43 "Attempts at International Outreach During the Movement—Daybreak Project," *Daybreak Project*, July 20, 2017, https://daybreak.newbloommag.net/2017/07/20/international-outreach/.
44 Democracy at 4:00 am, accessed December 3, 2019. 4am.tw
45 Hsaio and Wan, "The Student-Led Movements," 72.
46 Ibid., 62.
47 "Free Hong Kong: Stand with Us at G20," *Freedomhkg.net*, accessed July 10, 2019, https://freedomhkg.net/openletter.
48 "Freedom HK (@Freedomhkg) on Twitter," *Twitter.com*, accessed July 10, 2019, https://twitter.com/FreedomHKG?lang=en.

4 The Slovene Zombie Uprising

Ksenija Berk

Introduction

This chapter is a contribution to the critical analysis of "disobedient objects"[1]—the material culture created, designed, built, or constructed for and from within street protests. It addresses the emergence of zombies as they appeared in the second *All-Slovenian People's Uprisings* in 2013. The uprisings took place over the course of six months, from December 2012 until June 2013 in all major Slovenian cities. December 21, 2012 was the day of the first *All-Slovenian People's Uprising*. The citizens protested against the systemic corruption of political, economic, and ecclesiastical elites, which was crippling the young democratic state[2] and causing feelings of alienation and betrayal. The underlying tone of protests was a deep dissatisfaction with governmental policies and a call for a systemic change. During peaceful street marches, protesters sang revolutionary songs from different historic times, such as *The Internationale*, and carried a diverse palette of posters, banners, flags, and other typical protest materials. When Janez Janša, the appointed prime minister, saw the rebelling protesters on the streets, he was irritated to the point that he tweeted that these were not protests of Slovene citizens, but an uprising of communist zombies: "'#resistance? Communist International, rhetoric of civil war, totalitarian symbols? The rise of Zombies not the rise of nation.'"[3] The reaction of the PM, who was also a leader of the right-wing Slovenian Democratic Party (SDS), not only stirred vigorous debate, but also influenced a creative approach to the second uprising. Slovene citizens were determined to show the PM and his political allies that the people had a democratic right to publicly protest against any government and they should not be shamed or ridiculed for doing so. Therefore, the protesters decided to respond in a way that would reflect the PM's comment, while being intelligible to both political elites and the larger public. As a result, on January 11, 2013, the *Uprising of Zombies* emerged on the streets of Slovene capital Ljubljana.

This chapter emphasizes the importance of bottom-up zombie protest as a direct response of the Slovene citizenry against the PM's ridiculing of the street protests, analyzing its materialization and its relation to similar political zombie protests on a global scale. The chapter is organized roughly chronologically, introducing a historical background and the political context of the protest, following trajectories of different zombie insurrections in contemporary street protests around the world, and touching upon the notion of the monstrous in relation to Slovenian daily politics. Although I present a number of analogous episodes of zombie protests, I argue that protest materials should not be extracted from their social and political context; otherwise,

they could result in misleading conclusions that would render important details about the origin and context of these protest actions irretrievably lost. It is worth remembering the words of semiotician Gunther R. Kress in his seminal book *Reading Images: The Grammar of Visual Design*,[4] that forms might share similarities, however, they are always culturally and politically specific. The visual and material culture of the *Uprising of Zombies* is thus inseparable from the larger political realm of Slovenia's daily politics, which set the conditions for the *All-Slovenian People's Uprisings* (ASPU). This chapter was realized using discourse analysis of media and protest materials, and historical and ethnographic research methods, engaging in participant observation and interviews with a range of active participants in and contributors to the *Uprising of Zombies*, both on and off the streets.

Zombies: From Indigenous Practices to Popular Culture to Street Protests

The figure of the Zombie in contemporary protests largely gained its currency within the *Global Justice Movement*, for the most part during the 2011 *Occupy Wall Street* protests in New York City. However, zombie characters came to the streets gradually, moving along a path from their origin in indigenous practices to figures in popular culture such as literature, theater, and film. Caribbean in origin, more specifically of the Haitian *Vodou* practice, zombies were introduced to North American popular culture in 1929, when William Seabrook published his novel *The Magic Island*. A few years later, in 1932, Victor and Edward Halperin directed the *White Zombie* feature film based on Seabrook's novel, which had a significant influence on future generations of movie directors around the world. One of these was George Romero, who in 1968 directed the horror movie *Night of the Living Dead*, which became the template for the visual representation of zombies in the popular culture. There is one particular characteristic, Hughes claimed, that all zombies share and that is that they belong to a "horde," which means they are a participant in "collective action and the unpredictable and dangerous crowd," but also reflect a "fear of social, racial and class upheaval."[5] *Zombie Theory: A Reader*, edited by Sarah Juliet Lauro,[6] gives a very comprehensive analysis of zombies through history, and classifies zombies as belonging to various categories such as old school or classic zombies.

Varieties of zombie embodiments have a long and colorful history on the streets, and in the past decade in protests.[7] Their appearances vary according to the historic times in which they were created, the "role" they were playing, or whom they were representing. Zombies in early protests and zombie-carnivals alike were to a large extent employed to express the abject nature of their bodies, as argued by psychoanalyst Julia Kristeva in her *Powers of Horror: An Essay on Abjection*.[8] The notion of the un-dead, the decayed, the biologically contagious, and the lethargic were the main communicative features of these zombies. One example is documented by Canadian theorist Peter A. Russel, who, during World War II, wrote an interesting analysis entitled "BC's 1944 'Zombie' Protests Against Overseas Conscription." He discussed at length the protests against the home defense conscripts in British Columbia and compared the compulsorily enlisted soldiers with zombies, creatures who "had no will of their own—no will to volunteer for overseas duty."[9] The instantiation of the abject nature of zombies as a symbolic embodiment of

negative aspects of neoliberalism is contemporary and, to a large extent, can be traced to the *Occupy* movement. The rapid growth of zombie protesters on the streets embodied the demand for a power shift from political elites to the multitude. It reflected a "crisis of representation"—that is, the rejection of the current political system in favor of greater autonomy and citizenship, as well as a revolt against neoliberal corporate capitalism and autocratic tendencies in politics. News media and different scientific journals deemed these zombies "corporate zombies," who were symbolically marking "undead corporations" that were "sucking the life blood of the 99%, soulless executives that who had lost their humanity in pursuit of capital."[10] In June 2011, students in Chile protested against fees charged by their country's privatized school system. Under such circumstances, they created a "flash mob,"[11] inspired by Michael Jackson's 1983 music video *Thriller*, outside the home of President Sebastian Piñera. In 2013, zombies appeared in street protests in Slovenia. In 2016, protesting zombies appeared in front of the London office of the European Commission, to call on the EU to stop the Electronic System for Travel Authorization (ESTA) agreement. The most spectacular and massive appearance of zombies occurred in summer 2017 a day before the G20 summit in the German city of Hamburg. A group of zombies, organized by 1000 GESTALTEN,[12] a charitable cultural association, appeared in grey office suits, covered with gray clay, conquering the streets in an eerie political performance called "Welcome to Hell," demanding an egalitarian society and criticizing a lack of enthusiasm in politics.[13]

The Uprising of Zombies in Slovenia and its Political Framework

The political background of the "Uprising of Zombies" and its role in All-Slovenian People's Uprisings deserves to be sketched before we dive into the complex nature of zombie materiality. In winter 2012–13, people gathered in large numbers on the streets and organized a continuous series of protests against the pervading corruption of the Slovenian political elite. To the outside observer, the protests did not stand out from the ongoing protest movements in the broader Balkan and Central European region.[14] In 2012, people across Europe, from Spain, Italy, Portugal, France, Belgium, and Greece united[15] in economic justice and anti-austerity protests.[16] To a certain extent, the Slovene uprisings were also inspired by those protests and the ideas of the Global Justice Movement, however with an important difference—the All-Slovenian People's Uprisings (ASPU) emerged from diverse civil society initiatives, which called for systemic change and a fight against corruption.[17] The conditions that produced these protests were in large part the result of citizens' dissatisfaction with the political elite since Slovenia gained independence in the early 1990s. They share several parallels with other protests that placed systemic corruption in democratic political systems under scrutiny,[18] which in the case of Slovenia is not a new phenomenon and can be traced back to the socialist political system of the former Yugoslavia.[19] The most notorious tycoon privatization stories[20] were in large part responsible for the Slovenian financial crisis which drove protesters into the streets across the country.[21] In order to mobilize as many protesters as possible, uprisings were organized during weekends, so that working people were able to join in. Although many protest participants and activists (among others: anti-globalists, anarchists, socialists, LGBTQIA[22]) were predominantly of left-wing political orientation, others belonged to a vast array from across the political spectrum, and came

from all walks of life, operating in free association according to a loose set of principles. Many people who joined the protests refused to declare themselves as belonging to any political idea, movement, or ideology. That being the case, no political party or group could actually claim to own or organize the protests. Regardless of the open support of the left-wing political parties, the protests managed to keep their autonomous character, which reminds us of the Spanish *15-M/Indignados*[23] movement and the Greek *Aganaktismeni*.[24] The tactics of creative protest activism was far from guerilla-like, primarily because all protests and public gatherings in Slovenia are required to give advance notice to the authorities, who then give the green light for such an event to take place; the organizers are fined if they proceed without approval. In Slovenia, the option of free, legal protests is systemically controlled through legislation, which conditions codified behavior in public places.

The first protests over corruption started in November 2012 in Slovenia's second largest city, Maribor,[25] demanding the resignation of the city's corrupt mayor and other members of the political elite.[26] Soon after, protests spread to other cities, becoming the All-Slovenian People's Uprisings (ASPU), demanding the resignations of corrupt mayors, members of the political and ecclesiastical elite, and CEOs. The appointed right-wing prime minister, Janez Janša, fell out of favor with many Slovenian citizens for brazen attempts to dismantle social programs and welfare. As I mentioned in the introduction, shortly after the first ASPU started, the Slovene PM tweeted his dissatisfaction with protests, labeling protesters as "communist zombies." This rather surprising characterization of the PM was not taken lightly by citizens and echoed far beyond Slovenia's borders. The PM's shaming of protesting citizens resulted in strong reactions, the cohesion of civil society groups and at the Second ASPU, on January 11, 2013, the "Uprising of Zombies" took to the streets of Ljubljana.

The Specificity of Slovene Zombies in Protest

One of the specificities that all street protests have in common is rather limited media coverage. The visual aspect of this research analyzes materials in mainstream and progressive media, the academic press, on social media platforms, and participant observations at the protests. Rather than describe all the individual materials, I will review, by way of examples, how zombie protest materials shaped a specific tone of the Slovene protests by challenging the circumscribed space of national politics with dramatic content. To recognize what distinguishes Slovene zombies from other zombie-like protests, it is crucial to know the sociopolitical conditions which led to the uprising. Zombie protest materials occurred from within the ASPU as a direct reply, or more precisely, as a reflection of and response to the PM's labeling of protesters as such. In my previous research on Slovene protest materials,[27] I have, in relation to zombies, focused on identifying major, albeit rather limited, categories of zombie masks. Nevertheless, the additional field research, media analysis, and discussions with protesters, has led me to consider zombie materials in a much broader way, outside the narrow frame of the category of a protest mask. For the large part, zombie materials *did* appear in forms of face masks; however the diversity of creative approach gave rise to different designs, which can be divided into four major categories: white paper masks, zombie body paintings, paper zombie puppets, and zombie posters.

In the first group, we can find big white paper masks, which have several parallels with the white mask of the Anonymous hacktivists. In comparison, Slovene masks were at least twice as big, made of white cardboard paper, and designed to be held in front of the face with both hands, which also allowed protesters to perform different group choreographies (Figure 4.1). They gathered in small groups and moved the masks in front of their faces in unison. However, these masks did not bear a resemblance to any real person as in the case of the Anonymous mask, which is attributed to the legendary anarchist Guy Fawkes. What is more, the masks portrayed neither a human, nor a zombie. Narrow and elongated, with cut-out orifices, they are at first glance suggestive of traditional wooden masks from Africa and Oceania that influenced Pablo Picasso (in his proto-Cubist or Black Period in 1907–09). Iija Tomažić Trivundža described them as "origami style masks,"[28] because they resembled origami in the way they were folded from a square-shaped paper with visible folding lines, which helped to cut out symmetrical rectangular holes for eyes and mouths. We can indentify a similar design of geometric DIY paper masks, in the "foxy-boxy" masks by Steve Wintercroft in the 2015 Westminster, UK anti-hunting protests.[29] The power of those masks lies in their accessibility and easy production; they are downloadable as free paper craft templates. Slovene protesters could help themselves to create these white cardboard zombie masks with the help of a DIY tutorial[30] on YouTube by the activist Mitja Solce, the creator of that particular mask design. Protesters were encouraged to make as many masks as they could, to be brought and distributed to those who did

Figure 4.1 Paper zombie masks, "Protestival" at the second All-Slovenian People's Uprising (ASPU), Ljubljana, December 22, 2012.

Photo: Borut Krajnc.

not have a chance to create their own mask, but were prepared to wear one and help to construct a large, homogeneous, and very visible groups of protestors, who stood out from the masses. The anonymity of individual protesters in the "Uprising of Zombies" made manifest the notion of a coherent political body of the citizens. In the way in which they created anonymity, uniformity, and bottom-up dissent, they bore a resemblance to the global Million Mask March.[31] Their choreographed movements generated a gestural dialogue with other "zombie" characters as well as with other protesters who were not disguised.

The second group of protesters that belong to the zombie category were those who did not wear a paper mask, but acted as the zombie characters we know from the fictional movies and popular culture. They were wearing everyday clothes, but their faces were painted in black and white, and they wore unusual head covers. The protesters' faces were camouflaged with a white and grey color and their lips tinted black to achieve a zombie look. Wearing mostly black clothing, they covered their heads with the white knit tubular elastic net bandage usually found in first-aid kits, with holes cut out for their face orifices. The specificity of these zombies, who did not carry any props in their hands, was their immense agility and liveliness, which enabled them to be more aggressive and militant in their performance. During the protest, they performed sudden jumps in front of other protesters, member of the press, and especially the police. They climbed the façades of the buildings in the center of Ljubljana, where the headquarters of banks and ministries are situated, roaring for the return of property to the people, while posting stickers with the slogan "*Naša last!*/Our property!" (Figure 4.2). Their liveliness, quite the opposite of the popular depiction of lethargic, rotten zombies, was a deeply symbolic action aimed directly in reply to the prime minister's designation of protesters as zombies. Although the PM might see protesters as such, they, on the contrary, were very much alive, rebellious and determined to highlight the debauchery, impropriety, and corruption of the Slovene political system.

The third group of zombies was the most diverse and theatrical, consisting of huge white caricatured puppet-skeletons made of cardboard, papier mâché, tissue paper, and crepe paper. The mechanics of this giant puppet enabled the protester to mount it on their shoulders and use the puppet's long arms to help navigate spatial movements. Some of the giant skeletons had attached white organza veils to their heads, lightly floating in the air and creating a flair of drama when moved around. They were used as props in order to dramatize the political content of protests and to contribute to the specific visual language of the protest. The puppet-like technique worked very well with the populist vision of zombies—a rather eclectic combination of different puppet styles and zombie movie influences. This creative approach demonstrates the inventive possibilities of protest mask design, which is simultaneously grounded in the collective unconscious while finding the unique symbolic language of a specific community. The "Uprising of Zombies" happened in response to a series of unpopular actions by the government. The zombies were not only questioning the PM's remarks, but were also challenging the entire democratic system in Slovenia. While there have been some notable protests in the past, it was the "Uprising of Zombies" that had the strongest pull to lure people to the streets, irrespective of their professions.

The fourth and smallest zombie grouping was a handful of zombie posters, portraying the corrupt politicians in a caricaturized grotesque manner. These were mostly

Figure 4.2 Two different types of zombies acting together in front of the Slovenian Central Bank building. Third ASPU, Ljubljana, February 8, 2013.

Photo: Borut Krajnc.

overlooked, for there were only a very small number, visible only after a thorough scrutiny of photographs documenting the uprisings. The question that this category opens is how it relates to the other categories and what it means in a symbolic sense. The other categories of zombies mentioned above represented the people's will to protest against the labeling of protesters as zombies. Putting zombified politicians on posters was a logical step further in a process of reflection, explaining that when protesters are labeled as zombies, it is understood that politicians are zombies, too.

If we set aside the last category of visual materials, zombies in the context of Slovene protests did not portray a specific character. Their dramatic character, on a symbolic level, helped to release the pressure of undisclosed political frustrations on the collective level. What is of particular importance here is that they were as much a matter of politics as they were of style. Within this spectrum, one can stress the importance of cooperation between activists and other participants in creating a memorable visual protest language. As part of "Protestivals,"[32] the artistic part of the ASPU, the variety of zombie materials brought to the fore the coexistence of different alternatives. "The Protestival is a calling for a social renaissance and a return to the human while rejecting the manipulations of capital,"[33] stated publisher Rok Zavrtanik and artist Matija Solce, who were among the most active organizers of the "Protestivals": "It is connecting people through their cultural expression, via musical performances, physical theatre, puppets, poetry, as well as giving a voice to the protesters themselves, thus creating a unique people's forum."[34] Zombies acted in a twofold manner, on the one hand as a strong political message to the prime minister, and on the other as a form of

political performance embodying the important legacy of the Interventionist and Situationist strategies of the 1960s. They additionally served as an unwelcome reminder of the excessive exercising of political power in young democracies such as Slovenia.

If we sum up the most significant differences between zombies of the larger Global Justice Movement and the Slovene zombies, we can see that the former were an embodiment of either dead or soulless corporations, while the latter were an ironic rebellion against the labeling of the supposedly "dead" citizens from the prime minister of a democratic European state. The comparative account shows that while both categories share the notion of "non-alive, but not dead," they represent different categories of the political, and bring to the fore concepts that are both local and transnational, universal and particular. The Global Justice Movement zombies emphasize the issues of neoliberal capitalism, while the Slovene zombies question the limits of democracy and manifest citizens' sovereignty in their right to freely criticize their leadership. What arouses our curiosity here is the heteroglossia of this sort of "political carnival," expressing a variety of political claims and concerns of protesters.[35] Moreover, the form of political performance as repeatedly manifested through zombie actions created the space for activist citizenship. A collective action in the form of participatory performance was an instrument for waking up the usually politically dormant Slovene civil society to become an active, emancipated subject in political protests. Precisely for this reason we should not dismiss the importance of that "performance art into political action"[36] on the streets of Slovene cities. The protestors staged parodies of satirical spectacles that both mocked and denounced governmental ideology and behavior.

Category of Non-human, Abnormal, and Monstrous

There are several categories inextricably linked to the notion of zombies. One of them is the category of the abject, which I have briefly mentioned in previous sections, and the other is category of the monstrous. In particular, the category of the monstrous has captured both public imagination and scholarly interest when it comes to zombies. French philosopher Georges Canguillhem explored monstrosity and the monstrous in relation to how health and disease were defined in the early 19th century. Monstrosities in his regard were severe anomalies, which affect the body of the individual to such an extent that it functions "very different from that ordinarily found in their species."[37] Zombies in protest do not share a specific anomaly that would prevent them from functioning differently than their species. They are still human, but trapped between life and death, and they possess features from both sides, actions that belong to the living and corporeality of the dead. However, if we read Canguillhem's *Monstrosity and the Monstrous* closely, we find that he draws the conclusion that monsters are something that defies order.[38] This is precisely the point where Slovene zombies meet Canguillhem—in defying the prime minister's shaming of protesters by adopting the zombie-look and going to the streets as a mirror of governmental politics. Visual culture specialist and artist Alexa Wright, reminds us of the particular triad—monstrous/monstrosity/monster[39]—and its contradictory nature, which we need to take into account when we are researching any of the mentioned categories. She claims that "although monsters and monstrosities act to symbolize or 'realize' monstrousness, what is truly monstrous is that which stands outside the process of representation or

articulation ... once it can be symbolized, monstrousness loses its terrible power."[40] When people went onto the streets and created an uprising "in command of" zombies, it did not mean solely to reflect on and refract the PM's laments, but to form an action, which would, by embodying the monstrous, in a symbolic sense deprive the PM of his power.

Finally, I cannot conclude the reading of the "Uprising of Zombies" without at least briefly mentioning the Foucauldian category of the monstrous,[41] for it shows us the conceptualization of power relations and political practices in a particular society. Foucault has explored the category of monstrous in his lectures at the College de France in 1974–75, later published in a book under the title *Abnormal*.[42] Foucault anchors his category of the "human monster,"[43] and correspondingly the abnormal, within the frame of the law (society and nature), which therefore falls under the "juridico-biological" domain.[44] He shows us that until the 19th century this monstrosity was tucked away under various abnormalities and deviances, similarly as in Canguillhem's theories. From the late 18th century and in early 19th century, Foucault identifies the category of human monster in three major categories, all connected to the development of different social institutions which can be traced to the present.

The first category is the so-called "pale monster," connected to the "judicial and medical techniques that revolve around abnormality," whose frame of reference is "nature and society."[45] The second category is the "individual to be corrected," where his frame of reference is the "system of laws of the world": "The individual to be corrected emerges in the play of relations of conflict and support that exists between family and the school, workshop, street, quarter, parish, church, police, and so on."[46] The third category is the "masturbator," whose frame of reference is the "microcell around the individual and his body,"[47] including his parents, family members, doctors and nurses. It is the second category, "the individual to be corrected," which is related to all the zombies in street protests. Labeling protesters who joined the organized public protests against corrupted elites as zombies was much more than just a simple parapraxis or Freudian slip[48] on the part of the Slovene prime minister. The explicit assignation of protesters as zombies is not a practice of political elites in democratic governing systems, and can be analogous to totalitarian or authoritarian regimes, often as a method of discouraging a specific political collective action.[49] Although people who protested peacefully in the streets did not breach any law, they managed to cause an anxiety on the side of political elites. Following Foucault, we can conclude that when power structures see protesters in advance as individuals to be corrected, the outcome is usually very different from what the law proscribes and "provokes either violence, the will for pure and simple suppression, or medical care or pity."[50] Slovenia achieved its democratic freedom in 1991 with independence from the former Yugoslavia, and a change of the political regime. However, several scholars[51] have raised the question of whether democratization in south-eastern Europe should be approached through a distinct model of regime change. What is interesting is that protests and strikes were common during the Socialist regime, seen as an important mechanism through which worker's rights were displayed, and authorities did not question their legitimacy. The idea of protest or revolutions seen exclusively from the point of disturbance or disorder is a form of "police interpretation," of the type that Rosa Luxembourg extensively about in *The Mass Strike*.[52]

Conclusion

What does the uprising of zombies as political phenomena in Slovene protest mean? They, for one, have revived a form of political performance,[53] very much present in the European protest movements and Situationist practices of the 1960s, and managed to awake otherwise dormant citizens into a "collective dimension of social experience," which according to Claire Bishop, in her analysis of participatory aesthetic practices, collapses "the distinction between performer and audience, professional and amateur, production and reception."[54] Additionally, masks in general help to construct and reconstruct social memory,[55] which is of particular importance as they appeared at different times of crisis and turmoil, such as in public protests. Various zombie characters captured the social and political "image" of a conflict between the Slovene prime minister and the citizenry. As a direct expression of their strong disapproval of the PM's public despising of protesting citizens as zombies, the citizens created different zombie protest materials and used them in the second ASPU on the streets of the capital Ljubljana. The bottom-up "zombified" protest functioned as a mirror to the governmental politics, and as an activist action against the ridiculing of street protests. The "Uprising of Zombies" was not a practice of disruptive activism, but a conscious protest action with deeply symbolic meaning. Protesters employed the zombie attributes as a creative mechanism for citizens' political participation, demonstrating that protests are a fundamental institution in democratic society, where people can bring their demands and emotions into the public space. The zombies' visual occupation of public space was strategic, well executed, and deeply symbolic. Zombies helped people to locate themselves socially and politically. As the most visible and unconventional of the large number of people protesting by means of irony and parody, zombies were not only simply against what was oppressive.[56] They were an embodiment of the disorder that resulted from the pathological dysfunction of the Slovenian governing politics. At the same time, the collective dimension of the zombie hoard united the physical bodies of the protesters across class divisions into a robust political body with its own structural logic.

Notes

1 This was the title of an exhibition at the Victoria and Albert museum (July 26, 2014–February 1, 2015.) that displayed art and design artifacts produced by social movements actors the world.
2 Slovenia gained independence from the former Yugoslavia in 1991. For further details, see Reneo Lukić and Allen Lynch, *Europe from the Balkans to the Urals: The Disintegration of Yugoslavia and the Soviet Union* (Oxford: Oxford University Press, 1996); Beáta Huszka, *Secessionist Movements and Ethnic Conflict: Debate-Framing and Rhetoric in Independence Campaigns* (London: Routledge, 2014).
3 M.R., "Janševa stranka ne vidi protestnikov temveč zombije" ("Janša's Party Does Not See Protesters, but Zombies"), 24ur.com, December 21, 2012, accessed June 17, 2017, www.24ur.com/novice/slovenija/janseva-stranka-ne-vidi-protestnikov-temvec-zombije.html.
4 Gunther Kress and Theo van Leeuwen, *Reading Images: The Grammar of Visual Design* (London: Routledge, 1996).
5 James J. Hughes, "Posthumans and Democracy in Popular Culture," in *The Palgrave Handbook of Posthumanism in Film and Television*, eds. Michael Hauskeller, Thomas D. Philbeck, and Curtis D. Carbonell (London: Palgrave MacMillan, 2015).
6 Juliet Lauro, ed., *Zombie Theory: A Reader* (Minneapolis: University of Minnesota Press, 2017).

7 Simon Hawkins, "Teargas, Flags and the Harlem Shake: Images of and for Revolution in Tunisia and the Dialectics of the Local in the Global," in *The Political Aesthetics of Global Protests; The Arab Spring and Beyond*, eds. Pnina Werbner, Martin Webb, and Kathryn Spelman-Poots (Edinburgh: Edinburgh University Press, 2014), 41.
8 Julia Kristeva, *Powers of Horror: An Essay on Abjection* (New York: Columbia University Press, 1982). Kristeva defines the abject body as something that disturbs identity, system and order, causes fascination and repulsion at the same time.
9 Peter A. Russel, "BC'S 1944 'Zombie' Protests against Overseas Conscription," *BC STUDIES* no. 122 (Summer 1999).
10 Henry Jenkins, "Youth Voice, Media, and Political Engagement: Introducing the Core Concepts," in *By Any Media Necessary: The New Youth Activism*, eds. Henry Jenkins, Sangita Shresthova, Liana Gamber-Thompson, Neta Kliger-Vilenchik, and Arely Zimmerman (New York: New York University Press, 2016), 1.
11 Non-announced choreographed group interventions/pranks in public spaces. Mark Mattern, *Anarchism and Art: Democracy in the Cracks and on the Margins* (Albany: State University of New York, 2016).
12 "*1000 Gestalten*" translates to English as "1000 figures."
13 Caroline Elbaor, "A Horde of Zombies Overtook Hamburg Ahead of the G20 Summit, for Art's Sake. The City Sees a Host of Artistic Interventions Calling for Political Action," *Artnetnews*, July 6, 2017, https://news.artnet.com/art-world/g20-summit-hamburg-zombie-performers-1014083. See also "The Performance of July 5th: That's How Our Day Went," *1000 Gestalten*, accessed January 22, 2018, https://1000gestalten.de/en/the-performance/.
14 Florian Bieber and Dario Brentin, eds., *Social Movements in the Balkans. Rebellion and Protest from Maribor to Taxim* (London: Routledge, 2019).
15 Raphael Minder, "Workers across Europe Synchronize Protests," *The New York Times*, November 11, 2015, 2017, www.nytimes.com/2012/11/15/world/europe/workers-in-southern-europe-synchronize-anti-austerity-strikes.html.
16 Isabel Ortiz, Sara Burke, Mohamed Berrada, and Hernán Cortés, "World Protests 2006–2013," *Initiative for Policy Dialogue and Friedrich-Ebert-Stiftung New York Working Paper 2013*, September 2013, http://policydialogue.org/files/publications/papers/World_Protests_2006-2013-Complete_and_Final_4282014.pdf.
17 To provide some background on the situation, a joint declaration written by KOKS (Coordinating committee for cultural Slovenia), DSP (Slovene Writers' Association), ODBOR (Committee for just and solidary society), and TRS (Movement for Sustainable development of Slovenia) was released in order to clarify the political background of ASPU protests in Slovenia: "We would like to clarify to international observers that these demonstrations are not ‚rebellions against austerity measures and necessary reforms', as the ruling rightwing neo-liberal autocratic government of Janez Janša has tried to depict them. The demands made by Slovenian citizens on the streets of their country are not merely for improved economic conditions, but for the basic foundations of a just and democratic state: the rule of law, the preservation of social services, and a sustainable economic policy that will serve the interests of the majority of the population rather than the narrow interests of a few." Critical Legal Thinking, "Slovenians Demand Radical Change," *Critical Legal Thinking–Law and the Political*, January 15, 2013, accessed February 2, 2020, http://criticallegalthinking.com/2013/01/15/slovenians-demand-radical-change/.
18 Cristina Flesher Fominaya, "Redefining the Crisis/Redefining Democracy: Mobilising for the Right to Housing in Spain's PAH Movement," *South European Society and Politics* 20, no. 4 (2015): 465–85. Donatella della Porta, *Can Democracy be Saved: Participation, Deliberation and Social Movements* (Cambridge: Polity, 2013).
19 Yahong Zhang and Cecilia Lavena, *Government Anti-Corruption Strategies: A Cross-Cultural Perspective* (Boca Raton, FL: CRC Press, 2015). Ian Jeffries, *The Former Yugoslavia at the Turn of the Twenty-first Century. A Guide to the Economies in Transition* (London and New York: Routledge, 2002).
20 For more details see: Ksenija Berk, "Die slowenischen Proteste 2012/13 im Lichte von Protestgrafiken" (The Slovene Protests 2012/13 in Light of Protest Graphics), *RGOW*

(Religion & Gesellschaft in Ost und West) (Religion and Society in East and West) 4–5 (2015): 34–37.
21 For more details see: Nicole Lindstrom, "In Its Efforts to Tackle Banking Crisis and Avoid a Bailout, Slovenia is Now Facing a Crisis of Democracy," London School of Economics and Political Science Blog, June 24, 2013, http://bit.ly/19v7ijd.
22 LGBTQIA, refers to Lesbian, Gay, Bisexual, Transgender, Queer, Intersex, Asexual.
23 Cristina Flesher Fominaya, "Debunking Spontaneity: Spain's 15-M/Indignados as Autonomous Movement," *Social Movement Studies* 14, no. 2 (2015): 142–63.
24 Costis Hadjimichalis, *Crisis Spaces: Structures, Struggles and Solidarity in Southern Europe* (London: Routledge, 2018); Georgios Karyotis and Wolfgang Rüdig, "The Three Waves of Anti-Austerity Protes in Greece, 2010–2015," *Political Studies Review* 16, no 2 (2017): 158–169, doi:10.1177/1478929916685728.
25 Live participatory movie documentary of Maribor protests which later grew into *All-Slovenian People's Uprisings* was created by Maple Razsa and Milton Guillén, *The Maribor Uprisings: A Live Participatory Film*, http://mariboruprisings.org/thefilm/.
26 For more details on Maribor protests and All Slovenian People's Uprisings, see Gal Kirn, "Maribor's Social Uprising in the European Crisis: From Antipolitics of People to Politicisation of Periphery's Surplus Population," in *Social Movements in the Balkans. Rebellion and Protest from Maribor to Taxim*, eds. Florian Bieber and Dario Brentin (London: Routledge, 2019); Ksenija Berk, "Die slowenischen Proteste."
27 For further details see: Ksenija Berk, "At the Crossroads of Cultural and Ideological Exchange—Behind the Visual Communications of 2012–213 Slovene Protests," in *Social Movements in the Balkans*, eds. Bieber and Brentin..
28 Ilija Tomanič Trivundža, "And the Word Was Made Flesh, and Dwelt among Us: On Zombies, Political Protests and the Transmodality of Political Metaphors/Beseda je meso postala in se naselila med nami: O zombijih, političnih protestih in transmodalnosti političnih metafor," *Družboslovne razprave*, 30/80 (2015): 29–46.
29 Anna Hart, "Steve Wintercroft's Fox Masks Stole the Show at This Week's Anti-Hunting Demonstrations," *Independent*, accessed February 8, 2018, www.independent.co.uk/life-style/fashion/features/steve-wintercrofts-fox-masks-stole-the-show-at-this-weeks-anti-hunting-demonstrations-10391614.html; Amer Ghazzal, "A Group of Animal Rights Protesters Stage a Protest against Skin Trade outside London Fashion Week," *Alamy*, February 18, 2017, www.alamy.com/stock-photo-london-uk-18th-february-2017-a-group-of-animal-rights-protesters-stage-134116965.html.
30 Brane Solce, "How to Make PAPER ZOMBIE MASK," YouTube, accessed March 9, 2013, www.youtube.com/watch?v=WkpmnuvyCqo.
31 *Million Mask March* is a worldwide annual protest against neoliberal capitalism, which started in 2013 and is performed in different countries around the world on November 5th. See more: Anonymous, "Million Mask March," millionmaskmarch.com, accessed November 11, 2016, www.millionmaskmarch.com/.
32 The Protestivals were organized by a large variety of social movements and initiatives. To name just a few of them: the General Assembly of the All-Slovenian People's Uprising, the Committee for Social Justice and Solidarity, the Coordination Committee of Slovenian Culture, the Committee for Direct Democracy, the Movement of the Responsible, and Today is a New Day, the Federation for Anarchist Organization (FAO), the Workers and Punks' University (WPU), the student association *Iskra*, the Invisible Workers of the World (IWW), The Association of Free Trade Unions of Slovenia, the Pirate Party, and the Party for Sustainable Development.
33 Marjeta Novak, "Slovenia Rises in Artful 'Protestivals'," *Waging Nonviolence*, March 21, 2013, http://wagingnonviolence.org/author/marjetanovak/2013.
34 Ibid.
35 Pnina Werbner, Martin Webb, and Kathryn Spellman-Poots, eds., *The Political Aesthetics of Global Protest: The Arab Spring and Beyond* (Edinburgh: Edinburgh University Press, 2014).
36 Paula Serafini, "Subversion through Performance: Performance Activism in London," in *The Political Aesthetics of Global Protest*, eds. Werbner, Webb, and Spellman-Poots, 320–41.

37 George Canguillhem, *The Normal and the Pathological* (New York: Zone Books, 1991), 134.
38 George Canguillhem and Therese Jaeger, "Monstrosity and the Monstrous," *Diogenes* 10, no. 40 (1962): 27–42.
39 Alexa Wright, *Monstrosity: The Human Monster in Visual Culture* (London and New York: IB Tauris, 2013), 4.
40 Ibid., 4.
41 Laura Lunger Knoppers and Johan B. Landes, eds., *Monstrous Bodies/Political Monstrosities in Early Modern Europe* (Ithaca, NY and London: Cornell University Press, 2004).
42 Michel Foucault, *Abnormal. Lectures at the Collège de France 1974–1975* (New York: Picador, 1999).
43 Ibid., 55.
44 Ibid., 56.
45 Ibid., 57.
46 Ibid., 57–58.
47 Ibid., 59.
48 A slip of tongue, a verbal, memory, or physical action mistake believed to be linked to the unconscious mind. See Sigmund Freud, *The Psychopathology of Everyday Life* (New York: WW Norton & Co, 1990); Sebastiano Timpanaro, *Freudian Slip: Psychoanalysis and Textual Criticism* (London: Verso, 2011); Henk de Berg, *Freud's Theory and Its Use in Literary and Cultural Studies: An Introduction* (Columbia, MD: Camden House Inc, 2004).
49 Robert M. Fishman, "Rethinking State and Regime: Southern Europe's Transition to Democracy," *World Politics* 42, no. 3 (April 1990): 18.
50 Foucault, *Abnormal*, 56.
51 Geoffrey Pridham, *The Dynamics of Democratization: A Comparative Approach* (London and New York: Continuum, 2000).
52 Rosa Luxemburg, *The Mass Strike, the Political Party and the Trade Unions* (Detroit, MI: Marxist Educational Society of Detroit, 1925), online version Rosa Luxemburg Internet archive (marxists.org) 1999.
53 Aldo Milohnić, "Artivistic Interventions as Humorous Re-appropriations," *European Journal of Humour Research* 3, no. 2/3 (2015): 35–49.
54 Claire Bishop, "Introduction: Viewers as Producers," in *Participation*, ed. Claire Bishop (London and New York, NY: White Chapel Gallery and MIT Press, 2006), 10.
55 John W. Nunley and Cara McCarty, "Introduction," in *Masks: Faces of Culture*, eds. John W. Nunley, Cara McCarty, John Emigh, and Lesley K. Ferries (St Louis, MO: St Louis City Art Museum, 1999), 15–21.
56 See Berk, "At the Crossroads of Cultural and Ideological Exchange," 2019.

5 The Distribution of Abilities
Disability, Dissent, and Design Activism by the Gothenburg Cooperative for Independent Living

Otto von Busch and Hanna af Ekström

Introduction: The Politics of Disability

A political party for "normal" people. A beer that makes you behave like a "retard." Disabled dolls. These are examples of polemical products designed collaboratively by the Gothenburg Cooperative for Independent Living (GIL), an advocacy group for disability rights, based in Gothenburg, Sweden. With their provocative language and design, these objects break not only the "norm" of able-bodied designs, but also the tone of politics concerning functional variations in Sweden, a country with a history of consensus culture. Sweden is marked by an absence of strikes and protests, especially concerning the services and institutions of the welfare state and the sphere of care, which takes the privilege of ableism as its norm.

From the perspective of the Swedish welfare state, the norm-deviant body has been considered a medical issue—that is, the prevailing viewpoint places the locus of struggle within the body of the disabled person: *Something is wrong or imperfect in the body of the disabled person and thus in need of a cure, rehabilitation, or prosthesis that compensates for the lost ability or limb. With good enough medical innovation, amplification, and motivation, the person will become almost fully human.*

The social model of disability, on the other hand, places the locus on the struggle between the body and society: *The disabled body is not wrong or in need of cure, but instead is excluded by society through normative obstacles.* This perspective is at the foundation of the GIL collective's advocacy work. Instead of putting all the focus and responsibility on the body, the social model suggests that society can be organized differently to better accommodate the non-norm-abiding body.[1]

Swedish institutions have tried to address accessibility through design, predominantly through the paradigm of "universal design" (UD) or "design for all." This approach can generally be described as the design of products, services, and environments that are useful for as much of the population as possible, without the need for special adaptation.[2] Even if the approach often has an explicit focus on accessibility for disabled people, the general goal is to include all users without regard to distinguishing features such as age, gender, or background, and to mitigate obstacles and processes that may exclude or stigmatize. As a design methodology, UD often incorporates into the design process the knowledge, expertise, and experiences of user groups, sometimes naming them "extreme users."[3] As disability

scholar Aimi Hamraie posits, the "universal" in UD "worked as a seemingly neutral term and as a challenge to the previous efficacy of the normate template," with its focus on rehabilitation in order to ensure compulsory productivity.[4]

Critical disability studies emerged from the activism of disabled people in the 1970s and took societal power relations as their point of departure, especially grounded in the lived reality of people with disabilities and their place in the world; such studies critique the normative emphasis on "independence."[5] From this standpoint, disability is not a tragic condition to be "overcome," but an existential condition to be socially and physically accommodated—a position often echoed in GIL's rhetoric. When its focus is on "everyone," design erases and sometimes even comes to stigmatize difference, enforcing a uniformity of what abilities "everyone" should have, and this resounds throughout the institutional apparatus of the Swedish welfare state. This is even more apparent today with the rise of a regulatory society, increasingly measuring individual performance according to managerial categories.[6] The risk is in turning UD into a utopian methodology, driven by designers with little experience of the mechanisms they are challenging, who unwittingly transform helpful prejudice into normative designs of "universality," which in turn render invisible a multiplicity of users of different abilities.

Much of GIL's activism concerns raising the visibility of the struggle between society norms and people with functional variations. For GIL and other disability activism groups that shine a light on the politics of accessibility, the matter of concern is what one might call the "distribution of abilities," a phrase that draws parallels to philosopher Jacques Rancière's discussion on aesthetics as the distribution of the sensible.[7] From this position, accessibility could better be read as "access-ability," as it comes to signify the uneven distribution of access. Disability activism in the realm of design often arises in controversies around who has physical access not only to public spaces, but also to *living environments*—that is, physical spaces as much as living-forms (for example, seeing a band at a concert or drinking at a bar). Living-forms do not offer equally distributed access, and struggles emerge along their boundaries. The issue of access-ability becomes the means by which to engage fully in various living environments. Furthermore, universality of access does not guarantee universality of experience. More specifically, the distribution of a general environment, or the living experience of that environment, is not universal or equal; some groups still struggle to take part. To echo Rancière's notion of politics emerging at the boundary between the included and the excluded, design activism arises in a clash among discursive, social, and physical boundaries of accessibility. Yet the boundary typically is not seen from the "inside": able-bodied people notice neither the steps, the narrow entrance, nor the derogative treatment of a person in a wheelchair trying to order at a bar. Access-ability means more than mere physical accessibility.

Design, Disability, and the Distribution of Abilities

Design tries to solve problems, and disability is often seen as a problem that a person should surmount as they hope for a cure. In its worst form, this social construction of disability is a reduction of humanity to the form of a less-worthy life. Not only is disability considered an "abnormal" condition, but across the ages it has been interpreted in moralist terms. As highlighted by disability scholar

Sunaura Taylor, the disabled person has traditionally been seen less as a human than as an animal,[8] reaffirming Plato's view that the erect posture is what differentiates humans from animals, and reiterating religious representations of erect human bodies drawn upwards toward heaven whereas only beasts are bent over. This sentiment is apparent in the classic image of human evolution, the 1965 diagram *March of Progress*, wherein primate and ape evolve into upright, European-looking (and able-bodied) man, as if to indicate that walking is the pinnacle of biological progress. On the other hand, the disabled body is often used to project super-human attitudes, with the "super-crip" used as what writer, comedian, and disability activist Stella Young calls "inspiration porn" for able-bodied people, to prove that any hurdle can be overcome with enough virtue, conviction, and endurance.[9]

As designers address exclusion and the spectrum of functional variations, their conventional role has been to develop prosthetics and give aesthetically pleasing shells to medical devices.[10] In design discourse, there is a tendency to emphasize successful cases—for example, how glasses turned from standardized and unappealing prosthesis into fashionable identity signifier. Yet disability has traditionally been surrounded by moralization and stigma—such as, in its most everyday form, children being bullied for wearing glasses and older people feeling shame as they begin to need a hearing aid. Captain Ahab with his wooden leg, and Captain Hook with his missing hand, are models for the socially disturbed disabled character, and it is not uncommon to portray the evil antagonist in movies with a limp. A less-than-perfect body is a disgraced body, an amoral body, a marginal body, shunned by ideal sociality. As disability studies scholar Fiona Campbell argues:

> From the moment a child is born, he/she emerges into a world where he/she receives messages that to be disabled is to be *less than*, a world where disability may be *tolerated* but[,] in the final instance, is *inherently negative*.[11]

Social scientist Langdon Winner famously notes how obstacles and steps are *technologies* of exclusion, and it should be added that these act in tandem with social *habits* of exclusion.[12] Such habits are equally important to challenge yet, given their invisibility and stigmatization, more difficult to discern, more elusive as legal targets, and harder to mobilize around. As Campbell frames it, "Unlike other minority groups, disabled people have had fewer opportunities to develop a collective conscious, identity or culture."[13] Even though up to 20 percent of the world's population consists of disabled people, these individuals are often isolated from one another, dispersed and cordoned off, sometimes in institutions but also in their own homes. Disabled people are segregated into separate spaces: transport vehicles, classrooms, entrances, bathrooms. Even when society acknowledges their existence, the separateness created in order to give attention to their specific needs often becomes an excuse for invisibility. Whereas other groups at the margins can claim visibility for their standpoint or culture, or take pride in their identity, there are few such occasions of mobilization and prominence for disabled people.

The very symbol of disability access (often posted at entrances, bathrooms, parking spots, and so forth) is as much a sign of exclusion as inclusion. It is needed exactly because it signifies the exception: that this is a special, inclusive space in a world of normative exclusion.[14] In a similar vein, few people proudly claim their

disability, instead refusing to consider themselves disabled. Taylor argues, "Being disabled is often profoundly stigmatizing, so it is no wonder that many people choose to 'pass' as nondisabled rather than identify themselves with a population that is largely considered to be unfortunate, broken, and burdensome."[15]

Taylor continues, "Even at the best institutions, individuals are stripped from countless freedoms that people on the outside take for granted, such as choosing when and what to eat, when to sleep, and whenever to engage in consensual sexual intimacy."[16] The abilities of life are not distributed equally, and the invisibility, shame, and stigma around these varied abilities present an obstacle to action.

Access-ability: Introducing GIL

The independent living movement has organized around global advocacy for self-determination, self-respect, and dignity for disabled people, and can be traced back to the American civil rights crusade in the 1960s. The movement was largely fathered by disability activist Ed Roberts, a co-founder of the internationally renowned World Institute on Disability in Berkeley, California, which is considered an important hub for disability politics and activism.[17]

The Swedish branch of the independent living movement started in 1989 and is guided today by both the Gothenburg Cooperative for Independent Living and Stockholm Independent Living (STIL), assistance cooperatives that work in parallel to address sociopolitical questions regarding disability rights. As the most vibrant advocacy group on these topics in Sweden, GIL has garnered wide recognition across the country, with Anders Westgerd as its spokesperson, and has received several prizes and nominations for its domestic activist campaigns. The movement was one of the leading forces pushing for assistance reform that resulted in the passing of LSS, the Swedish entitlement law, in 1994.

The law, which entails supplementary support as assistance for persons with significant and long-term disabilities, has offered greater independence and equality for people with disabilities in Sweden. Assistance reform, including the right to personal assistance or other support, profoundly increased the opportunities for adults with physical, intellectual, psychiatric, and cognitive disabilities to live an independent life in their own apartment or a group home. Whereas adults and children with disabilities previously were institutionalized in Sweden, the LSS law made it possible both for able-bodied parents to raise their children with disabilities at home and for disabled adults to raise their own family. From GIL's viewpoint, LSS made room for emphasis on the social and cultural model of disability rather than the medical model that has long dominated the discourse on disability. Yet for GIL, even with such laws in place, supporting disability rights is not enough; cultural and social reform is needed to eliminate bias and the undercurrent of ableism throughout Swedish society, and this requires more leverage than merely waiting for things to happen spontaneously or through the general goodwill of the people. According to GIL, *disability does not need to be normalized—it needs to be politicized.*

As GIL spokesperson since 2008, Westgerd is a driving force in the organization's activist campaigns and one of Sweden's predominant voices on issues concerning rights for disabled people. He points out that disability can happen to anyone (as it happened to him after a skiing accident) and thus is a topic that

concerns everybody. This attitude is taken up by cultural critic Michael Berube, who writes:

> Any of us who identify as "nondisabled" must know that our self-designation is inevitably temporary, and that a car crash, a degenerative genetic disease, or a precedent-setting legal decision could change our status in ways over which we have no control whatsoever.[18]

As Westgerd posits, we humans are born "disabled," and most of us spend our last years that way, too. Insisting that others see disability as our shared fate is not an easy task. The challenge demands an escalation of both rhetoric and direct action, as well as an approach where means and ends meet: where projects realize their own goals.

Westgerd argues that the living conditions and agendas around disabilities have tended to be isolated and fragmented, making it difficult to establish a united approach in pushing for political change:

> As a group, we have been repressed and institutionalized. Traditionally, the disability movement has been quite fragmented, to the point where we have had difficulty agreeing on certain key issues and questions. People with spinal cord injuries focus on their priorities, and people with visual impairments have their main questions. There has probably also been the fear of just protecting their own agendas and different forms of financial support received from either region, municipality, or state.[19]

Paradoxically, raising awareness on issues of disability is particularly troublesome in Sweden, Westgerd suggests, because of the country's strong tradition and consensus in support of the welfare state. Not only do the fully abled, or "normates," prefer not to see or be reminded of disabilities (or aging), but the general perception is that the government already takes good care of the poor, sick, and weak. Thus, matters concerning disabilities are seen as bureaucratic issues—something that concerns the state rather than society at large. People tell themselves that awareness around disabilities is a matter for the state, not a function of relationships between citizens, or an issue with relevance to broader societal change. As Westgerd explains:

> Most young people probably think that Sweden is a welfare society, and that we are at the forefront when it comes to accessibility and disability justice. But there is a common misconception that for disabled people, life has less worth, and that you don't have the same ambitions in life compared with normates. Like, you don't want to participate in society as everyone else does. People generally think you are quite happy to stay home and play bingo instead of going out to have a beer. I think many normates find it hard to relate to the idea of having a disability. People don't want to think about it, because it's so terrible, so they just ignore the thought of it ...
>
> For many disabled people, it's hard to be involved in the disability rights movement. They spend so much energy on just getting through the day—going to and from work via inaccessible public transports, or participating in family life and doing the chores at home. Also, during the time you get with personal assistance,

you may need to do other things, not spend that time on disability justice issues. Some people have been part of the disability rights movement in the past, but the struggle was too hard, so they quit or gave up. Sometimes you also need physical strength when participating—for example, in actions or demonstrations. Others do not have the confidence to be part of a movement, or they feel excluded or uncomfortable in different situations. So there are many, many parameters that make it difficult to get involved.

The Development of GIL Activism: From Sit-ins to Designerly Interventions

Over the past decade, GIL has been a strong voice for disability activism as its agenda and actions have moved from early media stunts and sit-ins modeled on civil rights movements to the designing of events, disabled dolls, sex toys, and special beer. GIL also redesigned its office to comment on the able-bodied norms of society, making the "normal" bathroom hard to access for normates, lowering the doorframes to prioritize sitting access, using wheelchairs rather than standard chairs in meeting rooms, and so forth. These actions and interventions have commonly used jokes and irony to highlight the seriousness of the issues, as well as direct action toward citizens and politicians in a bid to gain political leverage. Critical citizen agency, GIL observes, is claimed by stressing the subject's own uniqueness and embodied perspective in the push for changes in norms and to materialize discourse among politicians, planners, and fellow citizens.

In 2012, GIL created the "CP doll" (for "cerebral palsy," translated here as "retard doll") a series of specially produced disabled children dolls that were shop-dropped in toy stores with labels reading: "The retard doll GIL. Treat her like a real retard!" (Figure 5.1, Plate 4). The Facebook page for the campaign added, "She doesn't swear, have sex, drink booze, or poop. So much better than a real retard." The doll targeted the infantilization of disabled people by the public and informed the discussion on how disabled people often are met with overprotection and pity. The campaign got a lot of attention across Sweden and even in international media, and set the standard for GIL's next actions, including the CP beer, one of the organization's most recognized campaigns.

First released in 2014, the CP-beer ("retard beer") aimed a spotlight on the social and cultural attitudes toward disabled people in restaurants and bars, and sought to raise awareness of the failure to implement and enforce many aspects of accessibility laws and regulations. This has been one of GIL's central concerns for many years; the struggle for accessibility pertains to the right to a social life as a living-form; also, if this includes drinking, this requires more than just physical access. It means also breaking into the habitual social practices of alcohol consumption and opening up the taboo around disability and drinking. It requires that restaurants and bars recognize people with functional variations as guests with legitimate and equal rights compared with normates:

AF EKSTRÖM: What was the question or conflict you wanted to raise with the CP beer campaign?
WESTGERD: We wanted give more beer to the people! No, I'm just kidding. The campaign was about stressing the question regarding inaccessibility and having the right, as

Figure 5.1 CP doll, created by Gothenburg Cooperative for Independent Living (GIL), 2012. Courtesy of GIL.

a disabled person, to make your own decisions. We have been working toward accessibility rights, with a focus on restaurants and bars, for quite a few years. In 2009, we developed a campaign called *Alla Ska Fram*.[20] It was based on a government proposition called From Patient to Citizen, made in the early 2000s, which included (among other things) that public environments should be made accessible based on the *Enkelt Avhjälpta Hinder* [Easily Rectified Obstacles] law. The law addresses inaccessibility and affects municipalities, regulators, real estate, and the private sector. In 2009, we felt that nothing was happening with the law, and we wanted to highlight the issue in some way. We thought that addressing the problem in every public environment would be too overwhelming. Instead, we focused on restaurants and bars—places that many people do not expect us disabled people to visit. Also, these settings are often quite inaccessible. In recent years there has been a shift in Sweden, with bars and restaurants becoming a social scene where people hang out, and we wanted to be part of that.

First we worked with the *Alla Ska Fram* campaign for ten weeks. Our webpage published reviews each week of four restaurants and bars: three poor examples with low accessibility, based on *Enkelt Avhjälpta Hinder*, and one good example that followed the accessibility regulations. We posted pictures and addresses of the restaurants and bars. Then we sent out letters to these restaurants, where we presented the accessibility regulations but also the reason why we did this campaign. We also wrote

that we could help them make their space more accessible. So this was the starting point of the focus on restaurants and bars.

Then, in 2012, we worked with the CP doll, where we addressed the issue of prejudiced kindness. We had a discussion forum on Facebook, and many people said that the restaurant environment was a place where disabled people were exposed to prejudice and ableism. People who were drunk often misbehaved and said things like "Are you allowed to drink that beer?" We realized that promoting a beer would be a good campaign. It became obvious that the combination of alcohol and disability touches on several taboos at the same time. Many people do not expect us to appear at bars or to like drinking beer, good beer. All of this inspired us with the idea to brew a beer.

Parallel to this idea to make our own beer, we wanted to challenge the concept of the *Leva & Fungera* [Live & Function] fair, which is the biggest fair for care and accessibility. I think it is very sad that the fair focuses on diagnoses, assistive tools, and care rather than on living. Historically, [GIL] had chosen not to exhibit at the fair since we are an assistance organization, and we focus on social issues [rather than institutional care]. So if we were to participate at the fair, we wanted to create a social event, serve some beer, have DJs, and create a space where people could meet to talk about social and political questions regarding disability.

We wanted to serve beer, but not ordinary beer like Carlsberg. We were more interested in niche beer from microbreweries in Gothenburg, because it's more fun and it's better beer. I did some research before the fair and discovered there were restrictions regarding giving away free beer and sponsoring alcohol. When I called around, no brewery was interested in sponsoring us. But then there was someone in our acquaintance circle saying, "I can brew a beer. Let's make our own beer instead!" And then it became clear that instead we could brew our own beer and at the same time package it with a message regarding inaccessibility and negative treatment toward disabled people.

As noted by Westgerd, both the CP beer and the CP doll tackled the issue of disabled people being both reduced and mistreated in social contexts, where they are objectified and targeted for the benefit of normate people. To the degree that disabled people are seen in such contexts, Westgerd asserts, it is as exceptions. They are either treated as problems that need to be addressed and whose access needs to be "solved," or idolized as "super-crips" who should be complimented just for leaving their home; seldom could they simply be equal guests at the establishment. Stella Young's aforementioned term "inspiration porn" aims precisely to draw attention to the instrumental use of disabled people and efforts to make able-bodied people feel good about their own failures. Young points toward how disability is seen as a disadvantage that disabled people can overcome with acts of pure willpower—an objectifying perspective in line with the medical model of disability.

In GIL's activist work, the use of the CP beer also became a way to challenge alcohol laws and utilize the position of disability in order to make political statements. For example, at the beginning of the campaign, GIL used the beer as an accessibility symbol, distributing it only to bars and restaurants that met Swedish accessibility standards. GIL has since used the CP beer at various events to promote the organization and its agenda. One example is Almedalen Week, an

annual political event where national organizations meet to debate and discuss political issues. Under the slogan "Crip Is Hip," GIL and the activist organization Utopia threw parties where CP beer was served. The parties were planned without an alcohol license, with visitors drinking beer outside the event, on the street, and yet the police did not interfere. Thus GIL, as a disability rights organization, also stretches legal boundaries, using disability as an advantage in the political struggle for social justice. In Sweden, the police are often confused when it comes to arresting wheelchair users, not least because their police vehicles are not adapted for accessibility. In addition, many police officers seem uncomfortable about exercising their power toward disabled people, as the difference in power accentuates the pity surrounding disability. Thus, compared with normates, disabled people may enjoy more positive treatment by the police.:

AF EKSTRÖM: When we had the beer at Almedalen, our parties were pretty wild. But I've thought quite a lot about how when the police came, they did not care since we (with functional diversity) were the ones who arranged those parties. We were positively treated based on a functional perspective.

WESTGERD: Yes, you can do a lot of things before people kick back. The limits can be stretched quite far. Even when the police actually came to investigate our party, they just lifted their police hats and thought what we did was nice, and then they left.

The aim of GIL's activism is to "hack" into daily habits and conversations. Another GIL design action was the modification of a minivan into a street-marking vehicle that paints a disability parking symbol on the space where it is parked. The CP truck, or "retard wagon," set out to ensure that accessibility becomes an integral part of all development processes, by challenging the norm of what municipal accessibility could look like (Figures 5.2 and 5.3). On December 1, 2015, in the city center of Gothenburg, an entire parking lot comprising 95 spaces was marked with disability parking symbols. The goal of this action was to foster awareness regarding the 60–90 percent of Sweden's city centers that are completely or partially inaccessible, and to expose the lack of compliance with 1966 legislation requiring all new buildings to be accessible. The experience is discussed in a short movie about the CP truck:

WESTGERD: For a couple of hours, we let tired drivers in the morning experience this inaccessibility. They were clearly frustrated to find that even after circling the parking lot a few times, there was no place for them. It is a feeling most of us who live with a disability might experience several times every day, all year round, as long as we live.[21]

AF EKSTRÖM: What happened after the CP truck?

WESTGERD: We wanted to show that while some parking spaces and handicap toilets are places exclusively for us, we want accessibility throughout all of society. It is important to start with the soft values of accessibility; otherwise the hard facts and values won't be included or considered.

GIL's webpage about the CP truck states that disability parking spots and toilets are the only public spheres where people with disabilities are allowed to exist with specially designated places. As discussed before, however, these spaces do not

Figure 5.2 CP Truck with team, created by GIL, 2015.
Courtesy of GIL.

Figure 5.3 Converted parking spaces in Gothenburg.
Courtesy of Hey, it's Enrico Pallazzo!

indicate privilege; they signal how people with different abilities cannot participate in society on equal terms. Drawing parallels to the famous 1955 civil rights action of Rosa Parks, GIL argues that its protest is a matter of taking ownership of place, of claiming a right to access places where society does not allow you. To take one's

place—to be allowed to be seen—may be a human right from a legal perspective, but it is also a basic form of civic right, of the social and cultural recognition of disabled people as equal to, and just as "normal" as, the normies.

In 2014, GIL launched a political party in the Gothenburg municipal elections, whose posters, advertising, and discourse consisted of caricatures of people with disabled bodies fighting for the "normal" people:

WESTGERD: 2014 was the so-called super-election year. There are a lot of people with different kinds of disabilities in our society—about 20 percent of the Swedish population—but no one ever discusses disability rights, which is kind of strange because so many of us have disabilities. Disability issues are rarely prioritized, and work around accessibility moves very slowly. So we just decided that we would do it ourselves: start a political party and register it with the electoral authority. We focused only on the municipal election, because we did not have the muscle to make it onto the county council or the parliament.

The aim was not to get as many votes as possible, but more to act as an information party that introduced disability issues onto the agenda, and to make politicians understand that these are important issues that should be integrated into all politics. At the same time, we were turning to the voting citizens so they would have a better understanding of our situation. Disability rights are often overlooked or forgotten. We, the Normal Democrats, got 315 votes in the city council in Gothenburg.

I remember reading all the party political programs, and I think all the parties mentioned disability just once, in the context of a section regarding human rights. But otherwise it was completely unnoticed. It is like disability rights are just a checkbox that needs to be mentioned in the party program.

AF EKSTRÖM: What happened after the election? Did everyone who voted realize that Normal Democrats was just a campaign and that there was no political plan in case you had been elected?

WESTGERD: "Campaign"? I would rather call it a "push for general education." I think people did not understand it, because I still get inquiries. Not so often, but people ask me on Facebook how things are going with the party and whether we will participate in the 2018 election. We won't do that, because that was not the party's aim. If we participate in an election once more, then we would have to do it right, and then you need people who can administrate. Only three people work with the campaigns at GIL. And we have other responsibilities, too, so there is just too little time.

AF EKSTRÖM: But if people were interested, would you consider passing along the Normal Democrats to someone else, with the goal of making it sustainable, of making the party grow?

WESTGERD: There is nothing that prevents the party from continuing, as long as there are wise people who engage in it. There was no self-interested purpose in keeping the party to ourselves. At the same time, I think it is a pity that we did not continue with the party, because it is for an important cause, even though we were a single-issue party.

It was the same situation with the beer: We were not supposed to brew beer. We never intended to sell the beer in that way either. But it became a spin-off; we started selling the beer, and then we realized that a brewery is not our thing because it requires quite a lot of resources. Brewing beer is about logistics and money, and we realized that it was not our thing. We are an assistance organization, not a brewery. Likewise, it was the same thing with the party; it was not meant to be a regular political party.

AF EKSTRÖM: It's interesting, though, because it feels like quite a few campaigns had greater effects than you were prepared for.

WESTGERD: Yes, and that's a sign that what we are doing is damn good work. The CP doll could also be a permanent product, because there was a huge demand from people who wanted to buy the doll, including kindergartens, preschools, elementary schools, universities, colleges, etc., and who wanted to use the doll as an educational tool. It was for sale for a while, but as a limited edition, based on the fact that many were interested in the idea behind the doll and wanted to buy it.

AF EKSTRÖM: If you're developing a future campaign and it's going to have a spin-off effect, do you now have tools to manage that idea? Or would you like to take it over sometime so it would become educational and so forth, as with the CP doll?

WESTGERD: Of course, we want to get away from the idea of actions as "sparklers"—something that people feel engaged in, and after a day or two, it fizzles out and is forgotten. I think we have managed the CP beer quite well. After a while, we sold it to a brewery that has completely different resources. They can brew, sell, and distribute the beer. For them, that is no trouble. For we who work with these issues, it's not really our job to be brewers. We are an assistance organization, and we need to do other things as well. Of course, we could make more beer with each campaign, but unfortunately there is also a lack of time, resources, and money too.

Discussion: From Access and Abilities to Dissent and Design

Knowledge is unavoidably implicated in power relationships, and sociologist William Carroll distinguishes three overlapping critical modes of inquiry to help unpack power: *oppositional*, which involves challenging the status quo and taking the side of the oppressed; *radical*, which includes getting at the root of matters to challenge the deeper, systematic bases of the challenges we humans face, and finally *subversive*, which disturbs the ordinary, interrogates the commonsensical, and opens doors to alternatives.[22] The design activism of GIL underscores how benevolent actions intended to promote awareness are not enough to challenge the normative boundaries of society or to push for the enforcement of civil rights laws otherwise taken for granted; the distribution of abilities presents a continuous struggle for accessing normate living-forms as these keep evolving.

GIL's actions thus fit well into Carroll's three modes: they act *oppositionally* in challenging the social as well as physical boundaries and obstacles of exclusion. They act *radically* in questioning not only technical obstacles, but the social roots of exclusion and the unequal enforcement of laws that disregard disabled bodies. And they act *subversively* in that they use the normative everyday while simultaneously undermining it to expose the mechanisms of exclusion, as in GIL's subversion of dolls, beer, parking spaces, and political parties. Although their polemical design campaigns evoke debates around the role of design in society and the equal enforcement of laws and regulations, their work also manifests utopian and prefigurative milieus where accessibility is already realized. CP beer is sold at accessible bars. The CP truck creates new, reserved parking spaces. In such endeavors, GIL goes well beyond the design-for-debate so often woven throughout the discourse on critical, speculative, or adversarial designs, to redefine design dissent as a proactive reality. It is a matter of enacting functional variations over the whole social and cultural spectrum, as Westgerd points out, but what unites these actions is their

focus on the social and political distribution of abilities—and their insistence that cultural living-forms should be accessible not only to normates.

Throughout GIL's work, dissent is marked by playful, often ironic or absurd humor. Despite their playfulness, however, the organization's actions can provoke controversy, and perhaps the greatest challenge for GIL's activism, according to Westgerd, is media fatigue. No matter how smart, advanced, and strategic the campaign may be, the local media in Gothenburg tires of lifting the disability agenda. Similarly, Westgerd speculates, as more and more campaigning moves to online platforms and social media, it is no longer only journalists and editors who need to be convinced of the political importance of action; in GIL's experience, digital algorithms seem to disfavor continuous campaigning, which, the collective argues, has happened with some of its later actions. There is a need to continuously reinvent the dissent; otherwise the question disappears from view, falling once again into willful ignorance as the stigma around disability repeatedly reemerges simply because it reminds people of the fragility of human life.

GIL's *oppositional*, *radical*, and *subversive* work is not only a struggle against a political status quo, bureaucratic malpractice, or social bias, but a questioning of the norms around human life and dignity at the cultural roots of society. And perhaps most important, GIL merges protest, proactivity, and existential matters by taking direct action through design, making things happen on their own initiative, and refusing to wait for politicians to effect change or for media channels to shape awareness. The organization's playfulness is an explicit method for recognizing the seriousness of the issues while not stigmatizing human frailty.

In many ways, GIL's actions play with its audience, but the play is real. The dissent is designed to make the group's propositions tangible and to give rise to a new civic realm of true inclusion. Means and ends blend into new prefigurative modes of togetherness, where boundaries are displaced. These designs subvert the fear of disability in favor of a celebration of difference. They unearth the radical roots of normate bias, but they do so in highly material and practical ways, building a new society along the way and redistributing abilities, even if only during a temporary event. The CP truck creates parking spaces for disabled drivers. CP beer crosses boundaries between the fully abled and the social groups with functional variations. These acts affect both factions equally while simultaneously offering an open milieu for breaking laws in civic ways. Merging play, satire, and critique, GIL's actions push for change beyond the often stifling format of seriousness, to expose shared ground where universal drunkenness, everyday parking, and sexual pleasure are designed realms of civic possibility—policy and play, all rolled into one.

Notes

1 Michael Oliver, *The Politics of Disablement: A Sociological Approach* (New York: St. Martin's Press, 1990).
2 Ronald Mace, *Accessible Environments: Toward Universal Design* (Raleigh, NC:Center for Accessible Housing: North Carolina State University, 1990).
3 Darren Reed and Andrew Monk, "Inclusive Design: Beyond Capabilities towards Context of Use," *Universal Access in the Information Society* 10, no. 3 (2011): 295–305.
4 Aimi Hamraie, *Building Access: Universal Design and the Politics of Disability* (Minneapolis: University of Minnesota Press, 2017), 182.

5 Aimi Hamraie, "Universal Design and the Problem of 'Post-Disability' Ideology," *Design and Culture* 8, no. 3 (2016): 285–309.
6 Ann Heylighen, "About the Nature of Design in Universal Design," *Disability and Rehabilitation* 36, no.16 (2014): 7.
7 Jacques Rancière, *The Politics of Aesthetics* (London: Continuum, 2013).
8 Sunaura Taylor, *Beasts of Burden* (New York: New Press, 2017), 87.
9 Stella Young, "I'm Not Your Inspiration, Thank You Very Much," filmed April 2014 in Sydney, Australia, TEDxSydney video, 9:13 min., www.ted.com/talks/stella_young_i_m_not_your_inspiration_thank_you_very_much/.
10 Graham Pullin, *Design Meets Disability* (Cambridge, MA: The MIT Press, 2011).
11 Fiona Campbell, *Contours of Ableism: The Production of Disability and Abledness* (New York: Palgrave, 2009), 17.
12 Langdon Winner, "Do Artifacts Have Politics?" *Daedalus* 109, no. 1 (Winter 1980): 121–36.
13 Campbell, *Contours of Ableism*, 22.
14 Elizabeth Guffey, *Designing Disability: Symbols, Space, and Society* (London: Bloomsbury, 2018).
15 Sunaura Taylor, *Beasts of Burden* (New York: New Press, 2017), 7.
16 Ibid., 10.
17 Steven E. Brown, "Zona and Ed Roberts: Twentieth Century Pioneers," *Disability Studies Quarterly* 20 no. 1 (Winter 2000), 26–42.
18 Michael Berube, foreword to Simi Linton, *Claiming Disability: Knowledge and Identity* (New York: New York University Press, 1998), viii.
19 Anders Westgerd was interviewed by Hanna af Ekström at the GIL office in Molndal, Gothenburg, Sweden, on March 5, 2018.
20 The slogan "Alla skall fram" ["Access for everyone"] plays with an election slogan from the Social Democratic Party in the 2006 election, "Alla skall med" ["Bring forth everyone"].
21 GIL Goteborg Assistans, "CP-trucken—Parkeringskonverteraren," ("The Retard-truck—The Parking Converter") February 23, 2016, YouTube video, 4:38 min., www.youtube.com/watch?v=mc5qm1KW7TU.
22 William Carroll, *Critical Strategies for Social Research* (Toronto: Canadian Scholars' Press, 2004), 3.

Part 2

Artifacts in the Afterlife of Protest

6 Art of the March

Archiving Aesthetics of the Women's March—Interviews with Alessandra Renzi, Dietmar Offenhuber, Siqi Zhu, Christopher Pietsch and Navarjun Singh

Grace Van Ness and Prakash Krishnan

Introduction

On January 21, 2017, the day following the inauguration of United States President Donald Trump, millions around the world organized and took to the streets in protest. Gathering to advocate for women's and human rights, the Women's March marked what is possibly the largest single-day protest in US history to date. Simultaneous protest marches took place across the globe and throughout the US, with millions joining together in solidarity to resist the threat posed by Trump's regime.

Not far from the official march site in Washington, DC, the Women's March contingent in Boston, Massachusetts comprised an estimated 170,000 demonstrators. In keeping with traditional protest aesthetics, many marchers arrived equipped with hand-made signs, visually expressing both their denouncement of the recent election results, as well as a desire for social, systematic, and political change. As the march came to a close, hundreds of these signs were discarded along the iron fence of the Central Burial Ground on Boston Common in a final act of protest (Figure 6.1, Plate 5). Upon discovering that the signs were slated to be destroyed by the city because of fire risk, a trio of Boston-based professors sprang into action to preserve the signs. After obtaining permission from city parks workers, a van and warehouse were quickly acquired and a group of over 20 volunteers succeeded in rescuing approximately 6,000 signs.

After consulting with the library at Northeastern University—which maintains an archive of local social movements—conversations began around methods of archiving the signs, whose corpus contains a wealth of information regarding current political rhetoric and the concerns of civil society. The outcome of these discussions ultimately formed "Art of the March," an online archive and interactive presentation of the protest signs and posters collected in the aftermath of the historic Boston's Women's March.

From inception to launch, this archival project spanned one year, and the website was publicly released on the first anniversary of the Women's March. Following the collection of the signs, the Art of the March team found a space large enough to lay out and view the signs in their entirety, at which point they were photographed and tagged by volunteers (Figure 6.2, Plate 6).

As part of this digitization effort, a system of cataloging and organizing the signs was developed in collaboration with several librarians at Northeastern, as well as the

Figure 6.1 Signs of the Women's March in Boston arranged along the fence on Boston Common, 2017.
Courtesy of Alessandra Renzi.

Dean of Libraries, members of the media production faculty, and 11 research assistants. To make the images searchable online, metadata was collected around the context and content of each sign. This metadata was furnished as a product of over 200 hours of sign transcription and necessary calibrations, allowing for a broad spectrum of categories that effectively describe the various aspects of the signs. Ultimately, this archive transforms the signs from a physical manifestation of protest aesthetic to one of a digital nature—an online manifestation which in itself is an act of extending and relaying the protest. In this way, Art of the March becomes a kind of virtual cemetery fence, recalling the affect of the signs' original display.

In order to critically explore the methods and meaning behind Art of the March, this chapter puts into conversation the designers and technicians who created the archive. Through a series of asynchronous interviews with initiators and producers,[1] Dietmar Offenhuber[2] and Alessandra Renzi,[3] as well as visualization designers, Christopher Pietsch[4] and Siqi Zhu,[5] and website designer, Navarjun Singh (Navi),[6] this chapter uncovers not only the what, but the how and why of protest signs as data. As expressed by the project's organizers, Art of the March seeks to bring together "an abundance of revelatory visual examples with which to study the voices and visions of social movements, analyze communication concepts, and preserve idiosyncratic expression in the era of social network media."[7]

Figure 6.2 Aerial mosaic of rescued signs from the Women's March in Boston, 2017.
Courtesy of Dietmar Offenhuber.

Coming from interdisciplinary backgrounds rooted in communication studies, organizing, and technology, authors Grace Van Ness and Prakash Krishnan curated a dialogue that uncovers the many layers of design upon dissent upon design. Tracing the journey of a sign from its individual or collective creation to the statement it makes at a march to the moment it is photographed, tagged, and catalogued in the archive, these interviews seek to better understand the relationship between design and dissent; and, through understanding, to learn how to harness its political power.

Archive Design

GRACE: To start, I'd like to hear more about how you categorized and tagged the signs you collected. When you visit the "Archive" component of the Art of the March website, for example, you can filter the signs by "Concern," "Strategy," and "Contains." Clicking through the "Concern" tags,[8] if I select the "indigenous" tag, I'm left with 40 of

the 6,000 signs, 30 of which are also tagged as "solidarity"—listed as one of several strategies. Three of that set include "drawings," which is classified as a "Contains" tag. In this way, multiple tags can be selected in one search—allowing for greater and greater specificity (Figure 6.3). If I click on one of these signs, the metadata appears—including a list of all attached tags, as well as notes on "cultural context" and "tone" (Figure 6.4). What was the process of deciding what the tags would be, and how were they employed?

ALESSANDRA: It was a multistage process. We thought we had a couple of hundred signs when we first collected them, but it turned out it was over 6,000, so we had to completely change the way in which we were dealing with the signs as data—suddenly we had Big Data, basically. As such, the categories that you see online are not the only categories that we have. They are the overarching categories, which each contain a variety of other categories that we developed and used to tag the signs as we analyzed them. That's why, for instance, when you type in "Black Lives Matter" you see a sign that may not necessarily say the words "Black Lives Matter," but that includes something related—like a quote from Dr. Martin Luther King, Jr., for example. In terms of the cataloging, we were really trying to figure out how to cast the net as wide as possible so that the archive held the possibility for other people to do something useful with it. We didn't want to restrict the project to our own research interests, so the process of cataloguing was one of trying to figure out how to produce metadata that makes the archive searchable in a variety of different ways.

PRAKASH: These signs are such a singular representation of one person at one time, so what does it mean to translate, essentially, someone's entire feminist ideology into a few tags? What gets lost in that translation? And how do we maintain that person's agency, or personhood, when we translate them from a person to a sign to data to a visualization?

Figure 6.3 Images from "Art of the March" (http://artofthemarch.boston). CC BY-SA 4.0.

Art of the March 85

title	We A(re sist)ers
text	We Are Sisters / We Are Sisters / We A(RE SIST)ers / RESIST
show	female symbol
strategy	solidarity, call to action
cultural context	famous protest slogan
tone	assertive, loving
concern	feminism, resistance
lettering style	hand-written
contains	text
made	marker
condition	good

title	Heartbeat
text	
show	a heart beat on a heart monitor
strategy	solidarity
cultural context	famous protest slogan
tone	loving
concern	love
lettering style	
contains	drawing
made	marker
condition	good

Figure 6.4 Images from "Art of the March."
CC BY-SA 4.0.

DIETMAR: In general when we talk about data visualization, qualitative data is always a big challenge. Public protests or social movements are almost impossible to really represent with traditional approaches to data visualization. These approaches tend to abstract and reduce and try to come up with some kind of essentialist perspective. In this project, however, none of that really matters. You have to remember, this march was just after Trump's inauguration—which is a very, very specific point in history—so the particular context is incredibly important.

Basically, when we deal with cultural phenomena, we are looking at concepts from many different perspectives and many different frames, but when we encode them into data visualizations, there is a very limited palette—the human eye is only able to really distinguish seventy different color categories, for example. The strategy with Art of the March, then, was to develop multiple perspectives of access in order to show the same dataset in many different ways—which led us to produce multiple visualizations.

86 *Grace Van Ness and Prakash Krishnan*

GRACE: As the designer of the "Immersive" visualization in Art of the March, Siqi, can you talk to us about how your approach to categorization and tagging played into your design process?

SIQI: The actual design process was very iterative. Initially the idea was to recreate that immersive experience of being in the march and seeing the signs go past you. That was interesting, but it didn't work quite as well as I thought—it was too literal. So we experimented with a few different visual metaphors and then we came to the idea that all of the signs could be coalesced around a giant sphere (Figure 6.5). I think the process by which you end up with a particular visual idiom always has an accidental component to it. This visualization happens to do a good job of showing everything at the same time—it gives you a sense of the scale and cacophony of the whole march, but also lets you easily interact with each sign individually.

GRACE: Chris, you designed the "Visual Interface" of this project, and I know you had a similar approach to interpreting the dataset. I'm curious to hear about your process as well, and how you got involved in Art of the March.

CHRIS: Dietmar brought me onto the project after we got to talking about visualizations while I was visiting Boston. When we met, I showed him the first prototype that Katrin Glinka and Marian Dörk and I created for Vikus Viewer,[9] a visualization tool that I designed and developed.[10] Out of this first prototype—which was made for a historical drawing collection—I began working on a more generalized tool for large image collections with text. The goal was to create an all-encompassing, overview visualization which can be filtered down into deep, specific subsets, allowing you to view the very detailed objects at the same time as the whole. This makes it possible to really see the connections in the data (Figure 6.6). The tool is open source, and it's a pretty straightforward program—just plain HTML, Javascript, and CSS. What's

Figure 6.5 Immersive interface image from "Art of the March."
CC BY-SA 4.0.

Figure 6.6 Image from Vikus Viewer (https://vikusviewer.fh-potsdam.de/).
CC BY-SA 4.0.

most important to me is making the visualization accessible, so my approach has always been to make it quick and easy for people to explore the visualization as a whole. Still, you can do a lot with it. With a tool like this, I think the possibilities are endless. Even though this visualization was based on a tool that I was already developing and wasn't made solely for Art of the March, when I put in the signs, it just fit, you know? It was a great fit.

GRACE: This makes me wonder about your unique role in the project, Navi. You're a student of design, but you also come from an engineering background. How did these two disciplines come together for you in your role as web designer and developer?

NAVI: It was a little tricky, because whenever we made decisions about design, I was the one coding everything, so I would have to say sometimes, you know, "This will be hard to build, let's think about alternatives." Personally, I feel like having the role of developer in this project has really influenced what I now think of as good design.

GRACE: Right—and I think constraints can potentially play a very generative role in technical and creative projects. Are there aspects of Art of the March that you'd like to revisit and change?

NAVI: I think after any project is over I personally feel like I could have done things a little bit differently. Almost always. So, that was the case with this project as well. Right now, the website has about 6,000 images, and if you load all of them at once the visualization becomes slow on most computers. We did some level of optimization for the web (only loading the images that are visible and removing the rest), but it didn't quite work by the time we launched, so I'd like to handle that bug. There are other things, as well. For instance, now all the images load the same way when you visit the website—so the first image will always be the first image. I wanted to try randomizing the images to some extent, so that visitors to the website will have

a more discovery-oriented experience. However, we wanted this to be a research-based interface, so that was fighting against the decision to randomize.

PRAKASH: Another behind-the-scenes conversation I'm wondering about is how you dealt with any signs using problematic or exclusionary rhetoric. Were those signs included in the project? Was there a quality assurance process involved in choosing the signs or did you include all the signs you collected?

ALESSANDRA: Yes, we included everything we collected. It would have been interesting if we'd had to make a decision about some signs that can be violent for people to see if they're looking at the archives. I'm not sure because we didn't come across any, but maybe we would have come up with a section with a trigger warning if we were to still remain truthful to the sample. I mean, those people *were* at the march, and we may need to start having conversations about the different groups and individuals who have some ideas that intersect on certain issues, but are completely on different planets about a variety of other things. So, if you physically isolate certain triggering signs, how do you deal with that in terms of this intersectional metadata? That would have been an interesting technical and methodological question to tackle.

Politics and Research

GRACE: How do you see the role of the researcher or the academy in projects like this? It's certainly a balance, and I wonder how your academic and activist identities come together for you—or don't—in Art of the March.

ALESSANDRA: In this context I would not identify as an activist. I would identify as a researcher with a political intent—simply because I don't belong to the group of people who organized this march.

One of the reasons we put together Art of the March is because we knew that we had the resources to pull it off. Of course, there are some *amazing* activist archives—I'm thinking, for example, of Interference Archive,[11] or A People's Archive of Police Violence in Cleveland[12]—but they've been the labor of love for years and years and years, right? Academic settings, however, are particularly useful for preserving social movement artifacts because they not only can access the resources to create archives, but can also maintain them. Often, university libraries can host archives—and there are some amazing librarians and scholars supporting this kind of work. For instance, the project Doc Now,[13] which ethically documents social media content around struggles like that of the Movement for Black Lives, involves many experts and activists from multiple fields.

Of course, I'm assuming that academic positions are stable, and this is no longer often the case. Many academics today are in precarious positions with short-term appointments where this kind of labor is neither easy to do, nor acknowledged by the institution because it is not part of the teaching work that they are hired for. Another caveat is that some institutions restrict access to their archives to those who can make it through their gates—physical or paywalls—and do not develop ways of making social movement archives available or visible to community members.

Hopefully, projects like Art of the March can provide a model of openness to make sure the signs are easy to find. In an ideal world, activists would have access to the same infrastructure, resources, and time to preserve their own cultural history.

PRAKASH: I really like the phrase "research with political intent." I think it applies to a lot of the work that I'm doing outside the academy in which I explore my own subject positioning. I also usually identify as an advocate instead of activist. I think there's a connotation to activism that I don't always feel comfortable holding—especially in the context of movements where I'm not a part of the demographic.

ALESSANDRA: It makes sense, right? And there is, in the context of research, an entire tradition—or multiple traditions—of research with political intent. As much as there is activist research. Sometimes the two are conflated, but I think as people—and as researchers especially—we can learn to be more self-reflexive, and those nuances should be part of the way in which one positions oneself.

DIETMAR: I think about this a lot. You know, are you an outside observer or are you one of the protesters? I mean, the fact that we work at the university is completely accidental to this project. We were at the march because we wanted to participate and we collected the signs because we would have hated to see all those materials thrown away.

SIQI: Oftentimes this kind of data visualization work is client driven, right? You usually come in with business or organizational requirements that drive these projects, but this work is obviously very different. It potentially springs from personal identification with a cause or just general curiosity as a human being. Then the question is exactly as Dietmar said. What is your role in all of this? Are you in a way a medium? Are you in some way a more subjective storyteller in all of this?

DIETMAR: The kind of Participatory Action Research that this project engages with emerged from a social science background and has only recently been adopted by design, but it's a paradigm that encourages intervention in order to learn something. You are not standing at a distance and looking at the world through a telescope or a microscope. Instead, you build something and then see what kind of dynamic unfolds. This approach is apparent in a lot of work, for example, with vulnerable communities in the environmental justice context. And, while it's still not yet mainstream in the social sciences, it has started to gain much more respect as a very important way of doing research.

Public Participation and Collaboration

GRACE: What has been the public reaction to Art of the March? Considering the importance of making the dataset accessible and usable to those within the movement, I'm curious what response you've gotten from those who attended the march.

ALESSANDRA: Many people who were in the march will look through the archive for their own signs, of course. And we've received many emails asking, "Can you add this one?" or "I'm going to go and collect other signs, can I donate them to you?" So, for some, this archive has become a way of reflecting back on a moment and reliving the experience of being in that crowd, of being a part of something—many for the first time, or the first time in a long time. And it is a very specific moment in time when so many different emotions came together—hope, desperation, indignation, disappointment, fear ... That was one of the things we really paid attention to in the cataloging process—the emotions, the feelings. I think including that kind of metadata helps keep the human in there. These signs are not just pure messages, they're artifacts—and they are parts of a larger assemblage. These signs are *connected*. And, also, they're potentially *made* collectively.

GRACE: Totally. That's what this discussion brings up for me. The process of making the signs.

ALESSANDRA: There were lots of sign-making parties, right? Which is a very important part of the process of bringing together a critical mass of people for the emergence of a movement.

DIETMAR: We collected the traces, these physical artifacts, but the process of how these signs were actually made is invisible to us. There are all these different kinds of communication that take place in preparation for the march itself. Then, of course, there's also the afterlife of the protest—people are taking photos, and that generates viral content that is then disseminated. This continues the protest in virtual space.

ALESSANDRA: If we had access to more resources, the preparation and afterlife of a sign would be a really interesting component to incorporate into the archive. We could start trying to do a reverse-image search to identify the people who made or carried these signs—maybe they posted pictures from the march on their social media platforms, for instance. Then we could try to contact them to see if we can connect their sign to their personal story. That's one way we could use the archive to keep the energy going—to rally people and to remind them of how they felt at the march that day.

GRACE: Going forward, is that your primary hope for the project?

DIETMAR: I'd like other researchers, activists, or members of the public to use this dataset and visualize it in different ways—do things that we didn't think about. That's one hope. The other is that, because we started the project with an attempt at machine learning, that's something I'd like us to look more into and even push further. That would also make the archive more accessible.

SIQI: To build on what Dietmar is saying, if you take a certain starting point in your exploration of this archive—let's say a sign that employs a particular rhetoric or visual strategy—then what are the similar ones? In what ways are they similar and how common is that characteristic? I think we tried to accomplish this a little bit with filtering by tag, but I do think that if we were able to apply a machine-learning overlay on top of that so there's a different way of helping people explore similarity, that would be really good. That would be my next step if we had some more time with the project.

PRAKASH: Machine learning and artificial intelligence are terms that are often brought into conversation when talking about data mining or processing—especially when it comes to Big Data. What are your thoughts about using automated processes such as these to perform the kinds of categorizations done in Art of the March?

ALESSANDRA: I am slightly mistrustful of using only automated processes to do any kind of research because I think something gets lost there, and it is that relationship that one develops with the data. When you're doing qualitative analysis especially, you can make data do a lot of different things with an algorithm. I think those things are useful, but at the same time, we're dealing with a collection of artifacts from a social movement—and let's not forget that a lot of movements don't have the resources to collect their own material. When you're trying to make the materials accessible back to those movements, I think it is useful not just to think mechanically, but to develop a relationship, to actually feel the passion behind the signs, and to really try to read some of the messages beyond what image-recognition software can do. A sign might quote Frantz Fanon or Angela Davis, for example, but the software can't tell me who they are—you need a person who gets the reference. And, I mean, there's even human

error when we're looking at the signs. For instance, there were signs that had something that looked like a heartbeat, so we cataloged them as "love" or "life," when in fact they were "resistor" symbols being used by MIT students to signify change or resistance (Figure 6.4).

DIETMAR: Right—and there's an improvisational aspect to this kind of visual communication too. If you go to the archive and search for "resist," you'll get posters that use the idea in all kinds of different ways. There is, of course, a repeating "resist," "resistance," "join the resistance," and then we get to Star Wars ... and then there is also—as Alessandra has mentioned—this word play on "resistors," as well as "we are re-sisters" (Figure 6.4).

It almost becomes like a poetry of some sort. People see a sign or an image or a slogan that they like and they start modifying it. This is what I mean by an improvisational process. Through an iterative reuse and remix, protesters combine and recombine text and visual elements from many different sources—introducing the kind of wordplay we see with the "resist" example. These visual messages emerge from a space of cultural resonance, in which ideas and tactics emerge, change shape, disappear, and reappear—all in close entanglement with the social ties among groups. This is, in a similar way, how we approached the categorization process. It, too, was very improvisational. We started off just by transcribing what was written and drawn on the signs—then we identified and constructed certain motivations and strategies around that data, which became the categories that organize the archive on the webpage now. Along the way, however, we had to revise our categories as we discovered additional themes in the signs. Just as you cannot understand a sign without exploring the textual or visual traces that it references, you cannot know the best method for categorization without looking at the archive as a whole. Even the collaborative process itself was very improvisational. Just the very nature of Art of the March didn't allow it to go step by step and proceed in a linear way. It was always a kind of conversation among a group of people.

NAVI: This was my first project in any university that involved more than five people. Before that, I worked as a manager for ten or twenty people, but it was in a corporate setting, so I was mostly working with people who spoke my language. We were all developers, so I knew what they did, and they knew what I did. This project felt much different. Dietmar and Siqi are architects by background and Siqi has done a lot of urban planning work using data visualization. Then, of course, all the people tagging the images are scholars of politics—and they had a completely different vocabulary than I did as a developer. For example, while a developer describes creating a "ranking" for the images, non-developers will "collate." Or, whereas a designer might use colors or visual cues to make interface-related features easier to use, because this can impact how the data is read, we had to use other techniques for making the website user-friendly. So, in the process of designing the website for Art of the March, I was learning how to communicate familiar ideas in a new way.

PRAKASH: I feel it's very poetic the way you have people from different institutions, fields, and perspectives initiating this project. It very much mirrors the way activist organization works. You have people who come from different backgrounds and experiences, but then you collaborate to have a very multidimensional social movement.

DIETMAR: In a way, this is nothing unusual. We all come from backgrounds where these kind of multidisciplinary—and, okay, multidisciplinary sounds very academic—but basically this kind of diversity of backgrounds plays an important role.

Data Processing

GRACE: To me, this project represents an interesting physicalization of a process of gathering data that I've only ever done in a digital context. Instead of using certain technical tools, here you're "scraping" the streets with your hands for posters or data. Has any part of collecting the signs felt reminiscent of other kinds of data collection or scraping that you've done in the past?

ALESSANDRA: The digital data scraping that I've done in the past has been mostly of metadata through Twitter, for instance—hashtags and things like that. So, the data wasn't necessarily connected with a physical artifact or even an image. It was mostly the kind of data that is already pure data, in a way. The only related experience was when I translated—together with an Indonesian activist and a designer—all the research that we'd done about flooding in Jakarta into a climate adaptation from several heterogeneous sources into data points and then into images that would capture a specific public. Which is kind of an inverted version of Art of the March—instead of reading from one symbol or sign all of these other meanings, we were trying to condense lots of information into one little sign.

PRAKASH: That's something I like about data visualization, generally. When you're dealing with huge datasets, the words "six thousand" mean nothing, but when you're physically confronted by all of the signs it really brings you into that moment. As we talked about earlier, even though these are just pixels, there are people behind the pixels—so it's kind of blurring these lines between the corporeal and the Cybernet. There's something happening behind those various images that I think is really interesting.

ALESSANDRA: That can also be explored as a political strategy, I find. Of course, media production—as well as the production and interpretation of data—are important ends in themselves to the circulation of alternative knowledge. However, I also think that the processes involved in this kind of production and articulation of meaning can be important sites of intervention in social justice-oriented work. It is through these processes of collaboration that people build connections—they subjectivize collectively, they negotiate meanings and narratives about the world and what they are doing, and they can develop new tools and strategies to potentially build scalable projects and longer-lasting ties. For this to happen, it is necessary to reflect on and invest in the infrastructures and facilitation methods that can harness these processes as veritable tools of struggle. I encountered this kind of work in Italy with the media collective insu^tv, which uses participatory media production as a way of bringing communities into dialogue. The Urban Poor Consortium in Jakarta, as well, uses participatory mapping and urban design in informal settlements to build critical mass and mobilize local support in anti-eviction campaigns. In both cases, while the outcomes themselves are impressive, it's the connections that emerge between people that can relay and push forward further organizing, friendship, and hope.

GRACE: And this kind of creative rethinking feels so pressing because there's such an immense amount of power in the translation of data into story and back again. Figuring out how to navigate and operate within that space is essential to harnessing its power.

ALESSANDRA: Exactly. You need to understand it now because someone else is telling the only story with that data, right? So—either you'll produce alternative kinds of data or you have to be able to read the existing data and contextualize it in a different

way, because otherwise whoever is telling the story can make it say anything they want and everyone will go, "Oh yeah, it's data, so it must be true."

PRAKASH: Exactly. There's this idea that data is objective. I think that's the con of both media and Big Data—they present "facts" as fact. But facts are not facts. You really need to be both media literate and data literate—and you don't have to work in data to be confronted by it.

ALESSANDRA: Totally, yes. These days, we hear more and more about algorithmic bias, and while it is still very hard—or impossible—to audit algorithms for bias, more and more researchers are scrutinizing and developing methodologies to do so.[14] At the same time, the idea of algorithmic bias has also opened up a wider conversation on bias in design. Networks like Design Justice[15] are devising creative and radical approaches to more ethical design that centers the voices and needs of the people whose lives it affects. This activism, as well as emerging scholarship from Safiya Noble, Virginia Eubanks, Sasha-Constanza Chock, and Arturo Escobar—to mention a few—give me hope that more people will invest in media and data literacy. There need to be more examples of technology designed whose best practices adhere to a set of shared principles for social, racial, and economic justice. The important thing is—now that we know about this bias, what are we going to do about it?

* * *

While there are no current plans to expand the Art of the March website, the project's legacy continues. The project was exhibited in Berlin, Germany at the 2018 IEEE Visualization Conference (VIS), and a variety of works continue to be produced and presented using the Art of the March archive. These include projections, time-lapse videos, and, most recently, a large mosaic canopy print of the corpus in its entirety.

While a small sample of the signs were kept at Northeastern University, the majority have been donated to Poster House, the first museum in the US dedicated to the history and impact of posters, where they were exhibited between October 17, 2019–February 10, 2020. The archive, visual interface, and immersive visualization remain available at www.artofthemarch.boston.

Notes

1 Alessandra Renzi was interviewed by authors on January 25, 2019. Dietmar Offenhuber and Siqi Zhu were interviewed on January 30, 2019. Navarjun Singh was interviewed on February 6, 2019. All interviews were conducted from Montréal, Canada.
2 Dietmar Offenhuber is an Associate Professor at Northeastern University in the fields of Art + Design and Public Policy. He holds a Ph.D. in Urban Planning from MIT, and Master's degrees from the MIT Media Lab and TU Vienna. His research focuses on the relationship between design, technology, and governance. Dietmar is the author of the award-winning monograph "Waste is Information" (MIT Press), works as an advisor to the United Nations and has published books on the subjects of Urban Data, Accountability Technologies, and Urban Informatics.
3 Dr. Alessandra Renzi's interdisciplinary work explores the linkages and relays between media, art, and civic engagement through ethnographic studies and media projects. She has studied pirate television networks in Italy and the surveillance of social movements after 9/11. Her current research investigates how society's increasing reliance on platforms, algorithms, and Big Data is changing social justice activism. This research had led her to Indonesia, where she has been facilitating research-creation projects with local NGOs that use information design and data visualization for advocacy.

4 Christopher Pietsch is an independent information visualization researcher. He blends art, design, and technology to create interactive experiences and spaces. He studied Computer Science at the HTW Berlin and Interaction Design at the University of Applied Sciences Potsdam. His current research circles around aesthetic interfaces in order to enable novel forms of data exploration. As an associate of the Urban Complexity Lab at the University of Applied Sciences Potsdam he focuses on making cultural collections graspable.
5 Siqi Zhu is a Boston-based designer and urban planner working at the intersection of urbanism and information design. His work focuses on applying the techniques of information design to discover and elucidate the complex social, physical, and economic processes driving urban change, and on creating new modes of visual representation to make them legible to decision makers and the wider public.
6 Navarjun Singh is an engineer and designer who is enthusiastic about data visualization. He graduated with a Master's degree in information design from Northeastern University in Boston, US. Previously, he has worked as an engineer and product manager, and holds a degree in computer science from Thapar University, Patiala, PB, India.
7 "A Documentary Project," Art of the March, accessed February 24, 2019, http://artofthemarch.boston/page/about.
8 "Art of the March" categorizes the signs with a total of 186 "Concern" tags. Of these tags, the most frequently used are "resistance" (2554 signs), "women's rights" (1660 signs), "feminism" (1518 signs), "Trump" (1276 signs), and "love" (1049 signs). However, each "Concern" tag frequently references far fewer signs. For example, "Black Lives Matter" is tagged 189 times, "trans rights" is tagged 25 times, and "patriarchy," "capitalism," and "intersectional" are each tagged six times. There are also four "unclear" signs and 15 signs tagged as "other." Additionally, there are 20 "Strategy" tags, with the vast majority of signs in the archive tagged as "solidarity," "demand," "complaint," "encouragement," and/or "call to action." The website also lists 10 "Contains" tags, which categorize 5,812 of the ~6,000 signs as "text," while nearly 1,000 signs include a drawing or illustration.
9 According to the tool landing page, "VIKUS Viewer is an advanced web-based visualization system that arranges thousands of cultural artifacts on a dynamic canvas and supports the exploration of thematic and temporal patterns of large collections, while providing rapid access to high-resolution imagery."
10 "VIKUS Viewer: Explore Cultural Collections along Time, Texture, and Themes," VIKUS Viewer, accessed February 5, 2019, https://vikusviewer.fh-potsdam.de/.
11 Interference Archive, accessed March 15, 2019, https://interferencearchive.org.
12 "A People's Archive of Police Violence in Cleveland," accessed March 15, 2019, www.archivingpoliceviolence.org/.
13 "Documenting the Now," accessed March 15, 2019, www.docnow.io/.
14 "Auditing Algorithms: Adding Accountability to Automated Authority," accessed March 15, 2019, http://auditingalgorithms.science/?page_id=82.
15 "Design Justice," accessed March 15, 2019, http://designjusticenetwork.org/.

7 Dissent, Design of Territory, and Design of Memory
The Museum of Slavery and Freedom at the Valongo Wharf, Rio de Janeiro

Ana Helena da Fonseca and Barbara Szaniecki

In 2011, two anchorages—Valongo and Imperatriz—were discovered during excavations in the port area of Rio de Janeiro, Brazil. The excavations were part of an urban revitalization program that was accelerated by the mega-events hosted by the city. Rio's City Hall did not fail to realize the historical value of that discovery even though it was busy with works for the mega-events. Indeed, Rio de Janeiro today is a city entirely affected by the mega-events that took place there and the urban transformations required in order to accommodate them. For example, the renowned Maracanã Stadium was completely renovated for the FIFA World Cup in 2014 and once again for the Olympic Games in 2016. Yet the Olympic park in Barra da Tijuca that housed the main venues for the Games and other Olympic projects now lie abandoned.

Efforts to resist these processes occurred throughout the city, but they were largely defeated. Ways of life were lost, as were actual lives. Almost immediately after the Olympics closing ceremonies, newspapers pointed out neglected venues, diverted funds, and a deep financial and social crisis faced by the city and the state. It is important to recognize that the crisis was not due solely due to the mega-events but also due to the economy's dependency on oil, unpredicted market fluctuations, the inefficient management of resources, and corruption. Still, the crisis that affects Rio de Janeiro is serious, and today its citizens struggle with the city's and the state's complete incapacity to grant basic services.

Now, even in the midst of crisis, some accomplishments are emerging. In 2016, the National Historic and Artistic Heritage Institute (*Instituto do Patrimônio Histórico e Artístico Nacional*—IPHAN) and the city of Rio de Janeiro prepared for UNESCO an application that finally led in 2017 to the declaration of Valongo Wharf (*Cais do Valongo*) as a World Heritage Site (Figure 7.1). Faced with the surprise discovery of this historical landmark and the urgency of constructing a memorial—the Museum of Slavery and Freedom (*Museu da Escravidão e da Liberdade*)—to welcome the archaeological findings, we intend to discuss the possibilities of a "design of territory" and a "design of memory." Although the path that took Rio to the Olympic Games was marked by heavy protests against urbanization and conflicts over its implementation, which happened without the participation of citizens, the current situation might open itself to the exercise of citizenship. In the following, we intend to discuss how collaborative design can help in this process of democratization

by articulating a variety of voices in a new territorial production that takes the distinct memories of the area into account.

Porto Maravilha and the Discovery of the Valongo Wharf

Rio's port area was one of the most affected territories during the mega-event projects, especially the 2016 Olympic Games. It was there that *Porto Maravilha*, an immense project of "urban revitalization," took place whose most visible works included the demolition of the Perimetral Viaduct and the construction of new transportation and cultural facilities. Several infrastructure improvements were implemented, including the construction of expressways, the repair of sidewalks, and the installation of essential services. The area was redefined and now is essentially focused on entertainment and culture, anchored by two large, spectacular museums: the Rio Art Museum (*Museu de Arte do Rio*) and the Museum of Tomorrow (*Museu do Amanhã*) (Figure 7.1).[1]

The official statement held that the port area was sparsely occupied, and that it had deteriorated with the decline of industrial and port activities. Although it is true that certain economic activities had declined, in fact the area remained inhabited and continued to embody particular social and cultural characteristics. The revitalization process led to the removal of buildings that were occupied by the urban poor, samba schools, warehouses, and sceno-technical spaces (related to the carnival and other spectacles), not to mention people who had been living there for years. Yet the official *Porto Maravilha* website[2] claims a commitment to urbanism, environmental rules, and social issues, perhaps anticipating the dissent of the locals that follows a lineage of cultural resistance practices since the slave trade, such as the samba born in that area (Figure 7.2).

Figure 7.1 The Museum of Tomorrow, Rio de Janeiro, 2017.
Photo/Courtesy: Philippe Leon Anastassakis.

Figure 7.2 Afoxé Filhos de Gandhi, carnival group rooted in Candomblé practices at the Valongo Wharf, Rio de Janeiro, 2017.
Photo/Courtesy: Philippe Leon Anastassakis.

Rio de Janeiro's revitalization indicates that if in the twentieth century the city was inspired by Paris, today it takes Barcelona as its model. Like that former Olympic host, Rio has revitalized its waterfront, creating an esplanade equipped with cultural spaces and new real-estate investment opportunities. But like the rest of the city after the Olympics, *Porto Maravilha* is encountering a dual crisis: The area was devastated by the removal of popular housing, just as in Barcelona and other Olympic cities, while the projects that were designed for the more privileged classes were only partially executed.

Unexpectedly, during the excavations for the *Porto Maravilha* in 2011, the stones of the Valongo Wharf emerged alongside other archaeological findings (Figure 7.3). These findings resulted, by means of a decree, in the creation of the Historical and Archaeological Circuit for the Celebration of African Heritage (*Circuito Histórico e Arqueológico da Celebração da Herança Africana*)[3] and of the Curatorial Work Group for the Urban Architectural and Museum Project (*Grupo de Trabalho Curatorial do Projeto Urbanístico*). The discovery presented itself as though to advocate for a history that tends to remain hidden. Its relevance did not go unnoticed by the *Porto Maravilha* organizers; information about the Valongo Wharf was soon posted on the official website. Above all, the discovery led IPHAN and the City Hall to file together for the archaeological site to become a UNESCO World Heritage Site.

Although the Valongo Wharf today is well-circumscribed, the broader area is much larger, and associated with both past and current resistance movements. As the entryway for men and women from Africa, even after the end of the slave trade, it became an area where people showed strong manifestations of African-Brazilian faith and culture. Thus the UNESCO preparations were carried out by a multidisciplinary group

Figure 7.3 Valongo Wharf (*Cais do Valongo*) in Rio de Janeiro, declared in 2017 a World Heritage Site.

Photo/Courtesy: Philippe Leon Anastassakis.

whose 2016 document provided a justification and proposal for the protection and management of the site.[4] Valongo Wharf was recognized as a World Heritage Site in July 2017, both for the memory of the African diaspora and for its contribution to the social and cultural formation of Brazil and the Americas. Without disregarding the terrible effects of slavery or the more recent removals of people in the wake of the 2014 and 2016 mega-events, here we imagine by means of design what might happen from this point forward. Despite the crisis of the city and the state, may the UNESCO's recent recognition renew and create new perspectives?

On September 2017, two months after the Valongo Wharf was declared a Heritage Site, a public hearing on the region and its cultural policies was convened by the Culture Permanent Committee of Rio de Janeiro's Municipal Chamber (*Comissão Permanente de Cultura da CâCera Municipal do Rio de Janeiro*).[5] The hearing included speeches by representatives of institutional policy, such as city councilors; of social and activist organizations, such as the Unified Black Movement (*Movimento Negro Unificado*); and more important, of the area's social and cultural associations, such as the Institute of Research and New Black Memory (*Instituto de Pesquisa e Memóeia Pretos Novos*) and the Community Descendents of the Quilombos of Pedra do Sal (*Comunidade de Remanescentes de Quilombos da Pedra do Sal*). African-Brazilian religions were also represented. And finally, the academic world was represented through anthropologist Milton Guran and economist and sociologist Carlos Vainer. The hearing lasted approximately three hours and proved to be a mosaic of divergent perspectives.[6] In the midst of the disagreements, Guran's speech indicated a shared interest in establishing some

common paths. One such path leads to the construction of a museum, the third in the port's area.

Design of Territory and Design of Memory

Once the Valongo Wharf was declared a World Heritage Site, a crucial issue arose: how would the heritage project be implemented democratically? At the public hearing, despite countless differences, people from various groups eventually agreed to create a museum. This fact was foreseen in the report developed for the candidacy of the Valongo Wharf, which stated that City Hall and IPHAN are committed to the permanent exhibition of the area's archaeological findings in a memorial to be installed at the old Dom Pedro II Docks. Now serving as headquarters of the activist organization Action of Citizenship against Hunger and Misery and for Life (*Ação da Cidadania contra a Fome, a Miséiia e pela Vida*),[7] this warehouse has remarkable symbolic importance, having been built in 1817 by black engineer André Rebouças, who refused to use slave labor. The proposed name of this future memorial, though it has not yet been confirmed, represents a history of struggle. Yet the name—Museum of Slavery and Freedom—marks only the beginning of a huge debate.

In the aftermath of the public hearing, and with an interest in contributing from the field of design, we have articulated some of the current discourses about the archeological site and the museum, organizing them around two axes: one focusing on spatial questions and another on temporal issues. This approach has led us to put forward a hypothesis of two future intertwined possibilities: a design of territory and a design of memory, the first corresponding to "the museum is the city" idea, and the second to that of a "living museum."

"The Museum Is the City": Design of Territory

Many participants in this debate agreed to establish a territorial museum. But the interpretations of the term "territorial" vary, from an approach to the territory that is merely material to one that gives priority to decision-making processes. Whereas some have perceived "territory" in this context as the area of Rio that was recognized by UNESCO, others have extended the meaning of this term to include the whole city—and yet others, considering the African diaspora, the whole world.

"The museum is the city," said Carlos Vainer at the public hearing, reflecting Brazilian artist Hélio Oiticica's words: "The museum is the world."[8] For some, the term "territory" implies the right to access urban land without risk of eviction as well as to enjoy a worthy existence in social and economic terms. For others, the term signifies the *terreiros*[9] of African religions. And finally, "territory" is also the place of political debate. Some of these meanings given to the term "territory" related with what Henri Lefebvre deemed the "right to the city" (discussed in the next section).

Among the representatives from academia, Vainer stated his desire to discuss what "this space, this equipment, this place, this center, this house" might be. He gave examples of possible functions for the new museum: an education center for students and teachers, so this particular story can be told; an art and culture center, so the community can express itself; a research center for the study of the history of Africa, the African diaspora, and *afrobrasilidade*;[10] a political center, because it is a museum that concerns not just slavery, but also struggle, resistance, and freedom, and as economic

and social development hub, because it is necessary to guarantee employment for the local people. Subsequently, Vainer concluded that the museum will "stand on a territory that is not an ordinary place. It's from Little Africa[11] in the city of Rio de Janeiro that will spread its roots and, therefore, by being territorial, it will be universal."

Milton Guran agreed, suggesting the creation of a territorial museum that would encourage people to remain in the area, thereby creating jobs. It is important to remember, however, that the economic production of a territory is not necessarily connected to the creation of jobs. It is also possible to reach and evaluate economic production using other approaches.[12] Guran also mentioned that the city harbors other local institutions, such as the José Bonifácio Cultural Center (*Centro Cultural José Bonifácio*), the African-Brazilian Culture Reference Center(*Centro de Referência da Cultura Afro-Brasileira*), and the Institute of Research and New Black Memory, and that this would be an opportunity to expand the African heritage circuit. Thus, what emerged from the discussion was an interest in an open-air museum intertwined with the existing map of the African presence in Rio de Janeiro.

To assert this territorial dimension is significant insofar as the African-Brazilian presence in the port region is still in jeopardy. The public hearing made clear that residents of the surrounding area continue to feel threatened by *Porto Maravilha*. Their relation with the territory is strongly connected with both an individual and a communal sense of land ownership and belonging, and yet the development of *Porto Maravilha* leaves the community, and especially its most vulnerable populations, vulnerable.

How can these populations resist, and how can design assist this resistance? While it is certainly valid to research architectural and territorial forms of *quilombos* (Brazilian settlements founded by people of African origin) and *terreiros*,[13] it is also important to take into account forms that have visual or oral dimensions, as highlighted by several women at the public hearing. Municipal Culture Secretary Nilcemar Nogueira, for example, stressed the importance of

> a museum that gathers all of our history's literature but that also safeguards the stories of those who keep this underground memory—stories that were never heard outside the community and that might actually be recognized as historical document or testimony in oral form.

This more delicate type of territorial production can be accomplished not by the state or municipal powerholders who promote typical methods of urban planning, but rather by a multiplicity of actors who reject top-down processes. Here design might play a role in upholding the right to the city.

From the Production of Space to the Design of Territory

In the 1960s, Henri Lefebvre turned our attention to a type of "space" that escapes urban planning. In his 1968 book *Le droit à la ville* (*The Right to the City*),[14] Lefebvre criticizes the functional urban planning leveraged by the French government in favor of industrialization and argues that cities must be thought of and treated not as a finished project but as a work in progress. These reflections

continue with *"La production de l'espace"* ("The Production of Space"), in which Lefebvre identifies, in a way, the root of the problem.[15] He asserts that throughout modern times, mathematicians took ownership of space, always turning it into just another mental thing. This "mental space" has deepened the abyss between the physical and the social realms. Understanding in this field was developed more as *speech about* space than as *knowledge of* space. In our particular case, *Porto Maravilha* is an example of this logical sense of space, creating alienation precisely because it didn't take into consideration the social relations that already existed there. The work carried out might be technically correct, but it disfigured the culture and the lives of the inhabitants.

Is it possible to exercise a "knowing" different from the modern "knowledge" about space? If so, such a knowing would bridge the gap between the "ideal" (the formal abstraction of logical-mathematical space) and the "real" (the practical-sensitive aspect of social space), and would reveal the conflicting character of this "real." This is how Lefebvre conceives a "production of space," which does not consist of a discourse about space, but prioritizes practices surrounding space. And so he asks: "the activities that mark the floor, that leave tracks, that organize the gestures and the works in common should not have priority over the well-regulated, well-articulated languages of logic and philosophy?"[16] By adopting the notion of "production," Lefebvre follows Marx pointing out that all things—from objects to spaces, but also including immaterial "things" such as knowledge—are the fruits of social, productive, and power relations.

The recent transformation of the port area and, particularly, the construction of the Museum of Tomorrow and the Rio Art Museum are examples of these relations. They tend to result in the production of spectacular spaces of consumption related to tourism and entertainment, reproducing an international model of urban renovation of waterfront areas—as in Olympic Barcelona. In Rio's case, the renovation of the port's space demonstrates the power of the economic and political forces that supported these projects over the spatial practices that have historically configured that place. Since the term "space" as defined by Lefebvre coalesces the mental and lived dimensions, we propose the use of the notion of "territory"[17] to denote the realm of social practices. By considering the production of "territory," we aim to escape the economist's bias of space production and gain an ontological dimension.

At the Rio de Janeiro port area, a traditional community thrived thanks to dockworkers, samba artists, art and culture agents, and many more. All these groups were in some way removed (or threatened with eviction) and, as a consequence of the "revival" project suffered the loss of their specific ways of life. Today the area also attracts newcomers from the so-called "creative class." Thus the urban renovation of the area has given license to a slow, but not less violent, gentrification process.

How is it possible to turn the port into a space where the established residents and the newcomers can coexist? What could be the role of the Museum of Slavery and Freedom, and how would it vary from the other two museums? We imagine that the introduction of a new museum could mobilize a production of territory together with a community production. Through this, the port area will always carry a collective memory rooted in tradition and a creative memory focused on innovation, without concealing its ongoing injuries.

Place Making and the Redesign of Communities

In order to imagine this production of territory as a process of collaborative practice between designers and non-designers, we seek the help of design educator and engineer Ezio Manzini and anthropologist Arturo Escobar. Their reflections may offer significant insights on how to articulate the symbiosis of existing and new communities.

In *Autonomia y Diseño (Designs for the Pluriverse)*[18] before presenting his own proposal for an autonomous design, Escobar comments on some of the pillars of design for social innovation developed by Manzini in *Design When Everybody Designs*.[19] Manzini discusses design's reorientation for the support of individual and collective life projects; design's transition to distributed production and consumption systems, which redefines relations between the local and the global; the rediscovery of collaboration in design as a necessary pathway for achieving change, and the bridging of specialized and non-specialized design. He provides a way of thinking about "place making" on a local scale as an alternative to the global capitalist production of space criticized by Lefebvre. For social innovation projects, Manzini suggests that the solutions continue to be local yet open to new networks and relations, taking into account that "today the small is no longer small and the local is no longer local."[20] Manzini defines as "SLOC" (small, local, open, and connected) the place where social innovation happens by means of design. Through their cosmopolitan localism, creative communities diverge from reactionary localism, which rules out those who don't possess a purely "local" identity.

According to Escobar, these two points—place making and the remaking of communities—by means of collaborative design practices and more particularly of co-design, allow distancing from authoritative structures such as governments, corporations, universities, and religions. They offer an approach to "territorial ecologies" characterized as "tangles of ecosystems of places and communities" that long for well-being. Both authors prioritize well-being over development based on economic performance. To Manzini, social innovation targets well-being: the quality of places and communities achieved by working together to create a new culture. This concept of well-being has close affinities with the South American philosophy of *buen vivir* (good living), where Escobar finds great value. In dialogue with Manzini and other authors, Escobar proposes his autonomous design and a favorable scenario for the development of a design program that derives from the theoretical-political space of current social movements, especially those founded by indigenous, African descendants and peasant communities.

Escobar's provocative proposal of autonomous design arises where communities struggle to occupy their own territories, and is decidedly welcome in a violated area like Rio de Janeiro's port. The construction of the Museum of Slavery and Freedom, from the perspective of co-production of territory and community, and performed via the collaborative practices of design, presents itself as a potential act of urban resistance against the continual violence committed through urban revitalization projects. This endeavor is tantamount to claiming the right to the city, and thus it must remain open to effective collaboration among the community of residents, workers, and newcomers.

It seems that in order to build an autonomy beyond governments, corporations, universities, and religions, sympoietic practices (the making with the other, as Donna Haraway defines it) or collaborations between designers and non-designers (as suggested

by Manzini) are necessary. Autonomy implies alterity—a relationship with the other that embodies both difference and equality. For those at Rio de Janeiro's port area, these urban occupations evoke the ancestral resistance against the appropriation of their specific territories and ways of life—they call themselves *Quilombo das Guerreiras* or *Zumbi dos Palmares* (Quilombo Wariors or Zumbi of Palmares)[21]—even as they simultaneously join global movements that resist evictions. Thus when talking about the port area community, the residents consider "others" to be not only people of Rio's creative class who have been moving to the area, but also *global* others. Instead of looking only inward, the traditional community is opening itself to various local and global partners[22] who can help claim their right to the territory.

The transformation of the modes of production that led to de-industrialization—the decrease in port activity and the conversion of port areas into spaces for services and creative activities—was simultaneously local and global. The resistance was too. A museum celebrating the African heritage of Rio de Janeiro and the African diaspora is part of these efforts, and serves as a counterpoint to *Porto Maravilha*. As Vainer mentioned during the public hearing, the project

> has already failed after using our resources, but is still a threat because it is giving that territory to national and international developers and speculators, resulting in the expulsion of the workers from downtown to the outskirts far away from the city.

These urban planning projects follow "global city" models[23] and target the "creative class."[24] Addressing them demands new critical approaches from the perspective of both urbanism and design—approaches that evaluate the plans of urban transformation and demand co-design so that more democratic projects can emerge. At the root of it all lies a need for the redesign of representative democracy itself, by welcoming dissent in order to open up the processes of political life in general, and of life in the city more specifically.

"A Living Museum": Design of Memory

The design and creation of the Museum of Slavery and Freedom is a lengthy process and will take time. The expansion of its territoriality—from the Valongo Wharf to the global diaspora—implies amplifying memory as well. Several speakers at the public hearing raised the idea of a "living museum," and this concept comes with spatial and temporal subtleties that are interesting to explore. What is a living museum? A space where co-design and speculative design experiments can explore the connections between past, present, and future, through activities by all the actors within its growing, moving community.

Historical Reparation, Affirmative Policies

For some, the idea of a living museum is linked to historical reparations. To Júlio César Condaque, historian and coordinator of the Quilombo Race and Class movement *(Quilombo Raça e Classe)*, "this museum must be a living museum" similar to the Holocaust Memorial in Berlin, so that visitors become aware of not only the history of slavery but also the persistent extermination of black youth in Brazil today.

Condaque angrily connects past and present by examining a continuous line of persecution of black people—less lethal but always dramatic, including evictions that took place throughout the twentieth century and increased even after the completion of the mega-events in Rio. Evictions continue to be carried out in spaces where new museums are built and shopping centers are under construction. Yet Condaque's fight for historical reparations has nothing to do with, in his own words, "victimization," and therefore these reparations must come not as assistance but as affirmative policies.

As Nogueira, the municipal culture secretary, stated:

> This debate about putting the word "slavery" at the center of our collective memory ... strengthens the need to revisit the history as it was told. Because you will be able to see ... that slavery has not ended only when you visit and see the modus operandi of contemporary slavery.

Like Condaque, she supports reparations that draw on the present, and she turns toward the future by stating that unlike a traditional memorial, the museum will provide experiences and training that focus on African-Brazilian culture, aiming to serve teachers and schools, as well as university graduate students pursuing research.

Guran—who is a member of the Scientific Committee of the Slave Route, and a member of the committee appointed by IPHAN and City Hall for the preparation of the Valongo Wharf's World Heritage Site candidacy—gave a powerful speech at the public hearing. One of the last to speak, he expressed concerns with the implementation of the project. He took this important opportunity to organize the debate into three distinct issues: The first focuses on how the Valongo Wharf, as one of the most important slave ports, makes essential the issue of reparations and social inclusion of a population that historically has faced discrimination. The second raises the opportunity to support memorial tourism, a type of cultural tourism with the most potential around the world, through the creation of the Museum of Slavery and Freedom. And the third aims to equip Rio de Janeiro with the largest research center on slavery in Brazil and throughout the Americas.

Guran ended by stating, "*This* is reparation! We owe this type of proposal and institution to all who declare themselves African descendants." By presenting these three points of significance, Guran reminded the audience of the multilayered historical meaning—sociocultural, economic, and educational—behind the proposed museum. His perception indicates that a "design of memory" for a "living museum" is urgent.

Afrofuturism, Science Fiction, and Speculative Design

Several distinct temporal forms were presented during the public hearing. The first outlined a direct line from slavery to the forms of violence and discrimination that linger in the present. This perception of time does not take into consideration the complicated relationships between different temporalities—that is, the possibility of abandoning the chronological time that governs our daily activities (in particular, those related to work) and welcoming the events related to other encounters and opportunities beyond those that are projected or programmed.[25] Guran provoked an acute sense of urgency when he used a football (soccer) metaphor to illustrate his apprehension: "This museum is hitting the goalpost. It will go in. But will it go in, in Rio de Janeiro?"

Júlio Cesar Condaque expressed a different approach to temporal dimensions, stating: "We want a living museum, a museum with an African cosmogenic vision. We think in circles. We think about the permanent change in the situation of our people thanks to the African diaspora." The important references here are to the cyclic nature of time and, even more, the ongoing fight against the linear timeline of progress. But perhaps, when insisting on a "living museum," yet another temporality is in evidence: the *Kainós*, which Donna Haraway[26] defines as a thick present, dense with beginnings and resurgences—a present that understands responsibility as an ability to respond and be responsible. In her theorizing, Haraway summons a series of "S.F." constructions: "string figures, science fact, science fiction, speculative feminism, speculative fabulation, so far."[27] During the era she calls Chthulucene, "fiction" doesn't oppose the "fact" of modern science, nor does "fable" oppose "history."

In the 1990s, Mark Dery wrote and published an essay that became an afrofuturist manifesto, which arose from the following question: "The idea of *afrofuturism* creates a worrisome antinomy: can a community whose past has been deliberately erased throughout the years, and whose energy was subsequently consumed by the search for readable traces of [its] history, imagine possible futures?"[28] The answer is yes. Dery presents several fictional examples, speculating on the issues and concerns of twentieth-century African Americans, starting with technology and unfolding in various cultural practices: literature, painting, films, games, animation, and hip-hop, among others. For Dery, African American voices have "other stories to tell about culture, technology, and things to come."[29] These voices and visions simultaneously consider the magical African roots and the diasporic science fictions, creating territories and memories in cities around the world. Consider Adirley Queirós' movie *White Leaves, Black Stays*, which portrays Ceilândia, on the outskirts of the city of Brasília—a modern utopia that creates a contemporary dystopia, where only fiction or speculation may open other paths.

Fiction or speculation? In the field of design, there are subtle differences between the two. To Matt Malpass, design fiction is more a method than an academic field, bringing together approaches to product design, scientific fact, and science fiction by means of practices such as prototyping and storytelling.[30] Speculative design, on the other hand, focuses on sociotechnical issues and operates by transferring the experiments typically performed in research labs to everyday spaces. To our minds, speculative design endeavors not to present utopian or dystopian visions, but to challenge the ethical and social implications of science and the role played by industrial design products. In both cases, it is materiality—materials, prototypes, or products—that cause the confabulatory exercise.

Design anthropology, too, shows an interest in possible futures. According to Joaquim Halse, design consists of bringing into existence, whether in abstract terms (such as ideas or visions) or in more concrete terms (such as designs or prototypes), something that previously didn't exist.[31] The object of design is present not only in the material, but also in the processes and possibilities that unfold in the making. Halse's "ethnographies of the possible" consist of researching, by means of design practices, that which is still not available for ethnographic research—at least not in the conventional sense of field research.

Based on these theoretical references, designer Philippe Anastassakis has been developing his field research in Rio de Janeiro's port area by means of producing

"image games" that provoke imaginative conversations, and co-design possible scenarios for the area (Figure 7.4, Plate 7). Recently, Anastassakis was invited to participate in an artistic intervention called *Lanchonete* (Snack Bar) at Bar Dellas, a local bar where artist Thelma Vilas Boas organized activities that brought together artists and local residents. Attracted by the unusual activity, bar patrons—among them, many dockworkers—talked tirelessly about the projects that have affected their lives: removals, collective transportation, the two new museums that are inaccessible for most residents. After these conversations, residents felt encouraged to begin exercising their citizenship once again, despite the difficulties. This type of initiative that manages to unite "creatives" and local people demonstrates, in a sense, that through co-design with "others," it is possible to articulate local and global ... tradition and innovation ... past and possible futures.

Final Considerations: Defeating Binaries as the Ground Is Shifting

In Seattle in 1999, global movements discovered themselves in the slogan "Another world is possible." In this simple statement, philosopher Maurizio Lazzarato reads concepts from Leibniz and Bergson's philosophy, and looks at how Deleuze turns to the latter in order to consider the concept of "possibles." He criticizes the conceptual pair "possibles-execution," which generates an image of the real that can

Figure 7.4 "What Place is This?" an image-game by designer Philippe Leon Anastassakis, Bar Dellas Bar at Harmonia Square, Rio de Janeiro, 2018.
Photo/Courtesy: Philippe Leon Anastassakis.

be performed only within binary oppositions, such as local vs. global, past vs. future, or archaic vs. modern. Against this understanding, he juxtaposes the pair "possibles-actualization," which "brings a new distribution of possibilities, displaces the binary oppositions, and expresses new life possibilities."[32] After all, design must continually ask, "And what if ...?"

Here we have proposed exercises for escaping binary oppositions by means of collaborative design that articulates a variety of voices in the production of a unique space. We have called for a "design of territory" that challenges the binary pair of local vs. global. And we challenge the opposition of past vs. future by means of a speculative design that manages different visions of time, calling it a "design of memory." We wager these conceptual bets with the goal of promoting potential options for this much-desired "territorial museum" to become a "living museum."

On this journey, we encountered the spectacular projects that were imposed on the urban experience, and found resistance against *Porto Maravilha*, the strong symbol of a type of urbanization and political representation that distances itself from the processes of making cities and citizenship simultaneously. In contrast to this, the discovery of the Valongo Wharf and the creation of the Museum of Slavery and Freedom signify opportunities for dissent—and signal possible resurgences in a territory as impregnated with memories as it is infused with possibilities. These processes, woven by design, which itself is woven by all who participate, know nothing of binary oppositions.

In this process of exploration, we also discovered that the political ground is constantly shifting. For instance, the resistance efforts that arise from the creation of the Museum of Slavery and Freedom are not necessarily in binary opposition with the two new museums of the port area. "How many millions were spent for the Rio Art Museum and the Museum of Tomorrow? And how much will be invested in the preservation of the memory of the afrodescendants of Brazil, of our state, and of our city?" asks Marcelo Dias, member of the Unified Black Movement (*Movimento Negro Unificado*). These militant words are simple and direct, but the reality is more complicated. The UNESCO application by IPHAN and City Hall states that part of the new museum's collection may come from the African Brazilian art collection of the Rio Art Museum. Managing this could introduce, once again, interests not necessarily shared with the population. "New life possibilities" will, therefore, continue to lie in the practice of resistance.

By the end of the public hearing, we heard the municipal secretary emphasizing the difficulties that she had encountered as a public manager which she tried to overcome by encouraging participation. Yet the Quilombo Race and Class coordinator responded with distrust, pointing out that the government had already made three decrees regarding the Museum of Slavery and Freedom, that had prevented social movements, and especially black movements and academia from developing projects together, a cause of discontent within the local communities. Discord is also evident in the State of Rio de Janeiro's decision to establish the museum at the José Bonifácio Cultural Center despite the city's proposal to house it at the Dom Pedro II Docks.

The overall picture is extremely complex, and the process is moving slowly, with unexpected occurrences at every turn of the road. But one thing is certain: the case of Rio de Janeiro is a rich field for the kinds of actions—both organized and informal—that we as designers and as citizens desire to see in a living city and a democracy.

Notes

1 Gerado Silva and Barbara Szaniecki, "Rio: dois projetos para uma cidade do conhecimento" ("Rio: Two Projects for a City of Knowledge"), *Outras palavras*, September 28, 2010, https://outraspalavras.net/posts/rio-dois-projetos-para-uma-metropole-conhecimento/.
2 Porto Maravilha, accessed December 30, 2018, http://portomaravilha.com.br/portomaravilha.
3 The Circuit consists of Valongo Wharf (*Cais do Valongo*), Wharf of the Empress (*Cais da Imperatriz*), Quilombo Rock of Salt (*Quilombo Pedra do Sal*), Suspended Gardens of Valongo (*Jardins Suspensos do Valongo*), Dockers' Square (*Praça dos Estivadores*), Institute of Research and New Black Memory (*Instituto de Pesquisa e Memória Pretos Novos*), and José Bonifácio Cultural Centre (*Centro Cultural José Bonifácio*). Porto Maravilha, accessed December 30, 2018, http://portomaravilha.com.br/circuito.
4 IPHAN, "Sítio Arqueológico Cais do Valongo: Proposta de Inscrição na Lista do Patrimônio Mundial" ("Archeological Site Cais do Valongo: A Submission Proposal for the World Cultural Heritage List"), accessed December 30, 2018, http://portal.iphan.gov.br/uploads/ckfinder/arquivos/Dossie_Cais_do_Valongo_versao_Portugues.pdf.
5 Public Hearing, "Port Region, Little Africa, and Cultural Policies," accessed September 2017, www.facebook.com/reimont13/videos/1471372399551843/.
6 Quoted statements in the sections below come from the hearing's presentations.
7 Acao da Cidadania, accessed December 30, 2018, www.acaodacidadania.com.br/.
8 César Oiticica Filho, ed., *Hélio Oiticica—Museu é o mundo* (*Helio Oiticica—The Museum is the World*) (Rio de Janeiro: Azougue, 2011), 82.
9 *Terreiro* is the place of gathering for the performance of African-Brazilian religious rituals.
10 "Afrobrasilidade" means the mixture between African and Brazilian culture.
11 The port area of Rio de Janeiro includes the Saúde, Morro da Conceição, Gamboa, and Santo Cristo neighborhoods. Freed slaves began living in this area in the second half of the nineteenth century, and it became known as "Little Africa," the birthplace of the city's African-Brazilian traditions.
12 Giuseppe Cocco and Gerardo Silva, *Territórios produtivos: oportunidades e desafios para o desenvolvimento local* (*Productive Territories: Challenges and Opportunities for Local Development*) (Rio de Janeiro: DP&A, 2006).
13 Roberto Conduru, *Arte Afro-Brasileira* (*Afro-Brazilian Art*) (Belo Horizonte: Editora C/Arte, 2007); Roberto Conduru, *Pérolas negras—primeiros fios: experiências artísticas e culturais nos fluxos entre África e Brasil* (*Black Pearl—First Yarns: Artistic and Cultural Experiences in Flows between Africa and Brazil*) (Rio de Janeiro: EdUERJ, 2013).
14 Henri Lefebvre, *Le droit à la ville* (*The Right to the City*) (Paris: Anthropos, 1968).
15 Henri Lefebvre, "La production de l'espace—L'homme et la société" ("The Production of Space—Man and Society"), *Sociologie de la connaissance: marxisme et anthropologie*, no. 31–32 (1974): 15–32.
16 Ibid., 26.
17 We are aware that the notion of territory can be controversial when associated with the rise of bio-politics—in other words, with the use of power over all aspects of a population's life. See Michel Foucault, *Naissance de la biopolotique—Cours au Collège de France* (*Birth of Biopolotics—Course at the Collège de France 1978–1979*) (Paris: Gallimard/Seuil, 2004).
18 Arturo Escobar, *Autonomia y diseño: la realización de lo communal* (*Autonomy and Design: The Realization of the Communal*) (Popayán: Universidad del Cauca sello editorial, 2016).
19 Ezio Manzini, *Design when Everybody Designs—An Introduction to Design for Social Innovation* (Cambridge, MA and London: The MIT Press, 2015).
20 Ibid., 178.
21 Zumbi dos Palmares (1655–1695) were pioneers of resistance to slavery in Brazil.
22 One such partner is Goma, an association for social innovation situated at the port area. Among its associates, Estúdio Guanabara develops activities with residents and cultural groups.
23 Saskia Sassen, *The Global City: New York, London, Tokyo* (Princeton, NJ: Princeton University Press, 1991).

24 Richard Florida, *The Rise of the Creative Class. And How It's Transforming Work, Leisure, Community and Everyday Life* (New York: Basic Books, 2000).
25 Barbara Szaniecki, *Disforme contemporâneo e design Encarnado: outros monstros possíveis* (*Contemporary Misfit and Design Incarnated: Other Possible Monsters*) (Rio de Janeiro: Annablume, 2014).
26 Donna Haraway, *Staying with the Trouble—Making Kin in the Chthulucene* (Durham, NC: Duke University Press, 2016).
27 Praise of *Staying with the Trouble* by Nancy Jane Moore, accessed March 21, 2020, www.dukeupress.edu/staying-with-the-trouble.
28 Mark Dery, *Flame Wars. The Discourse of Cyberculture* (Durham, NC and London: Duke University Press, 1994), 180.
29 Ibid., 182.
30 Matt Malpass, *Critical Design in Context: History, Theory and Practices* (London: Bloomsbury, 2017), page?
31 Joaquim Halse, "Ethnographies of the Possible," in *Design Anthropology—Theory and Practice*, eds. Wendy Gunn, Ton Otto, and Rachel Charlotte Smith (London and New York: Bloomsbury, 2013), 182.
32 Maurizio Lazzarato, *As revoluções do capitalismo* (*The Revolutions of Capitalism*) (Rio de Janeiro: Civilização Brasileira, 2006), 18.

8 Beautiful Trouble

A Pattern Language of Creative Resistance—An Interview with Nadine Bloch

Evren Uzer

Introduction

Beautiful Trouble (BT) is a multi-faceted platform that supports creative resistance and activism (Figure 8.1). Their work provides tools for activists to expand their repertoire of political action towards creative action, and includes web resources,[1] two books titled *Beautiful Trouble* and *Beautiful Rising*[2] as well as a Strategy Card Deck.[3] BT also utilizes these online and analogue resources as tools in training sessions for activists across the globe, while it also provides them as open-source tools that activists can use on their own. These resources are based on activists' experiences from different contexts, articulating tactics and strategies, and linking with theoretical frameworks, without prescribing what successful resistance should look like. BT targets generative aspects of nonviolent resistance, and also aims at creating networks of activists and infrastructures of support.

The tools and resources of BT aim to trigger the change they wish to see in the world through creative resistance. A fundamental value of resistance is its role in expanding our imaginaries, building unimagined alliances and opening up possibilities by shifting, undermining, or restructuring power relations. BT presents tools and resources for activists and organizers on the ground to use creativity as a mode of prefigurative politics. The following interview[4] with Nadine Bloch,[5] the training director of BT, discusses the definition of creative resistance, the origins and methods of BT, its connection to international solidarity and challenges moving forward.

Practicing Creative Activism

EVREN: Beautiful Trouble's work is committed to supporting, elevating, and encouraging creative activism. Can you give us a definition of creative activism?

NADINE: We have a broad working description of "creative activism" as the use of artistic and cultural methods, everything from singing, dancing, writing, and spoken word to things like delineating space, and setting up institutions that preserve a language or a culture. We encourage people to use a definition that fits their context, and just to be really clear in defining that with the people they are working with. Besides the term "activist-artist," I also use the term "cultural worker." Because we are talking about a much broader spectrum of activities than "art" which people use in the more traditional sense. When we talk about art sometimes people think of painting, dance, music, theatre, and writing. And our approach is beyond that. I even consider

Figure 8.1 Two huge photographic cutouts of hands—generated during the creative imagery section of Beautiful Trouble's training in Budapest in 2014. They culminated on the streets in a 1,000-person demonstration against the raiding of liberal NGOs by the right-wing government who saw them as "fronts for leftist influence from abroad." The hands became the main symbolic image of the protest, appearing on Hungarian news and television, and were picked up internationally by the news agency AFP.

Photo: Oriana Eliçabe.

creative facilitation as part of this work, because nothing kills a movement or a campaign faster than horrible meetings that no one wants to attend.

EVREN: I'm curious to hear about the origin of Beautiful Trouble. What ignited the need to generate the resources and tools, and how did they develop?

NADINE: The first thing that happened was really the book, which is a collection of methods of creative action. Previously I had been working within creative resistance, for a long time, and I did trainings. At that point I called them "The Art(s) of Protest": to help activists be more effective, while harnessing creative cultural resistance, and help them bring more people in—combining people's powers and building numbers. Many people have been doing this work, of course, over the years, and I met at some point a person named Andrew Boyd, who worked for United for a Fair Economy.[6] He wrote a small pamphlet called "The Activist Cookbook," talking about effective creative action.[7] He teamed up with Dave Mitchell who is a Canadian and a fabulous writer and activist himself, and they are the ones who started the

Beautiful Trouble book. This book was eventually written by about 70 artist-activists who recognized the need for and the value of not only telling stories about what happened, but being able—from those stories and lived experience—to distill lessons from them. And they developed a pattern language, where we could then basically collect stories, as an open-source collection of experiences, and help people distill the principles, the theories, the tactics, the methods that make activism more effective. I got involved because they were writing this book in the cloud, which is something that I had never done before. I also knew Andrew and I respected his work. And some of the other people who were involved—Yes Men, and others—were really great activists, as well as creative thinkers. So I thought that we will end up with a useful product. And, in fact the notion of accessibility (all is licensed under Creative Commons), the fact that the material is open source—as long as the users acknowledge where they get it from—was important for me as well.

Online we did some really creative work as well. You can see that it was a really innovative website since 2013. And there's a very nice interactive feature where you can see how all these modules are interconnected to all the other things in the book. We recently developed a strategic card game. People love to play games, and if you can make it more fun, it's more likely that the learning will happen in a way that engages people. This new version of Strategy Deck has a full playbook of about a dozen games you can play to help kickstart your creative activities, which we recently published (Figure 8.2).

EVREN: Can you explain how the case studies or creative activism are gathered and what is your approach in understanding these contributions, structures, and tactics—how do you extract that information?

NADINE: For the BT book (Andrew Boyd and Dave Oswald Mitchell, eds.) it was really a network of networks. A call went out to artist/activist groups groups, particularly those who do some form of organizing, that BT was happening and there was a big collection of proposed topics. People wrote different pieces depending on what they proposed and what other people were writing.

Our second book, *Beautiful Rising* (Abujbara et al., eds.), which focuses on the Global South, on the other hand, and what we do now, is a much more intentional process where we hold what we call "jam sessions." The jam sessions are times where we bring people together to share stories and extract and learn this pattern language, and for reporting on the lessons that we can take from the stories. We try to get people who are pretty familiar with these sites to help us figure out the lessons from them and tell the stories. Sometimes it's them telling the stories, and we help them, by saying "oh that sounds like the principle of 'make the invisible visible'— which is a key principle in a lot of activism"—for instance. These jam sessions also combine training on how you analyze things, how you write things, etc. Sometimes we get people who are interested in writing it up themselves. They write, and we help edit their writings and make them read as better stories. Or, we get people who don't want to write it up, but they tell the stories to one of our editors and *we* can help them frame it as a written document. So, it goes in a few different directions.

All of the stories in BT and BR are very short. And they're all very specific. So the stories are exactly in context. For instance, this story of making the invisible visible, could be from an environmental movement, it could be from an economic justice movement, it could be from a racial justice movement. These tools and principles have been used to expose banks, for instance, in making people homeless, to expose polluters, to show the ridiculousness of race laws—separation of races, etc.

Figure 8.2 Theory cards from the Beautiful Trouble Strategic Creativity Deck presented at Busboys and Poets in Takoma Park, MD, February 16, 2020.

Photo: Bill Simmons. Courtesy: Beautiful Trouble.

EVREN: Do you identify success in any way?

NADINE: We encourage people to tell stories both of failure and success. The failures and the worst actions are sometimes the clearest learning opportunities that we have, and we really encourage people to do analysis in thinking about the failures as much as the successes. We define success as the possibility to move closer to a goal that we have set. And that's the key—do you have a goal? How do you know if something is effective or ineffective? I always like to use a clear-cut example. When we talk about property destruction, if you're going out to bring down a corporation, and what you do is go get a brick and throw it through a window and you break the window. Well you broke the window, but you didn't bring down the corporation! But if you're

going out and your idea is to break a window, and you go get a brick and you break a window with the brick, well good job! You were successful, you broke the window! Right? But this doesn't necessarily translate into the bigger conversation about bringing down a corporation. And we talk about different forms of action towards these kinds of goal. For instance, you're going into a bank lobby and you're gonna do a sit-in there and your idea is to stay long enough to get somebody to pull their money out of their bank account. Your judgment of whether you were successful or not is whether you actually stayed there long enough to talk to anybody to get them to withdraw their money. You might need to do a series of de-escalation techniques, such as to get the manager [to] calm down, and not call the cops. So the whole description of success is mostly based on whether or not you have a goal that is defined well enough so that you can actually make an analysis or judgment call: Did we get enough people there? How many people did you want involved?

We use the phrase SMART—Specific, Measurable, Achievable, Realistic, and Time-bound. And we sometimes add another question: is it related back to your theory of change? Does it make sense for your bigger goal, and for the objective that you have during your action? That's how we help people think about it.

EVREN: I don't know how much you have been involved in the design decisions, but can you tell us about the intended medium of each of these products—the website, the books, and the cards—and how they were thought and designed in this way?

NADINE: As far as design goes, we worked with the design firm The Public Society, which is in New York. They have a big commitment to activism and activist community support, working on economic justice and with racial justice groups. There are a couple of other interesting features in the book and the website in particular. We call it a toolkit. In particularly online, not only can you access what's there, but you can also contribute. You can suggest your own module, whether it's a principle, theory, or tactic. You can also download, not only via the website but with a chatbot on your phone, because we acknowledge that many people don't have good Internet access. So you can customize your own collection of modules for your own use. We also have an online guide on "how to," basically a study guide, if you will, that can be used by instructors, or book groups, to be more effective readers and users of the material. And we've got another innovation—QR codes—in our deck cards. QR codes were, for a little while, very popular but hardly anyone uses them. But quietly, QR codes have been an ongoing development. And what we found out, is that if we put a QR code on our card, it will link you right back to the module online in the BT toolkit, which makes it really powerful. So you get a one-sentence description of a tactic or principle in the card. But if you want more information, you just hold your phone and—if you are connected to the Internet—it will take you right to that web page where you can read the module on it. That's another little innovation that helps make things more accessible, and links the cards with the website as a resource.

EVREN: Can you tell me about the game and its intended audience? Does it reach a wider audience than the training module does? Will it have its own life—like a classroom resource?

NADINE: Each of these components has its own life. That's the most interesting thing always about putting things out into the world. So, I will say, the book, the modules and online materials are obviously used by individuals, but also by professional organizations; they're referred to in courses that are in formal education situations like Parsons [School of Design], or other universities and colleges, or high schools.

They're also used by groups on the ground who are more informal, and we anticipate that the game will increase our reach as it is an easier entry point into the things that are in the book and in the toolkit through play.

Training Sessions and a Community of Praxis

EVREN: It seems that there are two types of menus and activities: collecting and disseminating these tools, and then training. How do they inform each other, and how are they connected?

NADINE: We have various types of trainings. Some trainings happen with specific groups of individuals or organizations who need training to make their actions more effective (Figure 8.3, Plate 8). Then we have jam sessions where people come and tell their stories, and we also offer some trainings with our tools. Those two types are intimately related, and they result in a collection of stories and tactics, principles, and lessons of those stories. There is a third type as well, for people who are motivated to continue to be a part of the BT community. They go through a "training of trainers," they participate in some kind of community, they help write up some of the principles, theories, or tactics, and that feeds back into the BT collection.

Figure 8.3 "Blanket Game," Beautiful Trouble Strategic Creative Actions planning workshop with United We Dream organizers, Denver, CO, August 2016.

Photo/Courtesy: Nadine Bloch.

EVREN: How does the training module evolve? And in connection to that, does the database create new connections between different practitioners?

NADINE: Well the answer to that is yes. People find each other all the time, and that's one of the big ultimate goals I would say, it is for people to connect and build a network of practitioners of BT basically. A network that is committed to using creative intervention techniques or nonviolent intervention techniques around the world that could be useful. We are a really small organization. We don't have an office, we're completely virtual, and nobody on staff is full time. Everybody is part time and active in their own communities in lots of different ways. So this ideal thinking that there would be stories and people and community building coming out of our trainings, it does happen, and it is really limited only by our physical limitations of money, time, and resources. If we had full-time staff, if we had a big budget, we would be doing way more than that. We have this view, this vision of a community of praxis. With this idea that we would iterate together most effective techniques, we would learn together, and we would generate peer support for a better world.

EVREN: Do you ever promote some training with the intention to generate those connections?

NADINE: Yes we do. Last year we did a couple of training of trainers for example, and very intentionally had an application process. There were four or five descriptors of what we were looking for. We wanted to have more than one person per community come—whether it was geographic community or an organization, so they could support each other when they went home from the training. Let's say you might have two people coming who work on fracking, and then you might have two people coming who are working on student debt—and you might have two people coming, who are working on economic or racial justice. Then those six people are cross-fertilizing on purpose. We'd like there to be a cadre of people who can work together and count on each other for support. It's very intentional, and it's very effective, to help activists build these relationships and trust so that they can then continue to support each other afterwards.

EVREN: Is there any other type of group that seeks these trainings in different ways? Do you work with governmental institutions for instance?

NADINE: Yes we have done all of these different things. We've worked with groups that we can't even tell you who they are, because they don't want people to know that they're paying a group that's quote-unquote as "radical," if you want to use that term, or as progressive as BT. A particular group in a small country, for instance, had reached an impasse on issues around nationality and status, and they had only been doing this work very traditionally. They needed support from on-the-ground partners to think about what other creative ways they could use for education and mobilization on the ground, beyond what a formal, international non-governmental organization was capable of doing. They had funding, they had to route it through one of their partners and they actually got us to go and do this work on the ground. This happened more than once.

But we very clearly only work with groups that we feel compatible with on the basis of our principles. Sometimes in campaigns you might end up having unusual bedfellows. You know—the enemy of my enemy is my ally. We don't do that. We train with groups where we feel there's a compatibility in our values. So we're not going to train people who we feel would be a liability. That's pretty important.

EVREN: Can you talk more about the open trainings that you offer? How are they different from the ones offered to specific groups? Like the one you did at Parsons for instance? You don't know the group as you haven't invited them, but they signed up responding to a call and didn't necessarily know each other.

NADINE: This year we did a really big open training in L.A. We had a few groups that bottom-lined the training: it was an environmental group, a #MeToo-related group, and another one working on housing. Then we had probably 25–30 people in the room, of which half may have been affiliated with one of these groups, and half were from the community without affiliations. To develop creative resistance, we give people the opportunity to select a particular campaign to work on, or they can select a particular tool to use and apply on the campaign that the group selects. This may or may not be something they're actually involved with, but the process of using the tool will be something that is useful for them to take away.

Supporting Global Resistance Networks

EVREN: You have mentioned there's now an idea about merging *Beautiful Trouble* and *Beautiful Rising*, and having a new iteration of it.

NADINE: When we published the second book, *Beautiful Rising*, we did it with a partner—ActionAid in Denmark[8]—and it was about highlighting the stories of the Global South, making sure that there was stronger representation of those activist traditions and campaigns. Moving forward, the power of it, we believe, is to bring it all together so it's all accessible in one space, and to make it accessible in more languages across the board. Right now *Beautiful Rising* is online in four languages: Arabic, Spanish, Portuguese, and English. The *Beautiful Trouble* book is available in six languages in addition to English.

EVREN: Do the non-English versions contain all the cases? I saw the one in Turkish, and it is using different visual language. I wonder if there are other different additions/iterations that come in from these local branches?

NADINE: Yes, first of all, the titles are slightly different. They're all translated to make sure they resonate in the culture of the language that they're in. So when looking for a title for *Beautiful Rising*, that was also a question. We wanted to differentiate it. A lot of the translations are done by volunteer translators, interpreters, with support from Beautiful Trouble. One of the limiting factors is raising money to have this done in many more languages.

We have right now in process what we are calling the "African Edition"—tentatively titled. We're collecting a lot of stories from mostly Southern and Eastern Africa, but it might be broader in the end—stories of resistance throughout the continent of Africa. And there have been thoughts of doing all kinds of collections—for example, a collection about gender-based violence, and activism focused on that. It can be a result of trainings that we did, or the result of jam sessions, or could be the result of a community saying, "We would like some assistance collecting these stories."

EVREN: What do these more local-specific sites do for your overall project? The Africa collection, for instance? Are we talking about something that would be a subsection of BT offering more specific lenses on certain topics, or would it capture the local resistance?

NADINE: If we publish the African edition, we would have a collection of all African examples. Even now if you go to the BR or the BT website, you can actually search, for example, "Tell me everything that happened in Zimbabwe." Or, "Tell me everything that happened around student debt." There are lots of ways to reference and research what might have been particularly useful or have failed completely in a particular campaign. There might have been something that was particularly useful in your situation either because it's a particular country, or a particular culture, or a particular focus. So that's the goal in the end. It should be searchable by some keywords that help people identify what could be useful for them.

When we go to different parts of the world—and we do trainings all over the world—we try to incorporate lessons that are applicable to that part of the world. But there's always this tendency to say, "Oh, our situation is so unique. Our situation is so complicated, you possibly can't understand it" There's an element of truth to that, but there's also an element that's dead wrong, in that there are always lessons you can learn from other people—either because they're so far out of your experience that they become really inspiring for you, or because they offer exactly something that you could also use in your own context.

The Future of BT and Creative Resistance

EVREN: How would the ideal future landscape look like for BT? Would there be an intention to scale up if the conditions were right?

NADINE: There is always an idea of scaling up. For instance, if we could make this resource available at a bigger scale, there would be a lot more resources accessible in the guide, a lot more voices represented, a lot more ways of getting information out. Right now each of us is engaged part time, which is between 5 and 15, maybe 20 hours a week. I don't count trainings in that. So we have two of us who are in the training crew, we have three people involved in admin. We have four or five people involved in editorial, and cross-over into admin. Also we have 10 to 20 trainers that routinely work with us on a random basis, depending on where we're doing a training. The core group is 8 to 10 at any point, or to 12 if we have interns. Right now we have someone in East Africa in Kenya, we have someone in Canada—4 in the US, someone in Scandinavia, we have a part timer in Brazil. We are really all over the world. Our Arabic editor is now in Canada, but she was living in Jordan before.

We also don't pay ourselves very well, as it turns out. We struggle to make money.[9] It's just not a very well-paid field we're in: at the intersection of education, activism, and art. Those three things are not exactly the money-makers. And we don't have benefits in BT, because we're part time. This is a struggle, and it would be great to scale it, to do more targeted editions to serve different activist communities. It would be wonderful to be able to have a more robust and secure way to support peer networks and support bringing in all these stories and lessons at scale, offering the resistance hotline service for instance. So that's something that we are trying to figure out. What would that look like? And how would we do it?

EVREN: How do you place BT as a project in the global picture of struggles? Is it changing the landscape of resistance?

NADINE: It feels to me like we're in a position right now where there's so much at stake. We've got increasing threats to global democracy, and civil society, all over the

world, increasing right-wing populism, and climate disaster, economic collapse: we have increasing threats on every front. We also have in this moment, a lot of people rising up. Many people don't exactly know where to start. Or they need support in being more effective: they need help with a strategic approach, they need more creative ideas, they need support for being more innovative and nonviolent, and remaining nonviolent. We believe that nonviolent action is more effective. We see the numbers, the data, and we also understand that practicing for the future you want is critical to success in the future. This is one reason why our trainings and workshops are rooted in popular education principles, highlighting both the lived experience and value of each person in the room as well as focused on building our capacity to work together across difference.

Our tagline is making the struggle irresistible, making the nonviolent revolution irresistible. We don't have unlimited resources. We don't have unlimited people, time, or money. We need to be as effective as possible with what we do have, and practice putting in place anti-oppressive, feminist, power-sharing ways of moving forward together. We're putting together both resources, a tool kit, and ways of training people that can be adjusted to different contexts and help groups build community and learn how to work together. I think this is really valuable, and that's where we come in.

Notes

1 Beautiful Trouble, "Beautiful Trouble: A Toolbox for Revolution," accessed May 29, 2019, www.beautifultrouble.org; Beautiful Rising, "Beautiful Rising," accessed May 29, 2019, www.beautifulrising.org.
2 Andrew Boyd and Dave Oswald Mitchell, eds., *Beautiful Trouble: A Toolbox for Revolution* (New York and London: O/R Press, 2012); Juman Abujbara, Andrew Boyd, Dave Mitchell, and Marcel Taminato, eds., *Beautiful Rising: Creative Resistance from the Global South* (New York and London: O/R Press, 2018).
3 Strategy Deck was released December 2019. For information on the game's numerous contributors see: https://beautifultrouble.org/2019/07/01/beautiful-trouble-a-card-deck-for-revolution/.
4 Nadine Bloch was interviewed on May 29, 2019. The interview was transcribed by Abby Zan.
5 As an innovative artist, nonviolent action practitioner, political organizer, direct-action trainer, and puppetista, Nadine Bloch's work combines the principles and strategies of people power with creative use of the arts in cultural resistance and public protest. Her work has been featured nationally and locally, in newspapers like the *Washington Post* and magazines from *Ms.* to *Time*. She is a contributor to the books *Beautiful Trouble, Beautiful Rising* and *We Are Many, Reflections on Movement Strategy from Occupation to Liberation* (Oakland, CA: AK Press, 2012). She is the author of a *Special Report Education & Training in Nonviolent Resistance* (Washington, DC: US Institutes of Peace, 2016) and the co-author of *SNAP: An Action Guide to Synergizing Nonviolent Action and Peacebuilding* (USIP, 2019.) She regularly contributes to *Waging Nonviolence* with her column "The Arts of Protest."
6 United for a Fair Economy, "United for a Fair Economy Introduction," accessed December 2019, www.faireconomy.org/.
7 Andrew Boyd, *The Activist Cookbook. Creative Actions for a Fair Economy* (Boston, MA: United for a Fair Economy, 1997).
8 Action Aid Denmark (original name: Mellemfolkeligt Samvirke [MS]) is the Danish Association for International Co-operation providing opportunities for action for people who accept a shared responsibility for global sustainable development https://www.ms.dk/en.

9 Beautiful Trouble has also a group of dedicated people doing volunteer work. They have individual donors, a Patreon, which is a private content site for donors. Members get advance information about publications and receive advance copies. Additional revenue comes from the sales of books and games, but they are mostly sold at cost so they can reach as many people as possible.

– Response to Section 1
Social Movements as Design Agents

9 The Objects of Political Creativity

James M. Jasper

In the years since I turned sixty, I have noticed changes in how my body interacts with the world. A touch of thumb arthritis makes it harder to open certain jars; I think twice about renting a top-floor walkup apartment when I travel; a subdural hematoma has left me wary of bumping my head. Rather than taking for granted both my built environment and my competence to maneuver through it, as I used to, I have become more aware of how objects are designed and how I interact with them. It is the kind of explicit awareness of what is usually taken for granted that many social movements try to promote.

Scholars of protest (a term I will use interchangeably with social movements) have begun to appreciate the role of bodies, and of the feeling-thinking processes that they sustain. We have come to understand bodily urges, moods that affect our energy levels, the affective loyalties we have to groups and places, the sources of pride and shame that define our morality.[1] But social-movement scholars have done less work to understand the objects that we create, reject, and otherwise engage as we carry out our politics. These objects can enhance, inhibit, elicit, or redirect our bodies' capacities.

Social movements have long been laboratories for social analysts, allowing us to spin new theories of human action, intention, and constraint. In situations where people coordinate their actions and agree on ends and means, they formulate goals and reasons to persuade others, they adjust to each other, they bargain and negotiate, they even betray those close to them. All the normal actions that make us human are intensified and made visible. Participants also criticize, bend, and rebuild social relations; they make transparent much of what social scientists hope to understand. They question the limits of laws, problematize how groups make decisions, argue over what is personal or political.

Perhaps most of all, protesters articulate moral intuitions that have been hidden, repressed, or simply have not emerged until now. These new understandings and the practices they engender add up to moral change. Protesters are extremely creative, making an art out of their activities. They are designers of our moral futures. But we should not let this metaphor of design distract us from the other—more literal—connections between protest and the world of objects.

If protesters try to make us think about practices that we take for granted, this is especially true of the objects in the world around us. Their goals frequently include not just greater democratic inclusion for oppressed groups, a different political world, but a different physical world, with safer objects: cleaner smokestacks, safer toys, well-designed highways, stable neighborhoods.

Classic theories of social movements in the 1970s focused on political opportunities and on resources. Theories of opportunities, associated especially with Charles Tilly and Doug McAdam, largely took for granted people's willingness to participate based on obvious material and political self-interest; potential insurgents would mobilize when there was some glimmer of hope that they would not be repressed if they tried to mobilize. The main obstacles to protest revolved around threats (and realities) of physical repression, elite unity against them, and a lack of access points such as voting rights or standing in courts. The props and tools of protest, even the cultural meanings needed to move people, were not of much interest, and they were often swept into the catch-all category of "opportunities."[2] There was little sense that grievances and goals had to be culturally created.

With their theory of "resource mobilization," John McCarthy and Mayer Zald focused more on what protesters need to do their work, especially the funds that disadvantaged groups must raise, often from more privileged and affluent sympathizers.[3] They originally had money in mind, using a set of metaphors that compared social movement organizations (SMOs) to firms, and a social movement sector parallel to other sectors of the economy. SMOs compete with one another in raising funds, just as companies compete for customers. As Nadine Bloch poignantly shows in her interview, money is crucial for almost everything that protest groups do. But like opportunities, resources gradually came to encompass every and any advantage for a protest group. There were cultural resources, legal resources, emotional resources, and more.

A cultural approach to protest developed in the 1990s to address some of the problems with structural models.[4] To understand the cultural construction of political action, scholars deployed concepts such as frames, collective identities, tastes in tactics, and narratives.[5] Meanings tended to be treated in idealist fashion as disembodied thoughts and assumptions (easily listed in a table) rather than as tools or dimensions of action. And yet it is hard to say what exactly a frame is: a few words on a banner, an image of enemies, a book-length treatise, intentions and understandings inside people's heads? Later, scholars began to add a variety of emotions to their models as well, which could incorporate bodies better than they could other physical entities.[6] The cultural and emotional turns still offered little room for objects.

A more precise delineation of resources can take us a step toward appreciation of the objects created and used by social movements. I have long promoted a definition of resources as money and the things it can buy, whether t-shirts, bullhorns, or computers.[7] It excludes the people who use them, their feelings and understandings, the time they contribute; it excludes the structured arenas in which they maneuver. The distinction allows us to see how people interact with objects, use them in various ways, invent them, discard them, trade them, and so on, all in physical settings. We need to be careful to acknowledge the physical capacities of objects but also the cultural meanings and emotions that they help sustain.

For theories of objects, we need to look outside traditional theories of social movements. Bruno Latour and other scholars developed actor-network theory, or ANT, as a vocabulary to describe the ways in which networks of people and things interact with each other to produce action. By insisting on the most concrete possible descriptions of these entities, ANT scholars hope to avoid a number of essentialisms and metaphors that plague social science, such as the positing of social forces, structures, fields, opportunities, or the use of terms such as "center" and "periphery."

These are concepts in the mind of the observer, not visible material objects. ANT is materialist, but it is also semiotic, in that the elements in social networks have meaning for one another; indeed the networks are engaged in creating meanings as well as material products. The fine descriptions of ANT research do not *contribute* to explanation; they *are* explanations of action. Get the sequence of acts down right, and there is no need to add extraneous, unseen elements.

ANT has not been used much in work on protest, with a few exceptions.[8] I suspect the lacuna is due to a more general inattention to the objects used in protest, which are either analyzed idealistically as carriers of cultural meanings (especially art) or are reduced to the familiar catch-all term "resources." With ANT we can ask what kinds of people and things need to be brought together to have a protest or a social movement. What role can a can of beer or an old warehouse play in political engagement? Museums, like Rio's Museum of Slavery and Freedom that Fonseca and Szaniecki discuss, are obvious cases, as their mission is to display objects (both recovered and created) for guests. But all action entails a similar kind of aggregation of people and things, in certain temporal sequences of interactions. (Architecture theorist Albena Yaneva has applied ANT to the design of buildings, finding in these an opening to politics.)[9]

One way to incorporate objects into the study of political interaction is through the concept of arenas, defined narrowly as the places where strategic engagement occurs and from which outcomes emerge.[10] As physical settings, arenas include entrances and exits, lighting, recording devices ranging from cuneiform tablets to video feeds, quotes from founders hanging on or chiseled into the walls, various types and capacities of seating (which may or may not provide for bystander viewing of the proceedings), restricted areas, flags and other august symbols, inspiring artworks. Physical objects, along with formal and informal rules, exert enormous influence over the actions that occur in these arenas.

Unlike ANT, this approach allows us to incorporate but distinguish between humans and objects, especially on the grounds that the former have emotions. Objects and emotions are similar in many ways. They are both means and ends of politics. They are involved with our bodies, most of the time unconsciously, yet they can usually be brought to awareness, problematized, and changed. Aside from the parallels, emotions and objects interact with each other: we have feelings about objects, and we create objects to reflect our feelings.

If social movements are laboratories for us to investigate all sorts of social processes, that must include design. Design is usually unobtrusive, sometimes designed to be unobtrusive, but we can highlight the agency behind it nonetheless. Take the wonderful world of font design. On the one hand, few readers think much about the fonts they see, taking them as nothing more than a means for conveying language. Fonts seem like a part of the world that we must take for granted, and yet dozens of choices go into them, both in the design of a new font and in the choice of fonts for the rhetorical purpose at hand: simplicity or elaboration, references to past historical periods, jaunty, scientific, literary—or angry. Because they seem natural, we don't recognize the impact they may have on our moods. They may allow us to feel outraged and energized, calm and satisfied, part of tradition or rebelling against it.

In his chapter on the increasing resistance to "One China," Kyle Kwok shows how language can be subverted into parody or critique, in this case through the

complexity of Chinese characters. Written forms and spoken sounds can be played off against one another, and written characters may connote other, hidden words and meanings. A Western parallel might be Latin's openness in word order, which allowed Roman theorists of rhetoric to elaborate dozens of aesthetic and emotional effects based on sound sequences. Language is no different from other cultural tools, capable of multiple meanings, hints of other times and places, the subtle inflation or deflation of public characters.

Humor, and especially ridicule, are staples of protest and rhetoric. Most often they are weapons of the weak, of those without more aggressive tools such as guns, who deploy jokes to undermine the aura of strength in those above them. But the powerful can use them as well. Donald J. Trump has an evil genius for the kind of epithet that highlights weaknesses in his opponents: the ethics of Crooked Hillary, the affirmative action system possibly exploited by Pocahontas, the physical puniness of Little Rubio. Portraying the umbrellas of Hong Kong mischievously as deadly weapons reveals the paranoia of Chinese officials, while leaving its creators some (albeit small) scope for deniability if accused of treason.

The power to design is unequally distributed, like all other powers. The idea of co-design is intended to redress that inequality, incorporating input from unpaid non-professionals. Most often these are organized communities, because these can demand and give reasons for their inclusion. In Rio, there was not simply a neighborhood being threatened by development but a well-formed historical identity of African Brazilians whose ancestors had been processed at Valongo Wharf. (It is easier to transform an existing collective identity than to create a new one.) "Outsiders" are rarely brought into design processes unless they demand to be—and sometimes not even then.

Objects can be disobedient in many ways. Ksenija Berk uses the term "disobedient objects," echoing a famous 2014 exhibition at the Victoria and Albert Museum, for the most obvious meaning: the material culture created by protesters to further their aims. Only rarely are those aims to change the design of objects themselves; most often the objects are crafted to carry other messages. But objects do not necessarily obey their designers' wishes, either; they can be reinterpreted in unforeseen ways, backfire, take on lives of their own, or be co-opted by other players. They may simply fail to achieve their purpose, which is usually to gain media attention.

Berk's example of zombie imagery shows how multivocal symbols always are. Zombies are normally villains, out to kill and eat humans. The portrayal of corrupt politicians as zombies fits this mold. But the main use of zombies in the Slovenian march involved a battle over the nature of crowds. Are they lacking minds of their owns, thoughtlessly following demagogic leaders? (Such theories of crowds were applied to both fascists and communists in the 1950s.) Or are they courageous heroes, masked in order to protect themselves from a repressive state? (As suggested by Anonymous' adoption of Guy Fawkes masks.) Design decisions can never prevent some slippage and reinterpretation as to what zombies are meant to represent.

Among so many other things, political players craft reputations for themselves and their opponents. In doing so they both use objects as props—a victim holding a teddy bear, a hero with a gun—and create objects which portray characters—posters, films, murals, stories, and so on. Some reputations come to resemble the familiar characters

of fiction: heroes, villains, victims, and minions. We can envision these "public characters" as the result of two simple binaries: good versus bad, and strong versus weak. These are the players in myth and epic, but also in today's public relations and campaign publicity. They populate narratives; indeed they are the reason we care about narratives. They suggest the emotions we are supposed to experience: pity for victims, abhorrence of villains, admiration for heroes, contempt for minions (Table 9.1). Extensive character work goes into these constructions, especially in adversarial arenas such as politics. The professionals who design political posters, cut politicians' hair, and send them on photo-ops are familiar with the backdrops, props, gestures, postures, clothes, facial expressions, emotion displays, and words that make their client seem heroic, able to lead and conquer and to save victims from villains.

Public characters are central in narratives, but they are also efficiently constructed through visual images, as simple as several lines of a caricature. Music as well readily arouses a foreboding as a villain approaches, or suggests the triumph of a hero, the pain of a victim, even the ineffectual, high-pitched giggles of a crowd of minions. Analysis of public characters helps us recuperate and appreciate the power of visual information.

Victoria Hattam points to the troubled relation of social analysis and the visual. Perhaps rooted in Judeo-Christian-Muslim suspicion of icons, the denigration of the visual has left scholars blind to the salience of the visual in human action.[11] What we see or "sense" around us sends a continuous cascade of feeling-thinking processes through our nervous systems, influencing actions and articulations. The sights and sounds of protest strongly influence the moods of participants, the elation or deflation or trepidation that push and pull action in different directions, or merely change participants' energy levels. Words are a small proportion of those feeling-thinking processes, even though our eventual labels for the world (including labels for our own feelings) have a disproportionate influence, feeding back to discipline other feeling-thinking processes.[12]

But Hattam focuses on a different question, the impact of a photograph on later viewers, not the impact of the visual on participants themselves. We must always distinguish audiences. A photograph encapsulates and reduces information for a later viewer, and so is subject to various feeling-thinking processes that differ from those of the protesters at the time, set in a different context. The color green may mean something different to participants and to us as magazine readers. It can arouse different feelings, but we know it will arouse feelings. A crowd may feel exhilarated, while a viewer of a photograph of that crowd may feel fear, not least because the viewer may know the final outcome of the protests. The viewer may not be subject to the hopefulness of the marchers.

Table 9.1 Characters

	Strong	*Weak*
Good	Heroes	Victims
Bad	Villains	Minions

Source: James M. Jasper, Michael P. Young, and Elke Zuern, *Public Characters: The Politics of Reputation and Blame* (New York: Oxford University Press, 2020), p. 3.

Stigmatized reputations require special character work. Many sources of stigma have to do with weakness or malevolence, standard character traits. When Black Americans fought for their rights in the 1960s, Martin Luther King Jr. emphasized (and embodied) their moral goodness, while the Black Panthers boasted of their threatening strength. They were worthy of full citizenship rights *and* had the strength to make trouble until they were granted those rights. Other efforts to reduce stigma may simply have to do with establishing the normality of the group, rather than their morality or power.

Von Busch and af Ekström recount several strategies for redressing stigma. The most striking is the head-on approach of heightening the stigma to an excruciating level, as with "retard beer." This turns out to be a pressure system for accessibility in bars and restaurants as well as a startling attention-grabber. Another strategy is to convert victims into heroes, like the inspiring "super-crip" who triumphs over hurdles. But this strategy has its drawbacks, asking too much of the disabled. Neither victims nor heroes are normal, and their dramas of transformation focus on their character strength rather than on the built environment and objects that would make it unnecessary for the disabled to act heroically just to have a normal life. Physical abilities are unequally distributed across bodies, just as they are across the life cycle, and human artifacts should be designed accordingly.

The final arena in any political conflict consists of how later generations remember and explain what happened. In some cases, the activists themselves become scholars, historians, or at least memoirists, continuing the battles they fought with opponents inside and outside their movements. Aside from real-time tweets, *most* descriptions and analyses are retrospective, even if they appear in print just a few weeks or months after events, but more obviously when they appear years later. The more scholarly analyses are the last to emerge, after activists have endured PhD programs, written dissertations, and turned them into books and articles.

The raw materials of those conflicts are important objects for future analyses, and the better they are selected and preserved the better our understandings can be. "The Art of the March" addresses some of the dilemmas involved in archiving hand-held signs, in this case from the Women's March in Boston in 2017. Their techniques could be applied to other carriers and other protest events, indeed to many kinds of culture. The methodological tradeoffs, which can never be fully resolved, have to do with recreating the felt experience of the march versus extracting coded meanings from the signs, with being as factual as possible versus being guided by political concerns, with preserving original artifacts versus digitizing them in durable new forms, with finding codes that will be useful for future researchers as well as current ones, with respecting the individual perspective behind each sign and yet also noticing patterns. The same objects that were carried through the streets with political intentions now have digital form for later viewers and analysts.

The design, use, and preservation of objects is a central task for protesters and for those who study them. They deserve the attention this volume gives them. At the same time, we must remember to view them in context, with the other elements of protest: the intentions of activists and of other players, the arenas that constrain what can be seen and said, the money available for supporting the activities, and the multiple outcomes of political battles. This piece of the puzzle must be fitted with all the other pieces. This volume takes a major step forward, and should inspire the kind of interdisciplinary dialogue that can put all the pieces together.

Notes

1 James M. Jasper, *The Emotions of Protest* (Chicago, IL: University of Chicago Press, 2018).
2 Political opportunity theory emerged from the extensive research of Charles Tilly, such as *From Mobilization to Revolution* (New York and London: McGraw-Hill, 1998), and was pulled together and labeled political process theory by Doug McAdam in *Political Process and the Development of Black Insurgency 1930–1970* (Chicago, IL: University of Chicago Press, 2010). Theda Skocpol adopted a similar perspective in *States and Social Revolutions* (Cambridge: Cambridge University Press, 1979).
3 John D. McCarthy and Mayer N. Zald, "Resource Mobilization and Social Movements: A Partial Theory," *American Journal of Sociology* 82 (1977): 1212–41.
4 James M. Jasper, "Cultural Approaches in the Sociology of Social Movements," in *Handbook of Social Movements across Disciplines*, eds. Bert Klandermans and Conny Roggeband (New York: Springer, 2010). On the relationship between cultural and social psychological approaches: James M. Jasper, "The Doors that Culture Opened: The New Focus on Action in Social Movement Studies," *Group Processes and Social Psychology* 20:3 (2017): 285–302.
5 David A. Snow, E. Burke Rochford, Jr., Steven K. Worden, and Robert D. Benford, "Frame Alignment Processes, Micromobilization, and Movement Participation," *American Sociological Review* 51 (1986): 464–81; Alberto Melucci, *Challenging Codes* (Cambridge: Cambridge University Press, 1996); James M. Jasper, *The Art of Moral Protest: Culture, Biography, and Creativity* (Chicago, IL: University of Chicago Press, 1997); Francesca Polletta, *It Was Like a Fever* (Chicago, IL: University of Chicago Press, 2009).
6 James M. Jasper, "Emotions and Social Movements: Twenty Years of Theory and Research," *Annual Review of Sociology* 37 (2011): 285–304; Jasper, *The Emotions of Protest*.
7 Jasper, *The Art of Moral Protest*.
8 Most notably, "Reassembling Activism, Activating Assemblages," special issue of *Social Movement Studies* 17:3 (2018).
9 Albena Yaneva, "Making the Social Hold: Towards and Actor-Network Theory of Design," *Design and Culture* 1 (2009).
10 I have tried to incorporate ANT into theories of arenas: James M. Jasper, "Introduction" to Jasper and Jan Willem Duyvendak, eds., *Players and Arenas* (Amsterdam: Amsterdam University Press, 2015), and "Linking Arenas: Structuring Concepts in the Study of Politics and Protest," *Social Movement Studies*, published online October 28, 2019.
11 Jonas Barish, *The Anti-Theatrical Prejudice* (Berkeley: University of California Press, 1981); Gilbert Beaugé and Jean-François Clément, eds., *L'image dans le Monde Arabe* (Paris: Editions CNRS, 1995); Alain Besançon, *L'Image Interdite* (Paris: Arthème Fayard, 1994); and Martin Jay, *Downcast Eyes* (Berkeley: University of California Press, 1993).
12 I elaborate on feeling-thinking processes in *The Emotions of Protest*.

Section 2

Dissenting through Material Engagement

Part 1

Political Contention by Design

10 Vulnerable Critical Makings

Migrant Smuggling by Boats and Border Transgression

Mahmoud Keshavarz

This was going to be the second time. It was a hot afternoon in July and when I arrived at the restaurant where we were supposed to meet, many were outside including Bagou and his friend. They guided me in, ordered food and then sat next to me.

> "So, Mahmoud, what do you want to know?"
> "I do not know really, but I am interested to listen to your stories and struggles, how as you mentioned yesterday you have helped people to leave Greece."
> "Do you not want to take notes? I do not see any notebook with you" asked his friend and we laughed.
> "No. I do not take notes. I listen and then will write down my thoughts."

This was the beginning of our talk, accompanied by tea, soft drinks, and coffee, which lasted for three hours in that hot summer of 2014. At that time, I was working on my research on how passports can be thought as a materialized articulation of the right to move; as designed acts that produce and regulate citizenship and the right to movement materially, rather than merely representing national identity.[1] I was interested in the limits of these designed artefacts, which forgers and smugglers tease out masterfully. It was within such a context that I was introduced to Bagou—a self-chosen pseudonym —a man who facilitates the movement of West African migrants from Greece to Central Europe. He made it very clear from the beginning that he is no longer active in the business, except in rare cases when he knows the person in need of traveling. However, I found his insights and experiences about irregular migration an important contribution to understanding the complexity of European border politics and different contested positions within it.

The technical,[2] geographical,[3] and material[4] practices which shape contemporary European border politics have forced migrants, refugees, and asylum seekers, those who I choose to call travelers without the "right" papers,[5] to take lethal routes through the Mediterranean Sea, using so-called "unseaworthy boats." These boats have been termed unseaworthy in official discourse because they are not fit for a sea voyage. Their shape, size, and low hull, as well as the materials they are constructed of such as wood or rubber, make them ill-fitted for longer journeys like those which travelers without the right papers take. This chapter discusses these vessels and the ways in which smugglers and travelers repurpose them in order to claim the right to move for those who have been denied access to freedom of movement. Taking unseaworthy boats to travel, while not completely "optional" and in

practice an extremely lethal and vulnerable strategy, produces a different political reality. Such boats due to their specific design, the vulnerability they impose on their passengers, and the environment in which they operate, produce a specific politics which frames irregular migration as a "smuggling problem" that needs to be controlled, or as a humanitarian scandal that requires intervention. While they expose the vulnerable situations of travelers without the right papers, these boats are not passive vessels: they pose certain demands. They carry the demands of their passengers "to be saved" and taken into a space of asylum, and expose the passengers to the surveillance system in high seas,[6] as opposed to other tactics of border transgression, such as traveling with forged passports, which hide their illegalized status from sight.

By drawing upon an interview with a former smuggler and his take on vulnerability, this chapter relocates the theorization outside the academy and repositions it in the world. It does this by reframing the making, repairing, and reusing of fishing boats from a small village in West Africa in order to be able to cross the Mediterranean Sea, as a critical and dissensual practice of design within the current mobility regime. This serves to contest the dominant image of boat migration, frequently put forward by EU politicians and nationalist discourses, as an act promoted and facilitated by "smuggling networks." It argues that in current mobility regimes, in which Western countries push those who are forced to move irregularly towards even more vulnerable modes of border crossing, these reconfigured boats provide momentary and fragile support for crossing borders. It is this reconfiguration of the relations involved in the process of border crossing that make these vessels a minor form of dissent, one which circumvents corners and the margins of law, thus challenging the state's monopoly over controlling mobility.

I argue that consequently these practices produce another form of criticality compared with notions such as "critical makings" and "maker culture"—two dominant approaches in critical design discourse in Western contexts. By challenging the absence of unseaworthy boats in current critical discourse on design and making, the chapter unsettles a racialized conception of making and calls for recognition of how travelers without the right papers, as well as smugglers, develop material dissensus against the hegemonic and securitized border politics.

Borders on the Move

> Europe is the point in the world whence border lines set forth to be drawn throughout the world, because it is the native land of the very representation of the border as this sensible and super sensible "thing" that should be or not be, be here or there, a bit beyond or short of its ideal "position," but always somewhere.[7]

Etienne Balibar's quote outlines the uncertainty of the space of Europe, which is both in constant expansion through its historical colonialist visions and, at the same time, limited by its desire to maintain its historical identity "rooted" in a specific geography. In truth, Europe's ambiguity has led to a designable space where various practices continuously redefine it by moving its borders here and there, a bit beyond, or short of, its ideal position. Despite the fact that state borders are globally delocalized and located somewhere beyond their conventional geopolitical

locations,[8] this does not mean that borders are everywhere. Borders can be relocated to many places, and can be found within mundane sites or banal objects. However, some sites and certain artifacts, due to their design, performance, and materiality, contain a strategic potential for the particular mission of bordering. Because borders are always in a state of becoming, their conceptualization remains provisional in nature.[9] These ambiguous, anticipatory, and suggested spaces of borders thus require an investigation of certain strategic sites and artifacts that help to shape borders (and our perception of them) in the contemporary world. The potential for certain sites and artifacts to become part of the space of European borderwork is not neutral. There is a historical and technological apparatus that operationalizes or exhausts such possibilities.

Frontex is one such apparatus. As a European Union regulatory agency, Frontex is tasked with the integrated border security and fortification of the European Union's external borders. Frontex manages operational cooperation at the external borders of the European Union's member states. Established in 2004 and located in Warsaw with financial, administrative, and legal autonomy, Frontex works to promote a "pan-European model of integrated border security."[10] The original idea behind Frontex lies in a conception that to foster the idea of the free movement of people within Europe as an important objective of European integration, the member states need to collaborate under one centralized entity to control and regulate the movement *into* Europe at its shores and neighboring countries. Harsher visa policies, the establishment of the Schengen Information System (SIS) and Eurodocs, as well as monitoring European external borders through aerial surveillance and coastal guards, all work towards achieving such a goal. Much has been written about Frontex and its production of borders as a manifestation of the Europeanization and institutionalization of member states to increased levels and in new technological directions. Frontex has also been explored in terms of its representation of new measures of security and its role as a response to the discourse surrounding the war on terror.[11] As Frontex grows stronger financially and technologically, the mobility of travelers without the right papers through common means becomes practically impossible. Despite being the deadliest route of migration in the world in recent years,[12] the Mediterranean Sea has become the only accessible way to cross to Europe for many travelers without the right papers. The growing number of migrant deaths in the Mediterranean Sea is linked to the increase in restrictions placed upon traveling into the EU for the majority of world population. The introduction of visa obligations and restriction of regular means of travel exercised by transportation companies—the so-called "career sanctions"—has led to a shift from using airplanes and ferries towards using irregular means of transport such as fishing boats. "The closure of the most accessible border sections means that 'geography will do the rest,' and it does," writes Shahram Khosravi.[13] Governments, by using natural resources like water, forests, and islands as fortifications against illegalized travelers' movement make travel routes more lethal for certain groups. Moreover, by projecting borders onto water, islands, and forests, the state represents borders as "natural," as things which have always been "there," rather than being artificial, and designed, made and sustained by artifactual makings.

Bagou comes from a small village in Gambia, a coastal country in West Africa. Up until 2010, many Gambians would travel to a Senegalese coastal town, hoping to embark on pirogues (medium-size fishing boats) and head to the Canary Islands.

However, an agreement for migration control between Spain and Senegal led to a more extensive presence of Frontex in the western Mediterranean, consequently pushing both Senegalese and Gambians into taking other routes which are longer, more expensive and more lethal. "Everyone used the back way," Bagou told me:

> When I took our own boat to travel to the Canary Islands together with other travelers, we drifted in the sea for 7 days. We were very close to death until we were saved by the Spanish border guards, but then all of us were deported back to Gambia as our government had a deal with Spain.

The Gambian government, ruled by Yahya Jammeh for 23 years, frequently signed agreements with European countries to collaborate with European migration policy, including by restricting possibilities of border crossing, as well as deporting individuals in exchange of monetary aid or logistical equipment. Gambia, along with Senegal, Mali, Morocco, and Libya, is therefore acting as a border guard for European states.[14] The use of unseaworthy boats rises as the space of asylum shrinks[15] due to the militarization of borders through transnational cooperation, which always positions Europe as the central actor, using its power to force other countries into policing measures against migration.

Boats and Their Makings

Due to their size, speed, and scale, unseaworthy boats facilitate irregular movement as well as provide possibilities for interceptions, push-backs and ultimately, deportations by state or semi-state actors.[16] Beyond being simply vessels, boats are devices through which borders can be enforced and performed, or contested and transgressed. Vehicles of migration, or to be clear, vehicles used for irregular migration, are not metaphorical borders. Looking through the frequently updated checklists for vehicle detection provided by various countries' border agencies reveals the detailed instructions given to drivers or conductors to check particular sections of their vessels for "stowaways."[17] These instructions are based on the actual shape and internal structure of the vehicle as a particular site and space to be secured and protected like a border. Furthermore, boats, due to their limited space on a seemingly "blank" canvas of water, render cramped bodies visible the most, which invokes a spectacle of borders.[18] Borders have always been sites of spectacle and sovereignty performance. As Wendy Brown argues, in her discussion of the ever-growing number of border walls being installed around the world in the decades following the end of the Cold War: "walls and fences are nothing more than spectacularly expensive political gestures."[19] Other scholars of border studies have argued that if borders are the suitable spaces for states to perform and stage their politics and power, those arriving by, and dying in, the sea have a much stronger impact on public opinion than overstayers and those entering a country irregularly by land.[20] Thus, the sea border is an ideal stage for the performance of a range of political spectacles, whether these are humanitarian concerns,[21] security marketing, new migration policies, or acts of nationalist and xenophobic propaganda.[22]

It is in such a context that the image of unseaworthy boats in the Mediterranean Sea is reproduced and circulated on television, in scholarly presentations, and through governmental and humanitarian organizations' reports, framing complex

acts of migrating as different crimes: "illegal border crossing," and smugglers' exploitation of desperate human beings. What these framings render most visible is the "illegality" of those who arrive or die during their journey by using unseaworthy vessels. These images supply the rationale for what Nicholas De Genova calls "the border spectacle," a spectacle of "enforcement at 'the' border, whereby migrant 'illegality' is rendered spectacularly visible."[23] It is not a new idea that the securitization of migration is part of a political spectacle.[24] Nonetheless, the specific sites of borders provide "the exemplary theatre for staging the spectacle of 'the illegal alien'."[25] The image of boats arriving at Europe's shores and the "problem" that Europe faces with the phenomenon of "boatpeople" is simultaneously framed through "tougher"—i.e., more militarized—as well as more "humanitarian" approaches to the situation.[26] The spectacle of boat migration signals a specific form of illegality, as well as vulnerability, that calls for certain actions, discourses, and practices which are exemplified in the nexus of securitization-humanitarianism. A dominant focus on illegalized travelers' vulnerability as a result of this spectacle renders them as passive, helpless, and in need of protection from smuggling networks. At the same time, this focus ignores European border politics, materialized through the Frontex apparatus, and pushes for greater militarization in the name of saving vulnerable travelers without the right papers.

The reality on the ground is different. Many like Bagou have expended significant amount of time, labor, creativity, networking, and planning in order to transgress the militarized border apparatus. When they arrive—if they manage to do so—all of the labor behind their journey is either criminalized or ignored, being replaced instead by a simple binary image of "vulnerable refugees" and "criminal smugglers." Recently, European governments have also deemed local fishermen who have saved travelers without the right papers in the sea as being suspect of enabling smuggling.[27]

Speaking in the summer of 2014, almost a year before what became termed as the "refugee crisis," Bagou told me that "the back way" he and others have used consisted of the western Saharan route into Senegal, towards Libya and then a boat from the Libyan coast to Italy: a more dangerous route compared with the Canary Island route. "I think the back way is going to change again," he speculated, "it is very dangerous and almost impossible to go through the Mediterranean. And even when you succeed, you face deportation. I was deported three times. One should think of another back way." "From where, how?" I asked him. "Well, through Balkan countries," he replied confidently. Only a smuggler like him, who had the experience of being a refugee, would be able to imagine future alternative escape routes for travelers without the right papers.[28] This route was ultimately realized on an enormous scale in the summer and fall of 2015.

(Re) Making Vulnerabilities

Bagou, like many of his family members, was formerly a boat maker, but as the local fishing industry went into decline due to the presence of transnational fishing companies in the region and new EU economic deals,[29] requests for fishing boats began to decrease. Due to economic difficulties and political pressures that have left many young people hopeless and precarious, some boat makers began to repurpose existing fishing boats or make bigger boats, which are a variant of fishing boats, for those forced to use the sea as a route to Europe. During the second half of the 2000s, many

fishing villages in Gambia were transformed into irregular boat-making hubs that would facilitate the departure of those whose access to freedom of movement is strictly regulated and systematically denied. While today there are fewer boats made in Gambia for this purpose—as traveling to the Canary Islands by boats has become completely impossible—we can learn from the practice of boat making in relation to the use of unseaworthy boats in other routes as a form of dissent within the current mobility regime. The use of unseaworthy boats to cross the Mediterranean Sea shows that "the border has historically figured not only as a site of security but also as a domain of dissent and a place of encounter where the visceral difficulties of political life are exposed and challenged."[30] Ships and boats are a specific colonial technology, designed in relation to a space romantically seen as an open space of freedom.[31] Furthermore, they carry stories, memories, and cultural productions mediating ideas around "departure, failure, and struggles with the elements, of encounters with other laws, the law of the other, and that which is outside the law."[32] The historical idea that boats and ships are associated both with freedom and with vulnerability, resistance, and struggle with the law can still be found through today's unseaworthy boats.

Moreover, ships and boats have made it also possible to launch practices otherwise unthinkable: colonialism[33] and slavery.[34] Without the deep seafaring provided by deep hull ships and round ships, neither of these two practices, which became determining factors in the current geopolitical distribution of the right to movement, would have been thinkable. Vehicles are not simply functional products serving a single private interest. They overcome one vulnerable condition imposed by physical geography but produce several, sometimes overlapping, sometimes competing, vulnerabilities. This is why "vehicles and their environments are irreducible sites of power relations. They are themselves little territories, mobile territories on which games of power and resistance play out."[35] In the current context of European border politics, in which the EU tries to push the zones of border crossing to sites that impose more vulnerability on border transgressors, the vehicles which provide a possibility to traverse these spaces can be considered as specific forms of dissent. This is a form of dissent that operates through reconfiguration of the relations involved in a particular situation. This goes beyond the practicality of their design. A boat might be seen as a vehicle that is designed according to the mechanical laws of engineering, and the specific conditions of its operating environment—water—to enable human bodies to bear, enjoy, and colonize an environment otherwise inaccessible to them. But it is not only that. Unseaworthy boats produce new spaces not simply by accommodating bodies that are not legally entitled to travel across the sea, but also through their role as supporting structures which traverse zones, corners, and margins of the law and state practices of regulating mobility.

There is a fundamental difference between regular boats and unseaworthy boats. While legalized seafaring vessels could afford to be "forgetful about the sea"[36] and the danger it poses, unseaworthy boats must always take into account the sea and the vulnerability it imposes. While they acknowledge and sometime redefine their limits, through for instance extending the hull, changing the motor, and equipping passengers with satellite mobile phones, they also constantly expose the violence of the European border regime. Those like Bagou who make, provide, and use unseaworthy boats, always acknowledge the vulnerability of such an environment and engage with it on different levels.

Many of those I spoke with who had taken a boat to cross the Mediterranean told me about this awareness. They had taken boats which they were aware had only a slim

chance of successful crossing because of maritime conditions, the heavy presence of border guards on the shores of Turkey, Greece, Libya and Italy, and the ill-fitted structure of the vessel. They often told me if others did not make the journey, it does not mean that they would not necessarily make it. "Every attempt is different," because boats and their capacities, boat owners, boat captain, and passengers differ, time is not the same and routes might change. Such recognition of contingency and performativity in border crossing remakes the vulnerability contained within the act of traveling, an activity which has become less vulnerable in modern times. The act of making boats, repairing fishing boats, or repurposing other types of boats for seeking asylum in itself acknowledges the vulnerability brought by the sea and relies upon the impossibility of full surveillance. It is the vulnerability of the device and its operating environment that makes it qualified for acts of border transgressing:

> People try, try, and try. They fail, fail, and fail again, but they try again. I tried with boats three times, then with other means. It did not work but I did not give up. It worked at the end because you have to make it work, because you [have] got no other option,

Bagou told me calmly. This historical and imperative act of escape carried out by refugees[37] becomes a political, legal, and moral source of dispute for those in power, or those displaying compassion towards refugees. The act of escape, which requires transgressing different types of borders, involves different techniques and tactics of reconfiguration facilitated by material means. A boat overcomes corporeal vulnerability by providing a supportive platform for bodies on water, but it also exposes the travelers' bodies to new forms of vulnerability. When reconfigured for clandestine mobility, unseaworthy boats also overcome one form of vulnerability—imposed immobility—while exposing their passengers to other forms of vulnerability—the chance of drowning, drifting away, or being pushed back to the port of departure.

Unseaworthy boats in this sense do not claim any great gesture of dissent. Like the majority of material dissents, they support the reconfiguration of the relations involved in a situation. In this case, they dissent by making those who are not considered worthy of safe travel able to claim their right to movement. Unseaworthy boats indicate how not only the right to mobility, but also the generated vulnerability as a result of regulating that right, is unequally distributed.[38] They also show how different material vulnerabilities can be mobilized as acts of dissent with their own specific limits. They demonstrate that resisting one form of vulnerability may entail accepting another one. The question of how one decides which forms of vulnerability are more urgent to resist is one that only travelers without the right papers can take into account as long as the European border regime continues to systematically violate their right to travel safely.

Where Are the Missing Unseaworthy Boats?

Many of Europe's southern shores, often associated with the arrival by boat of travelers without the right papers, have dedicated parts of their ports to boats that have been capsized. These areas are known as "boat graveyards." Unseaworthy boats evince the illegalized acts that smugglers and travelers without the right papers have

committed and are used in courts against those who are presented as the brokers of the journey.[39]

Meanwhile, and especially after the long summer of migration in 2015, dozens of hackathons, "maker spaces," and start-ups appeared in European countries to address "the problem of refugees," coming up with "innovative solutions to the European Refugee Crisis" as "Startupboat," one of endless such numbers of initiative claims.[40] The majority of these initiatives stopped the moment Europe intensified the militarization at its borders, leading to fewer travelers making the crossing successfully and therefore fewer images of "vulnerable refugees" appearing in Western media. Concern began and ended with the spectacle of borders. The majority of these initiatives proposed solutions in the form of an app or a website providing information to asylum seekers in one or two languages about the asylum process in different EU countries. Many of these ideas have been put into practice since the 1990s through the work of activist groups,[41] who for decades have continued to update, translate, and spread this information. What these design initiatives lack most is the recognition that working in solidarity with travelers without the right papers requires a substantial amount of labor, time, and transnational organization, as well as an understanding of the labor and autonomy that these travelers put into their acts of border transgression. An app, website, or product with its limited temporal politics, not only fails to "solve" such complex political and historical issues adequately, but often also produces harm to those it seeks to support or collaborate with.[42]

While the actions of Bagou and others are seen as criminal activities by the law, they are in practice specific forms of making that in their risk-taking try to resist the imposition of unequal rights to mobility. These makings, repairs, and reuses reveal to us the inequality of freedom of movement as it is played out in the precarious space of the sea and in practice challenge the border regime. Consequently, these makings expose the vulnerability of the militarized apparatus of border control: despite their seemingly simple design, they often manage to transgress the European border regime. In this sense, these acts of transgression, involving fishing boats and rubber dinghies, are specific forms of critical making, with their specific purposes and limits in relation to a particular situation, which dissent with power. This dissensual form of critique is not carried out through the means of grand discourse, or speaking truth to power, but through minor acts of escape and technical reconfigurations of specific vessels and devices at different stages of the journey.

Over the past decade, we have witnessed a celebration of hacking, "maker space," and safe disobedience by governmental agencies in the Global North. At the same time, acts such as the technical reconfigurations carried out by smugglers in order to transgress borders have been criminalized by these authorities and thus have fallen outside of design discourse. While certain acts of hacking have been praised as innovative progress, other practices have been framed as violent, evil, and threatening to national security. Daniel Cardoso Llach identifies a growing interest in "technological civil initiatives," such as "maker spaces", "hackathons," and "D.I.Y.," which are widely invested in and promoted by top-level political entities including the US government, the European Union, and the Defence Advance Research Projects Agency (DARPA). The slogan of the latter lays this out explicitly: "To innovate we must make, to protect we must produce."[43] This shows how ostensibly civil initiatives which argue for "democratizing design" (a term used by DARPA) have their roots in national security discourses.

One way to think of the distinction between smugglers' makings and other makings in hackathons is through examining the way in which the act of making has been racialized historically. Today, governments use large amounts of resources to identify, track, and detain not only those who cross borders without the right papers, but also the commodities that threaten the exchange-value of designer goods (often designed in Western countries but produced in non-Western sweatshops). For instance, the Dutch Customs Department has launched a massive campaign to warn European travelers who go abroad—mainly to countries outside Europe—not to buy counterfeit designer goods, and to be careful not to bring back such commodities. This warning against the inauthenticity of certain products can be understood in terms of the discourse surrounding unseaworthy boats and forged passports, as objects made by "the others." In both, a certain racialization beyond the perceived economic threat is enacted. The racial other, who is outside the "lawful" territory of Europe, makes bags, shoes, and watches which are not certified by Europe as authentic. This narrative consequently positions forged passports bought by travelers without the right papers on the streets of Athens, Istanbul, or Kuala Lumpur and the unseaworthy boats made in western and northern shores of Africa merely as criminal activity, without any worth. Whilst fake consumer products activate the fear of irregularity and disorder in the apparently lawful and ordered design market of Europe, the use of unseaworthy boats and making of forged passports represent both an illegal product *and* an illegalized body. The East and the South are associated with fake copies of products, passport forgeries, unseaworthy boats, and bogus asylum claims, while the West and the North are associated with lawful, authentic, and original products, and ultimately, people.

It is important to note that makerspaces not only reinforce the distinction between different types of making *across* the constructed North–South and West–East division, but they also structurally and uncritically accommodate more white middle-class bodies than non-white and working-class bodies *within* Western cities. Susan Luckman points to a disturbing lack of reflection from design scholars on the white "creative class" dominance over makerspace culture.[44] At a time when hackerspace and makerspace occupy the discourse of democratizing design[45] and critical making[46] for design researchers and the state, one should consider why unseaworthy boats have no place in such discourse. Could they ever be acknowledged as critical practices of making? It is not a coincidence that these boats are only visible as devices of criminality in migration discourses, rather than being seen as instances of critical making, as dissensual material practices. This reveals how the Western-oriented understanding of critical making is structurally unwilling to recognize certain illicit practices as critical, or indeed political. Consequently, travelers without the right papers' material acts of dissent go unnoticed.

Bagou tells me that people try to get out of transit countries like Greece by all means necessary, because they cannot have even a basic life: "No paper, no life. The only paper they get is a warrant to leave the country after 10 days. But to where?" Bagou and I kept in touch for a few years more. Then I stopped hearing from him. When I asked our mutual contacts what had happened to him, I was told that his brother had been on one of the boats that sank off the coast of Libya in 2016. What Bagou and others carry out are imperative acts of survival which are deemed criminal activity by nationalist discourses. Transgressing borders via material supports, such as unseaworthy boats, is criminalized because it dissents with the politics which have

been imposed upon travelers without the right papers by the nationalist order of borders: to stay still, while others move smoothly and unquestioned.

Notes

1 Mahmoud Keshavarz, *The Design Politics of the Passport: Materiality, Immobility and Dissent* (London: Bloomsbury, 2019).
2 Ruben Andersson, "Hardwiring the Frontier? The Politics of Security Technology in Europe's 'Fight against Illegal Migration'," *Security Dialogue* 47, no. 1 (2016): 22–39; Stéphane Rosière, and Reece Jones, "Technopolitics: Re-considering Globalisation through the Role of Walls and Fences," *Geopolitics* 17, no. 1 (2012): 217–34.
3 Martina Tazzioli, "Which Europe? Migrants' Uneven Geographies and Counter-mapping at the Limits of Representation," *Movements. Journal for Critical Migration and Border Regime Studies* 1, no. 2 (2015); Alison Mountz and Jenna M. Loyd, "Constructing the Mediterranean Region: Obscuring Violence in the Bordering of Europe's Migration 'Crises'," *ACME: An International E-Journal for Critical Geographies* 13, no. 2 (2014).
4 Mahmoud Keshavarz and Eric Snodgrass, "Orientations of Europe: Boast, the Mediterranean Sea and the Materialities of Contemporary Mobility Regime," *Borderlands e-journal* 17, no. 2 (2018).
5 The term "right" here refers to two meanings of the term ironically: (i) being right in relation to the legal framework in which those papers are assessed; (ii) right in its social and political status in current international politics and geopolitics. There is a deliberate political decision here to choose this term instead of the conflating use of the terms "migrants," "refugees," and "asylum seekers." The categorization of certain travelers who according to border politics are named asylum seekers, refugees, irregular migrants, economic migrants, "illegals," etc. has different legal and political consequences. This categorization is part of a long and wider politics of criminalization of racialized people on the move that allow the states to manage as well as expel them legally and politically. The use of the term, "travelers without the right papers" thus aims to avoid the essentialization of heterogenous groups of people on the move and push back on the language of borders that constantly indexes and categorizes them. For a full discussion on what the use of this term entails see Keshavarz, *The Design Politics of the Passport*, 10–13.
6 This has been the case for many years until recently, when Italian Prime Minister and Interior Minister Matteo Salvini announced the closure of Italian ports for NGO boats that carry travelers without the right papers saved in the Mediterranean. For recent initiatives that try to break this closure, see https://mediterranearescue.org/en/ and https://alarmphone.org/en/.
7 Etienne Balibar, *Politics and the Other Scene* (London: Verso, 2002), 88.
8 Corey Johnson, et al., "Interventions on Rethinking 'the Border' in Border Studies," *Political Geography* 30, no. 2 (2011): 61–69.
9 Alison Mountz, "Specters at the Port of Entry: Understanding State Mobilities through an Ontology of Exclusion," *Mobilities* 6, no. 3 (2011): 317–34.
10 Nick Vaughan-Williams, "Borderwork beyond Inside/Outside? Frontex, the Citizen-Detective and the War on Terror," *Space and Polity* 12, no. 1 (2008): 63–79.
11 Ibid.
12 Vicky Squire, Angeliki Dimitriadi, Nina Perkowski, Maria Pisani, Dallal Stevens, and Nick Vaughan-Williams, "Crossing the Mediterranean Sea by Boat: Mapping and Documenting Migratory Journeys and Experiences," University of Warwick: Coventry, UK, 2017, https://warwick.ac.uk/fac/soc/pais/research/researchcentres/irs/crossingthemed/ctm_final_report_4may2017.pdf.
13 Shahram Khosravi, "Is a World without Borders Utopian?" *The Silent University Reader*, ed. Emily Fahlen (Stockholm: Tensya Konsthall, 2013), 6–11; Australia has been a pioneering actor in regulating the access to asylum through naval border controls. See Jennifer Hyndman, and Alison Mountz. "Refuge or Refusal," in *Violent Geographies: Fear, Terror, and Political Violence*, eds. Derek Gregory and Allan Pred (New York and London: Routledge, 2007), 77–92.

14 For the most recent deals of this kind signed between the EU and various African countries to regulate migration see the Khartoum process (www.khartoumprocess.net) and the Valetta process (www.consilium.europa.eu/en/meetings/international-summit/2015/11/11-12/).
15 Mountz, "Specters at the Port of Entry."
16 A push-back is a law enforcement tactic whereby the coast guards of sovereign nations engage in a series of military operations to intercept and force illegalized boats to change their routes and push them back into international waters—if the boats are in a stable enough condition to do so. For a systematic documentation of push-back operations carried out by both EU and non-EU actors in the Mediterranean Sea see https://alarmphone.org/en/category/reports/. Further to this, Italy has made a deal recently with a faction of the military governing the northern coast of Libya to draw irregular boats back to Libyan water where travelers without the right papers will be arrested and sent to detention centers in Libya. The EU and Turkey have also made a deal to stop travelers without the right papers from leaving Turkish waters.
17 "Secure Your Vehicle to Help Stop Illegal Immigration," UK Border Agency, accessed March 10, 2015, www.gov.uk/guidance/secure-your-vehicle-to-help-stop-illegal-immigration.
18 Keshavarz and Snodgrass, "Orientations of Europe."
19 Wendy Brown, *Walled States, Waning Sovereignty* (Cambridge, MA: The MIT Press, 2010), 91.
20 Paolo Cuttitta, "'Borderizing' the Island Setting and Narratives of the Lampedusa 'Border Play'," *ACME: An International E-Journal for Critical Geographies* 13, no. 2 (2014): 196–219.
21 I have written elsewhere about humanitarian design projects proposed to prevent the deaths of travelers without the right papers at sea: see Mahmoud Keshavarz, "The Violence of Humanitarian Design," in *Design Philosophy Reader*, ed. Anne-Marie Willis (London: Bloomsbury, 2018), 120–26.
22 Both Lampedusa and Calais have been, and remain, ideal places for neo-nationalist and fascist right-wing parties in Europe to stage their speeches and demonstrations. For example the leader of *Front National*, a French extreme right-wing party, Marine Le Pen, traveled to Lampedusa to give a speech in 2011.
23 Nicholas De Genova, "Spectacles of Migrant 'Illegality': The Scene of Exclusion, the Obscene of Inclusion," *Ethnic and Racial Studies* 36, no.7 (2013): 1181.
24 Jef Huysmans, "The European Union and the Securitization of Migration," *JCMS: Journal of Common Market Studies* 38, no. 5 (2000): 751–77.
25 Nicholas De Genova, "Migrant 'Illegality' and Deportability in Everyday Life," *Annual Review of Anthropology* 31 (2002): 436.
26 "Tough but humane" was how Kevin Rudd, the prime minister of Australia, described his government's approach to those attempting to reach Australia by boat irregulalry, during a speech on October 28, 2009. The consequence of this approach was a reshaping of Australia's borderscape and travelers without the right papers were sent by boat to Nauru Island.
27 "Italy Releases Tunisian Fishermen Held on Suspicion of Smuggling Migrants," *The Guardian*, accessed April, 2019, www.theguardian.com/world/2018/sep/22/italy-releases-tunisian-fishermen-arrested-on-suspicion-of-smuggling-migrants.
28 Before the war in Syria, many African travelers without the right papers would travel by airplane to Syria visa-free and then cross the borders to Turkey and then Greece.
29 John Atta-Mills, Jackie Alder, and Ussif Rashid Sumaila, "The Decline of a Regional Fishing Nation: The Case of Ghana and West Africa," *Natural Resources Forum* 28, no. 1 (2004): 13–21.
30 Louise Amoore, "On the Line: Writing the Geography of the Virtual Border," *Political Geography* 30, no. 2 (2011), 64.
31 Philip E. Steinberg, *The Social Construction of the Ocean* (Cambridge: Cambridge University Press, 2001).
32 Bernhard Siegert, *Cultural Techniques: Grids, Filters, Doors, and Other Articulations of the Real* (New York: Fordham University Press, 2015), 68–69.
33 John Law, "On the Methods of Long-distance Control: Vessels, Navigation and the Portuguese Route to India," *The Sociological Review* 32, no. 1, (1984): 234–63; Carlo

M. Cipolla, *Guns, Sails and Empires: Technological Innovation and the Early Phases of European Expansion, 1400–1700* (New York: Pantheon Books, 1966).
34 Éduoard Glissant, *Poetics of Relation* (Ann Arbor: University of Michigan Press, 1997); Markus Rediker, *The Slave Ship: A Human History* (London: Penguin, 2007).
35 William Walters, "Where are the Missing Vehicles? Critical Reflections on Viapolitics," 7, www.academia.edu/1823268/Where_are_the_missing_vehicles_Critical_reflections_on_viapolitics.
36 Siegert, *Cultural Techniques*, 69.
37 Dimitris Papadopoulos, Niamh Stephenson, and Vassilis Tsianos, *Escape Routes: Control and Subversion in the Twenty-First Century* (London: Pluto Press, 2008).
38 Judith Butler, Zeynep Gambetti, and Leticia Sabsay, *Vulnerability in Resistance* (Durham, NC: Duke University Press, 2016).
39 Supreme Court of Canada (SCC), *R. v. Appulonappa*. Case number: 359589, 2015-11-27. Accessed January 15, 2016. http://scc-csc.lexum.com/scc-csc/scc-csc/en/item/15648/index.do.
40 Startupboat.eu homepage (last accessed October 16, 2018). For a short reportage on the project see "Startup Boat: How Entrepreneurs Are Solving Europe's Refugee Crisis," *Forbes*, September 25, 2015, accessed March 15, 2019, www.forbes.com/sites/amyguttman/2015/09/25/startup-boat-how-entrepreneurs-are-solving-europes-refugee-crisis/#3454b4bf6242.
41 See, for example, http://w2eu.info.
42 Mahmoud Keshavarz, "Violent Compassion: Humanitarian Design and the Politics of Borders," *Design Issue*, forthcoming.
43 Daniel Cardoso Llach, "Software Comes to Matter: Toward a Material History of Computational Design," *Design Issues* 31, no. 3 (2015): 41–54.
44 Susan Luckman, *Craft and the Creative Economy* (Basingstoke: Palgrave Macmillan, 2015), 36–37; One of the rare critiques of the racialized dimensions of making was written by Nicole Dawkins. In her research about makerspaces in Detroit, Dawkins writes about how the city of Detroit has been framed as a utopic "blank canvas" waiting to be inscribed by makers, artists, and entrepreneurs who will transform the city from "Motor City" to "Maker City" through the arrival of a new and predominantly white creative class, who will conduct transformation through urban farming, artists' collectives, hackerspaces, and business start-ups. She argues that these practices, which often espouse values of pleasure, autonomy, and consumer choice, in fact reproduce neoliberal rationalities which limit the space for the political potential of craft and community activism in Detroit which have been carried out for a long time, for example, the work of an all-female grassroots collective of makers. See Nicole Dawkins, "Do-it-yourself: The Precarious Work and Postfeminist Politics of Handmaking (in) Detroit," *Utopian Studies* 22, no. 2 (2011): 261–84. Lilly Irani has also problematized the dominance of middle-class entrepreneurs in hackathons. She argues that, in such spaces, a specific politics of time geared towards entrepreneurial spirit paradoxically excludes those who hackathons claim to care for through its technological solutions. See Lilly Irani, "Hackathons and the Making of Entrepreneurial Citizenship," *Science, Technology, & Human Values* 40, no. 5 (2015): 799–824.
45 Joshua G.Tanenbaum, Amanda M. Williams, Audrey Desjardins, and Karen Tanenbaum, "Democratizing Technology: Pleasure, Utility and Expressiveness in DIY and Maker Practice," Paper presented at Proceedings of the SIGCHI Conference on Human Factors in Computing Systems, 2013.
46 Garnet Hertz, *Critical Making* (Hollywood, CA: Telharmonium Press, 2012).

11 The Madrid Hologram Protest and the Democratic Potential of Visuality

Ksenija Berk

The spirit of protest and revolt can spread contagiously through urban and digital networks in some remarkable ways. Several landmark events that shook up the world between 2011 and 2016—the Occupy protest movements around the globe, the Arab Spring uprisings in the Middle East, the Taksim Square protests in Turkey, the Syntagma Square movement in Greece; Los Indignados/15-M in Spain, and a number of smaller but equally important anti-neoliberal protests throughout Eastern Europe, the Balkans, and the Mediterranean—had a significant impact on the history of contemporary urban street protests. Digital technologies and social networks played a crucial role in the organization, dissemination, and propagation of these events, and in the participatory experience at many of them.[1]

A growing number of activists, together with ordinary people from around the world, are continuously exploring the possibilities of digital technologies in order to express more articulately and efficiently their dissatisfaction with pending social and political issues[2] and to prompt much-desired change.[3] Participants increasingly employ such technologies to create visual culture and communications in countless dissenting events.[4] This chapter will shed light on how different technological methods of image production can open up new potential for dissent through the visual culture of contemporary protests. More specifically, it will analyze a particular protest action that occurred in spring 2015 on the streets of Madrid, Spain, commonly known as the Hologram Protest.

I am interested in the Hologram Protest because it suggests an alternative aesthetic model for civil disobedience. Among the rich body of scholarly research on the digitality of contemporary protests, some work focuses on the use of networking micro-operations,[5] while others investigate the influence of social media in mobilizing a variety of uprisings,[6] and still others analyze the propagandistic effects of digital technologies in the process of disseminating concepts of dissent.[7] Yet the Spanish Hologram Protest does not fit into any of these research categories. What significantly differentiates the Hologram Protest from other contemporary street protests is its symbolic and material substitution of hologram-like projections for people protesting on the streets. Aside from the organizers who initiated, created, and staged the virtual protest, along with the handful of invited photographers who had the privilege of documenting the event, no actual observers participated in or witnessed this atypical street protest.[8] In other words, no real protesters occupied the streets with their physical bodies.

This chapter details how activists addressed, transgressed, and transformed the Spanish government's repressive political attitude toward street protests by using

digital technologies to create a memorable and effective form of visual political disobedience. It analyzes documentary photographic images of the Hologram Protest, offers a comparative analysis of the media discourse, and most importantly, provides a visual and designerly interpretation of the event. This reading is not that of a political analyst or ethnographer, therefore, but of a design and visuality analyst. It scrutinizes the aesthetic vocabulary of that unique revolt, and how it has countered the hegemonic narrative of political elites—namely, the "gag law."

The research takes as its starting point certain photographs that appeared in various Spanish and international news media, informing the general public about the Hologram Protest. Even to an eye unversed in the history of visual communications, it is apparent that the photos feature a specific street protest action on what seem to be realistic terms, but under conditions that look anything but real. Why are the photos of the event so unusual? What do these images stand for? How do they depict and construct the reality of a protest action? The answers will unfold as this chapter takes a closer look at how divergent layers of visuality were constructed and finally put together, and how the materiality of production and the materiality of representation merged in the aesthetic of the Hologram Protest. Attention to what might initially seem to be marginal visual details in relation to digital technologies in fact can elucidate how, in the long run, aesthetic processes can charge the dissenting potential for street protests in new and unexpected ways.

The chapter begins with an introduction to the Madrid Hologram Protest, outlining its primary motives and goals, and how these shaped a specific visual aesthetic that became the hallmark of the protest. Next, it focuses on a deeper visual analysis of the protest action and on how its visuality deployed a broader reference to the rich histories of contemporary art and digital technology. Further on, this study deconstructs the documentary photos of the protest action, and concludes by exploring the democratic potentiality of this particular protest aesthetic and its revolutionary relevance to the street.

A Brief Outline of the Madrid Hologram Protest

The dissatisfaction among Spanish citizens that brought about this spontaneous protest went all the way back to 2014, when the Spanish government adopted the Citizen Security Law, "an appropriately banal, *1984*-esque moniker"[9] for a bill that came to be popularly called the *Ley Mordaza* (Gag Law). Passed by the conservative People's Party in both houses of the Spanish Parliament, it set unusually high fines for protesters who demonstrated in front of any government building. Under this law, which was to come into effect on July 1, 2015, it would become illegal to gather in the shadow of any Spanish public hospital, university, library, and the like without prior permission. According to several news outlets, the fines for anyone daring to violate the law—especially the organizers of unauthorized demonstrations—were established at up to a startling €600,000, with additional fines of €600 for not showing respect to police officers and €30,000 for filming or photographing them.[10]

Such policies rather quickly fueled a considerable amount of additional dissatisfaction among the people, while at the same time offering no solution to the pressing issue. These developments in government policy were precisely the point that had led citizens, feeling deprived of their rights, to express their ongoing discontent

and unrest. An unidentified group of United Nations representatives claimed that the program "violated the very essence of the right to protest," however, "the ruling party, which has an absolute majority in parliament, held firm and forced the law through the lower house."[11]

On Sunday, April 12, 2015, organized under the umbrella of the activist group *NoSomosDelito* (WeAreNotACrime), activists in the Spanish capital staged the Hologram Protest in response to the Citizen Security Law. The protest action was described by various international news outlets as the "world's first ever virtual political demonstration"[12] (Figure 11.1). Nevertheless, the Hologram Protest was not the first protest against the gag law in Spain.[13] Members of *NoSomosDelito*,[14] started in 2013 "by activists who were politically active before and during 15-M movement."[15] *NoSomosDelito* had staged street protests for months, expressing their dissatisfaction with the governmental proposals for diminishing the right to peaceful street protests. The activist platform brought together more than 100 activist groups and organizations. Social movements scholar Cristina Flesher Fominaya, who was also one of the spokespeople of *NoSomosDelito* (NSD), explains how the platform operates:

> The way the assemblies are run is very much in line with and inspired by 15-M political practice, and many of the participants are activists from the 15-M movement, and they share many of the same ideals and forms of practice. However, as a platform that brings together over 100 associations, NSD is also somewhat independent of 15-M in that it includes collective actors such as NGOs who have their own organizational identity and do not necessarily identify with 15-M, such as Rights International.[16]

According to various sources, a simple remark made by someone—that with the implementation of that law, people would be reduced to holograms, and that people in virtual reality would have much greater freedom of expression than people in the real world—sparked the aesthetic fire behind the Hologram Protest.

Figure 11.1 Hologram protest in front of the Spanish Parliament against the "gag law," Madrid, 2015.
Courtesy: DDB/ANTILOOP. © David Bardos.

Before the protest could happen on the streets of Madrid, however, several well-planned, smaller actions were necessary, each dealing with a different level of visuality, to achieve the final result of a projected protest. Spanish activists would have to unite the efforts of hundreds of people worldwide to secure the desired visual outcome.

Further discussions with Flesher Fominaya reveal that the staged protest was a joint initiative between *NoSomosDelito* and the Spanish advertising agency DDB:

> The initiators were creative professionals at DDB; they thought up the campaign and designed it. They then pitched it to a couple of organizations to carry it forward, and NSD accepted the offer. NSD provided the specific content and the messages, and drew on its network of activists to actually participate in the protest and preparation, and they also were the face of the campaign, as DDB originally preferred to remain anonymous and very much in the background, as they wanted the political message to be the most important focus.
>
> DDB provided all the material resources and technical support, and NSD provided the political content; the network, participants, and spokespeople, as well as the media outreach. NSD had a lot of political legitimacy because of its important campaigns on the issues around the Law of Protection of Citizen Security and the reform of the penal code, both of which severely put at risk basic freedoms, such as freedom of expression, association, and protest.[17]

A special campaign website was developed to call upon supporters around the world to participate in the holographic protest. People from all over the world had a chance, for a limited time, to contribute in the spirit of solidarity to the common cause. They were offered a range of options for participating in the creation of the event; by sending recorded messages to be shouted during the protest and videos to be included in the street projection; by uploading their face via webcam to the campaign site, or by sending full-body photographs of themselves gesturing, cheering, and holding placards with various statements. Activists crowdsourced more than 2,000 photos and innumerable recorded sound messages, slogans, and acclamations. Knowledge of computer software for visual manipulation helped a great deal in the process of selecting, editing, and montaging sounds with full-figure portraits into an hour-long demonstration.[18]

Conversations with participating political activists revealed to me the numerous logistical issues that had to be taken into consideration throughout the planning of the protest action, especially when it came to picking out the location and choosing the right time for the action. Protesters chose several streets they thought would be most suitable for this sort of protest action, eventually deciding on the street that runs in front of the Spanish Parliament in Madrid[19] (Figure 11.2). As Flesher Fominaya explains, the whole event was presented as "a film shoot in order to get the permit"[20] for performing an action at that specific location. The protest took place at night, when the streets were empty; no sunlight interfered with the projection, and the streetlights were too weak to have any substantial influence. Furthermore, the potential number of authorities that might intervene and stop the protest was considerably lower during the late hours; so was the number of random passers-by, thus allaying concerns about possible confrontations with unwanted observers.

Figure 11.2 Hologram protest.
Courtesy: DDB/ANTILOOP. © David Bardos.

As mentioned in the introduction, the specificity of this protest was in the true absence of any real people protesting in flesh and blood on the street. Rare interviews with the protest organizers indicate that they were very particular in not wanting any audience, given the event's deep symbolic meaning:

> Spokespeople from *NoSomosDelito* and the media were there, but no one else; it was a virtual protest. It was really important that people not show up for it, because the symbolic impact was for there to be only holograms protesting, so the location was kept under wraps until the last moment.[21]

The members of *NoSomosDelito* played the prerecorded sounds, voices, and statements of protesters on the scene from several speakers, as if an original rally were taking place on the street in real time. After the sounds of a marching, protesting crowd were played, the image phase began, with the holograms[22] of protesters magnified and projected not directly onto the building's façade, but on a special translucent foil extended along the street. Thus, what potential viewers could see if they were present was a ghostlike crowd marching alongside the government building.

The process behind the Hologram Protest—how the action was prepared, created, and performed—is documented in a short film made by the activists and available on YouTube.[23] The film shows how activists from Spain and beyond

created the visual material for the protest's projection, by photographing the protest participants; designing posters, placards, and banners; editing the visual and audio materials; and much more.

Tracing the Visual Origins of the Hologram Protest

The creative approach of the Hologram Protest is a departure from traditional street protests in that its creators developed a set of new ideas around ephemerality rather than adhering to the conventional form of marches and public gatherings. It is worth taking a moment to consider the cultural context in which this influential design for protest action came to light. In line with the art historian and contemporary art critical analyst Claire Bishop, let us explore in greater detail "how style and aesthetic are deeply entwined in the social structures in which they operate."[24] The tactics of the Hologram Protest embraced three important historical lineages, all of which influenced its aesthetic: art-infused collective actions and theatrical interventions of the 1960s, projection art, and electronic civil disobedience.

The guerrilla-style theatrical approach and media interventions behind the Hologram Protest parallel the 1960s social interventions of Socialist International (SI), whose members believed that intervening in various sites of the city was instrumental in effecting major social change and encouraging political demonstrations in order to defend the freedoms of speech and association. These rights were particularly espoused by the American Youth International Party (Yippies), formed in 1968 by the free speech activist Abbie Hoffman.[25] Both SI and the Yippies intensively borrowed strategies from historical avant-gardes: Futurists and Dadaists in the 1910s and '20s, Conceptualists, and libertarian Marxists.

According to German art historian and media theorist Oliver Grau,[26] every epoch in history uses all technical means available to produce maximum illusion. On that account, *NoSomosDelito* progressively explores the potential of various technologies to achieve the group's political goals. It would be rather ignorant, however, to discuss technological aspects of the Hologram Protest without taking into account other street protests wherein activists employed projections in public space to bring attention to larger political issues.[27]

The most notable examples of established visual technologies being used in protests are the projections by the Occupy and post-Occupy movements, which call to mind early experiments of the pioneers of "projection art." Erwin Piscator[28] was one of the first directors to use film projections substantially in theater, as early as 1925. Bertolt Brecht[29] adopted Piscator's theater projection technique in 1931, in order to heighten spectator participation. In the 1950s, Jozef Svoboda introduced mixed media technology in theater, including combinations of different projections and, perhaps most interesting, the use of laser beams and holograms. Svoboda became known to a wider international audience with *Laterna Magika*, a bold combination of actors interacting with projections, designed with stage director Alfréd Radok for the 1958 Brussels Expo, and *Polyecran*, a simultaneous projection of slides and films on several screens, devised for the 1967 Expo in Montreal. In similar fashion, Charles Eames introduced multiscreen large-scale projections for the 1959 American National Exhibition in Moscow.

Nevertheless, it is the legacy of Krzysztof Wodiczko and his public projections on buildings and monuments since the 1980s that has been the most influential in

terms of projections being used by recent political movements. One of Wodiczko's most significant political projections was in January 1991 in Madrid, where he used the notorious *Arco de la Victoria*—erected to celebrate the victory of the fascist General Franco—as a background for his projection, to express his dissatisfaction with the beginning of the first Gulf War.[30] Wodiczko has profoundly informed and inspired numerous contemporary activists—namely, the Illuminator art collective, which first appeared at the Occupy Wall Street protest to express anti-neoliberal and anti-capitalist messages, and also *NoSomosDelito*.

It is important also to consider the projection of visual data used to defy a government proposal or ban—a citizen action such as the Hologram Protest—in light of politically empowering local communities and citizens through electronic disobedience performances. The long and rich history of the development of net art,[31] reaching back to the 1990s,[32] involves activists such as the Critical Art Ensemble[33] and agitprop performance group Electronic Disturbance Theatre (EDT), which started using computer technology to disrupt and protest against the politics of the state. Of special interest here, according to Ricardo Dominguez of the EDT, is that the prefigurative conditions for "a core gesture that could initiate a new performative matrix"[34] came not from digital networks, but from the 1994 Zapatista uprising against the NAFTA agreement:[35]

> The Zapatistas not only ripped into the electronic fabric of First World networks; more important, they created new types of political subjects and new conditions of agency on a global scale. The online agitprop performance group the Electronic Disturbance Theatre (EDT) created a mass-demonstration machine (*FloodNet*) that enabled "virtual sit-ins" that could connect mass actions on the streets to alter-globalization communities online.[36]

The Hologram Protest, in similar fashion, functioned as a visual representation of the disobedient political subject who disrupts the tissue of social networks by using technology to claim the streets.

Photographic Construction of the Event

Photographs of the Hologram Protest, which circulated through social networks and various news media following the event, defy any typical or traditional categorization. Far from being an assemblage of photographs documenting just another European street protest against diminishing civil rights, these semiotically dense images reflect a complex collection of visual information.

NoSomosDelito chose a rather unconventional approach for documenting the Hologram Protest action, albeit one that is dramaturgically very much in line with NSD's strategy for total control of the event. As mentioned earlier, the activists decided to invite only a handful of photographers to be physically present at the street scene to witness the staged protest and to shoot the pictures that later appeared in news media as documentary photos of the Hologram Protest. The strategy of completely controlling the protest action from beginning to end is understandable given the group's position: by controlling the visual documentation, NSD maintained the coherence and dramaturgy of the staged protest, and furthermore resisted media appropriation and manipulation of the event. Nevertheless,

this course of action can be rather unsettling for non-activist observers, particularly members of the general public, who do not have (as a visual analyst does) the benefit of any specific knowledge regarding the indexicality of documentary photography. In this regard, any attempt to discern what happened on the streets of Madrid and to follow the accurate sequence of events solely from watching the photographs distributed in the media leads one to risk falling into the trap of false, invented documentarism, all while chasing the so-called "politics of truth."[37]

The visuality of the Hologram Protest cannot be explored just from a narrow documentary perspective; rather, visual analysis should focus on its more complex nature in relation to street protests.[38] Photographs were both a constitutive part of this action and a document of the same event. From the documentary point of view, one should consider several levels of visuality—photographs and short clips collected from the website and montaged into the final projection—that merge in a final documentary photographic image.

The background on the photos is almost black; one can discern the darkness of the night sky against the bright, yellow-lit front façade of the Spanish Parliament building. This scene functions in a fashion similar to that of an early 19th-century panorama, set up to bring the absent content to the figures in portrait. In front of the building there is an empty public space that functions as a stage, upon which the contours of ghostlike, marching human figures—off-white, almost translucent—are visible. The bodies appear to be carrying different posters, banners, and megaphones, and moving horizontally through the center of the image as if in a procession, march, or demonstration. Here the analogy with a panorama can be extended, for the protesting figures in the foreground symbolically connect to the parliamentary building and its proposal to ban civic protests on the streets. A "delineation of figure from ground," or in other words, a "contrast between a thing and an environment in which it is located,"[39] is fully visible and not only draws the iconologist's attention, as Mitchell develops in his theories of the image, but stirs the imagination of any viewer who casts their eye upon the photographs.

Several photo reproduction technologies and technological processes—real-time computation, relational databases, knowledge engineering, telepresence[40]—were employed in developing a projection that significantly influences the viewer's perception and understanding.[41] If one's thinking aligns with Oliver Grau's,[42] all the visual layers in the photographs silently sink or merge rather seamlessly into photographic documents of the protest action. Such details might seem trivial, but they raise an interesting paradox of documentary photography in light of the protest aesthetic. These photographs possess the quality of convincing the viewer that what they see was an event in a real time and place (the function of photography as an index),[43] while at the same time they create an illusion (the protest aesthetic) of a magical procession consisting of bodies of people who have been miraculously transformed into ghosts.

At that point, without additional information on how the protest was created and why these bodies were portrayed in such a form and location in the first place, an effort to assert the historicity of the event just from the indexical nature of documentary photographs alone would be untenable. In the case of the Hologram Protest, photography—our window into the world, or an engine of visualization[44]—frames the figures of protesters while simultaneously separating them from the exterior of the street. What's more, photography at the same time functions as

a symbol, signifier, and compositional device. Virtuality in the Hologram Protest, if we follow the analogy of Breidbach,[45] describes not an unknown thing, but something of which we already have knowledge: the symbolic substitution of protesters on the streets with their holograms. In this sense, the virtual protest action was in fact a simulation. The observer could experience from a computer screen a sort of "temporal sequence of successive images" looped into movie sequence, as can be seen in a short YouTube clip titled "Holograms for freedom."[46]

What is more, due to the intentional absence of observers and protesters who could have photo-documented the Hologram Protest, the photographs and some video footage now accessible on YouTube and platforms like Flickr, are the only publicly accessible archival material we have of that notable event. For this reason alone, we should also consider how we researchers approach the notion of documenting and archiving the material culture from unconventional, ephemeral protest events and should touch upon different aspects of the protest's visuality.

Appearance, Representation, Participation

The Hologram Protest occurred under specific cultural, political, and historical conditions. Difficult as it is to challenge and change the decisions of any government, *NoSomosDelito* activists decided to reach for a creative solution in protesting the Spanish government's regulation of the freedom of association, expression, and protest. When protest bodies on the streets were symbolically substituted with hologram-like projections, protesters successfully defied the governmental ban. In order to do so, they merged various representational models[47] and political performative practices while also borrowing ideas from different visual fields, to call for the democratic use of public streets as discussed by Rosalyn Deutche[48] and the right to peaceful civic protests. The Hologram Protest touched upon the notions of appearance, representation, and participation in street protests.

Appearance or manifestation (*aletheia*) in the Hologram Protest refers to something (the protest) that was about to be fined and prosecuted by government authorities, but instead claimed the streets and manifested in a process of dematerialization (the visual projection). To protest, in this particular case, literally meant to come into sight, to be manifest, to become a phenomenon—experienced as such through visual, sensory awareness and perception.

Faced with the opposing duality of reality and illusion in the Madrid Hologram Protest, we are compelled to distinguish between things as they seem to be (appearances, images, sense-data) and things as they really are, most notably in relation to the category of the human body. In this protest action, bodies of protesters were designed, organized, and operated upon by determinants that are also simultaneously social, aesthetic, and political. The relationship between the virtual and the real was transformed into projections directed toward the outside of the digital space on the screen/foil mounted on the street. The physical bodies of protesters are subject to various limitations, including persecutions;[49] immateriality, on the other hand—a constitutive part of the Hologram Protest—opens a colorful palette of possibilities for how to rethink the relationship between the notion of the political and the street. More important, by being present even in their absence, and represented symbolically by holograms, protesters created extraordinary visibility in the media and sent an important activist message not only to their government, but

to people and governments all over the world. Determining how to be present at the street protest while at the same time being physically absent further reveals the approach of *NoSomosDelito*, which leans toward self-management of risk in relation to the repressive capacities of the Althusserian ideological state apparatuses[50] (namely, the police). The locus of risk was displaced from the physical bodies of protesters to their symbolic signifiers, which points to the formation of new social and political memories through the "political strategy of representation."[51]

The transformation and symbolic substitution of protesters' real human bodies during their hologram-like representations on the street necessarily exposes issues related to direct participation in protests. Claire Bishop, in *Artificial Hells: Participatory Art and the Politics of Spectatorship*, reminds us of Debord's critique, in which he highlights the importance of participation, because it "rehumanizes a society rendered numb and fragmented by the repressive instrumentality of capitalist production."[52] If we draw parallels to Bishop in relation to the Hologram Protest, we can say that virtual participation was exceptionally important, because it "channeled symbolic capital towards constructive social change."[53] This call for change was the challenging of governmental decisions against freedom of association and public protest. According to political sociologist Paolo Gerbaudo, participation in protest events can be described as an involvement in collective space, organized and set up by leadership groups and digital vanguards, "by giving movements collective names, by coining a series of hash tags, of icons, of internet memes, and in so doing constructing a basic operational identity."[54]

Another element of the Hologram Protest stands out: the question of how these types of protests, supported and executed with the help of digital technology, are organized. Gerbaudo, in his book *Tweets and Streets*,[55] touches upon this somewhat unacknowledged matter and explains that use of the Internet and social media does not eliminate leadership in contemporary protests and social movements, as it is commonly believed. On the contrary, Gerbaudo argues, these sorts of technologies bring new forms of "soft and distributed leadership,"[56] which was also the case in the Hologram Protest, successfully organized by the social platform *NoSomosDelito* and the Spanish DDB advertising agency. Further ethnographic research is needed, however, to know exactly how these mechanisms of "soft and distributed leadership" were executed and applied to create the Hologram Protest.

Despite its "alienating nature," first elaborated by Karl Marx in his *Economic and Philosophic Manuscripts of 1844* and later studied by several generations of political theorists,[57] technology—as applied in the Hologram Protest—can function as a bridge connecting activists and their supporters. *NoSomosDelito* connected activist groups and hundreds of individuals from all over the world, who helped to create the projection material, with the advertising agency DDB Spain, which provided digital technology[58] and other support, and managed to unlock the revolutionary potential of civil disobedience by creating a critique of governmental decisions so powerful that it could not go unnoticed by the mainstream news media and other social movements across the globe.

Conclusion

New media technologies significantly helped the Spanish anti-gag law activists put to creative use some of the many potential tools digital technology can offer. These

activists used technology strategically, to speak out against restrictive state policies about limiting the spontaneous organization of street protests, and by designing tactical visual material to form a hologram-like protest on the streets of Madrid.

This chapter has explored how digitality (imagery and data transmission) has not only entered "the street," but also enabled protesters to be absent in a physical sense while simultaneously being actively present across the globe. Activist Carlos Escaño and researcher Hélène Michou, in an article for global media platform openDemocracy, uncovered a staggering fact:

> International coverage of the holographic march reached an audience of 800 million people and generated a worldwide online debate over issues of freedom of expression and civil liberties. Media impact extended to a *New York Times* editorial comparing the "ominous gag law" to "the dark days of the Franco Regime. It has no place in a democratic nation."[59]

By subverting the "gag law" and consequently avoiding arrest, this protest action inspired and empowered protests elsewhere in the world as they attempt to raise the issue of a state-level ban on public protests in public spaces. In similar fashion, the "Ghost Protest" was organized in February 2016 by Amnesty International at the Gwanghwamun Square in Seoul, South Korea, to protest against the "suppression of free speech and protest."[60] In November 2017, Greenpeace Canada staged a "hologram protest"[61] against the Kinder Morgan Pipeline, at the headquarters of TD Bank in Toronto.

The Hologram Protest in Spain, and all others that followed in its footsteps, were deeply symbolic, embodying the idea of a disobedient subject without being physically present at the scene.[62] These protest actions managed to speak a new language of dissent amid the reality of the street, by building heterogeneous connections between disparate historical events, urban movements, nonviolent protests, digital technologies, and human rights claims. At the same time, the procession of projected protesters in front of the Spanish Parliament building was an intervention in public space, which successfully disrupted governmental techniques of social control The Hologram Protest offered the opportunity to see how the "digital vanguard" operates—those "digital communication teams, often bound together by links of friendship and comradeship, who take the lead in initiating and steering relevant Internet conversations."[63] It stands tall in a line of remarkable protest events in history that managed to successfully shatter the networks of power through collective action against diminishing social and political rights and the denigration of public space.

On November 20, 2018, as reported by the Spanish newspaper *El Español*, the Council of Europe sent a letter to the Spanish government, demanding "the reform of the Citizen Security Law to guarantee full respect for the freedom of expression and assembly." In its current form, the law approved in 2015 during the government of Mariano Rajoy "allows potentially disproportionate and arbitrary limitations in the exercise of these rights,"[64] the Council denounced. In addition, the Council's Human Rights Commissioner, Dunja Mijatović asked the Spanish government to take advantage of the current revision of the gag law to "eliminate provisions that have the potential to undermine the protection of human rights in Spain."[65] As Ernesto Laclau puts it in his book *New Reflections on the Revolution of Our Time*, this sort of dissenting interventions confront "the political system

with growing demands … which become more difficult to manipulate and disregard,"[66] and empower citizens to continue their resistance against inequalities and diminishing social and political rights. There is still a lot to be explored in this promising area, where the unforeseen potential of spontaneous interventions in public space are arising within the material and political realities of everyday life.

Notes

1. Darin Barney, et al., eds., *The Participatory Condition in the Digital Age* (Minneapolis, MN: University of Minnesota Press, 2016). Gavin Brown, et al., eds., *Protest Camps in International Context. Spaces, Infrastructures and Media of Resistance* (Bristol: Policy Press, 2017).
2. Symon Hill, *Digital Revolutions: Activism in the Internet Age* (Oxford: New Internationalist Publications Ltd., 2013). Kathrin Fahlenbrach, Erling Sivertsen, and Rolf Werenksjord, eds., *Media and Revolt. Strategies and Performances from the 1960s to the Present* (Oxford: Berghann Books, 2014).
3. Rita Figueiras and Paola do Espírito Santo, eds., *Beyond the Internet: Unplugging the Protest Movement Wave* (London: Taylor and Francis, 2015).
4. John Michael Roberts, *New Media and Public Activism. Neoliberalism, the State and Radical Protest in the Public Sphere* (Bristol: Policy Press, 2014). Ricardo Dominguez, "Electronic Civil Disobedience: Inventing the Future of Online Agitprop Theater," *PMLA* 124, no. 5 (2009), 1806–1812.
5. W. Lance Bennet and Alexandra Segerberg, *The Logic of Connective Action. Digital Media and the Personalization of Contentious Politics* (Cambridge: Cambridge University Press, 2013).
6. Linda Herrera, *Revolution in the Age of Social Media. The Egyptian Popular Insurrection and the Internet* (London: Verso, 2014); Paolo Gerbaudo, *Tweets and Streets* (London: Pluto Press, 2012).
7. Manuel Castells, *Networks of Outrage and Hope: Social Movements in the Internet Age* (Cambridge: Polity Press, 2012); Heather Brooke, *The Revolution Will Be Digitised: Dispatches from the Information War* (London: William Heinemann, 2011).
8. Cristina Flesher Fominaya, "World's First Hologram Protest in Spain," *Interface: A Journal for and about Social Movements* 7, no. 1 (2015), Movement Practice(s), 144–149.
9. Dylan Kerr, "The Future is Here, and It's a Little Scary: Watch Spain's Hologram Protests," *Art Bytes*, April 24, 2015, www.artspace.com/magazine/news_events/art-bytes/spanish-hologram-protest-52768.
10. Simon Tomlinson, "The World's First Hologram Protest: Thousands Join Virtual March against Law Banning Demonstrations Outside Government Buildings in Spain," *Dailymail*, April 14, 2015, www.dailymail.co.uk/news/article-3038317/The-world-s-HOLOGRAM-protest-Thousands-join-virtual-march-Spain-against-law-banning-demonstrations-outside-government-buildings.html.
11. Jonathan Blitzer, "Protest by Hologram," *The New Yorker*, April 20, 2015, www.newyorker.com/news/news-desk/protest-by-hologram.
12. Zachary Davies Boren, "Spain's Hologram Protest: Thousands Join Virtual March in Madrid against New Gag Law," *Independent*, April 12, 2015, www.independent.co.uk/news/world/europe/spains-hologram-protest-thousands-join-virtual-march-in-madrid-against-new-gag-law-10170650.html.
13. Leónidas Martín, "#sinmordaza: Una intervención fotográfica contra la ley de protección ciudadana" ("sinmordaza: A Photographic Intervention against the Citizen Protection Law"), *LEODECERCA, Vida, obra y milagros de Leónidas Martín* (*LEODECERCA, Life, Work and Miracles of Leónidas Martín*), accessed September 11, 2016, http://leodecerca.net/sinmordaza-una-intervencion-fotografica-contra-la-ley-de-proteccion-ciudadana/.
14. "Who Are We?" Nosomosdelito, accessed August, 2016, http://nosomosdelito.net/page/2014/09/11/who-are-we.
15. E-mail discussion between author and Cristina Flesher Fominaya, December 2016.

16 Ibid.
17 Ibid.
18 Carlos Córdoba Vallet, "Hologramas contra la 'ley mordaza'" ("Holograms against the 'Gag Law'"), *El País*, April 11, 2015, http://ccaa.elpais.com/ccaa/2015/04/10/madrid/1428698276_149818.html.
19 Blitzer, "Protest by Hologram."
20 Flesher Fominaya, "World's First Hologram Protest in Spain," 147.
21 Ibid, 146.
22 From a purely technical point of view, the Hologram Protest does raise an eyebrow regarding its claims to a hologrammatic nature. If something is to be described or categorized as a "hologram," invented by Hungarian-British electrical engineer and physicist Dennis Gabor in 1947, it should qualify from the positions of both how it is created and how it is perceived. Holograms are to be understood in terms of images that are created by the interference of laser-beam light waves that, under specific conditions, become visible in 3D form. Was the Hologram Protest a two-dimensional projection on translucent foil, spread on the street—or a 3D hologram image produced by laser beams? Activists used the Illuminator machine for projecting a virtual march, so we can be quite sure it was not a real hologram, but a 2D projection. The question is, why did activists stick with the hologram tag when it was, in fact, a projection? One reason could lie in that activist's remark sparking the protest—that if the gag law is applied, people are to be reduced to holograms; perhaps, because of the powerful metaphor, despite its technical inaccuracy, it remained in use.
23 NoSomosDelito and DDB, "Hologramas por la Libertad" ("Holograms for Freedom"), YouTube, May 26, 2015, www.youtube.com/watch?v=vfhkM5zOGc4.
24 Claire Bishop, *Artificial Hells: Participatory Art and the Politics of Spectatorship* (London and New York: Verso, 2012), 195.
25 Abbie Hoffman, *Revolution for the Hell of It* (New York: Thunder's Mouth Press, 1968).
26 Oliver Grau, *Virtual Art: From Illusion to Immersion* (Cambridge, MA: The MIT Press, 2003).
27 Yates McKee, *Strike Art: Contemporary Art and the Post-Occupy Condition* (London: Verso, 2016).
28 Yael Farber, "Erwin Piscator—In Spite of Everything," threebathspa, February 29, 2016, https://threbathspa.wordpress.com/2016/02/29/erwin-piscator-in-spite-of-everything/.
29 Elizabeth Jones, "What Brecht Did for the Theatre Was to Heighter the Spectator's Participation, but in an Intellectual Way, Whereas Artaud Had Specifically Rejected Intellectual Approaches in Favour of Theatre as 'a Means of Inducing Trances.' Discuss," *Innervate; Leading Undergraduate Work in English Studies* 2 (2009–2010), 247–253, www.nottingham.ac.uk/english/documents/innervate/09-10/0910jonesbrecht.pdf.
30 Krzysztof Wodiczko, *Critical Vehicles: Writings, Projects, Interviews.* (Cambridge, MA: The MIT Press), 189.
31 Tatiana Bazzichelli, *Networking. The Net as Artwork* (Digital Aesthetics Research Center: Aarhus, 2008).
32 Marilyn Delaure, Moritz Fink, and Mark Dery, eds., *Culture Jamming: Activism and the Art of Cultural Resistance* (New York: New York University Press, 2017).
33 Critical Art Ensemble, *Digital Resistance: Explorations in Tactical Media* (New York: Autonomedia, 2001).
34 Critical Art Ensemble, *The Electronic Disturbance* (New York: Autonomedia, 1994), 57–60.
35 Dominguez, "Electronic Civil Disobedience: Inventing the Future of Online Agitprop Theater," 1807.
36 Ibid, 1807.
37 Hito Steyerl, "Documentarism as Politics of Truth," *Transversal – eipcp multilingual webjournal*, May 5, 2003, http://eipcp.net/transversal/1003/steyerl2/en.
38 Edgar Gómez Cruz and Asko Lehmuskallio, eds., *Digital Photography and Everyday Life: Empirical Studies on Material Visual Practices* (London: Taylor and Francis, 2016).
39 W.J.T. Mitchell, *Image Science: Iconology, Visual Culture, and Media Aesthetics* (Chicago: The University of Chicago Press, 2015), xi.

40 Grau, *Virtual Art*.
41 Walter Benjamin, *The Work of Art in the Age of Mechanical Reproduction*. (London: Penguin Books, 2008).
42 Grau, *Virtual Art*.
43 Index is a sign, which according to the French semiotician Charles Sanders Pierce points to its referent by means of a physical connection of causality rather than by resemblance (icon) or convention (symbol).
44 Patrick Maynard, *The Engine of Visualisation. Thinking through Photography* (Ithaca and London: Cornell University Press, 1997).
45 Olaf Breidbach, "Imagining Science: The Pictorial Turn in Bio- and Neurosciences," in: *Imagery in the 21s Century*, ed. Oliver Grau (Cambridge, MA: MIT Press, 2011), 114.
46 NoSomosDelito and DDB, "Hologramas por la Libertad," YouTube, May 26, 2015, www.youtube.com/watch?v=0jwmi6CguY0.
47 Norman Bryson, Michael Ann Holly, and Keith Moxey, eds., *Visual Culture: Images and Interpretations* (Hanover: University Press of New England, 1994).
48 Rosalyn Deutche, "Art and Public Space: Questions of Democracy," *Social Text* no. 33 (1992), 34–53.
49 Ayse Parla, "Protest and the Limits of the Body," *Cultural Anthropology*, October 31, 2013, https://culanth.org/fieldsights/403-protest-and-the-limits-of-the-body.
50 Louis Althusser, *On Ideology* (London: Verso, 2008).
51 John Tagg, "The Discontinuous City," in *Visual Culture*, 87.
52 Claire Bishop, *Artificial Hells: Participatory Art and the Politics of Spectatorship* (London and New York: Verso, 2012), 11.
53 Ibid, 13.
54 Paolo Gerbaudo, "The Persistence of Collectivity in Digital Protest," *Information, Communication & Society* 17, no. 2 (2014), 267.
55 Paolo Gerbaudo, *Tweets and Streets* (London: Pluto Press, 2012).
56 Gerbaudo, "The Persistence of Collectivity in Digital Protest," 266.
57 Amy E. Wendling, *Karl Marx on Technology and Alienation* (Basingstoke: Palgrave MacMillan Publishers, 2009).
58 Flesher Fominaya, interview with author.
59 Carlos Escaño and Hélène Michou, "United against Spain's Gag Laws: Change Bottom-up," openDemocracy, September 14, 2016, www.opendemocracy.net/can-europe-make-it/carlos-esca-o-h-l-ne-michou/united-against-spain-s-gag-laws-change-bottom-up.
60 Peter Rugg, "South Korean 'Ghost Protest' Is a Holographic Triumph for Freedom of Speech," *Inverse*, February 25, 2016, www.inverse.com/article/12028-south-korean-ghost-protest-is-a-holographic-triumph-for-freedom-of-speech.
61 Miranda Gathercole, "VIDEO: B.C. First Nation Joins 'Hologram' Protest vs Kinder Morgan Pipeline," *Columbia Valley Pioner*, November 24, 2017, www.columbiavalleypioneer.com/news/video-b-c-first-nation-joins-hologram-protest-vs-kinder-morgan-pipeline/.
62 Elena Loizidou, ed., *Disobedience: Concept and Practice* (London: Routledge, 2013).
63 Gerbaudo, "The Persistence of Collectivity in Digital Protest," 267.
64 Juan Sanhermelando, "Estrasburgo pide a España que reforme la Ley Mordaza porque no protege la libertad de expression" ("Strasbourg Asks Spain to Reform the Gag Law Because It Does Not Protect Freedom of Expression"), *El Español*, November 23, 2018, www.elespanol.com/espana/politica/20181123/estrasburgo-espana-ley-mordaza-no-libertad-expresion/355464773_0.html?fbclid=IwAR3wlY3Fq7nTFlkMHR-hG-RYJ4Q0SwBmwyAFqPsL5ub3f4zjYUaC0m40g-0.
65 Sanhermelando, 2018.
66 Ernesto Laclau, *New Reflections on the Revolution of Our Time* (London: Verso, 1990), 82.

12 Data Acquisition, Data Analytics, and Data Articulations

DIY Accountability Tools and Resistance in Indonesia—An Interview with Irendira Radjawali of Drone Academy, Indonesia

Alessandra Renzi

Introduction

During a recent research visit to Jakarta focused on the use of data visualizations for anti-eviction organizing, I joined some friends and colleagues on a trip to Central Kalimantan, one of Indonesia's provinces on the island of Borneo. The trip gave me a first-hand look at the resource extraction industry that is not only destroying one of the most important rainforests in the world but is also directing endless cash flows into Jakarta's real estate market. Much of the money and financial operations tied to palm oil production and resource extraction feed the real estate development that displaces vulnerable populations from the capital's urban core. I flew to Pangkalan Bun with Irendira Radjawali, or Radja,[1] and from there we made our way to join the rest of the group, moving through large swaths of deforested land where rows upon rows of young oil palms was all we saw from our car window for hours on end.[2]

Radja is the founder of the Drone Academy, a grassroots network of hardware hackers, data geeks, environmentalists, and community groups using drones for participatory mapping. Drone Academy is inspired by the DIY ethics of citizen science as much as by a long-standing tradition of participatory mapping, which have made Indonesia a global reference point for this kind of activism. They bring a solid critique of techno-fetishism and macho science to cutting-edge practices of design and data analysis for social and environmental justice. Drone Academy's quest for what they dub "data sovereignty" does not stop at the fast and efficient production of high-precision maps to delineate the boundaries of indigenous communities. They have used drones with homemade special cameras to detect unhealthy plants and improve local agriculture; they are mapping the informal settlements of Jakarta to document their property rights, and are constantly coming up with new uses for their drones.

In the following days, I saw Radja and some of his collaborators in action, flying drones in rural villages and over the tree canopies of Tanjung Puting National Park, lined with empty orangutan nests. Forest fires[3] have destroyed and battered the ancient trees and the orangutan and hornbill populations are dwindling at dramatic speed as mining expands and plantations encroach—often after the fires, often illegally. At Tanjung Puting, the environmentalists and forestry experts I talked with fought the

forest fires with hardly any resources in an effort to save the saplings they were growing to revitalize the forest.[4] All over Borneo, it is not only trees and animals that are struggling to survive. Forest-dwelling communities of the indigenous Dayak people[5] are losing their land, their water, their ability to grow food, their customs—they are displaced from their ancestral lands. Many of these communities are fighting back with all the means they have, including the use of drones to map indigenous territory and customary forests in order to advocate for protection and sue encroaching corporations.

Most innovative data activism takes place off the radar of Western-centered gazes but Drone Academy's practices and discourses raise some crucial questions about the use of data science for activism the world over. At a time when the production of knowledge based on Big Data is the purview of a privileged few, the use of open source software, DIY hardware and open data crash the heavily guarded gates of the new data paradigm for "scientific knowledge production," positioning some of those who are directly affected by Big Data governance to provide counter-narratives. What I find unique about the Drone Academy is that they also keep a healthy critical distance from the techno-fetishism of Silicon Valley, NGOs and the likes—where, in most cases, there is nothing an app and some data cannot fix for the masses. Drone Academy advocates for unceasing investment in the social networks that emerge around the use of specific technologies for data production (and all technologies for that matter). The balancing act of doing cutting-edge technical work and keeping it open to as many people as possible is not always successful but is key for any scalable movement. To ignore the pitfalls of techno-elitism and to not develop tools and methods that are accessible and embraced by different groups dooms any kind of techno-social project to failure in the long term because it will not be generative, self-reproducing, and sustainable.

During the long trip with Radja, our conversation immediately took us to our shared interest in the processes of subjective and collective transformation that impact those involved in media activism and in traditional organizing. These transformations are important beyond the delivery of a finished product, be it a video or a campaign, because they generate connections among people and foster more potential. Our trajectories in activism have led us both to recognize the need to tend to, and harness, the transformative potential of collaborative knowledge production to sustain communities in struggle.

In this interview, Radja discusses the participatory process of mapping in terms of a "three 'A' algorithm": data acquisition, data analytics, and data articulations. For the process of mapping to be truly transformative, it is not enough to be able to fly drones together with the communities whose interests are at stake (data acquisition). The analysis and articulation of the data that has been acquired also have to come from the communities and groups involved. When one can attend to all three aspects in a truly collaborative fashion, new forms of knowledge and practices of resistance can emerge. Here, awareness of one's abilities, the valorization of local knowledge and a sense of control over the production and circulation of information can support or set the foundations for further organizing. Data sovereignty is about the ability to produce, make sense of, and deploy data in opposition to hegemonic narratives about the reliability and objectivity of data and the gatekeeping of knowledge production—collectively.

I returned to Jakarta in the spring of 2017 and took the opportunity to interview Radja about some of the current challenges for Drone Academy and where he thinks

this kind of activism for data sovereignty needs to go. In the honest self-critique and nuanced analysis he offers, I see the beginnings of an important conversation that should connect activist groups using data across continents. This conversation could facilitate skill sharing as well as troubleshooting about the problems that many face when dealing with inclusion, horizontality, infrastructural needs, and knowledge, as well as know-how dissemination. The principles of data sovereignty that Radja articulates are not only key to building long-lasting and scalable movements, they also speak to the ongoing struggle against forces of cooption through which corporations and institutional actors appropriate the tools, discourses, and practices that social movements and some NGOs develop. The history of grassroots innovation in communication is rife with examples of capital's capture of ingenious innovation. The case of Indymedia's open publishing platform leading to the development of proprietary blogging tools and, eventually, User Generated Content on social media is only one yet poignant example of the process. The rise of social media certainly made much of Indymedia's technical innovation redundant but the networks's ability to remain relevant was also reduced by its inability to attend to the social aspect of media production—issues of inclusion, access, and governance among others.[6] Since is difficult to avoid capital's capture of activist tools and redefinition of their functions, it is crucial that activists attend to the sociality that emerges around bottom-up media configurations in order to persist and resist. Radja's emphasis on all aspects of data use—acquisition, analysis, and articulation—is an invitation to never lose a project's sense of purpose in its technology and to maintain a wide view of the use and purpose of data.

ALESSANDRA: I'm particularly interested in the political perspective you bring to drone mapping. Tell me about your work with drones, how it started, the groups that you're connected with and what they are doing.

RADJA: My work with drones started in 2012 as part of my research with the University of Bonn in Germany. The research itself was using a political ecology approach and action research to understand the transformations of the Kapuas River in West Kalimantan, which is the longest river in Indonesia and stretches for 1,700 kilometers from upstream in the Putussibau in the Kapuas Hulu regencies to the downstream city of Pontianak. So it was a time when we were wondering about the kind of transformations in the area and their driving forces. But before going that far even, we decided to just go along the river, 1,700 kilometers with a very slow boat to have some insights into what's really actually going on. We knew that there were some areas, where some forests had been turned into oil palm plantations. There were conflicts between villages, between peoples, between groups, because of the land. There are conflicts also with the companies or even the government, so between the local communities and the government and companies. We thought we needed to see it first. We were very much interested in the river itself, instead of the land.

Already perhaps 80 kilometers away from Pontianak, where we started the trip, the landscape on both sides of the river changes a lot. I could tell because I had been there back in 2012. One of the things I saw was the bauxite mining—the one which then becomes aluminum. On the riverbanks you just see literally hills of reddish soil from the mining. Our boat guide mentioned that it had only been six months. Bauxite is becoming the new gold in West Kalimantan. When we stopped to enter the area, we couldn't because it's owned by companies. Starting from that time, I knew that

I had to look for spatial data, so maps, be it satellite or otherwise. After we returned back to Pontianak, we discussed a lot of what's going on with some local activists and also asked friends, teachers, academics about maps and how to see these changes spatially. Back then it seemed like they had some kind of ideas of how the space was changing, but their understanding of space was somehow reduced to maps, and these were not up-to-date. Governments in Indonesia at different levels have to have a spatial plan, which means that space is divided for different uses—residential areas, business areas, protected forest, plantations, mines, and so on. It seemed to me that they were somehow trapped in the mapping dimensions driven by the government.

It was certainly a good thing that my friends were already doing something with the maps, but who produced those maps? Can we make our own? How we do this is also important. Participatory mapping has been present in Indonesia for 25 years. I believe Indonesia is one of the most advanced participatory mapping adopters for indigenous people. It started in the early '90s, or even late '80s, when groups from South America went to Indonesia and taught indigenous groups how to use GPS and perform what's now called participatory mapping. The Indonesian indigenous groups took to participatory mapping very well. I was aware of this history and yet there still was the question of how fast it is. You know, it's about walking in the forest and the Alliance of Indigenous Peoples of the Archipelago[7] claims that they have 40 million hectares of indigenous land in Indonesia. That's huge, and in 2015 they registered an additional one million hectares. In 2012, this was all on my mind when I went back to Germany.

In Germany, the Internet connection was much faster. I could download satellite images to see changes in space but again, the most recent images available for a lot of areas in Kalimantan were from 2009 and one couldn't really access the most updated ones, even though I was in Germany, working for a university. Meanwhile, in Indonesia, people claim the data is out there but no one seems to know where it is. In West Kalimantan, even our friends and the *dinas* [government departments] and the *kantoor* [the local government officials] say they have these satellite images but when you try to access them, they're on a USB key ... somewhere ...

When I returned to Indonesia in 2013 I decided to make my own spatial data. I was really thinking of using a plane but the cost turned out to be too high. I started contacting my friends who studied aeronautics to make a plane and I remembered that they also somehow developed drones. I knew from watching *Democracy Now* that drones were for killing terrorists while also having huge casualties of innocent civilians. I started wondering if one could use drones for a good cause, to gather good data—spatial data. Back then I was so mad about the military drones that I wanted to call our drones something else. And then I bumped into a website called "Conservation Drones," run by two ecologists: Serge Wich from Liverpool University and Lian Pin Koh from the University of Adelaide.[8] Both of them are researchers of orangutans; they've made drones for researching their nests. [These were] the first ever self-made drones, which used open source design.

I was in contact with them through a platform of amateur drone makers called "DIY Drones" run by Chris Anderson.[9] In 2009, Anderson established the company 3DR robotics to develop open source hardware to make the drones fly autonomously. This was really a breakthrough because the drones could fly with or without remote control, just using GPS. This company produced an Arduino-based flight controller, which makes the drones fly autonomously. This is the brain of the drones that

processes all the flight information based on the input from the GPS. Before this was available, every drone had to be flown by someone who could see where it was going and assume the camera had captured the data, which is hard given the different altitude and other factors. This revolutionary thing was also rather cheap and it became even cheaper because, since it was open source, Chinese clones flooded the market. With 200 US dollars, you can have a system with a flight controller and GPS, which you couldn't imagine before. Systems of drones, which can fly autonomously with ground-control stations—basically a laptop or other controller, are now available on the market but are still costly, like 40,000 euros or US dollars, minimum. You need software that detects where your drone is at the moment, sets the speeds, even online, you know, things like that. It's available, but it costs a lot. So I started to assemble my own with the open source design and it cost me around 1,000 euros. With that drone I started "the drone academy" in Kalimantan, and then went to Papua and other places. I was interested in using drones to make high-precision data maps collectively—to use the maps and the drones themselves as a platform for increasing people's political power. Since the beginning, there was this idea that this is also about knowledge sharing and growing power. If we have sovereignty over our habitat, living areas through our sovereignty over data, we might have power.

ALESSANDRA: Now that drones have become so affordable, do you still assemble them yourself or do you buy them pre-assembled?

RADJA: Both. Two things came up for us: First, the requests for droning skyrocketed from various communities, be it from the community members themselves who ask or from organizations like AMAN, like WALHI (the Friends of Earth Indonesia), and also some other NGOs, and even ministries. So, even with drones available on the market, there was higher demand, which we couldn't really support. We don't have enough people to do all the training required because it's not only about making and flying the drones, it's also about the data analysis.

We do not always have enough financial resources. I started it with my personal money and was also financing partnerships with the local NGOs in West Kalimantan. To meet the demand, we started using both kinds of drones, DIY and cheap commercial units, especially from DJI-DJI, a Chinese company. I think they have almost 80 percent of the world's consumer drone market. Once they developed a version that could fly autonomously, we started using those too. They only fly 20 minutes per flight, which is okay, if you fly at an altitude of 100 meters you cover around 50 to 80 hectares per flight. The ones we make fly further because they are basically planes. The multicopters with all the rotors fly more stably, but cover less ground than the plane. We built plane-like ones with similar capabilities to those that will cost you around 40,000 US dollars. They can fly two, two-and-a-half hours. They cost us 1,500–2,000 euros. If you give us that amount, we can build you a really super one.

ALESSANDRA: So you build a drone for people and then you teach them how to fly it. Do you also teach people how to maintain it and to read the data?

RADJA: We teach how to make drones but it depends on the students. Some of them are interested in building, some in the flying. And some of them are interested in analyzing the data, which is also very good because then you have the diversity of people you need. We worked in Kalimantan, Papua, Sumatra, Sulawesi, and now we have started working outside of Indonesia. We have connections with the alliances of indigenous people of Central America.

ALESSANDRA: Who is Drone Academy now? How many are you?

RADJA: At the moment, I don't know exactly, because the Drone Academy itself was not intended as an organization, but it was completely intended as a network—as a thing where citizen science, if you want, could really flourish.

ALESSANDRA: What have you been mapping? Also, I'm actually interested in what you were saying in terms of how much the process counts more than the actual mapping, so I'd like to hear more about what you think are the effects of that mapping process?

RADJA: In term of what we have mapped, we started working with indigenous land issues, forest issues—land grabbing, to be really straightforward. We have mapped indigenous peoples' lands and also local peoples' land, to counter land grabbing. My academic papers were also around these issues. But we are also interested in environmental issues like climate change, so we've mapped, for example, peat land areas in Indonesia to develop ways of restoring them using high-precision data.

My interest in agriculture was also triggered by my research in Kalimantan, where the women we were working with during our interviews and focus group discussions told me that they had really bad harvest failure for some years already. It seemed likely that this had to do with the establishment of large oil palm plantations nearby but we didn't know how to prove it. We started wondering if there could be a system that might help them lower the risk of harvest failure. We found a system online called NDVI,[10] which is basically a spatial index telling you which plants are healthy and which are not, in term of photosynthesizing. To capture that image you need to have a camera called a near-infrared camera. To learn how to make it I went to Public Lab.[11] Their website explains that it is possible to make one, and with the help of DIY Drones we combined the two things. We are now still mapping with NDVI to promote food sovereignty. Food security and sovereignty, definitely, the two go together. Security is about the amount of food—whether it is enough or not. It is often associated with one staple crop, like rice, but we need more vitamins. It's not only about carbohydrates, it's also about other things. We have to make sure that the land, which is the source of all food, is preserved.

What we tried to do is to make a map that shows the spatial connectivities of things, so that you know what to conserve or you know what to do because it's not just about your patch of land where you plant your rice but it also has to do with nearby land uses. For example, one can think about preserving the water and how to make sure that the ground water is not decreasing because of the oil palm. We can tell this by flying drones that show that just some kilometers away you have these tens of thousands of oil palm plantations. Giving the farmers the knowledge that this is not just about your patch of land but also the rest of the territory. For example, they need to consider the possibility of more oil palm plantations. This knowledge helps them determine which plants to look after but also how to come together to protect what they have.

It is quite amazing to see how much more in control people feel when we show them the maps. Once they see how precise the images are—better than satellite images—and we zoom into the trees and plants, they feel proud of the mapping they are doing because it supports the community and can be a useful weapon against palm oil corporations.

ALESSANDRA: Do you think that because of how they are able to recognize the trees, which are very important for the indigenous peoples of the region, this high resolution allows them to bring in their traditional knowledge?

RADJA: Straight answer, yes. I tested the data several times, showing them the maps of the dense forest. I can walk with them to the forest entrance, but it will take really long whereas the drones can fly 1,000 hectares per flight—2,000 per day. Once the drone returns, we stitch the pictures together and show it to them; and so they know exactly where everything is: "Oh, this is the durian trees, oh!" It happens again and again. So I would say, yes, though I did not do a systematic study to confirm this. The images could also be useful for conflict resolutions: there are two sub-Dayak tribes in Kapuas Hulu who are in conflict over their territorial boundaries. These are not necessarily something that you can easily spot from the sky, from the satellites—even rivers sometimes are under the trees. They have used the images to spot the signs of the boundaries: "Ah! These are our trees!" One could use high-precision pictures as tools for resolving spatial conflicts.

ALESSANDRA: Spatial conflicts that don't necessarily need to go to court, that basically use indigenous knowledge about trees to identify territorial boundaries.

RADJA: Exactly. So, in a way, also supporting local knowledge.

ALESSANDRA: That's very interesting. So in a way, the maps, in addition to creating this politicization of the people because they feel empowered, produce knowledge that can be used both for agricultural practices as well as land disputes that are resolved at the level of the community. Do you also use the maps and that data as evidence for court cases?

RADJA: Yes, it was not done directly by us but by a network of activists in Jakarta, called PWYP, Publish What You Pay. I think they are also a transnational organization that promotes transparency in the mining sector. They launched an initiative called EITI, Extractive Industries Transparency Initiative, and then, in 2013 or 2014, the associations of mining companies in Indonesia, challenged the law on mining because they didn't want to build a smelter. According to this Indonesian law, any mining company working locally has to build a smelter, so that the raw materials that they take from the earth are not going directly to the importing countries but are processed here. This creates jobs—it creates additional value. An association of mining companies challenged this law and the government asked for support from NGOs. PWYP Indonesia contacted us and we sent one of our indigenous group leaders from West Kalimantan to give testimony in court using drone data proving that the mining companies are doing really serious damage in their area. We used the data to demonstrate that strong supervision from the government is needed to make sure companies abide by the rules. The government won the case in the high court of Indonesia, which deals with constitutional matters. I believe that it was the first time that drone pictures were used as a legal document. I'm not sure about other places, but certainly here in Indonesia.

ALESSANDRA: It seems like droning in general is becoming part of an activist infrastructure that supports and sometimes even catalyzes activist work and challenges to power. One of the things that I'm interested in when thinking about this infrastructure is the open character of the hardware and software. You would have not been able to build the drones had it not been for diydrones.com. But I wonder about the longevity and effectiveness of the infrastructure. How important are drones in a data activist infrastructure and what are the pitfalls of relying on them too much?

RADJA: Good questions. It's not that the drone is everything and it's not that everything is going smoothly—not at all. There are real challenges, technical and non-technical. So far, the drones that we built are cheap enough but they're still thousands of US

dollars, so the sustainability of this really depends on our capacity to secure financial support. And this has been a problem for our friends in some areas of Indonesia. They weren't really able to sustain their drone schools or the drone activism because they needed to secure their livelihood first. In some cases, they partnered up with NGOs, they wrote grant proposals and also ran other projects. So, the first challenge is financial: We need support.

In my opinion, money is one thing, but support also means social support—a system, groups, a movement. That's what is missing in my opinion—this is my self-critique, which led me to say that what is lacking at the moment, until now, is some critical research on the process itself: we need critical views on the processes, in terms of technical and non-technical aspects of the work. What is the impact? Who actually benefits from the data? Is it really helpful? Are we becoming overtly reliant on technology at the expenses of the social? What kind of technology is best? This is a challenge.

I am afraid that drones activism might fall into a trap. I feel it now, for example, when the Minister [of the Environment] herself gets too focused on the drones. It becomes hip but without understanding. I don't believe we have to drone everything. There are other sources of data—especially governments can access updated satellite images. People don't focus enough on the process that data production and analysis can trigger nor do they really consider what they want to see in the data. This renders everything technical. In terms of what we do with the data, I frame it in terms of a three "A" algorithm: data acquisition, data analytics, and data articulations. As a researcher, I would like to articulate the data by writing papers, but that's not enough. For me, drones, or any technology for that matter, need to go far into the political, into the politics of technology, of the use of technology and data. That, for me, is important and it's one of the challenges, in addition to the technological fetishism.

We also have technical challenges in terms of handling the size of the data. A high-precision map of 500 hectares of land is around 40 gigabytes of data, which is a lot. Already stitching the images together is challenging because you need powerful computers. At the moment I'm exploring how to turn Sony PlayStations into a super computer. It seems to work so far. This is one of the crowdsourcing projects that we have in mind. We want to make a website for people in Europe or America who no longer use their Sony PlayStations, so we can buy them for cheap. We are always also looking for second-hand cameras to use on the drones. People can be proud that their discarded technology has saved 500 hectares of forest. Then there is getting Internet access for people in villages. But I believe that the key is not only on the technical side but in the social system we create too. What about having somebody going every now and then from one village to the next, or to the smallest city where they can do something with data? Regularly, twice a month, for example, bringing a USB drive and talking to people instead of just having fast Internet in a village? So in that sense, I don't believe that we always have to rely just on the newest technical solutions.

Another issue to consider is how to build an information system online where one needs to compress the data. We need an algorithm to compress the data collected. This algorithm will be very useful for a lot of people in the world. If you can compress the data, you can build an information system, which takes up very little space in the cloud. At the moment, this is impossible and we have to select what we can store. But imagine if this very high-precision data could all go to the cloud, people could look at the maps from everywhere.

ALESSANDRA: So, at the moment, the processing of the data itself is a bottleneck. I would like to hear some more about the social challenges that you just mentioned, but also about gender. How many women get involved in this kind of work?

RADJA: Yes, that's also a challenge. I don't try to put myself as, you know, this superficial pro-gender parity advocate, but when women are involved there are some very important changes to the work. When a high-precision map is seen by men and by women, you often get different interpretations because there are different sets of local knowledge that come into play, that are tied to gender roles. For instance, in the context of agriculture in paddies—how to plant, when to plant, which paddy, etc.—at least in the community I was staying with, it was the women that made a difference. The women had more knowledge of these things than men.

In general, I'm convinced that if the whole process, not only looking at the maps, is done somehow equally involving both genders, it might give us really different perspectives and therefore results. But then, to answer you about numbers, there are some women involved not only in flying but also building the drones. But it's still a minority. We are thinking about how to increase participation. I just returned from Germany, speaking with my colleagues there, and the same thing came up. We are exploring options like running focus-group discussions with women only, examining the results of high-precision mapping just with them may encourage participation, especially at the beginning. I don't have to be there. Let the women lead. I always see the difference when we do focus-group discussions that involve everyone: As you can imagine, the men will talk first. The old men will talk first and long.

ALESSANDRA: So you need to have female facilitators and a set of protocols to guarantee that also the women get to speak. In general, though, this is an issue of access that applies to everyone who may feel intimidated by this kind of technical work.

RADJA: Definitely, it's not simply about being pro-women. Of course there's gender inequality in access that needs to be addressed but it's also about the richness of the perceptions that we might get if we provide equal access. In 2003, Ribot and Peluso wrote an interesting paper called "The Theory of Access,"[12] and they differentiate between access and property. They offer definitions like access is the ability of someone to derive benefits from something, while property is the right to have something. So, to return to the drones, it's not about the drone, about data acquisitions only, it's about data analytics. It's about data articulations. The second A and the third A that I mentioned earlier can't be forgotten as part of a collective process. We try our best to establish the first A, data acquisitions, with the drones in my case, as collectively as possible, but the way we analyze the data and the way we articulate it, it's a political process as well, and needs to be collectivized. I totally agree with you, the ability to derive things from the data is not the right of the experts alone, but of us all. So, personally, I really want to disappear in the collective effort of data analysis, challenging the hegemony of a few of us who "own" the data.

To go back to the issue of gender, for example, if I enter the women groups, people will say, "You're a man, you're good." In other cases, if I enter a community, people will step back and let me work, saying things like, "You went to the best school in Indonesia, you are even an engineer." They see me as special. But I didn't learn all this stuff with the drones in school. So it is way better if I step back. It is great that we have Patria now. Even though she was educated in France, she's a woman, and this makes a huge difference. She can teach other women, and their level of education doesn't matter all that much. So the second and third "A" need to be developed

while keeping in mind some of the challenges we have discussed. If we don't really think about the research—I mean, critical research on the whole process—our work might go the way of other technologies: commercialized, overly technical, privatized and black boxed. It seems at the moment that communities and NGOs are innovating with their use of drones, they are ahead of the private sectors and government, so there's a chance. But if we don't do it properly, attending to all aspects of the process, we will exclude many stakeholders, and for-profit companies will take over this kind of data production and analysis, like they have done with other technologies.

Acknowledgments

Thank you to Irendira Radjawali, Anne-Sophie Springer, Etienne Turpin, Alifa Rachmadia Putri, Basuki Budi Santoso, Paulo Tavares and Eyal Weizman for the insightful conversations and for inviting me to join them in Central Kalimantan. Thank you to Lucas Freeman for his comments on this interview.

Notes

1 Irendra Radjawali is a scholar activist associated with the Department of South East Asian Studies, Bonn University. He was a principal researcher on the project "Connecting the Urban and the Rural: A Political Ecology of the Kapuas River (Kalimantan, Indonesia)" (2011–15, funded by the DFG) and introduced the drone as a component of the action research. He is currently training hundreds of activists in Indonesia and globally in the construction and use of drones for counter-mapping, Big data analytics, and AI algorithm for social-ecological justice. Radja's current (action) research focus is on data politics, and ethics and algorithm politics.
2 Irendra Radjawali was interviewed on June 6, 2017.
3 Often for the purpose of poaching or getting concessions for oil palm plantations.
4 See Anna-Sophie Springer and Etienne Turpin, eds., *Reverse Hallucinations in the Archipelago*, Intercalations 3 (Berlin: K Verlag & Haus der Kulturen der Welt, 2017), 204–19.
5 "Dayak" is a generic term to describe over 450 ethno-linguistic indigenous groups with shared linguistic and customs on the island of Borneo, which includes territories that are now part of Indonesia, the Malaysian Federated States of Sabah and Sarawak, and Brunei Darussalam.
6 See Indymedia Montreal 2016 Convergence Working Group, "Holding Out for Un-alienated Communication," *Briarpatch Magazine* (January 2017), https://briarpatchmagazine.com/articles/view/holding-out-for-un-alienated-communication.
7 *Aliansi Masyarakat Adat Nusantara* (AMAN) is the Alliance of Indigenous Peoples of the Archipelago. It is an independent community organisation advocating for the rights and quality of life of all Indigenous Peoples in Indonesia. AMAN works locally, nationally and internationally to represent and advocate for Indigenous Peoples' issues. See *Aliansi Masyarakat Adat Nusantara*, accessed December 25, 2018, www.aman.or.id/.
8 Conservation Drones, accessed January 6, 2019, https://conservationdrones.org/.
9 DIY Drones, accessed December 25, 2018, https://diydrones.com/.
10 Normalized Difference Vegetation Index (NDVI) is used to measure the amount of live vegetation in an area. This system is used for agricultural assessment.
11 Public Lab is a community of citizen scientists investigating environmental concerns through the use of inexpensive DIY techniques, see: Public Lab, accessed January 6, 2019, https://publiclab.org.
12 Jesse C. Ribot and Nancy Lee Peluso, "A Theory of Access," *Rural Sociology* 68, no. 2 (2003): 153–81.

13 Politics of Design Activism
From Impure Politics to Parapolitics

Thomas Markussen

July 20, 2017: A 63-year-old woman sits cross-legged on the sidewalk at Nørrebro Station in Copenhagen and begs for money with a cup in front of her. August 1, 2017: the woman is sentenced to 20 days in prison for this deed; subsequently she is expatriated from Denmark to her home country Romania and given a 6-year entry ban. According to EU law, a member state can punitively expel a citizen from another EU country only if there is evidence that this citizen is a threat to the basic interests of its society. In court, the prosecutor pleaded that the woman had disturbed the general public by seeking eye contact with passers-by and eventually, since this was the third time she was caught begging, she was found guilty.

This sentencing was a direct result of a June 2017 clampdown in Danish law through Act L 215 on Punishment for Insecurity Evoking Importunity. With the "Beggar Act," as it was promptly labeled in the media, the politicians in Parliament gave local governments and police jurisdiction to displace homeless people of foreign origin. The Act was rushed through, not least because Frank Jensen, the social democratic mayor of Copenhagen, had complained that Romanian gypsies disturbed the public order by camping in public parks and begging on the streets. In fact, workers at the local Trinitatis Church were offered inoculations for hepatitis A due to their daily task of removing human excrement from the church park, bearing witness to some risk to public hygiene. I mention this incident not to belittle the health and safety concerns of many Copenhageners, but as an example to discuss the ongoing neoliberalization of the city and the social inequalities that follow from it.

What does the Beggar Act have to do with neoliberalism? Neoliberalism manifests itself, for instance, at a discursive level in the Act, as it states that aggravating circumstances are when begging takes place "on pedestrian streets, near stations, inside or near supermarkets or in vehicles for public transportation" (L 215, § 197, stk. 2). Supermarkets are singled out with pedestrian streets, which in Denmark are synonymous with shopping streets. Hence, one might suspect that the general public that is "disturbed" and which the Act has been passed to protect is largely that of the consuming public in central city areas. Or to put it bluntly: the Beggar Act is an example of yet another anti-homeless strategy that, according to Purcell, is criminalizing "everyday acts of survival (sitting on sidewalks, sleeping on benches, urinating in alleys) so that zero-tolerance policing has the power to remove the homeless from places that are not desired and contain them in other, more marginal places."[1]

In urban theory and geography, the notion of "neoliberalization" is used precisely to denote those mechanisms of exclusion that are characteristic of capitalist forms of urbanization.[2] Besides the intensity with which shopping malls and consumer areas are taking over urban space, such forms may manifest themselves in large-scale gentrification projects leading to rising house prices and the displacement of what Zygmunt Bauman refers to as "defective consumers," thereby designating those people who are not able to spend at a level deemed appropriate.[3] This group is constantly expanding and rather diverse, ranging from low- and middle-income groups, youth and students who cannot afford living in central city areas, to migrants and refugees who are fleeing poverty and war zones in their home countries to make a better future in the so-called "Global North." However, what they all have in common is that they are driven out of the city as a result of neoliberal commodification of urban space— space that becomes a site for investments, hyper-consumption, profit-making and city branding.

In this chapter, I am particularly interested in how design activist practices can be used in urban space to protest against and, at the same time, engage with some of these social and political issues.[4] This form of design activism is also known as urban activism, DIY urbanism, or tactical urbanism, which are often associated with the Right to the City movement. I will attempt to cast some light on the questions: what can be expected of design activism in urban space? To what extent does design activism enable emancipation from neoliberalism, if at all? These questions may at first seem misplaced. After over a decade with a growing number of research networks, publications, and conferences focusing on design activism, one would think that this issue has been extensively covered. Admittedly, rich sources exist on how urban activism works and its multifaceted forms. However, theoretical frameworks and critiques of design and urban activist practices differ quite significantly from each other in terms of how the emancipatory power and outcome are conceived. Focusing on urban activism and the Right to the City movements, at one end of the spectrum scholars like Harvey, and Borasi and Zardini, argue for unifying activist struggles into a totalizing movement that as its goal has the complete overturning of neoliberalism.[5] At the other end, Purcell, Mayer, and Schrijver argue more moderately that often activist urban practices are more likely to be seen as tangled up in neoliberal forces and creative city policies, even though "it means running the risk of becoming part of the system."[6]

Here I shall argue that the divergence between these two opposite views relies to a large degree on different *politics* of design and urban activism. By "politics," I mean the idea of design's capacity to resist and contest existing paradigms of power and control. To fully understand the politics of design activism, it is necessary to make a nuanced analysis of how dissent can be enacted through design activism in opposition to the ruling neoliberal system, and at the same time allow for varying outcomes. To clarify these various outcomes, I shall initially survey a radical and moderate interpretation of urban activism predominant within the existing literature. Then, I will elucidate the difference between these two interpretations by drawing upon the philosophical work of Jacques Rancière, notably his concept of dissensus. Following from this largely theoretical analysis, I will consider some design activist projects in Denmark, discussing whether and to what extent they enact dissensus in urban space. In conclusion, I shall argue that design activism in this context finds itself inextricably tied up with some contradictions and paradoxes.

Urban Activism as Revolution or Intervention

The city has always been a site of political struggle. But in the last decade, the intensity and severity of protesting acts in the city have dramatically increased. In Europe, which is the broader context of this chapter, these protests have manifested themselves in political forms such as mass demonstrations (e.g., during the Cop15 in Copenhagen and the G20 meeting in Hamburg), social counter-movements, and media activism, as well as through critical aesthetic practices within art, architecture, and design. Among scholars it seems to be commonly agreed that the current attention towards the city and politics—across various practices and disciplines—has to do with the desperate fiscal attempts to save the global economy (not the planet). In order to protect the city from yet another collapse, neoliberalism responded with its unmistakable hijacking of governance and the surveillance and anti-assembly policing occurring in the aftermath of 9/11, and incessantly after the tragic Islamist-extremism-inspired attacks in Nice, Manchester, London, Berlin, Brussels, Copenhagen, Stockholm, Paris, Madrid and Barcelona.

Under the label "the right to the city," many urban activist practices have been heralded for their ability to reclaim the streets and to give spatial agency to those who have no part in the neoliberal city.[7] However, activists and scholars have debated how much such practices are in fact able to resist neoliberal forces and control, and whether they can effectively lead to emancipation. Harvey, for instance, raises concerns that these practices are too fragmented to be able to effect any systemic changes.[8] In his view, what is required is that urban activists unite forces under a totalizing movement that has as its goal the definitive revolt against neoliberalism. Echoing Harvey, Borasi and Zardini observe new "microbe-like, singular and plural practices that develop outside the rules and regulations that inform our current urban system." They further argue that if these practices are to have a real impact, a "true and proper cultural revolution is necessary."[9]

However, in a direct critical response to Harvey, Crawford accuses him of adhering to an old grandiose hope of Marxist mass-revolution, which is out of tune, she claims, with how the right to the city was originally conceived by Lefebvre.[10] According to Crawford, we need to appreciate pragmatic urban experiments based on specific demands and be careful to avoid "irresponsible idealism."[11] Such experiments are spontaneous and tailor-made "to the needs of the inhabitants," and "results in a city produced for use rather than exchange values."[12] By "needs" one should not think of basic needs such as housing, access to water, etc., but of a human need for being able to freely project "alternative possibilities for urban life." The outcomes of such processes of urbanization may be unpredictable and "often paradoxical."[13]

Crawford's call for appreciating small-scale urban practices in themselves is echoed by Schrijver, who likewise (but not explicitly targeting Harvey) points out a gap between "totalizing theory and individualistic praxis," which, she says, "continues to be problematic of the evaluation of urban activism."[14] Rather than seeing them as being engaged in a radical transformation of the status quo, micro-spatial interventions must be considered, she argues, as taking place on "blurred boundaries" or on "the periphery of constraints" within the dominant order. In so doing, Schrijver disagrees with Borasi and Zardini's idea of these practices taking place outside the urban system.

In line with Schrijver, Mayer further argues that often, especially in the metropolitan north, it is not possible to clearly separate urban activism from neoliberal forces.[15] The

ongoing neoliberalization of the city has led to "a whole new set of policies that center on the marketization" of the creative city in order to "compete for global investors, affluent residents and tourists."[16] In this context, creative city policies often hijack urban activist practices for the purpose of making "event cities" and "culture cities." "First world activism" is Mayer's own term for these activist practices, while she uses "austerity activism" to denote those practices that advocate for poverty alleviation and consider the social needs of disadvantaged groups. Through a subtle analysis, she shows that today, austerity activism is often usurped as the essential ingredient in neoliberal urban policies, for instance, as part of local regeneration programs.[17] Her salient point is therefore that neoliberalism has a deep impact on both forms of activism and we need to work out a differentiated analysis of how they intertwine.

The disagreement I have only roughly sketched out here is representative of two opposite views predominant in the literature on urban activism. On the one hand, there is the radical idea proposed by Harvey, Borasi and Zardini, and others that urban activism is able to emancipate people at a systemic level, but only if it unites singular practices into a totalizing social movement of some sort. On the other hand, Crawford, Schrijver, Mayer, and Purcell represent a more moderate interpretation according to which the emancipatory power of urban activism is downscaled to meet social needs and demands at a local micro-level. This may even entail, as Mayer points out, that activist practices are instrumentalized, if not enslaved, by the very same capitalist forces that cause these needs and demands in the first place. A genuine concern is that if urban activism is conditioned by the hegemony of neoliberalism, does it not, then, lose its ability to resist and change the neoliberal city?

Does it still make sense to talk about activism, when urban activism is either exploited for the purpose of mobilizing event culture or taken hostage by roll-out policies that outsource social problems to volunteers and civic society? The first is usually the case with first world activism, and the second with urban activism within austerity. An affirmative answer to this question would require an elaborate explanation of how urban activist practice may lead to some kind of emancipation, while at the same time getting caught up in an endless and irresolvable struggle between acts of resistance and systems of power. Interestingly, such an account can be found in Rancière's political philosophy, to which I now turn.

Dissensus—Between Policing and Politics

The offer of Rancière's philosophy to design research is an invaluable explanation of how dissent or "dissensus," which is his preferred term,[18] can be brought about through aesthetic practices such as design and urban activism. As dissensus in Rancière's work can only be understood as an opposition of logics between what he refers to as "the police" and "politics," initially I will define these two concepts before returning to how dissensus can be enacted through urban activist practices.

In political science, it is common to associate systems of power and authority with the organization and the broad set of procedures that allow a specific political system to govern. Formally, governing as such can be manifested through the passing of acts and laws, the organization of political parties into parliaments, election procedures, and so on. However, power and authority should not be taken, as

Rancière warns us, as identical to "state institutions and governmental practice."[19] On the contrary, orders of domination extend into all aspects of human life and experience and make themselves felt, although sometimes only imperceptibly, in people's everyday practices and domestic life—i.e., how they think, talk, care for, and interact with each other.

Rancière's notion of "the police" refers precisely to how social formations, broadly speaking, can always be seen as distributing inter-human relations so that bodies and parts are "assigned by name to a particular place and task."[20] There are those, for example, who are allocated positions within the social order to be thought of and spoken about as rich and poor, middle class and working class, knowledgeable and ignorant, residents and migrants, powerful and weak, and so on. Such formations are fundamentally asymmetrical and structured into hierarchies. To establish such hierarchies, the police order must rely on ways of counting empirical parts of the social formation. People are divided into actual groups by their difference in birth, income, class, race, different functions, locations, and interests that are counted as constituting the social body.[21] Although such ways of counting can only be arbitrary, the police work through sophisticated processes of naturalization that seek to legitimize and make self-evident this counting and distributing of parts.[22]

Politics, on the other hand, is a momentary interruption and disordering of the police order. It is often conceived of in terms of a rupture that puts an existing police order into question by revealing "a miscount" or "wrongness." Notice that this wrongness should not be taken as the dismay or protest of certain groups or individuals. For Rancière, politics is not about expressing the interests and values of pre-existing identities or acts that are carried out by political subjects. Rather it is "a mode of expression that undoes the perceptible divisions of the police order by implementing a basically heterogeneous assumption, that of a part of those who have no part."[23] This means that politics reveals parts that are not yet inscribed into subjectivities or positions. If the police order, as mentioned above, is defined by assigning a name to bodies and parts so as to distribute them into particular places and tasks, then politics is the rupturing of this distribution so as to open a gap between name, body, and place. It is this gap between the ordinary perceptual field and meaning, between what is sensed and makes sense, that Rancière refers to as "dis-sensus."

Dissensus can manifest itself as a heterogeneous mode of expression in the form of political dissensus or aesthetic dissensus. Political dissensus is brought about through speech acts and political moments, while aesthetic dissensus can be conceived of as the disruptive effect of critical aesthetic practices. In both cases, dissensus holds a potential for emancipation, because it's opening-up of a gap allows for "new processes of subjectification," i.e. the renegotiation of roles of identities and a redistribution of ways of being, doing, and speaking. However, it is relevant to ask just how much can be expected of this emancipatory potential? Rancière would no doubt claim that this is the wrong way of posing the question. For him, a subject cannot instrumentalize dissensus for a political purpose. Dissensus is the momentary clash between politics and the police, and he insists that one cannot anticipate when it occurs and what comes after.[24] Hence, as Clarke has eloquently argued, what Rancière ultimately offers is a "politics of moments," rather than a "politics of movements" towards social change.[25]

Another basic tenet of his work is that the police order should not be conceived of in pejorative terms and most certainly not identified exclusively with an oppressive state, regime, or capitalist power. This point has been foregrounded, among others, by Chambers, who posits that police orders "are nothing more nor less than the very social order in which we all live."[26] What dissensus, produced through politics, can do is renegotiate and redistribute the police order; it can never escape from or replace it, as "it is always bound up with the latter."[27] For the same reason, Chambers argue that politics should always be thought of as "impure politics."[28] In line with this interpretation, dissensus should therefore not be taken in pure politics terms as if it would be able to completely revolt against and destruct the police order. On the contrary, police orders are most often incredibly apt in mastering dissensus by finding flexible ways of allocating it into new places and names within the existing order. One lesson of Rancière is that liberalism and neoliberalism provide two vivid examples of how police orders seek to eliminate dissensus by "cordoning it off into one small corner of a larger philosophy of order."[29] This neoliberal taming of dissensus has a certain name—it is called "parapolitics".

On the basis of the distinction between pure, impure, and parapolitics, we can now elucidate more precisely not only wherein the disagreement among urban activist theorists lies but also the inconsistencies and paradoxes that are claimed to be characteristic of urban activist practice. Harvey, Borasi, and Zardini understand urban activism in a pure politics sense as if it has the power to destruct and replace the neoliberal order, while the arguments mobilized by Crawford, Schrijver, and Mayer represent an impure politics position where urban activism may lead to momentary micro-like ruptures of that order, if only to be outmaneuvered and tamed afterwards. Hence, in their account, parapolitics lies just around the corner, so to speak, as a condition of urban activism.

In the following section, I shall redirect my attention towards the city of Copenhagen and a specific intervention made by an urban activist collective aiming at creating a more socially just and inclusive city. What I want to exemplify is that Rancière's notion of dissensus allows us to make a nuanced analysis of how urban activism may contest the order and hierarchy of the neoliberal city. However, by extending the analysis beyond the intervention itself, it also becomes clear that the enacting of dissent is deeply entrenched in complex and contradictory processes of exclusion, which can be properly understood by applying the concepts of impure politics and parapolitics.

Da/ennis Design Centre

In 2011, the design activist collective Bureau Detours[30] installed DENNIS Design Center as a temporary urban installation on Prague's Boulevard in Copenhagen, to last for about two weeks. DENNIS Design Center, which was part of the Metropolis festival, consisted of two freight containers fully equipped with wood, tools, bicycles, barbecues, and around 20 carpenters, designers, artist, architects, teachers, among others, who invited local citizens to take part in "designing useable designs inspired by local demand and site specific issues."[31] According to a newspaper article published at around the time of its opening, in a few days DENNIS Design Center had led to a transformation of a toxic site to a place where the locals took part in reshaping the area, discussing contemporary urban planning and collective street cooking events (Figures 13.1–13.3, Plate 9).[32]

Figure 13.1 DENNIS Design Center, an urban installation by Bureau Detours. Transforming a site on Prague Boulevard. Delivery of freight containers, Copenhagen, August 2011.
© Bureau Detours.

Figure 13.2 DENNIS Design Center. Preparing the site on Prague Boulevard.
© Bureau Detours.

Figure 13.3 DENNIS Design Center. Folk kitchen and public dialogue.
© Bureau Detours.

As a tongue-in-cheek hoax, a young man called Dennis was presented as the founder of the Design Center. He was portrayed as a design hipster, dressed up in a knight's attire, and described as "a weird, but most clever, 2.20 meter tall design enthusiast from Rotterdam in the Netherlands," who had asked the collective to collaborate with him.[33] Dennis was unable to attend the opening, but a speech presumably authored by him was read aloud. In DENNIS Design Center, citizens met design at street level and they collaborated with the activist collective in the making of free DIY furniture or the welding together of tall bikes.

This urban project provides a paramount example of aesthetic dissensus enacted through design activism. On August 20, 2011, the day of the closing of DENNIS Design Center, Bureau Detours officially received an email from the national Danish Design Center, demanding that the collective would stop using the name DENNIS Design Center and erase it on their website.[34] Allegedly, this was because "Dennis" phonetically sounded like "Danish" in English, and DENNIS Design Center used the same abbreviation "DDC," which was conceived of by the Danish Design Center as a violation of copyright. Bureau Detours was then given an ultimatum until September 6. If they did not accede to this demand, the Danish Design Center threatened to withdraw their invitation to the collective to exhibit work during the Copenhagen Design Week later that year. After an open meeting, the parties agreed however that there was "room for yet another design center, a practical of the kind."[35] So, when DENNIS Design Center re-opened its freight containers for

a wider public at the Milan Design Week in 2012, it was with the acceptance of the Danish Design Center.

Aesthetic dissensus here is heard in the phonetic slippage from a to e, an audible rupture that opens up a gap between design artifacts and the particular name and place they are allocated in the existing social order. By introducing heterogeneous DIY objects and modes of expression into urban space, which bear a brand unmistakably sounding like Danish Design, but visually very alien from it, DENNIS Design Center disturbed the institutionalized promoting of Danish Design in business and industry. To follow the line of reasoning in Rancière, this is not an act of resistance carried out by political subjects. No, it is rather a moment of interruption occurring unexpectedly at the end of the festival that made sensible a logic of equality, namely that the DIY furniture of local residents could be taken as synonymous with Danish Design. This aesthetic dissensus reveals as hollow the glorified branding image of Danish Design being promoted by the Danish Design Center as socially inclusive, rooted in true craftsmanship and design for the people. The citizen participation and furniture manufacturing enabled by DENNIS Design Center made perceivable a wrong between Danish Design Center's naming of Danish Design as democratic and the expensive furniture classics of Danish Design displayed as status symbols on pedestals in glamorous showrooms and magazines. In the gap opened up by this aesthetic dissensus, it became possible, if only for a moment, to let Danish Design take visible and audible form as furniture being designed not for a unified people, but for and by a multitude of local residents.

What can be derived from this example? First of all, in my view, it shows that aesthetic dissensus here is not enacted in the pure anarchistic form of an institutional overturning of the Danish Design Center, nor is it entirely enslaved by this order. DENNIS Design Center enacts aesthetic dissensus that should be conceived of as impure politics—at least in the moment of interruption, and until the conflict between the activist collective and Danish Design Center was settled. However, it remains a central question whether or not this aesthetic dissensus is itself mired in a series of contradictions and paradoxes having to do with how it is bound up with the policing order.

The Copenhagen Municipality and the Danish Arts Foundation sponsored the Metropolis Festival in order to explore the notion of the creative city and how urban space can be made for the many rather than the few.[36] However, the apparent goodwill and attention towards social inclusion should be held up against the de facto creative city policy in Copenhagen, which has been criticized for advocating the opposite. A critical incident, often referred to in the debate, is the 2007 tearing down of a historic building formally known as the House of the People on Jagtvej 69, which for 24 years hosted a civic cultural center where activists and volunteers collectively supported and gave space to artistic workshops, a folk kitchen, and an underground music and performance scene. But the Municipality sold the building to Faderhuset, a small congregation that founded a "free church" (a church that was not part of the nationally established church *Folkekirken*); the site was cleared by the police on March 1, 2007, and was finally demolished around midnight on March 6.

Paradoxically, the Metropolis Festival was organized the very same year, as an event where culture and the arts should regenerate urban space to include exactly what the House of the People seemed to offer. With this backdrop, however, it

becomes evident that we are indeed dealing with two incompatible notions of "the many" and "the creative city." The many of the House of the People represents what Mayer refers to as austerity activists, who remain at a leftist and autonomous distance from the political system and neoliberalism,[37] while the many of the Metropolis Festival must be conceived of as first world activists who participate in an event where culture and the arts are deliberately exploited for purposes of creative city branding. Moreover, since the Danish Design Center had, in fact, invited Bureau Detours, the collective behind DENNIS Design Center, to participate in Copenhagen Design Week, the collective was already recognized by the national institution as representing a certain branch of contemporary Danish design. Hence, DENNIS Design Center was deeply infected by the national branding strategy it humorously contested.

In fact, both the first world activist members of Bureau Detours and the austerity activists thrown out of the House of the People were tangled up in the ruling political power and agendas. On October 11, 2007, the austerity activists were invited to a meeting with the social democratic Mayor Ritt Bjerregaard, and agreed that an old building on Dorotheavej 61 would be transformed into a new House of the People. In so doing, the mayor effectively put an end to the mass demonstrations, squatting, and uproar in the streets of Copenhagen that had continued as a result of the police clearing of Jagtvej 69. By moving the House of the People from its previous address in the Nørrebro district to the poorer marginal district of North West, the mayor could even hope that underground culture and art would yet again regenerate old industrial buildings and city districts to become a sign of a hip and creative neighborhood.

Insofar as activism in this way was "cordoned off into a corner"[38] by the local government, one can argue that the impure politics of urban activism are eliminated by the policing order. More specifically, it exemplifies what Rancière calls "parapolitics." Parapolitics is precisely when acts of resistance and interruption are inscribed into a particular place, one that is already accounted for in the police order. Hence, the dissensus that occurred as a result of the marketization of urban space and the sale of the House of the People was tamed, as the mayor allocated the austerity activists to a new area. In a similar vein, the aesthetic dissensus brought about by DENNIS Design Center was subsequently policed into an event economy, as the first world activists from Bureau Detours participated in the design weeks in Copenhagen and Milan. Consequently, rather than resisting neoliberalization, both incidents show that urban activism is itself a victim of its mechanisms of exclusion.

Concluding Remarks

In this chapter, I have argued—in line with other authors such as Crawford, Schrijver, Mayer, and Purcell—that a theory of dissent as enacted through design activism in urban space needs to take into account how practices of contestation are inextricably bound up with the systems of power and control that they seek to subvert. On the basis of Jacques Rancière's work, I further argued that this intertwining of dissent and power could be adequately accounted for as a collision between politics and a policing order. Such a collision may effectuate aesthetic dissensus, understood as a momentary rupture or disordering of the policing order, rather than the overturning of it. Through this disordering, a wrongness can be made visible and

bodies and parts can be wrested out of the name and place they are assigned in the police order. Whether or not a lasting change of the police order ensues cannot be anticipated.

The implications of my analysis are twofold. First of all, for design research, I hope to have provided a sound argument for why we should not think about urban activism as an outside force that works itself into a neoliberal system in order to tear it apart. No doubt, one can only hope for the decline of neoliberalism, but if we really want to understand what can be expected of this type of activism, we need a more fine-grained conceptual frame of analysis—one that extends well beyond the singular intervention and which takes into account the whole urban ecology where the intervention unfolds, including material and immaterial factors such as city policies, laws, planning manuals, news and media, and so on. By doing so, I showed in the two case examples how aesthetic dissensus was eventually eliminated by neoliberal urban policy and the event city. More concisely, the aesthetic dissensus occurring with DENNIS Design Center was swiftly instrumentalized to become a part of the national branding of design, and the new House of the People has become a controlled place for underground culture and art. In this sense, these instances show how the impure politics of urban activism are transformed into parapolitics.

Secondly, the implication of my analysis should not be taken as if I see no emancipatory power in urban activism. On the contrary, I hope that the unraveling of the mechanisms of exclusion inherent in the neoliberal system will inspire or inform urban activist practices in their sustained attempt to reclaim the right to the city. I should emphasize that the context of my study is limited to the metropolitan north, where—to follow Mayer—activism typically takes the form of either first world or austerity activism. The activist projects I discussed belong to these categories and therefore the conclusion of this chapter should not be exaggerated and generalized to urban activism per se. Dissent and resistance must be understood in the moment and the setting in which it occurs.

Acknowledgement

This work was supported by the Danish Council for Independent Research (grant number DFF-4180-00221). I would like to thank Bureau Detours for permission to use project images, Jonas Fritsch, Bodil Marie Thomsen, Kristine Samson, and Camilla Møhring Reestorff from the Affects, Interfaces, Events research project, as well as Anna Feigenbaum and Anna Munster for their valuable comments on earlier versions of this chapter.

Notes

1 Mark Purcell, *Recapturing Democracy. Neoliberalization and the Struggle for Alternative Urban Futures* (New York: Routledge 2008), 22–23.
2 Neil Brenner, et al., *Cities for People, Not for Profit: Critical Urban Theory and the Right to the City* (New York: Routledge, 2012).
3 Mirko Zardini, "A New Urban Take Over," in *What You Can Do with the City*, eds. Giovanna Borasi and Mirko Zardini (Montréal: Canadian Centre for Architecture, 2008), 12–19.

4 This chapter is a sequel to my earlier article: Thomas Markussen, "The Disruptive Aesthetics of Design Activism: Enacting Design between Art and Politics," *Design Issues* 29, no. 1 (2013): 38–50.
5 David Harvey, "The Right to the City," *New Left Review* 53 (2008): 23–40; Zardini, "A New Urban Take Over," 12–19.
6 Purcell, *Recapturing Democracy*; Margit Mayer, "The Right to the City in Urban Social Movements," in Brenner, et al., *Cities for People, Not for Profit*, 63–85; and Lara Schrijver, "Utopia and/or Spectacle? Rethinking Urban Interventions through the Legacy of Modernism and the Situationist City," *Architectural Theory Review* 16, no. 3 (2011): 246.
7 See, for example, Nishat Awan, et al., *Spatial Agency: Other Ways of Doing Architecture* (London: Routledge 2011); Borasi and Zardini, *What You Can Do with the City*; Margit Mayer, "The 'Right to the City' in the Context of Shifting Mottos of Urban Social Movements," *City* 13, no. 2–3 (2009): 362–74; Lee Stickells, "The Right to the City: Rethinking Architecture's Social Significance," *Architectural Theory Review* 16, no. 3 (2011): 213–27.
8 Harvey, "The Right to the City."
9 Zardini, "A New Urban," 15.
10 Margaret Crawford, "Rethinking 'Rights,' Rethinking 'Cities': A Response to David Harvey's 'The Right to the City,'" in *The Right to the City*, eds. Zanny Begg and Lee Stickells (Sydney: Tin Sheds Gallery 2011), 33–38. See also Henri Lefebvre, "The Right to the City," in *Writings on Cities*, eds. Eleonore Kofman and Elizabeth Lebas (New York: Blackwell 1996), 63–181.
11 Crawford, "Rethinking 'Rights,'" 35.
12 Ibid., 34.
13 Ibid., 34.
14 Schrijver, "Utopia and/or Spectacle?" 246.
15 Mayer, "The 'Right to the City' in the Context of Shifting Mottos," 362–74.
16 Margit Mayer, "First World Urban Activism: Beyond Austerity Urbanism and Creative City Politics," *City* 17, no. 1 (2013): 9.
17 Ibid., 12.
18 Jacques Rancière, *Dissensus: On Politics and Aesthetics*, ed. and trans. Steven Corcoran (London and New York: Continuum 2010).
19 Jacques Rancière, "The Thinking of Dissensus: Politics and Aesthetics," in *Reading Rancière*, ed. Paul Bowman and Richard Stamp (London and New York: Continuum 2011), 3.
20 Jacques Rancière, *Disagreement: Politics and Philosophy* (Minneapolis: University of Minnesota Press 1999), 29.
21 Rancière, *Dissensus*, 35.
22 Cf. Samuel Chambers, *The Lessons of Rancière* (Oxford and New York: Oxford University Press 2013), 66.
23 Rancière, *Disagreement*, 30.
24 Rancière, *The Emancipated Spectator* (London and New York: Verso Books 2009), 63.
25 Jackie Clarke, "Rancière, Politics and the Social Question," in *Rancière Now—Current Perspectives on Jacques Rancière*, ed. Oliver Davis (Cambridge: Polity Press 2013), 21.
26 Chambers, *The Lessons of Rancière*, 66.
27 Rancière, *Disagreement*, 31.
28 Chambers, *The Lessons of Rancière*, 58–59.
29 Ibid., 29.
30 Bureau Detours were established in 2006, and define themselves as a "creative organization" with "interest in creating social environments in public spaces … A diverse mix of disciplines like designers, craftsmen, architects and visual artists work together to solve the task ahead." They "construct urban studies and present design methods in scale 1:1 in the public space." Bureau Detour, accessed on January 7, 2020, https://detours.biz/bureau-detours/.
31 "DENNIS Design Center," Bureau Detour, accessed on January 12, 2020 www.in-situ.info/en/artists/bureau-detours/works/en/dennis-design-center-39.

32 Birgitte Kjær, "DENNIS Design Center Er Åbnet På Amager" ("DENNIS Design Center Opens on Amager"), *Politiken*, August 11, 2011, https://politiken.dk/kultur/art5439146/Dennis-Design-Center-er-%C3%A5bnet-p%C3%A5-Amager.
33 Sophie Haack, et al., eds., *DENNIS Design Center—W.I.P.* Bureau Detours (Aarhus, 2012), 26–27.
34 Peter Nicolai Gudme, "Designcenter Vil Beskytte Sig Mod DENNIS Design" ("Designcenter Wants to Protect Itself against DENNIS Design"), *Politiken*, September 3, 2011, https://politiken.dk/kultur/art5024452/Designcenter-vil-beskytte-sig-mod-Dennis-Design.
35 Haack, et al., eds., "DENNIS Design Center," 21.
36 "Performance and Art in Public Space," *Metropolis*, accessed on March 6, 2018, www.metropolis.dk/en/.
37 Margit Mayer, "First World Urban Activism: Beyond Austerity Urbanism and Creative City Politics," *City* 17, no. 1 (2013): 5–19.
38 Chambers, *The Lessons of Rancière*, 29.

Part 2

Spaces of Contestation and Prefiguration

14 The Agonistic Design of Conflict Kitchen

Verónica Uribe del Águila

Conflict Kitchen (CK), a long-running, socially engaged art project by artists Jon Rubin and Dawn Weleski, was committed to serving meals from countries in active conflict with the United States, so as to challenge the polarizing versions of US international relations portrayed in the press. Beyond a focus on the countries in question, during its seven-year tenure (from 2010 to 2017), CK also became both a contested site for addressing conflicts relevant to the Pittsburgh community and a locus for discussing a variety of issues across culture, labor, race, territory, and even conflict itself.

Unlike most restaurants, CK did not aim merely at providing a smooth dining experience in exchange for money, nor did it expect only payment from its customers in return for their lunch. Instead, on a daily basis, the staff strategically used restaurant-related activities and objects—food purchasing and eating, as well as the menu, façade, and packaging—to spark moments of discussion. The production and maintenance of such a site was achieved in part through diverse and intermittent tactics. These aimed at "reframing the capitalist economic exchanges"[1] of the restaurant in order to generate community relations, instead of only profits, through such exchanges. Besides paying for their food—which already constituted, according to the artists, a form of engagement—customers were welcomed and expected to participate in discussions or/and contribute through other ways of engagement such as having lunch with members of the country addressed, collaborating with the project's cooking classes and other events, or simply inquiring about the project, as I did during my first visit in June 2014. For its creators, every engagement provided value and meaning to the project in its present iteration; hence each engagement was addressed, reflected upon, and incorporated. Similar forms of exchange and engagement took place between the artists and the kitchen staff. Those relationships constituted the core of the project.

This chapter maintains that CK fostered the articulation of agonistic public spaces through the exploration of different accounts of history and commensality, which allowed the emergence of new collective subjectivities around this restaurant's operations and meanings, and by extension the rise of questions surrounding capitalism and politics. Drawing on interviews, participant observation, and discourse analysis, the chapter analyzes Conflict Kitchen—its materiality, in situ operations, and research methodology—in order to explore the role that design played in CK's constitution of publics as a political category. Finally, this chapter contributes to broader discussions around embedded values in design, and around design activism and its possibilities for promoting social change.

"The Political," Agonism, and CK's Design

Located alongside other takeout restaurants on Schenley Drive in Pittsburgh, Pennsylvania, CK constantly reshaped itself in order to maintain the concept of conflict at the center of its activities. Following the familiar restaurant script, CK made use of graphic design for the façade, menu, and food wrapper, and in its architecture. Yet as a site of conversation, CK mobilized operations that subverted these scripts, tweaking familiar objects and forms of economic exchange to foster other forms of engagement around politics. It did so without compromising the familiarity of the interactions that take place in a restaurant. This aspect ensured the flow of "collaborators," which is how CK perceived its clients.

Although the artists themselves earned no profit, the project mimicked a typical takeout restaurant. CK was funded mostly (around 95 percent) by its own revenues.[2] Prices had to adjust to the market, dishes had to comply with takeout food standards (regarding speed, flexibility, and sanitary requirements), and workers were paid. More than the typical customers and workers, however, CK patrons and staff were treated as collaborators because they cared enough to spend their money and time at the restaurant. This demand for further engagement encouraged both groups to reflect and imagine other possible meanings for these familiar, mundane objects (food wrapper, menu, façade), including their nonverbal interactions with such objects (eating, sitting, looking), exchanges in the restaurant (paying, ordering, being paid for their labor), and the broader notions they encountered within the project (country, culture, community).

"The fact that we are charging for the food, i.e., engaging in a capitalist ecosystem, makes it more of a participatory project than getting a chunk of money from an art foundation," artist Dawn Weleski stated. "Selling the food creates a different relation between the public and the artwork."[3] According to Weleski, the collaboration between the artists and the Pittsburgh community created "a format to do a contextual work of art that was also participatory, where either a good or a service has been exchanged."[4] Within this format, the artists had to gauge the value of the good or service they were offering. "This was quite interesting to me as an art student—to begin to think about how what I have to offer is valued, and who values that,"[5] Weleski continued. Then questions about the audience or the public come to the forefront:

> You begin to think: *What kind of work should I make? Who is it for? Why am I doing this? Should I be the person doing this?* After the work begins to breathe and live with the public, you start to gauge what is failure, success, and everything in between, based in that ecology of "audience-ship" and participation that is a network that changes over the life of any project.[6]

CK's participatory format, and the public space that emerged from its relationships, can be grasped through the Mouffean notion of agonism—a notion also explored by Carl Di Salvo's ideas on adversarial design.[7] Chantal Mouffe's original idea of a "liberal democracy" in terms of agonistic pluralism assumes public spaces as sites of hegemonic confrontation. She sustains that modern democracy is paradoxical because it is the result of the contingent historical articulation of two different traditions: liberalism and classic democracy.[8] While liberalism emphasizes the

universal individual freedom beyond a given community—hence pluralism—democracy claims the equality of and unity among members of a given community with an ethos or form of life—hence the exclusion of those who don't belong. Maintaining democratic institutions requires acknowledgment that "the tension of [these] two components can only be temporarily stabilized through the pragmatic negotiations between political actors[,] which always establish the hegemony of one of them."[9] In Mouffe's terms, the goal of such a model is to establish "the political," i.e., the dimension of antagonism that is inherent in human relations.[10] Any social objectivity is ultimately political because it entails acts of power: the creation of a structure and an identity to the exclusion of others (hegemony).[11]

This doesn't mean, however, that any conflict would reveal this contingent and agonistic foundation of society, because the political specifically emerges when that temporary stability of one hegemony is disturbed and the political construction of the distinction between an "us" and a "them" is made evident.[12] By "political construction," Mouffe means that the community's identity is the outcome of a plurality of competing forces. Otherwise there is no political articulation, but only the mere recognition of an already established border.[13]

Although antagonism neither could nor should be eradicated, the political can articulate a different mode for its manifestation: agonism. Whereas proper antagonism refers to a relation between enemies with no symbolic space in common, agonism indicates a relation between adversaries (friendly enemies) competing in the organization of a shared symbolic space.[14] This is the crucial challenge of modern democratic politics: to envisage politics as a form of agonistic pluralism.[15] Mouffe, DiSalvo, and other design thinkers believe design and art can address this challenge by generating affects and cultivating public spaces where that transformation from antagonism to agonism is possible.[16] This chapter argues that CK constituted such spaces.

Several arguments have been made about how this agonistic approach is useful for design. DiSalvo presents Mouffe's argument to the design community as an alternative approach to the consensual ideal of democracy. According to him, the many ways in which democracy is understood should have an impact on design because they provide diverse, and "at times fundamentally different, courses of action, themes for inquiry, and bases for judgement and critique."[17] Drawing on Mouffe's ideas, DiSalvo addresses the design community with a call to action: "one of the tasks of those wishing to support and further democracy is, then, creating and enabling these spaces of contestation."[18]

Yet the role Mouffe assigns to art and design is bigger than that acknowledged by DiSalvo. Speaking at the Harvard Graduate School of Design in 2012, Mouffe addressed designers' and artists' potential to enact counter-hegemonies, stressing the fact that to construct oppositional identities, it is not enough to simply foster a process of "de-identification" or "de-individualization"—in other words, critique.[19] A second action, a moment of "re-identification" or "re-individualization"—the production of new collective subjectivities or publics—is decisive.[20] In this moment, affects play a crucial role; they are the motivating forces of political action.[21] Crucial to Mouffe's framework, then, is the assertion that there are no essential identities but only forms of identification. Consequently, at stake in agonistic politics is the construction of political identities, which always entails an affective dimension, a "space where the discursive and the affective are

articulated in specific practices."[22] Finally, despite being distinct processes, these two moments are not necessarily consecutive; they often take place simultaneously.

Conflict Kitchen encouraged both kinds of processes. As explained in the following section, its "politics" echoed Mouffe's agonistic model of democracy in their aim to maintain a space that domesticated conflict and "defuse the potential antagonism that exists in human relations."[23] This, as discussed toward the end of the chapter, led to moments of re-identification and, in some cases, to the configuration of new publics.

CK's Scripts: Commensal Practices and Speculation

Although it was an art project, CK's everydayness and relational nature required it to be conducted through design. This comes as no surprise if we pay attention to the close historical relationship between design and public art, particularly after a debate around public art emerged in the United States in the 1950s. Indifferent to the particular conditions of site or audience, as art historian Miwon Kwon explains,[24] public art pieces create a tension between two overlapping kinds of constituents in the space: the art-spectator/audience versus the public user/citizen. As a result of this debate, starting in the 1960s, public art commissions often required the input of design professionals to ensure an artwork's functionality.[25] This collaboration led to "site-specific art," whose integrationist goal provided a closer relation between the work and its site, and to a second debate, regarding the *nature* of public art's functionality: intervention or integration. By 1990, the notion of "site" had undergone a productive conceptualization that led to its broader understanding as "community" and to the emergence of socially engaged art (SEA).[26] SEA thus operates as a "trading zone"[27]—a common ground that allows long-lasting collaboration between the art and design communities and informs them in return, through feedback that can be significant for designers. CK's history holds this same relevance for designers—particularly those engaging in activist work, participatory design, or codesign, and in the broader discussion regarding embedded values.[28] (Conversely, a design studies approach to SEA might delve deeper into the roles that designed objects and processes play in relational practices.)

One important aspect of this trading zone is configurations—that is, inscriptions and scripts. Bruno Latour and Madeleine Akrich[29] refer to scripts as the social behaviors that are designed into an artifact. Like a film script, designed objects "define a framework of action together with the actors and the space in which they are supposed to act."[30] These objects are the outcomes of "inscriptions" by designers, who distribute (translate) competence and agency between objects and ideal users. Thus, scripts describe the manifold roles artifacts play in their context of use, including design's ethical role. SEA projects rely in this "surplus" of design functionality to achieve their relational aesthetics.[31]

The notion of these configurations implies a methodological commitment to an object's agency, to including "the missing masses" in sociological and political analysis.[32] From this perspective, actions and events—even those tagged as political—are distributed between human and nonhuman; our entire society is built on these sociotechnical configurations. Agency, therefore, is emergent rather than efficient; it is the "effect" of a "swarm of vitalities at play" (the confluence of several elements, both human and nonhuman) rather than an intended motion caused by a subject.[33] This is

not to say agency is contained in either humans or objects, but to "recognize the deeply mutual constitutions of human and artifacts, and the enacted nature of the boundaries between them."[34] Hence, any analysis of the capacity of design must entail an oscillation between the scripted designed object and the user—"between the world entailed in the object and the world described by its displacement."[35]

Any script is incomplete without the user's re-inscriptions, or feedback mechanisms. Yet CK's scripts were intentionally participatory, open, and plural. As Weleski explained:

> We begin with a context and then determine the form and content of the work, and oftentimes the content and the form are built in tandem and coproduced, with members of the public creating a participatory artwork. You don't set up immediately and say, "This is what I am going to create." It is the opposite of choosing your medium first ... There is a lot of conversation that begins with members of the public.[36]

This process also included both months of research on the topic and travel to various countries.

To experience and discuss CK's scripts, I traveled from New York to Pittsburgh one Tuesday in June 2014, during the Conflict Kitchen Afghanistan iteration. After ordering the basic meal for $7.50—lamb tikka kebab (grilled skewers of marinated lamb served over rice with tomato citrus relish)—I observed CK's front operations the rest of the afternoon. I also scheduled a time to return the next day to conduct further observations and informally interview a staff member named "Anna" (not the interviewee's real name). Anna, who seemed well aware of the project's aims and operations, explained that engagement often started with designed elements; most customers had questions regarding the façade, the opinions presented on the food wrapper, or the dishes and ingredient choices. Although they expected a definitive answer, the staff's informed opinions often engaged them in further discussion.

All staff members were apt to fulfill any task, from cooking, taking orders, and serving food to engaging with customers—like me—in conversation. They also engaged in research and the organization of events, often based on their day-to-day interaction with customers and CK's objects. At the time of my visit, the staff were preparing a lunch hour with area specialists from the University of Pittsburgh. They were also contemplating on the possibility of putting together a small mobile library,but were concerned about the kind of power relations the books might bring to these horizontal interactions, given that "a goal of the project [was] to show the complexity of cultures and [not to] reduce them to one coherent narrative,"[37] as artist Jon Rubin later pointed out.

Both the design elements and the staff interventions were part of CK's two different yet entangled scripts: one explicit and part of the takeout restaurant system, the other unique to CK. Agency was distributed among human actors (cashier, chefs, customers) and nonhuman objects (tables, menu, wrappers, storefront sign, food, recipes). Incorporated within these inscriptions were customers' re-inscriptions. Patrons were aware of their typical scripted roles as customers; they knew they needed to order, pay, wait until their name was called, and maybe find a table in the meantime. Certainly, they knew how to eat. The second script, on the other hand, often was unknown to them.

The kind of agency that emerged from this network articulated a potential agonistic public space by fostering moments of de-identification (critique) and producing potential moments of collective re-identification.

CK's moment of de- and re-identification relied on a second relevant element of design and art's trading zone: speculation. Speculative design makes critical use of configurations; it explores the fact that a design "acts" by bringing into being a situation within design itself.[38] For designers Anthony Dunne and Fiona Raby, "this form of design thrives on imagination and aims to open up new perspectives ... to create spaces for discussion and debate about alternative ways of being, and to inspire and encourage people's imaginations."[39] Speculation, as defined by feminist scholar Aimee Bahng, "is not exclusively interested in predicting the future but is equally compelled to explore different accounts of history."[40] CK was concerned not only with speculation about the future, but with the articulation of different accounts of US international relations, Pittsburgh's cultural landscape, and restaurant-based economic exchanges. Unlike most speculative design projects at the time, CK used speculation in its relational process or format—and these accounts were provided not just by designers but by staff and customers.

One form of speculation emerges from the design elements themselves. Throughout the seven years of CK's existence, its designs were the outcome of months and even years of research and relationship building with the city's diverse communities, including iterations that highlighted conflicts with, for example, Cuba, Venezuela, and North Korea. The iteration with the Haudenosaunee Confederacy took five years of research and community building.[41] Created by Pittsburgh designer Brett Yasko—at times in collaboration with members of the addressed community—both the wrappers and the façades had two set of scripts that rendered their seemingly plain objecthood into speculative objects. The façade, often using the language of the country addressed, stimulated engagement even before the restaurant opened its doors. It signaled something beyond the location: an encounter with the other or even a heterotopia—a single space that juxtaposes several spaces.[42]

Regarding the Iranian iteration, Weleski recalled the broad spectrum of reactions and moments of dissent generated solely by displaying the sign:

> Honestly, we thought it would last for three weeks. But from the get-go, people responded to it very immediately, even before any tasting of food, [b]efore the façade was finished ... While Jon and I were putting [up] the sign in Farsi, someone stopped in the middle of the street with his car, held up traffic, and started yelling, "I am Iranian! Who is opening this restaurant? Who is serving *kubideh*? When is it open?"

These engagements with the façade were also moments of speculation in which Pittsburghers explored different histories—past and present—of their own community and the project. The night before the restaurant opened, someone painted the words "cultural tourist" all over the façade. "We had expected if there were to be controversy, it would be coming from the right," Weleski revealed. "And of course, this was part of our ignorance, because if someone doesn't like what you are doing

The Agonistic Design of Conflict Kitchen 193

and they want to disempower you, they are not going to engage in a conversation about it."[43]

According to Weleski, however, these reactions launched the kind of discussion that was the project's aim. Once the restaurant was operating, as Anna explained, interested customers would approach employees for more information. Otherwise, staff members were instructed to engage customers in horizontal dialogue about the project and its current iteration (Figure 14.1, Plate 10).

The affordance of the food wrapper—the fact that customers could physically engage with one and take it with them—generated different kinds of speculation. The wrapper's reverse side displayed comments by members of the culture on a host of issues; the CK Afghan wrapper included opinions on food, the US presence, the Taliban and Al Qaeda, women, family, and culture (Figure 14.2). Thus, what should have been a relatively quick, unremarkable meal suddenly engaged the customers in a deeper discussion. To make sense of these objects in speculative ways, customers and staff had to reimagine their engagement with the already reimagined objects and then add meaning and value to the artwork through their interventions.

Figure 14.1 Conflict Kitchen Iran, Pittsburgh, 2010. The design elements of the wrapper sparked the customers' curiosity and speculation, while staff members engaged them in horizontal dialogues about the project and its current iteration.
Photo/Courtesy: Brett Yasko—Conflict Kitchen.

Figure 14.2 Conflict Kitchen Afghanistan, 2014. Wrapper reads: "People doubt the reality of this war. Of course, after the Taliban falling, the ordinary people's lives changed in a good direction. But these changes are more prominent in the lives of those Afghans who work in NGOs."

Photo/Courtesy: Brett Yasko, Conflict Kitchen.

Sherry Turkle's account of evocative objects resonates with Bahng's acknowledgment of the past and present as sites of speculation. Furthermore, Turkle's emphasis on the affective relations between objects and humans is useful for understanding the kind of speculation that emerged from the engagement between staff, customers, and the wrapper. She identifies three features of these evocative objects: they bring theory down to earth, they embody power relations, and they are uncanny—"known of old and yet unfamiliar."[44] CK's wrappers were evocative objects in all three senses. First, their contradictory and often polyphonic content grounded the fluid notion of culture identified by Rubin as part of the project's

theoretical framework. Second, they embodied the horizontal power relationship that Anna described in our conversation—a relationship that books, for example, and their power relations might disturb. Finally, these not-quite-ordinary wrappers invited speculation through their estranged familiarity. Moreover, since customers took the wrappers with them, the speculation extended beyond the space of the restaurant and often became part of a personal archive to which the customer (like me) could return while attempting to make further sense of this project.

Finally, although food was not the project's medium, Weleski was quick to recognize the role food and commensality played in shaping this and previous projects resulting from her artistic collaboration with Rubin.[45] As with other elements of CK, the food was familiar enough to stimulate participation and yet strange enough to allow speculation.[46] CK's dishes were collaborative adaptations that suited the takeout format of the restaurant and the city. The common table used for special events such as shared meals and cooking classes (Figure 14.3), however, carried a different sort of agency. According to Banu Bargu, the social space of the common table—where commensality practices take place—inspires intimacy between the individuals who inhabit it.[47] The commensal practices deployed in CK's daily operations and special events are forms of "commoning"—the act of producing and consuming in common. Through these practices CK managed to "foster popular participation, build networks of solidarity[,] and eliminate hierarchical ordering, thereby taking upon a critical, and at times even a subversive, attitude toward the social order at large."[48] In that sense, these acts of commensality constituted a space for the emergence of the political as defined by Mouffe, by providing a space both for critique (or de-identification) and for the articulation of new subjectivities.[49]

By its fourth year of operation, CK seemed to me so well adjusted to Pittsburgh's cultural fabric and daily landscape that it appeared to lack the fundamental element of conflict. In November 2014, however—a month after starting its Palestine iteration—the restaurant received an anonymous death threat. Clearly, conflict still existed. Mouffe's notion of agonism and Banu Bargu's articulation of commensal practices help make productive sense of my mistaken assumption. The social space of CK's common table, and the participatory format of its speculation, established an agonistic public space where discursive and collective identities are politically constructed through specific practices. Most important for the notion of agonism, the common table built a shared symbolic space where contesting forms of organizing, defining, and speculation (making sense of things) competed. At the same time, CK challenged "the social order at large": the restaurant format as a site of mere economic exchanges, the idea of Pittsburgh as a homogenous (mostly white US native-born) community, and the polarized version of US international relations portrayed by the media.

Antagonism and Agonism Beyond CK's Script

In the mainstream narrative, terms like "community," "United States," "Palestine," and "citizen" establish identities based on the logic of us/them. CK made explicit the arbitrariness of such logic. Its recurring enactments of Pittsburgh's diverse community, its polyphony of cultural narratives beyond national identity, and its commensal practices (typically precluded by the financial transactions taking place in regular restaurants) opened up a space for new forms of identification based on a multiplicity of configurations of this us/them divide.

196 *Verónica Uribe del Águila*

Figure 14.3 Conflict Kitchen Venezuela, 2014. Common table. Commensal practices such as those deployed by CK constituted a space for the emergence of the political, by fostering a space for both critique (or de-identification) and re-identification.
Photo/Courtesy Brett Yasko—Conflict Kitchen.

Upon receiving the death threat, Conflict Kitchen Palestine closed its doors on November 7, 2014, and remained closed for five days. Some members of the community perceived the iteration as one-sided and anti-Israel. At stake in this confrontation was the political question par excellence: who belongs to our community? Who gets to claim that "us"? As described earlier in this chapter, the political can emerge in any social situation, but conflict does not always reveal the political articulation of identities, a contingent and agonistic foundation of society. Here, CK gave rise to the political because its existence eroded the temporary stability of hegemonic discourses regarding both the communal "us" in Pittsburgh and the broader "us/them" narrative regarding US international affairs.

Going back to the role Mouffe assigns to design and art, it is clear that CK's scripts intended not to highlight a specific point of view or critique, but to deconstruct previous orders and identities by pointing to their arbitrariness. In that sense, CK did not include a script for the configurations of publics; it had no intention of answering the political question it raised, but instead strove to open up dialogue by allowing articulation and speculation of different answers. It nevertheless fostered moments of identification that led, in this case, to the configuration of a public. As mentioned earlier, antagonism manifests in two forms: proper antagonism (between enemies with no

common symbolic space) and agonism (between adversaries competing to organize a shared symbolic space). While the political emerged agonistically at CK's common table, an antagonistic form of the political also took place, pitting those who shared the art project's symbolic space against those who didn't.

Beyond the scripted conflicts of its daily operations and the unscripted conflict of the death threat, CK Palestine had another unscripted moment of confrontation, articulated by the *Pittsburgh Jewish Chronicle* on October 1, when an article qualified CK's Palestinian iteration as one-sided and demanded an Israel iteration or the inclusion of Israeli perspectives on the wrapper. The demand was reproduced by *Pittsburgh Post-Gazette* reporter Melissa McCart, whose two articles mapped the controversy around the iteration. McCart discussed the demand for inclusion, the conflicting statements released by members of project sponsor Heinz, and CK's position as captured in interviews with project members. A few days later, in a post on its website, CK clarified its perspective by explaining and contextualizing some of McCart's statements, and by including the voices of CK's Palestinian collaborators. Amid this controversy, CK and its wrapper were assumed to be a shared space by all. The value of such symbolic spaces is not questioned, but only its organization. In that sense, we have agonism: a confrontation between adversaries. Conversely, the anonymous death threat denied the value of CK as a shared symbolic space, giving rise to the antagonistic form of identification or collective identities.

While CK remained closed, members of the community posted messages of support on its façade. On November 10, 200 people gathered there for an event organized by the University of Pittsburgh's Students for Justice in Palestine (Figure 14.4). Even though such a gathering might include different, overlapping collective identities—namely, those who valued CK and those who were involved in the broader pro-Palestine network—it is clear that all participants acknowledged CK as a shared symbolic space. After discussions with staff members, Conflict Kitchen resumed its services on November 12.

In hindsight, although this controversy was unscripted, Rubin and Weleski weren't completely surprised. At other moments, however, collaborators' conflicting re-inscriptions were not only unscripted but completely unexpected. In 2015, for example, CK staff started a process of unionization through UFCW Local 23. The union advocated a contract that produced important benefits for CK's workers, yet that also disrupted the participatory research practices and reframing operations of the project by separating the workers' role from that of the artists and researchers. "People applied to CK [so] they could participate in the research in different ways," Weleski explained:

> To honor this, we created a committee for the staff to reflect on the kind of work they were doing, get to know about the background of the project in more detail, and work through what they wanted to make at the takeout window or as part of the special events.[50]

The goal was to create a scenario where staff began to make their own offering of socially engaged work within the restaurant's unique format. After the union bargaining, however, CK had to separate these activities; anything art- or research-related was managed by non-unionized collaborators.

Although the process of unionization escaped the scope of conflict CK had intended for its operations, it expands the discussion of conflict beyond the

Figure 14.4 Conflict Kitchen Palestine. On November 7, CK closed its doors for five days due to a death threat. On November 10, 2014, 200 people gathered in front of CK to show their support for CK.

Photo: Heather Kresge.

consensus established by the project. Thus, this artwork constituted a hegemony on its own: a configuration. While its reframing operations acknowledged and fostered relations made invisible by capitalist economic exchanges within the project, they also rendered invisible the CK staff's emotional, cognitive, and maintenance efforts—as wage labor—outside of the artwork. In that sense, this episode shows the limits established by boundary-making institutions (such as laws, labor rights, and property) even within CK's open-ended network.[51] However, those same reframing operations made possible the translation of this potential antagonism into agonism. As Weleski stated, "The fact that someone utilized CK as a moment for their own activism, to state their politics, to move policy forward, makes it a successful moment of the project that then became part of the work of art."[52] Through this unscripted conflict, CK gained further valuable meaning for the larger Pittsburgh community. It was both a work of art and a workplace: a source of income as well as a site of labor organization and class struggle.

Conclusions

As revealed by these two episodes in Conflict Kitchen's history—the Palestine iteration protests and the unionization effort—designed objects play a crucial role in processes of collective re-identification in SEA and design. Both the otherness of the

CK façade and the evocative quality of the wrappers allowed patrons to distance themselves from the mainstream narrative about Pittsburgh, US international relations, and the restaurant format—and to imagine and enact alternatives. Such contesting speculations found an agonistic space in CK's commensal practices, which built networks of solidarity and eliminated hierarchical ordering while viewing "the social order at large" with a critical eye. Furthermore, CK's operations indicate how SEA and public art in general operate as a common ground for the long-lasting collaboration of art and design. The feedback these trading zones provide for design is worth exploring.

The CK project also shows that if agency is understood as being distributed among the human and the nonhuman through inscriptions and re-inscriptions, then design's role in producing those moments of re-identification should be understood as emergent rather than efficient. Therefore, the emergence of the political in art and design projects of this kind should be analyzed within the bigger frame of a network, swarm, or assemblage where humans and nonhumans interact. This approach contributes further to identifying and understanding the role of the missing masses in political and social configurations. CK's way of resorting to agency (both to that of objects, and the one enacted through participatory design) has the capacity to inform design with new insights. It indicates novel ways in which sociotechnical configurations of human and nonhuman agents can be designed to create or acknowledge existing frictions instead of smoothing processes and pacifying conflicts.

Finally, the notion of agonism as a framework for design projects uncovers the fact that allowing dissent to rise—instead of suppressing it—creates room for the articulation of new identities that demonstrate the contingency of current social orders and imagine other possibilities. Encouraging CK's customers to reassess social norms resulted in the emergence of a public that acknowledges and values diversity in a seemingly homogenous community. By unionizing, CK's workers pushed the scope of this project even further, to question the narratives and assumptions of socially engaged art, and to reveal the particular hegemonies, power relations, and forms of invisible labor that the project established with its collaborative community.

Notes

1 Dawn Weleski was interviewed by Verónica Uribe del Águila via Skype in Pittsburgh–San Diego on September 4, 2018.
2 Support for CK came also from the Benter Foundation, the Sprout Fund, and the Frank-Ratchye Studio for Creative Inquiry. Carnegie Mellon University was a fiscal sponsor that provided further administrative support.
3 Weleski, interview.
4 Weleski, interview.
5 Weleski initiated her collaboration with Jon Rubin as a graduate student in one of Rubin's classes in the Art Department at Carnegie Mellon University, Pittsburgh, Pennsylvania.
6 Weleski, interview.
7 Carl DiSalvo, *Adversarial Design* (Cambridge, MA: The MIT Press, 2012).
8 Chantal Mouffe, *The Democratic Paradox* (New York: Verso, 2009), 2–3.
9 Ibid., 5.

10 Different from "the political," "politics" indicates the assemblage of practices, discourses, and institutions that aim at establishing "a certain order and organize human coexistence in conditions that are always potentially conflictual because they are affected by the dimension of the political." Ibid., 101, 135.
11 Ibid., 99.
12 Ibid., 55–57.
13 Ibid., 55–57.
14 Ibid., 13.
15 Ibid., 117.
16 Chantal Mouffe, *Democratic Politics and Agonistic Public Spaces* (Cambridge, MA: Harvard Graduate School of Design (Harvard GSD), 2012). www.youtube.com/watch?v=4Wpwwc25JRU.
17 Carl DiSalvo, "Design, Democracy and Agonistic Pluralism," *Design Research Society* (2010): 1.
18 Ibid., 2.
19 Mouffe, *Democratic Politics and Agonistic Public Spaces*.
20 Chantal Mouffe, "Democratic Politics in the Age of Post-Fordism," in *Thinking—Resisting—Reading the Political*, eds. Anneka Esch-van Kan, Stephan Packard, and Philipp Schulte (Chicago, IL: University of Chicago Press, 2010), 43–51.
21 Chantal Mouffe, "Affects in Democracy," *Eurozine*, accessed November 23, 2018. www.eurozine.com/the-affects-of-democracy/.
22 Mouffe, "Affects in Democracy."
23 Mouffe, *The Democratic Paradox*, 101.
24 Miwon Kwon, *One Place after Another: Site-Specific Art and Locational Identity* (Cambridge, MA: The MIT Press, 2004), 65.
25 Ibid., 67.
26 Ibid., 100.
27 Science and Technology scholar, Peter Galison used the metaphor of "trading zones" to describe how physicists and engineers had to develop a "creole," or reduced common language, that allowed them to reach consensus on design changes in order to build complex particle detectors.
28 In *Design Activism: Beautiful Strangeness for a Sustainable World*, Fuad-Luke defines such a subfield as "Design thinking, imagination and practice applied knowingly or unknowingly to create a counter narrative aimed at generating and balancing positive social, institutional, environmental and economic change" (2). However, the discussion around embedded values in design takes place at the intersection of different fields beyond design activism; see Arjun Appadurai, *The Social Life of Things: Commodities in Cultural Perspective* (Cambridge: Cambridge University Press, 1988). Some, concerned with the consequences of certain humanitarian designs, have questioned the imperialistic features of these practices by asking whose values get to be embedded in those designs; see Peter Redfield, "Fluid Technologies: The Bush Pump, the LifeStraw and Microworlds of Humanitarian Design," *Social Studies of Science* 46, no. 2 (April 2016): 159–83, doi:10.1177/0306312715620061. Terms such as "wild" and "wicked" have been coined for referring to these and other well-known, unintended consequences of designs (Richard Buchanan, "Wicked Problems in Design Thinking," *Design Issues* 8, no. 2 (1992): 5–21; Judith Attfield, *Wild Things: The Material Culture of Everyday Life* (Berg Publishers, 2000). Among those concerned with design for social change, the discussion centers on the difficulty of attaching political and democratic values to material and immaterial configurations (Lucy Suchman, *Human-Machine Reconfigurations: Plans and Situated Actions* (Cambridge: Cambridge University Press, 2007)). Eevi E. Beck's reflection on the progressively diminishing political capacity of participatory design in computing highlights the difficulty of maintaining the consistency of some design principles (Eevi E. Beck, "P for Political: Participation Is Not Enough," *Scandinavian Journal of Information Systems* 14, no. 1 (2002)).
29 Madeleine Akrich and Bruno Latour, "A Summary of a Convenient Vocabulary for the Semiotics of Human and Nonhuman Assemblies," in *Shaping Technology/Building*

Society: Studies in Sociotechnical Change, eds. Wieber E. Bijke and John Law (Cambridge, MA: The MIT Press, 1992), 259–62.
30 Madeleine Akrich. "The De-Scription of Technical Objects," in *Shaping Technology/Building Society*, eds. Bijke Wieber and Law, 208.
31 See Nicolas Bourriaud, et al., *Relational Aesthetics* (Dijon: Les presses du réel, 2002) and Tom Finkelpearl, *What We Made: Conversations on Art and Social Cooperation* (Durham, NC: Duke University Press, 2012).
32 Bruno Latour, "Where Are the Missing Masses? The Sociology of a Few Mundane Artifacts," in *Shaping Technology/Building Society*, eds. Bijke Wieber and Law, 225.
33 Jane Bennett, *Vibrant Matter: A Political Ecology of Things* (Durham, NC: Duke University Press, 2010), 31–32, 106–107.
34 Lucy Suchman, *Human-Machine Reconfigurations: Plans and Situated Actions* (Cambridge: Cambridge University Press, 2007), 260.
35 Akrich, "The De-Scription of Technical Objects," 209.
36 Weleski, interview.
37 Jon Rubin was interviewed by Verónica Uribe del Águila at The New School, New York, on February 18, 2015.
38 See Clive Dilnot, "The Critical in Design (Part One)," *Journal of Writing in Creative Practice* 1, no. 2 (2008): 18.
39 Anthony Dunne and Fiona Raby, *Speculative Everything: Design Fiction and Social Dreaming* (Cambridge, MA: The MIT Press), 2.
40 Aimee Bahng, *Migrant Futures: Decolonizing Speculation in Financial Times* (Durham, NC: Duke University Press, 2017), 8.
41 Weleski, interview.
42 Michel Foucault and Jay Miskowiec, "Of Other Spaces," *Diacritics* 16, no. 1 (1986): 25.
43 Weleski, interview.
44 Sherry Turkle, ed., *Evocative Objects: Things We Think With* (Cambridge, MA: The MIT Press, 2007), 8.
45 In the past, both artists participated in "The Waffle Shop (Talk Show)," a socially engaged art project that between 2008 to 2012 served after-hours waffles next to an iconic Pittsburgh bar while encouraging discussion around the site's ongoing gentrification process and other topics.
46 According to Anna, ingredients and cooking methods were also starting points of conversation about each iteration's culture. While CK's commitment to horizontal interactions left room for speculations in this case, ongoing collaboration with members of the community provided particular and subjective sources of information in order to minimize the risk of exoticizing the culture.
47 Banu Bargu, "The Politics of Commensality," in *The Anarchist Turn*, eds. Jacob Blumenfeld, Chiara Bottici, and Simon Critchley (London: Pluto Press, 2013), 43.
48 Ibid., 48.
49 Bargu's approach challenges Arendt's distinction between action (political), work and labor, and identifies, in agreement with Mouffe, the political in activities rendered as pre-political: labor and work.
50 Weleski, interview.
51 Anthropologist Marilyn Strathern calls this "the cuts in the network." Marilyn Strathern, "Cutting the Network," *The Journal of the Royal Anthropological Institute* 2, no. 3 (1996): 524.
52 Weleski, interview.

15 Events and Ecologies of Design and Urban Activism
From Downtown São Paulo to the Peripheries

Kristine Samson

The aim of this chapter is to explore ecologies of design and urban activism in São Paulo, Brazil, by examining the outburst of such activist events in the city in 2012–13, and by revisiting, in 2018, the ecology that gave rise to and emerged out of those events. Firstly, this chapter investigates how and to what extent urban activism (also characterized as DIY urbanism and tactical urbanism) has the potential to reshape urban power relations. Secondly, it looks into the aftermath of these 2012–13 activist projects that combined design with urban interventions, in light of subsequent spatial practices in the peripheral areas of São Paulo. The chapter argues that although the early cases of design and urban activism addressed the "right to the city" concerning the use of public spaces, they also reproduced existing power relations between center and periphery. Nevertheless, as is recognized upon examining the recent collaborative projects in the peripheries, the limitations of the earlier activities and the colonizing aspects of design and urban activism were questioned by the designers who initiated these events, leading to new forms of collaboration with the urban poor at the city's margins.

Dissent or Neoliberal Forms of Activism?

The impact of urban movements and activism has been heavily disputed in critical urban theory by Marxist geographers such as Margit Mayer, Erik Swyngedouw, David Harvey, and Neil Smith.[1] Raising a critique of the neoliberal city, they point out that the Right to the City movement has emerged as a counterreaction to the rapid gentrification processes taking place globally. In his book *Rebel Cities*, however, Harvey poses the question of whether "the urban manifestations" of today's diverse social movements, such as Occupy Wall Street, also referred to as urban social movements, can be understood without connecting capitalism with the urban condition.[2] Thus, Harvey links urban struggles and the right to the city to a struggle with capitalism in general. In that relationship, Henri Lefebvre's statement of a right to the city, first proposed in his essay "Le droit à la ville,"[3] serves as the main inspiration regarding how to deal with urban issues and spatial politics. The right to the city is, among other things, proclaimed as "a right to change ourselves by changing the city."[4]

According to Swyngedouw's critical approach, urban activism and social movements today are expressions of "placebo-politicalness," wherein the real political—understood as rupture, dissent, and fractures—has disappeared.[5] For Swyngedouw, such expressions of protest quickly become institutionalized in public-private

stakeholder forms of governance and soon partake in the tyranny of neoliberal participation.[6] Hence, critical urbanists question whether urban movements can lead to what Lefebvre calls "a radical restructuring of social, political, and economical relations, both in the city and beyond."[7] While this chapter draws on the notion of the right to the city as originally formulated by Lefebvre and further discussed by critical urban theory, it will problematize the critical approach of Marxist urbanists by drawing on event theories and will consider these design acts as part of broader ecologies of practices that can contribute to spatial acts of citizenship.

Urban Events and Ecologies of Practices

This chapter looks at design and urban activism events in São Paulo performed by designers, architects, and artists' collectives to explore how a series of events take place, are negotiated, and affect one another over time. Events are interpreted here not as singular incidents in causal chains of effect but rather as partaking in ecologies of practices; they are understood not as particular cultural events, but as what emerges when ecologies of practices change both how power is distributed and who has access to what. According to Isabelle Stengers, an ecology is processual and relational, adding new connections to a multiplicity of existing ones, and proposing new value systems, meanings, and modes of evaluation.[8] Ecologies of practices in this regard might consist of heterogeneous and politically diverse design and cultural acts that coexist despite differences. In a similar vein, we can understand the city as a constantly processual entity that consists of multiple related practices and micro-events. As claimed by non-representational geographers Ash Amin and Nigel Thrift, "the city is a kind of force field of passions that pulse and associate bodies in particular ways."[9] From this perspective, we may regard the city as a relational force field that produces events.[10]

In such an understanding of the city, design and urban activism are all acts struggling to break with existing geometries by creating, sometimes only temporarily, what time-geographer Doreen Massey has termed "spatio-temporal events."[11] As argued by Massey, cities are networks that can be considered "geometries of power," where "a major concern is the decline of public spaces in the neoliberal city."[12] With this specific understanding of an event as something that breaks with the governing geometries of power, we can potentially see design and urban activism as a process of restructuring the urban conditions, as they have the ability to change, for instance, how the city is planned, organized, and perceived by its citizens. Although design activism and urban activism can be said to renew spatial relations and the geometries of power especially as it concerns public space, they also enable questions that challenge both the current distribution of power and exclusionary processes.[13]

Assessing the Impact of Design and Urban Activism Events by Expanding the Notion of Citizenship

As the radical restructuring of the capitalist global order may not be the intention of DIY urbanism and design activism in the first place, a way of evaluating its effects might be to look into *whether* and *how* activists actually succeed in the production of alternative spaces in the city, whether projects re-enact the right to the city, and whose rights are reclaimed. Another point to evaluate is to what extent

civil actions are absorbed or rejected by civic society and planning institutions. Civil actions are by definition not monitored by state authorities or municipalities. Whereas "civic space is a place that is established or has taken root in policies, education programmes, (etc.), [it] is a space that remains fluid, a place where positions still have to be taken up or created."[14] This openness of civil action is closely related to the notion of the event, in the sense that a series of events potentially opens the city to new practices where civil actions can be adapted to local urban problems, and can also find a form in civic and institutional spaces such as cultural institutions or municipal initiatives. The right to the city has many manifestations, including the ability for urban citizens in the periphery to reclaim the city. The notion of *citizenship* as formulated by Holston and Appadurai in 1993[15] is useful here, as they relate citizenship not only to being a legal citizen within the nation state but to upholding a plethora of rights—social, economic, political, and cultural. This broad definition of citizenship is applied in the following analysis, in which the term "spatial citizenship" covers a broader ecology of practices taking place in São Paulo.

Contextualizing Design and Urban Activism Events in São Paulo

The Arab Spring (2010–13), Indignados in Spain (2011), and the Occupy movement—beginning with Occupy Wall Street (2011) and culminating in Istanbul with Occupy Gezi (2013)—can be seen as a global framework for the DIY urbanism and urban protests that took place in São Paulo in 2012–13. As noted by Earle, with reference to Foweraker and Landman, "social movements are linked to the acquisition of citizenship since they can act as 'both schools for understanding rights and vehicles for disseminating ideas and perceptions of rights.'"[16]

The São Paulo protests, or *Jornadas de Junho*—the June Journeys—followed the Gezi Park protests of May 2013. The choice of the word *jornadas*, meaning "journeys," relates to the 2013 protests in Brazil as a series of events that took place in time and space, spreading across the country in multiple acts. Although the same issues as those in Occupy Gezi were not at stake, these events were likewise reactions to local governments and their misuse of public space. In particular, the increase of the Paulistano bus fares ignited the protests, but the

> protests also provided an outlet for frustration with corruption in public life and the difficulty of bringing about change through the formal democratic process. Many of these protesters were young and middle class, and had never been on the streets before.[17]

Like Occupy Gezi, *Jornadas de Junho* was a particular event that made public opinion manifest by bringing thousands of people to the streets. However, also like Occupy Gezi, the outburst of protests must be seen as part of larger urban ecologies in which public opinion, the roles of both professionals and activists, and numerous practices are gradually transformed. For instance, since the protests in June 2013, São Paulo has experienced an explosion in activist land occupation and commoning of urban spaces and buildings.[18]

As this chapter argues, the protests can be seen as outcomes of a growing global awareness and of the manifold ways to enact the right to the city. Understanding this requires looking back to 2012, a year before the *Jornadas de Junho* event, to

analyze a series of design and urban activism events in São Paulo that—while sharing concerns with the global protest culture sketched above—were articulated not as protests but as affirmative design efforts stemming from a growing awareness of the city's spatial inequality and lack of public spaces. Whereas social urban movements such as Occupy Wall Street and Occupy Gezi helped to realize a global protest against neoliberal government claiming the right to the city, the design and urban activism events of 2012 and onwards illustrate how governing geometries of power are contested and gradually changed over time. This occurs not by protesting in singular events, but by a gradual change effected through a reflective understanding of what design and urban activism can do and its way of operating. Whereas neoliberal politics globally are an important framework for understanding the events of 2012, the rise of right-wing populism and the resulting resentment from the left in many cities worldwide (and particularly in Brazil) arguably are responsible for some of the conditioning factors that allow us to understand the 2013 events. This might also explain why notions such as the pluriverse and decolonizing design have become increasingly more highlighted, especially in the context of Latin America.

The empirical material reflected in this chapter largely consists of informal interviews with event organizers, activists, designers, and architects, yet these interviews are supported by participant observation, as I took part in public meetings, debates, and street events. Hence, the analysis not only draws on the discursive semantics of the informants' intentions with the design and urban tactics, but is based on a spatial and material analysis in which sites, the urban context, and the people present in the acts contribute useful knowledge. Combining interviews and *in situ* participant observation is thus a way of comparing and triangulating situated and partial knowledge about urban environments with the intentions of designers, urbanists, and activists.

The Rise of *Preliminares* in December 2012

The *"Mais amor São Paulo"* ("More love, São Paulo") and *"Existe amor em São Paulo"* ("There is love in São Paulo") campaigns were a series of urban events taking place from August to December 2012. Initially distributed as a guerilla campaign through street art, posters, and tags and by organizing public events, these concepts later became manifest in diverse street actions under the label of *Preliminares*, which means "foreplay" or "curtain raiser." The campaigns were intended to symbolize the act of stimulating a desire for social and urban change in São Paulo, interpreted variably as a mental change among its citizens; a change in urban practices; and for some, a political change in urban policy. They took place chiefly downtown, in the neighborhood around Rua Augusta and Praça Roosevelt—a public park and meeting point inaugurated in 2012.

The statement *Existe amor em São Paulo* was imbued with diverse meanings: Some saw it as a comment on the rising interest in public space and in new collaborative design approaches, and as a way to engage with an emergent urban public. For instance, the neglect of urban spaces and the lack of public meeting places were addressed in public debates and in site-specific events with the intention of bringing people together at neglected sites in the downtown area. Others saw the campaign as a political statement against right-wing Mayor Gilberto Kassab, who governed São Paulo at the time with an urban policy that included regulations against urban life—such as prohibiting street vendors and cultural activities in public spaces—and that,

according to several activists, was focused solely on economic growth and maintaining the image of São Paulo as the economic capital of Latin America. Therefore, the *Mais amor São Paulo* campaign deliberately took place in public spaces with the intention of influencing the election in January 2013. Yet some saw the movement as apolitical and postulated that it addressed the mentality of the citizens: the selfishness, the car-based society, the gated high-rise communities, the police surveillance and presence in the streets, and the general lack of use of (and interest in) public spaces. Because of their many interpretations, the campaigns and associated events gradually became symbolic of growing urban awareness in São Paulo.

It is important to note the support structure of these events as indicative of the current geometries of power in urban discourse. As many of the initiatives gained private support from the Goethe-Institut, whose Latin America headquarters are in São Paulo, several of the debates brought German artists and urban culture into the mix. In particular, many of the events had similarities with urban activism in Berlin, and terms such as "DIY urbanism" and "tactical urbanism" were global ideas that many of the participants were acquainted with at the time.[19] The Goethe-Institut contributed financial support and also gave a specifically Central European air to some of the events. Yet in retrospect, despite drawing inspiration partly from these European design and DIY urbanism trends, the campaigns revealed a failure to consider the socioeconomic and material situation of the entire city of São Paulo—by, for instance, being blind to the socialeconomical imbalance between the city's margins and its centers.

Some of the events took place during the *Preliminares* festival in December 2012, which occurred at multiple locations in downtown São Paulo and on *Minhocão*—a heavily-congested highway that cuts through downtown São Paulo but is closed on Sundays for cultural activities.[20] Many of the sites were chosen by the collectives according to their interest and engagement with the city. For instance, *SampaPé* (São Paulo on Foot) organized walks to pedestrian-unfriendly places on the outskirts of the city, where people met and walked in groups to call for better pedestrian conditions. Feminist activists organized planting days in the derelict but historical, central Parque da Luz and Bom Retiro neighborhood. Others arranged film screenings about neglected urban spaces and gentrification issues in the derelict areas of Sé and Luz—neighborhoods in downtown São Paulo—in areas known for vertical slums and drug addicts (i.e., Cracolândia). The NGO *Rios e Ruas* (Rivers and Streets) was engaged with reopening rivers and green spaces in the city, particularly in the neighborhood of Vila Madalena.

In general, many of the events pointed to the fact that middle-class citizens needed to meet in public to share moments and to debate the future of a city that had forgotten the value of public spaces.[21] Hence, here the urban geometries of power were mainly addressed from a middle-class, centralized perspective without considering how this particular desire for public spaces itself also distributed certain geometries of power.

Two Downtown Cases Raising Questions on Justice and Inclusion in São Paulo

One of the 2012 interventions questioning the right to use public space and to act against gentrification was performed by *Muda Coletivo* (Change Collective) in collaboration with *Basurama Brasil* (a word play with the word *basura* meaning trash

in Portuguese). These organizations joined forces on a DIY urbanism project addressing *Minhocão*, as the cultural activities that took place there earlier in 2012 were criticized as contributing to the cultural and socioeconomic gentrification that emerged in the surrounding neighborhoods. The event, *Bolha Imobiliária* (The Real Estate Bubble) can be described as a work about spatial appropriation, where both the design and the design process inspire reflective and critical rethinking on how spatial design takes place within gentrification processes and real estate development (Figure 15.1, Plate 11). *Bolha Imobiliária* was an inflatable structure that could be constructed only by the engagement of citizens blowing more air into the structure. Hence, it symbolically and spatially imitated the process of real estate development and urban gentrification but also pointed to the fact that citizens partake in the very same processes. Whereas The Real Estate Bubble shares similarities with other domes and bubble structures worldwide—for instance, Kitchen Monument by Raumlabor (Germany)—the project paved the way for interventions in other parts of downtown São Paulo.

On the same subject of material reuse, *Muda Coletivo* and *Basurama Brasil* collaborated in 2012 with the citizen initiative *Cooper Glicério* (Cooperative Glicério) —a collective for urban survival and reuse of materials—and worked closely with one of its dwellers, João Batiste, who was in charge of a boxing academy in the same space. On my way to visit the viaduct (Viaduto Glicério) in the Liberdade neighborhood, I realized that finding it was not easy as finding the design activists

Figure 15.1 Spatial production and interventions on *Minhocão*, São Paulo: *Muda Coletivo*'s *Bolha Imobiliária* (The Real Estate Bubble), December 2012.

Photo: Kristine Samson.

in the public places around São Paulo Centro and *Minhocão*. After navigating heavy traffic, garbage dumps, and empty buildings in the vast infrastructural space of downtown São Paulo, I finally recognized the place, underneath the Viaduct Glicério and intersecting highways, by how it stood out from its surroundings: a highly organized and structured space enclosed by a tall fence.

I was welcomed by Batiste, who offered me a tour of the place that, in many ways, changed my perception of tactical urbanism as a spatial form of citizenship. This space was truly organized as a community-led DIY urban alternative to the existing urban ordering of space. As a DIY reuse center, *Cooper Glicério*'s practice was to collect material from trash-disposed plastic, furniture, and equipment, and to organize it in terms of reuse value. If you needed furniture or kitchen equipment, you would access one specific area of the territory. The backstage area served as Batiste's private living room, while in the central area, social meeting places and an open-air gym were neatly organized, with the boxing ring as the centerpiece. Batiste talked about how this public space was designed to be used for tournaments by the local population, and how the services inside the territory functioned through an exchange economy, with visitors required to hand in objects in exchange for gaining access to and use of the space. As a "gated community" accommodating the urban poor and the disadvantaged, this space was constructed showing sensibility to a diversity of spatial rights: the rights to physical exercise, to cooking and sharing a meal together, to meeting with others, to playing and performing for one another. Here, the sharing economy covered not only material exchanges, but also the exchange of social and cultural gestures. For instance, two frequent users had brought in waste food from the surrounding neighborhood, cooked it in the kitchen facilities, and shared the food with the people present. While dining, passers-by outside the fence continuously handed in new goods through the wire (Figures 15.2, 15.3, and 15.4).

Whose Right to the City?

This urban encounter in December 2012 with *Cooper Glicério* pointed to a vague but growing awareness among the design and urban activists, collectives, and NGOs partaking in *Mais amor São Paulo* and the *Preliminares* festival in the downtown area—an awareness that included the social, cultural, and material resources inherent in the downtown area. *Muda Coletivo*'s spatial appropriation engaged with the right to the city in several ways: first, discursively, as a critical comment on gentrification processes in the city and how real estate interests govern urban development; second, by performing a more sustainable but also more porous and ephemeral kind of architecture, and third, by collaborating with other citizens and communities (such as *Cooper Glicério*), with an emerging awareness of potential contributions that lie outside white, middle-class communities.

The collaboration with *Cooper Glicério* also raised issues regarding spatial justice. It clearly pointed to the spatial inequality between, on the one hand, those who have a place to live but wish to claim public space for creative use, and on the other hand, those who have no place to live, have no access to social or cultural facilities and services, and are living off the leftovers of the consumerist city. Were these two constituencies equal participants in the *Jornadas de Junho* and other events in the city during the protest period?

Figure 15.2 Cooper Glicério, São Paulo. Entrance to the recycling station and boxing academy, 2012

Photo: Kristine Samson.

Figure 15.3 Batiste gives a guided tour of *Cooper Glicério*, 2012.

Photo: Kristine Samson.

Figure 15.4 Regular users of the boxing academy share dinner at *Cooper Glicério*, 2012.
Photo: Kristine Samson.

These issues point to the limitations of urban activism. The urban activism practiced by *Muda Coletivo* and other design activists and NGOs can be defined as "claim strategies." As noted by Oswalt, Overmeyer, and Misselwitz,

> For claim strategies, influencing public opinion is the key. The goal is to deprive existing town planning of its legitimation and gain an ideal majority for an alternative use and development scenario. The means for achieving this are not first and foremost protest, criticism, and negation, but the positive, constructive pursuit of one's own alternative idea and its gradual realization.[22]

Hence, claim strategies can be said to work as speculative and performative practices: they proactively formulate micro-utopias as "wish production," while at the same time implementing the idea on a practical level. While the events of December 2012 might have changed the mental conception of the city for the participating activists, they did not address urgent issues of inequality, poverty, and the right to the city—for instance, homelessness, drug addiction in Cracolândia, and other concerns of the people living at the city's margins. Nor did those events contribute to any lasting changes in terms of establishing public spaces or collaborative platforms for urban commons.

In other words, one can question the degree of actual participation from citizens who come from other parts of the city. While *Basurama Brasil* and *Muda Coletivo* established a design ecology between *Minhocão* and the Viaducto Glicério in

Liberdade neighborhood, the engagement was established not by accepting the homeless communities as equal partners, but by merely giving them the possibility of accessing reused materials in the design process. Although the tactical design practice clearly reassembled how urban design is made and understood as a material practice, the design activists did not try to establish an equal socio-material exchange between margin and center, between communities of color dwelling underneath the viaduct and the privileged middle-class dancing on the elevated *Minhocão*.

Nevertheless, besides spurring broader awareness of the lack of public spaces for citizens in central São Paulo, the *Mais amor São Paulo* campaign and the *Preliminares* festival succeeded in rousing awareness among the participating activists and designers themselves of the need for spatial justice. This would concern not only the middle-class urban activists with the networking ability to obtain support from the Goethe-Institut, but also the urban poor with no access to such privileges and support structures. Thus, one can rightly conclude by looking at the events per se that these forms of "tactical urbanism reproduce or even exacerbate the urban problems they seek to address,"[23] yet it is important to add that the acts showed a capacity to make participants and designers aware of how they partake in the geometries of power. Hence, in thinking within the framework of design activism and eventual urbanism, it is not sufficient to analyze only critically how design contributes to gentrification and partakes in the spatial geometries of power. We must also look at the extent to which such activism might spur subsequent events that unfold over time.

After the Party: Changes in Design and Urban Activism between 2012 and 2018

Revisiting the 2012–13 design and urban activism events in 2018 has also meant revisiting municipal politics. In 2013, many activists related the urban events to the mayoral elections of São Paulo in January 2013, when Fernando Haddad from the Workers' Party took over as mayor with promises to put urban issues on the agenda. Haddad initiated, among other programs, a public support program for drug addicts in Cracolândia and investments in bicycle infrastructure in the downtown area in particular. However, Brazilian resentment toward politics—closely related to the general corruption that, to some extent, culminated in the impeachment of President Dilma Rousseff of the Workers' Party in 2016—has led today to wide-ranging doubt that either city or national politics and policy making will ever change. Left-wing academics and commentators recognize that the Workers' Party has made many errors.[24] For architect-activist Marcella Arruda, who was a member of *Muda Coletivo*, a distrust in any municipal politics stands clear:

> I think [the political situation] has never been super pleasant. So, for instance, the last mayor we had, João Doria, destroyed urban gardens we built, and accused us of not providing maintenance for a project we did in Largo da Batata [a large square in São Paulo]. He discovered the architecture and took it out, so he was an extremist and not at all democratic.[25]

The lack of faith in the local political system's acceptance of design activism and DIY urbanism projects in the city's center can be understood as one reason activist-

designers increasingly seek the peripheries. Another reason is an increasing awareness of what citizenship is and what acts of citizenship can offer in terms of the right to the city. This has led Arruda, among others, to translate some of her former design activism in downtown São Paulo into a practice of architecture that is combined with pedagogy and learning, and into the founding of the collective *Escola sem Muros* (School Without Walls). According to its website, the *Escola Sem Muros* practices "a political pedagogical program that aims to foster a practical learning and put the knowledge of permaculture and architecture in the service of the society, together with the expertise that exist in the community."[26]

The first *Escola sem Muros* program took place in January 2018 in the Cultural Center Jardim Damasceno, in the area between Perus and Brasilândia in the northern part of the city. Seventy people, among them students, facilitators, and local citizens, participated in the program, which was made possible by a 2017 crowdsourcing campaign.

One of the founding ideals behind *Escola sem Muros* was to work with an expanded idea of sharing in the production of architecture, so it is a product not only of designers but of acts carried out by citizens and designers together. Arruda explained:

> We try to take responsibility for the mode of production of architectural works—not only [in] what we design but also [in] whom, why, and how. We are trying to understand from a critical perspective what we are doing. We try to engage with different resources available in the territory, and give value to them … We are working with the idea of sharing the surplus, creating a more just approach. We believe that the people who can pay, can pay for the people who cannot, and that everybody can then learn from the process. And finally, we operate in the margin … We make projects in the margin—in the periphery of the city but also in the margin of the social system, because that is where we have the freedom to experiment and to make mistakes.[27]

Situating the school in the periphery has been crucial. As Arruda notes, in the peripheries it is not so much about macro-politics and the disagreements between left and right, but more about local negotiations and disputes across the political spectrum.[28] In this sense, *Escola sem Muros* can also be seen as working on a micro-political level in its efforts to negotiate and design in local communities. By 2018, the spatial practices of *Muda Coletivo*, which was formerly oriented toward inserting temporary architecture for the making of urban public space, had become a shared and distributed practice in the peripheries, in which people and the resources available are of key value.

Conclusions

The notion of the assemblage can help us better understand the way these urban design activism events evolved between 2012 and 2018 I will apply. In a discussion with left-wing philosopher Antonio Negri, Gilles Deleuze and Félix Guattari have suggested assemblages as affirmative political approaches. According to Deleuze, the left should organize itself in assemblages, or "constellations of singularities,"[29] and political transformation should be not revolutionary but experimental, to allow

for an egalitarian political order.[30] The production of subjectivity, in that sense, could be based on loose and provisional socio-material assemblages, with an emphasis on creation at a micro level reorganizing the governing assemblages. As Tampio notes, this means that political assemblages can operate on several spatial scales, from that of the individual to those of friendships, networks, institutions, cities, nation states, and international bodies, even without the guarantee that such partners will fit together in their ideals, aims, and strategies.[31] Acts that might reorganize the geometries of power locally and temporarily do not necessarily fit with changing legal citizens' rights regionally or nationally, which remain a challenge in the Brazilian democracy. Deleuze and Guattari's assemblage is here relevant as it allows us to see the impact of design activism and DIY urbanism on a minor and translocal scale, and follow how they reassemble places, people, spatial practices, and tools, and as such support citizens' spatial rights claims. If we understand the city as a kind of force field of vibrant materiality—a term used by Jane Bennett[32]—and of social and material relationality, we see the production of space taking place through both mental and material ad hoc groupings. Here, spatial justice and citizen rights are strengthened through a reorganization of socio-material practices.

This is manifest in the spatial practices of both *Cooper Glicério* and *Escola sem Muros*, which can be seen as assemblages of heterogeneous actors, citizens, and materials. The spatial practices of *Escola sem Muros* seek to establish open design ecologies that draw local and social capacities into the design process by collecting and repurposing found materials and sites rather than by imposing skills or materials from the outside. Because these spatial practices insert themselves into an already existing ecology of practices, *Escola sem Muros* shares similarities with the spatial production of *Cooper Glicério* in that each practices spatial justice on many scales—caring for the expressiveness of the local citizens, for reuse of materials, and for an alternative exchange economy.

Assemblage theory indicates that spatial assemblages are partially effective. Values—social and mental—and spatial justice are always assembled and effect various degrees of impact in the urban milieu. Protest events like Occupy Gezi and the *Jornadas de Junho*—might have an impact in the short term, but in the long run pre-existing inequality in the city and social justice are rarely completely overcome by urban design practices alone. Hence, it is arguably necessary to look into ecologies of practices and the long-term change in spatial practices. While the incidents of 2012 had only a minor impact, primarily for a small group of middle-class citizens and activists, they contributed to broader ecologies of spatial practices in their aftermath. In the case of São Paulo, this meant not a change in urban policies but rather a change in how design activism and DIY urbanism evolved to foster emergent publics by supporting spatial ecologies in the peripheries.

The examples discussed here challenge the skepticism expressed by critical urbanists such as Mayer and Swyngedouw about the impact of urban activism, as they illustrate how space is always assembled through civil spatial acts that cannot be clearly categorized. Working with spatial assemblages, and exploring how they are practiced and performed, entails working with complexity. Here, design and urban activism can be considered as a manifestation of diverse politics—as "impure politics," as suggested by Thomas Markussen in his reading of Rancière via Chambers.[33] Critical urban geographers claim that this approach is problematic because the urban activists and their urban practices partake in and even contribute to the existing capitalist order and

gentrification. Yet I posit that the spatial practices of design and urban activism must be seen not as singular events, but as ecologies of practices that relate to and open up other ways of engaging with the city. These processes take place over time and are often heterogeneous; hence, they require comparative studies that investigate how the geometries of power change over time and how, in return, they change the practices of design activism.

In the case of São Paulo, one can define the series of events that took place in recent years—the tactical inventions on Minhocão in 2012, *Cooper Glicério*'s collective practices underneath the viaduct in 2012, the *Jornadas de Junho* protest movement in 2013, and the collaborative spatial practice of *Escola sem Muros* in 2017–19—as acts of spatial citizenship wherein a plethora of spatial rights claims were made. Many more examples could be added to this series. As spatial acts, they all differ in terms of how and for whom they interpret spatial justice, and why. Together, however, they constitute an ecology of practices in which they relate to and affect one another over time.

This chain of events indicates that design and urban activism movements can mature and gain awareness of the implications of the right to the city and spatial justice—an awareness that might lead to decolonialization of their own tactics. Such awareness was gradually fostered in São Paulo through a variety of critical spatial practices that led to acts of citizenship as a multitude of practices. As Ahmed Ansari points out in a discussion on decolonizing design activism, "There is no *single* approach to a decolonial politics … but a plurality, many possible politics."[34]

Following this idea, one might see decolonization as "a programme of complete disorder"—that is to say, "something that seeks to challenge, upset, and reconfigure modern/colonial institutions rather than fit comfortably within them."[35] Here, the critiques of design and urban activism and dissent through design as acts that are closely linked to the neoliberal order might be reconsidered from a decolonial perspective that poses design activism as a messier, more pluralistic, and nonlinear practice.

The example of *Cooper Glicério*, evicted in April 2017,[36] offers a glimpse of what decolonization might mean. In the years of its operation, the collective provided space and facilities for the urban disadvantaged and homeless in the neglected areas of São Paulo. In many ways, this recycling station and outdoor gym carried out a plural, citizen-led decolonization of the power geometries and the governing forms of spatial organization. Could such examples of citizen-led efforts at decolonization redirect design and urban activism, calling designers to leave behind their professional tools and increasingly work toward spatial justice as something to be co-created and claimed by citizens? Could the call of decolonizing design lead to opening up design not as a singular act but as an ecology of practices bringing in the pluriverse through multiple co-evolving acts? Being led by citizens' own spatial acts and appropriations, as we saw it unfold beneath the highway infrastructure in the *Cooper Glicério* collective, could be one route to decolonizing design activism and the force field that constitutes the urban.

Notes

1 See, for instance, Neil Brenner, Peter Marcuse, and Margit Mayer, *Cities for People, Not for Profit: Critical Urban Theory and the Right to the City* (London: Routledge,

2012). See also Margit Mayer, *Social Movements in the (Post)Neoliberal City* (London: Bedford Press, 2010). David Harvey, *Rebel Cities: From the Right to the City to the Urban Revolution* (New York and London: Verso, 2012). Erik Swyngedouw, *Designing the Post-Political City and the Insurgent Polis* (London: Bedford Press, 2011).
2. David Harvey, *Rebel Cities: From the Right to the City to the Urban Revolution* (New York and London: Verso, 2012), 119.
3. Henri Lefebvre, *Writings on Cities*, E. Kofman and E. Lebas, trans. and eds. (Oxford: Basil Blackwell, 1996).
4. David Harvey, "The Right to the City," *New Left Review* 53 (2008), 23.
5. Erik Swyngedouw, *Designing the Post-Political City and the Insurgent Polis* (London: Bedford Press, 2011), 38–40.
6. Erik Swyngedouw, *Designing the Post-Political City* (London: Bedford Press, 2011).
7. Mark Purcell, "Excavating Lefebvre: The Right to the City and its Urban Politics of the Inhabitant," *Geojournal* 58 (2002), 101.
8. Isabelle Stengers, *Cosmopolitics* (Minneapolis: University of Minnesota Press, 2010), 32–33.
9. Ash Amin and Nigel Thrift, *Cities Reimagining the Urban* (London: Polity Press, 2002), 84.
10. For a detailed description of the becoming of urban space, see Jean Hillier, *Stretching Beyond the Horizon* (London: Routledge, 2007). Or, for an architecture- and design-oriented reading of becoming, see Kristine Samson, "Becoming of Urban Space: From Design Object to Design Proces," in *Design Research—Synergies of Interdisciplinary Perspectives*, eds. Jesper Simonsen, Jørgen O. Bærenholdt, Monica Büscher, and Jan Damm Scheuer (London: Routledge, 2010), 172–86.
11. Doreen Massey, *For Space* (London, Thousand Oaks, CA, and New Delhi: Sage Publications, 2005), 130–31.
12. Ibid., 152.
13. Throughout the chapter "design activism" and "urban activism" are used as interchangable terms. I find it necessary to clarify that I do not believe that strict boundaries can be put between the two terms, and that they both partake in urban ecologies of practices. As the chapter illustrates, they both change and develop over time under the influnces of global movements, local citizens' initiatives and changes in institutionalized practices, among other factors.
14. Phillip Gielen and Pascal Dietachmair, *The Art of Civil Actions: Political Space and Cultural Dissent* (Amsterdam: Valiz, 2017), 15.
15. James Holston and Arjun Apparadurai, "Cities and Citizenship," *Public Culture* 8, 187–204.
16. Lucy Earle, *Transgressive Citizenship and the Struggle for Social Justice: The Right to the City in São Paulo* (London: Palgrave Macmillan, 2017), 36.
17. Ibid., 2.
18. Ibid., 3.
19. For instance, the Voodoo Hop street parties that took place in urban spaces, on top of buildings, and in forgotten non-places used bodily performances and body shields to dance against traffic congestion. While global activist events from the Arab Spring, Indignados, Occupy Wall Street, and Occupy Gezi have been influential in relation to how and in what spatial aesthetics the places were appropriated, the specific hybrid of Berlin's party and squatter cultures has been influential—not only as an urban trend but in terms of the supporting infrastructures and the people invited to participate.
20. In 2019 a municipal decision was made to turn the highway into a public park.
21. The collectives and NGOs participating in the 2012 events consisted of a diverse crowd of creative entrepreneurs, activists, collectives, and NGOs. They came from various fields and professions and counted, among others, *Basurama Brasil, Rios e Ruas, Fora do Eixo, Muda Coletivo, SampaPé*, and students from *Escola da Cidade*.
22. Phillipp Oswalt, Klaus Overmeyer and Philipp Misselwitz, *Urban Catalyst. The Power of Temporary Use* (Berlin: Dom Publishers, 2013); *Urban Catalyst: The Power of Temporary Use* (Berlin: Dom Publishers, 2013), 276.
23. Quentin Stevens and Kim Dovey, "Pop-ups and Public Interests: Agile Public Space in the Neoliberal City," in *The Palgrave Handbook of Bottom-up Urbanism*, eds. Mahyar Arefi and Conrad Kickert, (Cham, Switzerland: Palgrave Macmillan, 2019), 323–37.

24 Earle, *Transgressive Citizenship*, 289.
25 The project consisted of a DIY urbanism act with the collective planting several trees at the Largo de Batata without permission. See more at Cidade Democrática, "Coletivo planta árvores no Largo da Batata sem autorização da prefeitura" ("Collective Plants Trees in Largo da Batata without Authorization from the City Hall"), January 19, 2015, accessed January 2, 2019, http://blog.cidadedemocratica.org.br/2015/01/19/coletivo-planta-arvores-no-largo-da-batata-sem-autorizacao-da-prefeitura/.
26 Escola sem Muros website, accessed January 2, 2019, www.semmuros.com/escolasemmuros.
27 Marcella Arruda, interview by Kristine Samson, Sao Paulo/Copenhagen, Brazil/Denmark, December 11, 2018.
28 Ibid.
29 Nicholas Tampio, "Assemblages and the Multitude: Deleuze, Hardt, Negri, and the Postmodern Left," *European Journal of Political Theory* 8, no. 3 (2009), 383–400.
30 Ibid., 384.
31 Ibid., 394.
32 Jane Bennett, *Vibrant Matter: A Political Ecology of Things* (Durham, NC: Duke University Press, 2010).
33 Thomas Markussen, "Politics of Design Activism—From Impure Politics to Parapolitics" (Chaper 13, this volume).
34 Tristan Schultz, et al., "What Is at Stake with Decolonizing Design? A Roundtable," *Design and Culture* 10, no. 1 (2018), 81–101.
35 Frantz Fanon, *The Wretched of the Earth* (Harmondsworth, Middlesex: Penguin, 1971), 27.
36 Carina Barros, "Glicério tem protesto contra retirada dos objetos de moradores de rua" ("Collective Plants Trees in Largo da Batata without Authorization from the City Hall"), Folha de S.Paulo, April 10, 2017, accessed January 2, 2019, https://mural.blogfolha.uol.com.br/2017/04/10/glicerio-tem-protesto-contra-retirada-dos-objetos-de-moradores-de-rua/.

16 Temporarily Open

A Brazilian Design School's Experimental Approaches against the Dismantling of Public Education—A Conversation on Design Pedagogy as Dissent[1]

Zoy Anastassakis, Marcos Martins, Lucas Nonno, Juliana Paolucci, and Jilly Traganou

ESDI Aberta (Open ESDI),[2] a movement of political pedagogy, took place in 2016–17 during a period of financial crisis in the State of Rio de Janeiro, Brazil. It was initiated by faculty and students of ESDI (Superior School of Industrial Design),[3] part of the Rio de Janeiro State University (UERJ).

In 2016, ESDI was threatened with closure, due to a series of interruptions of fund transfers from the state to the university. *ESDI Aberta* diverted a state of political disorder into a condition of disobedience to the government's narrative of crisis, and made it possible to launch experimental, student-run design and educational initiatives, and bottom-up management processes. These actions hardly would have been imaginable during the school's regular operation (Figure 16.1).

ESDI Aberta was organized using familiar tactics of prefigurative political movements, such as sit-ins, squats and protest camps. With the use of radical material engagement, a new understanding of the school as a realm of collective action and knowledge generation emerged. On the one hand, keeping the school open was a clear response to both the actual condition of financial crisis, and the state's use of this situation as an excuse for dismantling public education. On the other, it forcefully reacted against the re-emergence of profoundly undemocratic forces that targeted fundamental rights and freedoms of thought, expression, and sexuality. Despite the resumption of some sort of "normality" in the university in 2018, the question of whether one could imagine a continuity between the *ESDI Aberta* initiatives and the school's regular operation becomes significant.

In the conversation below, Zoy Anastassakis and Marcos Martins, ESDI's co-directors from March 2016 to December 2018, as well as Lucas Nonno and Juliana Paolucci, students who participated in the movement, discuss with Jilly Traganou what was at stake from a design pedagogy perspective.

JILLY: Zoy and Marcos, you were co-directors of ESDI during one of the most difficult times in its recent history. Tell us about the *ESDI Aberta* movement, what led to it, and what happened under its umbrella.
MARCOS: We had just taken office as directors in March 2016, and very quickly the whole system nearly collapsed. Our basic imperative was to face this situation and

Figure 16.1 "Open ESDI, UERJ resists." Banners made by students for the inauguration of ESDI's new gate and entryway, during the period of the *ESDI Aberta* (Open ESDI) occupation, Rio de Janeiro, February 2017.

Photo: Ana Clara Tito.

 strategize on how we might keep this school open. We felt that a closed public university could be used politically to justify the idea of education's privatization; a threat that was increasingly present.

ZOY: In March 2016, our directorship started with a strike that lasted for six months. And after that, we stayed for almost two years in a very unstable situation, due to recurring shorter strikes, and also to the fact that the government wouldn't pay for the university's basic maintenance, which led to lack of services, such as garbage collection, cleaning, and maintenance. So, we faced different kinds of difficulties that caused the suspension of classes. Our reaction to this was to try to keep the design school open in a very particular way. This is the meaning of *ESDI Aberta*. We were in a double movement: trying to establish a new way of conducting education, and at the same time needing to improvise to keep the school open.

JILLY: What did a typical day at the school look like during this period?

MARCOS: There was no such thing as a typical day. We had to constantly face new scenarios and prognostics. For many weeks, the central administration of the university said, "we will resume classes next week." The next week came, the government hadn't paid the salaries and maintenance costs, and then they would say "no, we will wait one more week." There were several "next weeks," and we had to hastily "design" activities that would substitute for regular classes and very quickly inform the community about them. The help of the students was crucial for this new type of

routine. The crisis forced us to think carefully what it means to invent pedagogical approaches in a context of insecurity.

JILLY: I would like to discuss the particular design pedagogy that emerged from these new conditions at the school.

ZOY: Marcos and I were particularly optimistic that this moment could give birth to educational experimentation. The radicality and experimentation came from the students. This started clearly one day in March 2017 when we were in a faculty meeting. This group of students came in and declared that they were occupying the school, that they needed a kitchen, and that they were planning to sleep there (Figures 16.2 and 16.3, Plate 12). They also published a manifesto of "OcUPA Esdi," announcing that they were occupying the school not to fight against the university's administrators, but in support of efforts to keep the university open and operative (Figure 16.4). They reclaimed the school on their own terms. In a radical move, they occupied the school as a living space.

LUCAS: More than the manifesto's content itself, what was even more significant was the way it was circulated together with our daily reports, because this was done through the school's website and Facebook pages. Thus, our occupation of the physical spaces of ESDI was accompanied by our appropriation of its official media communication channels. This helped us expand our voice out of the school.

JULIANA: It is worth mentioning the *ESDI Aberta* event that took place on February 12, 2017, an open event that was held at ESDI to communicate that, despite the

Figure 16.2 Collective lunch during the occupation.
Photo: Carolina Secco.

Figure 16.3 Sleeping room during students' occupation at *ESDI Aberta*, Rio de Janeiro, February, 2017.

Photo: Juliana Paolucci.

government's neglect, the school remained open and active. Between lectures, "deconferences," and concerts, and throughout the program, more than 1,500 people passed by the school. On that day, we also launched the new visual identity and website, announced the relaunching of the Association of Teachers, Alumni, and Friends of ESDI (AexDI), and the inauguration of a new entryway to the school through Rua do Passeio. From that point on, students, alumni, teachers, staff, and volunteers organized a variety of activities that kept the school functioning. It was all this that happened during the course of 2017, taking care of the school's space, education and knowledge exchange, that we called *ESDI Aberta*.

JILLY: What kind of support was provided by *ESDI Aberta* and the occupation? Did the occupation help providing shelter to students who could not afford to come to school?

JULIANA: Yes, but more than that, the event *ESDI Aberta* that I mentioned earlier, in addition to its affective and political values, generated a considerable profit. This money was used for the purchase of equipment for the graphic workshops; the payment of ten months' salary for ESDI's janitor, Carlos Ferreira (better known as Carlinhos), who was dismissed from UERJ, and the Box *ESDI Aberta*, which subsidized the transportation of those who needed financial assistance. (Figure 16.5).

Figure 16.4 Student's occupation manifesto affixed on a wall in the main School's entrance. Manifesto excerpt: "Occupy ESDI. We, an ESDI student group, decided to initiate an occupation movement, today, on March 14, 2017. Due to systematic delays, and lack of payment of employees' salaries, student scholarships, and UERJ maintenance fees, we agree with the position of the board of directors that have declared the impossibility to return to normal university operation. In the meantime, emptying the university puts its very existence in danger. With the community fragmenting, looking for specific solutions, the collectivity is lost. With this in mind, we understand that the occupation is an alternative that can foster activities of creativity and learning in response to this reality. This, which is the essence of the university, is our real tool to reintegrate the community in defense of public and popular education."

Photo: Juliana Paolucci.

MARCOS: The box became an ongoing source that generated support for the students. This was a little box that we put in the school secretary's hall and whoever had some money to spare would make a deposit to help others that didn't have the resources to travel to school or eat. There was no surveillance over this box. Anyone could open it to place or withdraw the amount they wanted. It was completely improvised and in itself was a type of service design experience. When we talk about the changes that *ESDI Aberta* brought, we need to note all these kinds of experiments, which may seem very small, but profoundly impact people who are in precarious situations. It is actually very strategic to report things that are small and particular, and not monumental.

Figure 16.5 The "Box *ESDI Aberta*" used to collect money for community support.
Photo: Carolina Secco.

JILLY: Can you speak about the students' initiatives during the occupation?
JULIANA: Throughout the day, small groups were involved in various activities: taking care of the urban garden located at the school (Figure 16.6, Plate 13), performing graphic projects, cleaning the campus, holding workshops and debates on design and crisis. They also engaged collectively in design projects that generated income for the expenses of the occupation. Through these initiatives, we reaffirmed the right to stay there, without pretending to be finding solutions to the crisis, but trying modest alternatives to recover from the contingencies we found ourselves in.
ZOY: Some broader synergies and longer-lasting activities emerged during this time. One example was a collaboration between students, street poets, and a collective of artists. They created the "Colaboratório," a graphic experimentation laboratory, at the school's graphic workshop, where they hacked inkjet printing machines to reduce

Figure 16.6 Students working at the vegetable garden of Green Space, an experimental research lab at *ESDI Aberta*.
Photo: Gabriel Borges.

Figure 16.7 Students working at the Colaboratório, a graphic experimentation laboratory of *ESDI Aberta*.
Photo: André Aranha.

Figure 16.8 ESDI *Aberta* organizing meeting in January 2017.
Photo: Zoy Anastassakis.

printing costs. This led to experiments with typography, printing, and silk screening (Figure 16.7). There was another group of students that began the experimental research lab Green Space. Their projects included developing materials and products with kombucha, cultivating living furniture, working with garbage collection in favelas, and experimenting with growing vegetables inside apartments.

JILLY: Lucas and Juliana, can you reflect on the power structures during and within the occupation?

JULIANA: It is important to say that the occupation included 40 to 50 people. Taking into account that ESDI had about 450 students, one can say that the number was not significant. However, I lived the movement and I can say that these 50 people brought life to the school at that time. The relationship between the occupants was horizontal but, at the same time, leadership was perceptible. We all knew, for example, that to deal with matters related to the Colaboratório we had to talk to André; as for free courses, people would turn to me or Marina. I believe that this is inherent in self-organization: there is no election of a leader, but leadership emerges naturally when necessary. Among the students and teachers who were not with us, some did not have the energy nor the psychological condition necessary to participate in the occupation. This was completely understandable in the face of the crisis we were experiencing.

JILLY: Do you see the current political climate changing the education at ESDI?

LUCAS: For me, this movement represents a milestone that not only proves that we can change things, but also showed a way for doing so. What we did at ESDI was an act of resistance. But most of all, the movement proved that it is necessary for the students to take action in the school. At ESDI, the new political moment will encounter a group which became stronger due to the experiences of resistance that took place there (Figure 16.8).

Acknowledgments

We would like to thank Barbara Adams, Clive Dilnot, Mahmoud Keshavarz, and Luiza Prado de O. Martins for helping us contextualize and enrich this conversation; Paula Aimi Kawakami Ishihara for translations; Nicole Economides and Giulia Cezini for transcriptions, and André Aranha, Gabriel Borges, Carolina Secco and Ana Clara Tito for providing us with their photographs.

Notes

1 A full version of this conversation was published in *Design and Culture* 11, no. 2 (2019): 157–72.
2 *ESDI Aberta* 2017. Accessed March 7, 2020. https://ESDIaberta2017.wixsite.com/linhadotempo.
3 ESDI was founded in 1962 with the support of international faculty, including Max Bill and Tomas Maldonado, professors of HfG Ulm, and received additional influences from people with heterogeneous political and educational positions, such as Aloisio Magalhães, Renina Katz, and Décio Pignatari. ESDI has always been a place in which strict formalism coexisted with less orthodox experimentation.

17 Designing Post-carbon Futures
The Prefigurative Politics of the Transition Movement

Emily Hardt

Introduction

Starting in the UK in 2006, the Transition (Towns) movement has organized with the aim to "reimagine and rebuild our world"[1] in response to the interrelated crises of climate change, resource depletion, and economic insecurity. Over the past decade, the movement has spread to countries around the world, including the US. Transition's ambitious aims include ending dependence on fossil fuels and preparing communities for climate and economic shocks. Its initiatives, however, are organized through local, everyday life projects. The movement is bringing neighbors together to plant vegetable gardens and food forests and to create time banks and tool-lending libraries. Transition is "incredibly ambitious," a US Transition leader told me. "We're trying to change the whole vision for our community's future and start putting in the infrastructure to make that a possibility."[2]

When Transition was first emerging over a decade ago, the designer and design scholar Joanna Boehnert commented that the movement could "be seen as design activism—led by non-designers."[3] Today, though design pervades the movement, this aspect of Transition has been overlooked by sustainability-focused and social movement scholars. In this chapter, I discuss the role of design in the Transition movement, including its origins in an ecological design approach called "permaculture." I then explore Transition's organizing practices, which are centered on community-led design.[4]

Transition's design practices allow it to be open-ended and focused on transforming everyday lives. Through design, the Transition movement engages in what I argue is a prefigurative politics that, like many contemporary movements around the world, "emphasizes the local, the cultural, the present, and the possibilities of other ways of being."[5] Transition seeks to change the ways of being-in-the-world that underlie and maintain the dominant political-economic system. Paying attention to its specifically design-based processes provides a better understanding of the potential of this approach and its political significance. It also sheds light on the social tensions involved in its implementation, which in the US context include challenges in addressing racism and inequality.

Transition Towns

In *The Transition Handbook* (2008), Rob Hopkins, widely known as the movement's founder and its most visible spokesperson, lays out the four key assumptions of Transition:

- That life with dramatically lower energy consumption is inevitable, and that it's better to plan for it than to be taken by surprise.
- That our communities currently lack resilience.
- That we have to act collectively, and we have to act now to build community resilience and prepare for life without fossil fuels.
- That by unleashing the collective genius of our communities, it is possible to design new ways of living that are more nourishing, fulfilling, ecologically sustainable, and socially just.[6]

These core assumptions represent a marked departure from mainstream environmentalism.[7] Rather than attempting to replace fossil fuels with renewable energy sources to continue business as usual, Transition argues that the unprecedented converging environmental, energy, and economic crises demand an end to an economy dependent on high energy consumption and unlimited economic growth. Communities therefore need to undertake—the sooner the better—a managed process of "energy descent."[8]

Equally important in the movement is the concept of community resilience. Based on understandings of natural systems, resilience in Transition is conceived of as the capacity of a community to withstand shocks and adapt to new realities. Increasing community resilience involves meeting more of the community's basic needs locally, thereby reducing dependence on the energy required to transport food, clothing, building materials and other goods, and also leaving the community less vulnerable to climate, energy, and economic shocks occurring elsewhere.

As indicated in the final assumption quoted above, Transition sees managing energy descent and building community resilience as design challenges. Resilient communities need to be planned, Hopkins points out. Thus, building resilience as "a collective design project, is central to Transition."[9] Designing new ways of living is presented not only as a necessity, but also as an historic opportunity. With intention, according to Transition, we can design communities that are more connected, meaningful, just and sustainable than those we have now.

The Transition Handbook (2008) and later *The Transition Companion* (2011), both written by Hopkins, offer practical guidance for engaging in community-led design processes, from envisioning possibilities to implementing hands-on projects. The model seeks to engage all sectors of a community by being "inclusive" and prioritizing relationships, self-determination, and autonomy. Without central plans or coordination, each local Transition initiative develops projects and priorities based on its particular place and scale.

Transition's "do-it-ourselves," community-led design approach is presented as a pragmatic alternative to national governments' "alliance to global business interests, exploitation of nature and mandate of perpetual economic growth."[10] "The political process is corrupted by money, power, and vested interests," claimed Naresh Giangrande, one of the co-founders of Transition Town Totnes, "I can only see us getting sustainable societies from the grassroots, bottom-up."[11]

Permaculture Design and the Emergence of the Transition Movement

The Transition movement's focus on designing processes for energy descent and building community resilience can be traced to its basis in an ecological design

approach called "permaculture." Rob Hopkins was teaching a two-year course in permaculture called "Practical Sustainability" at an adult education college in Kinsale, Ireland when he and his students began learning more about climate change and peak oil. They soon began "pushing the idea that permaculture should become a much more inclusive, larger-scale approach to community organizing and design."[12]

The term *permaculture*, a contraction of "permanent" and "agriculture,"[13] was coined by Australians Bill Mollison, a forester, naturalist, and teacher, and his student David Holmgren. In the 1970s, motivated by concerns about environmental degradation, decline in the energy supply, and the limits of the growth economy, Mollison and Holmgren began to identify the features that made the systems they observed in nature and in indigenous societies both productive and sustainable. They sought to develop design principles that could be applied to plan and manage ecosystems for food production that "have the diversity, stability, and resilience of natural ecosystems."[14] Though Mollison and Holmgren initially focused on agriculture, over time they and others applied the principles in many domains, including the design of natural buildings and human settlements.[15]

Proponents of permaculture seek to move beyond sustainability toward regeneration, arguing that humans are an integral part of the ecosystems of the planet and that with thoughtful observation, creativity, and intelligent design, we can have a beneficial impact on our habitats. The goal is to design human communities that are "ecologically sound [and] economically prosperous."[16] Permaculture is composed of a set of ethics and twelve principles that "constitute a design process, based on whole systems thinking."[17] Overall, the focus is not on objects, but on the relationships among them—on the whole system rather than its component parts.

Though it has not been embraced by mainstream design, a well-established body of permaculture practice and writing has been in place since the 1980s, when more widespread attention to environmental concerns helped permaculture "gain a worldwide following from its modest start in Tasmania."[18] The concept has been further developed over the past 40 years through an international community of permaculture practitioners, Permaculture Design Certificate workshops, and permaculture design schools.

After Hopkins, along with his permaculture students in Kinsale, developed the initial idea of a "Transition Town,"[19] he moved to Totnes, England and further elaborated the concept with Naresh Giangrande, Sophy Banks, Hilary Prentice, Fiona Ward, and others. Through ongoing experimentation and reflection in Totnes, the group developed multiple iterations of Transition in practice, sharing their ideas and experiences widely along the way.[20] Many other groups formed in the UK and beyond, and the Transition Network (UK) was established in 2007 to inspire, support, and connect the growing number of initiatives.[21] Communities in 34 countries around the world have now organized under the banner of the Transition movement.

Prefigurative Politics and Contemporary Social Movements

The Transition movement is part of a broad trend within contemporary social movements of "de-center[ing] the state and its institutions."[22] As Janet Conway

observes, "the state is no longer the uniquely privileged space of progressive politics."[23] From the Zapatistas and the alternative globalization movement beginning in the 1990s, to the occupation and assembly-based movements of the 2010s,[24] scholars are drawing attention to the ways many contemporary movements organize prefiguratively, or in ways that enact in the present their values and their visions of the future. "A prefigurative process," Marianne Maeckelbergh writes, "is direct and unmediated by political or economic elites based on the assumption that political leaders will not or cannot bring about the kind of total social transformation that is needed."[25] The "other worlds" that activists assert are possible and the alternatives being prefigured are plural and open, allowing for heterogeneity.[26] They prioritize autonomy, self-determination, nonhierarchy, and democratic processes. They are often rooted in local places and focus on everyday life.

These movements point to the necessity of expanding the conception of "the political" in ways that go beyond its mainstream Western definitions, which have centered on the state and related institutions.[27] As Roberto Mangabeira Unger argues, "Politics means conflict over the mastery and uses of governmental power. But it also means struggle over the resources and arrangements that set the basic terms of our practical and passionate relations."[28] That the prefigurative practices of many contemporary movements contest the "resources and arrangements" that structure and define the terms of our daily lives, social relations, cultures, and economies is nowhere more evident than in these movements' analyses of contemporary capitalism. Within many of these movements there is an implicit, if not explicit, analysis that, as the theorist Félix Guattari has argued, "Capitalist power has become delocalized and deterritorialized, both in extension, by extending its influence over the whole social, economic and cultural life of the planet, and in 'intension,' by infiltrating the most unconscious subjective strata."[29] It is therefore imperative, according to Guattari, "to work towards rebuilding human relations" and "to confront capitalism's effects in … everyday life."[30] Through prefigurative practices, these movements contest the cultures, practices, and social relations through which neoliberal capitalist globalization exercises its power.[31]

The majority of recent scholarship on prefigurative politics centers on movements' practices of networking, direct action, and occupations, and their efforts to "democratiz[e] all spaces and processes."[32] Although a growing number of social movements around the world, including in the US—from immigrant rights movements and Black Lives Matter to climate justice organizations—are engaging in prefiguration,[33] less has been done to theorize the politics of building alternatives to, and autonomy from, the globalized neoliberal economy in local places.[34] Transition's use of community-led design as a key aspect of its prefiguration introduces an important dimension to this politics. It is at the juncture of the cultural and the material that Transition operates—on the terrain of design. It is therefore critical to understand how prefiguration features in Transition from the perspective of design.

Design for Transitions

Design, and its focus on creating alternatives, is central to the Transition movement because, Hopkins writes, our communities and economies must be remade to be

"more appropriate to our times."[35] The current crises are seen as material *and* cultural, future *and* present—calling for design practices that through their means and ends work toward different ways of living on the planet. Increasingly, many design scholars and theorists are reaching similar conclusions. As Cameron Tonkinwise observes, "designs influence how people act, making certain activities and their associated product ecologies inertial," and are therefore "crucial to shifting our societies out of current crises."[36] In large part inspired by the Transition movement, Tonkinwise, along with Terry Irwin and Gideon Kossoff, have developed a framework and an associated graduate program in Transition Design.[37] These design scholars are among many who are illuminating the ways "unsustainability is structurally designed into our everyday life"[38] and arguing that design has a key role to play in transitions to societies that can be sustained.

In *Design, When Everybody Designs: An Introduction to Design for Social Innovation* (2015), the design theorist Ezio Manzini argues that design, in addition to its potential for problem solving, can make a key contribution to bringing about the transitions demanded by the contemporary ecological crises through its capacity for sense making. Design, he writes, based on Herbert Simon, is concerned both with "how things ought to be" to solve problems, and also with how things "ought to be in order to create new meaningful entities."[39] Design thus contributes to the social construction of meaning and values.[40] In another example, the anthropologist Arturo Escobar builds on the work of Terry Winograd and Fernando Flores (1986), Anne-Marie Willis (2006) and others, making a case for the continued development of the concept of ontological design.[41] In *Designs for the Pluriverse*, he writes that "ontological design stems from a seemingly simple observation: that in designing tools (objects, structures, policies, expert systems, discourses, even narratives) we are creating ways of being."[42] This insight that the things that we design in our world in turn "design us"[43] is one of the most powerful arguments for the political significance of design. From the ontological perspective, design can support transitions toward new ways of being.

As these theorists illuminate the political significance of design and its (potential) role in civilizational transitions, they also provide concepts and language to understand the political dimensions of the community design-based Transition movement. Placing Transition in the context of design brings to light numerous ideas about how community-led design processes can facilitate social change.

Design in the US Transition Movement

As word spread about the work being developed in the UK, people in the US began organizing in their communities following the Transition Town principles and practices. By the end of 2009, around 50 local groups were recognized as official Transition initiatives, and dozens of other communities were interested or organizing in some capacity. A decade later, with 163 official initiatives, the US movement's rate of growth has slowed and many initiatives are no longer active.[44] On the whole, initiatives in the US have not achieved the scale and impact of some initiatives in Europe (building community-owned energy projects and housing developments, for example). Still, US-based Transitioners—primarily on the East and West Coasts and in the Midwest—are continuing to develop and deepen the community-led design model.

The Transition movement's foregrounding of local, practical projects and community-building has been criticized by many on the left, who argue that Transition is "post-political,"[45] and fails to challenge consumer capitalism and its mandate of economic growth.[46] Rather than engaging in anti-capitalist activism overtly, however, the movement embodies a politics that seeks to change the ways of "being/doing/relating"[47] that uphold our current political and economic system. Bringing people together by holding potlucks, engaging in visioning exercises, planting vegetable gardens and fruit trees, building tool-lending libraries and organizing repair cafés is part of a prefigurative political strategy intended to address the "deeper civilizational crisis"[48] at the root of climate change, fossil fuel dependence, and the related contemporary crises. Transition seeks to "[go] beyond reducing energy and planting trees, and needs, ultimately, to seep into the culture of a place," Hopkins writes.[49] Through its emphasis on building relationships and promoting autonomy and self-determination, along with its rootedness in local places, the movement engages in a cultural and material politics to bring about new ways of being-in-the-world.

Relationship-building and Inclusivity

One of Transition's stated goals is "to facilitate a degree of dialogue and inclusion that has rarely been achieved before."[50] In highlighting a common connection to a geographic place and a stake in its future, Transition seeks to bridge differences and engage a significant proportion of the population, beyond self-identified sympathizers and activists. Transition uses uncontroversial community potlucks and solutions-focused practical projects to provide people with an easy entry path into the movement. In Sarasota, Florida, for example, the Transition group started the Suncoast Gleaning Project to gather crops that local farms are not able to harvest for sale. Volunteers harvest the food and deliver it to local food banks for distribution. Participants don't need to join the movement or attend meetings, but can just work a shift at the farm, making connections and learning about the Transition movement in the process. One of the initiators reports, "local food is perhaps the most effective and accessible gateway to Transition."[51]

Relationships and community connections are also valued for their own sake—they are seen as contributing to changing subjectivities and cultures over the long term. A Vermont Transition initiator told me, "Transition is using personal conversation and relationships to help us transition to a new paradigm [of] thinking about what would serve the whole community." Transition is not working toward consensus, in that the main goal is not for everyone to share a common identity or to join a specific campaign. Instead, the movement builds on connections to a local place to forge alliances that create practical alternatives to neoliberal globalization. Transition Pasadena (California), for example, has started multiple free-food gardens in public places (Figure 17.1, Plate 14). The fruit and vegetable gardens are meant to increase social connectivity, both through gardening and by creating inviting public spaces for neighbors to congregate.

The Transition Town Media (Pennsylvania) Free Store, where people bring things they no longer need and can take items others have brought at no charge, is another example (Figure 17.2). Though the store is seen as a way to serve the community, it is more importantly understood as a way to engage people in thinking about how to

Figure 17.1 Transition Pasadena's gardens serve to bring people together and demonstrate permaculture principles. Shown here is the Free-Food Garden, which during its three-year existence was located outside of the Arroyo Food Co-op. The group has also maintained the Throop Learning Garden since 2011, growing apricots, blueberries, figs, corn, squash, olives, beans, tomatoes, okra, and more, Pasadena, CA, 2015.

Photo: Sylvia Crowley Holmes.

meet their material needs through community rather than consumption. "The Free Store connects people and shifts their thinking," says one of the organizers.[52] The hope is that through the experience of the Free Store, people will "compensate for reduced consumption with an increase in something else that they consider more valuable."[53]

Self-determination and Autonomy

Transition's participatory community-led design processes are also seen as a way to maximize self-determination and autonomy.[54] Autonomy, as in Arturo Escobar's discussion of "biological autonomy" (as well as *autonomía* in contemporary Latin American intellectual-activist debates), is not the autonomy of liberal individualism, but is deeply relational; it is defined as the process by which living systems (or "persons and communities or even worlds") "find [their] way into the next moment by acting appropriately out of [their] own resources."[55] Self-determination

Figure 17.2 Since 2014, the Transition Media Free Store has sought to meet people's needs through gift-giving, sharing, and community rather than the exchange of money and increased consumption. With dozens of volunteers, the Free Store is open five days per week and sees an average of more than 100 visitors per day, Media, PA, 2016.

Photo: Emma Medina-Castrejon.

and autonomy are seen as important because in the face of tremendous challenges, according to Hopkins, "what we need are tools that help us to find a creative, active and empowering response. To be able to face these problems we need to stand together, to not feel alone."[56]

Transition's practical and local focus provides people with an accessible path to "meaningful things to do, where they have a sense of agency and autonomy as opposed to waiting for someone else to do something," as a Boston-area Transition initiator remarked. Being design-based and having a "bias toward action," as a Transition Putney (Vermont) initiator put it, also facilitates a looser organizational structure and distributed leadership. Local, hands-on projects can be organized and led via decentralized working groups, which is one of the primary ways Transition initiatives operate. Similar to many autonomous movements within which people "[look] to each other as sources of power,"[57] Transition envisions a world in which people's basic needs are met close to home, through collective agency and mutual aid. Transition Montpelier's Village Building Convergence is one example of this, an effort toward creating a sense of "village" where people support one another with practical skills and community resources (Figure 17.3).

Figure 17.3 The Village Building Convergence, organized by a working group of Transition Montpelier, was held each summer from 2009 to 2016 in central Vermont. The VBC focused on increasing resilience through building skills and community connections with potlucks, music, and workshops on topics ranging from medicinal plants and timber frame construction to art and social justice, Brookfield, VT, 2011.

Photo: Peter Yao.

New Ways of Being

By allowing for and supporting relationship building and self-determination, Transition's community-led design practices are meant to bring about alternative ways of being in the world. The material and economic transition away from fossil fuels is seen as inextricably connected with social and cultural transition.[58] As people adopt new practices and engage with one another and the world in new ways, it is hoped that their living and thinking will shift toward relationality and openness to creating alternatives.[59] With its emphasis on building connections in local places and facilitating lived experiences of mutual aid and support, the Transition movement is enacting a cultural and material politics that challenges many facets of contemporary capitalism. In attempting to develop organizing tactics that promote alternative ways of being and relating to one another, Transition is trying to shift people's self-definition away from "the individualizing and economizing terms of the market."[60] As Naresh Giangrande

said in an interview, Transition "completely contradicts the image of human nature in the media, portraying it as greedy and selfish, competitive, nasty, and unsocial. That's a self-fulfilling prophecy. We're setting up the reverse."[61] Rather than leading to a "pull yourself up by your bootstraps" ideology, as in neoliberalism, Transition's emphasis on personal responsibility and autonomy is accompanied by an assertion that we're all in this together—we will succeed or fail not by our individual efforts, but collectively.

Place

Focusing on redesigning life in local places also allows Transition to "locat[e] discussions and activisms squarely and deeply within all of their contextual complexity."[62] It is "by being place-based, and … thinking about … something as big as a transition from a fossil fuel economy and a globalized economy [to] something more localized," that the movement finds power and possibility. Transitioners see the potential of the movement in its emphasis on reimagining and redesigning local places. Individuals I interviewed spoke about Transition being able to address the challenges that "all the other environmental movements wanted to limit and to draw a circle around" by being about a place, and therefore encompassing all of the relationships and the whole "ecosystem" of that community. Transition requires you to think holistically, one person told me, to "figure out a way to live that includes transportation, that includes energy, that includes food, that includes how … we make decisions together and what … we value." Because Transition is conceived of as a "collective design project" in a local place, Transitioners see their efforts as capable of going beyond contentious politics.[63] These efforts are part of a political strategy meant to bring about cultural shifts over the long term. Understanding Transition's place-based, prefigurative practices specifically as *design* draws attention to the fact that the movement is developing a model of social change that is holistic and all-encompassing and aims to contribute to an "emerging culture, and hopefully an emerging civilization."[64]

Challenges of Transition in the US

As many critics both within and outside the movement have observed, it is important to ask "Whose transition is at stake when we use the term?"[65] One of the primary challenges of the Transition movement in the US is that it has been a predominantly (though not exclusively) white and upper- or middle-class movement.[66] The movement is therefore in many ways ill-equipped to engage with diverse communities or to speak to the concerns of the many people who are politically and economically marginalized in the US. Given that the US is highly geographically segregated by race and class, organizing around local places can also be problematic. Despite Transition's stated values of inclusivity and diversity, there are few concrete strategies offered for confronting power relations and "inequalities within and between communities."[67] Further, as Charis Boke writes,

> resilience-building community organizing must also take into account a wide array of sociopolitical realities—the continued appropriation of land and resources from Native and First Nation communities in North America, for instance, or communities of color living in environmentally marginal spaces.[68]

There is a contradiction between doing such local-level accounting and Transition's primary strategy of promoting positive, generally uncontroversial projects.

Many within the movement recognize, however, that, in the words of a participant at a New England Transition and Resilience Gathering, "we are not going to be resilient if we maintain the same race and class structures we have now." A few local initiatives have prioritized support for wider social justice struggles and have made connections with Occupy, Black Lives Matter, Standing Rock, and other movements. One Transitioner's participation in the Standing Rock encampment protesting the Dakota Access oil pipeline, for example, led to the indigenous leaders Phyllis Young and Pearl Means giving the keynote address at the US National Gathering in June 2017 and leading a workshop on "Decolonizing Transition." Transition US has launched a Social Justice Working Group and has plans to hold a Movement Strategy Summit on "Bridging Social Justice and Community Resilience Movements."

Some local initiatives have emphasized addressing racism and classism in their communities. In Pittsburgh, the Transition initiative, called Urban Transition Cities Movement, centers race, class, and economic inequality.[69] When it was more active a few years ago, Jamaica Plain New Economy Transition (JP NET) intentionally sought to bridge race and class divides in Boston. JP NET started several projects that brought diverse people together and that continue to be developed outside the original initiative, including a food forest and an annual "State of the Neighborhood" forum. Several Transition initiators I spoke with pointed out the potential of place-based projects—"everything from getting off fossil fuels to local energy, local businesses, alternative currencies and local food"—"to be used to further equity and social justice." Transition is therefore taking some early steps toward prioritizing anti-racism, anti-classism and anti-colonialism within and through its community-led design approach.

Conclusion

Design theorist Tony Fry, considering the contemporary crises, asserts that design's "actual directive force on ourselves and on the world around us makes it inherently and profoundly political." When we recognize design's political nature and its "implication in unsustainability," he continues, we will "grasp the necessity and scale of the task before us: making design a politics."[70] Similarly, the Transition movement's local, everyday, practical manifestations can be understood as deeply political. Following from the permaculture-based model, Transition is using community-led design to build resilience for expected climate, energy, and economic crises in the future and to engage in a collective effort to "live differently on the planet" in the present. Recognizing the Transition movement as a form of community-led design highlights the many strategic dimensions of its practical, local projects. Engaging in community-led design processes as a form of prefigurative politics allows the Transition movement to achieve several aims: building relationships, reaching "beyond the choir," and encouraging autonomy, self-determination, and capacity building. Through community design practices, the movement attempts to bring about new ways-of-being and to shift toward ways of thinking and doing that are more relational, holistic, and contextual. Further, Transition embodies in its practices a critique of economic growth, which is not only

dominant but largely unquestioned in mainstream culture and politics in the US. As Escobar writes, "behind any vision of transition there lies, to a greater or lesser extent, a substantial challenge to the onto-epistemic formation embedded in the current dominant form of capitalist modernity."[71]

Understanding Transition, and the particularities of design, as prefigurative politics also draws our attention to some of the key contributions of the movement: taking on contemporary crises as interconnected and systemic, generating multiple possibilities and developing and practicing new ways of being-in-the-world. These aspects receive little attention in the social movement literature and sustainability-focused literature. They are, however, significant motivators for Transitioners themselves, and they are increasingly relevant in other movements that seek to address the root causes of contemporary global crises and chart the way toward alternate futures.

Acknowledgment

I appreciate Jilly Traganou and Alessandra Renzi for their generous and helpful comments as I developed this chapter.

Notes

1 "Homepage of the Transition Network," TransitionNetwork.org, accessed May 25, 2018, https://transitionnetwork.org.
2 All quotes are personal communications unless noted otherwise.
3 Jody Boehnert, "Design & Transition: What Designers Can Learn from the Transition Movement," Paper presented at "Changing the Change" Conference, Turin, Italy, July 2008, www.eco-labs.org/resources/papers-on-line/97-designers-a-the-transition-movement.
4 In this paper, I draw heavily on ethnographic research I carried out in the northeastern US in 2011–13, as well as on more recent observations of Transition around the US, gathered by engaging in conversations with Transitioners from around the country at the first-ever Transition US National Gathering held in 2017 in St. Paul, Minnesota; reading the movement's websites, social media sites, and newsletters; and conducting a small number of interviews with national Transition leaders and participants in local initiatives. I am grateful for the generosity of the many individuals involved in Transition who shared with me their time, experiences and insights. Prior to studying the movement, I was briefly involved in organizing an initiative in my own city of Somerville, Massachusetts.
5 Wendy Harcourt and Arturo Escobar, *Women and the Politics of Place* (Bloomfield, CT: Kumarian Press, 2005), 14.
6 Rob Hopkins, *The Transition Handbook: From Oil Dependency to Local Resilience* (Devon, UK: Green Books Ltd., 2008), 134.
7 Joanna Boehnert, *Design, Ecology, Politics: Towards the Ecocene* (New York and London: Bloomsbury, 2018), 105.
8 The term "energy descent" was "coined by Howard and Elizabeth Odum and permaculture co-founder David Holmgren." Ibid., 105.
9 Rob Hopkins, *The Transition Companion: Making Your Community More Resilient in Uncertain Times* (White River Junction, VT: Chelsea Green Publishing, 2011), 45.
10 Jonathan Crinion and Rob Hopkins, "Adapting to Peak Oil and Climate Change: Lessons from the Transition Movement" (unpublished book chapter, Totnes, UK, 2011), 19.
11 Jay Griffiths, "The Transition Initiative: Changing the Scale of Change," *Orion Magazine*, July/August 2009, www.orionmagazine.org/index.php/articles/article/4792.
12 Ruah Swennerfelt, *Rising to the Challenge: The Transition Movement and People of Faith* (Caye Caulker, Belize: Producciones de la Hamaca, 2016), 33.

13 Now it has "evolved to be seen as a contraction of 'permanent' and 'culture,' as it goes beyond agriculture, arguing that food production is part of a wider culture of permanence," in Hopkins, *The Transition Companion*, 98.
14 Bill Mollison, quoted in Rafter Sass Ferguson and Sarah Taylor Lovell, "Permaculture for Agroecology: Design, Movement, Practice and Worldview. A Review," *Agronomy for Sustainable Development* 34, no. 2 (April 2014): 253.
15 Ferguson and Lovell, "Permaculture for Agroecology," 253.
16 Toby Hemenway, *Gaia's Garden: A Guide to Home-Scale Permaculture*, 2nd edition (White River Junction, VT: Chelsea Green, 2009), 6.
17 See permaculture's design principles here: David Holmgren, "Permaculture Design Principles," PermaculturePrinciples.com, accessed August 20, 2018, https://permacultureprinciples.com/principles/.
18 Sim van der Ryn and Stuart Cowan, *Ecological Design* (Washington, DC: Island Press, 2007), 46.
19 The term was coined by Louise Rooney and Catherine Dunne in Kinsale. Rob Hopkins, "10 Years of Transition Network," TransitionNetwork.org, accessed August 20, 2018, https://transitionnetwork.org/news-and-blog/10years/.
20 Beyond permaculture, design continues to play a key role in Transition. Rob Hopkins' more recent writings have drawn heavily on Christopher Alexander's *Pattern Language*—Christopher Alexander, Sara Ishikawa, Murray Silverstein, *A Pattern Language: Towns, Buildings, Construction* (Oxford: Oxford University Press, 1977)—as a way of "re-communicating and reshaping" the Transition model. See Michael Brownlee, *The Local Food Revolution* (Berkeley, CA: North Atlantic Books, 2016), 80; and Hopkins, *The Transition Companion*.
21 "Homepage of the Transition Network," TransitionNetwork.org, accessed May 25, 2018, https://transitionnetwork.org.
22 Janet M. Conway, *Praxis and Politics: Knowledge Production in Social Movements* (New York: Routledge, 2006), 136.
23 Ibid., 136.
24 Marianne Maeckelbergh, "The Prefigurative Turn: The Time and Place of Social Movement Practice," in *Social Sciences for an Other Politics, Women Theorizing without Parachutes*, ed. Ana Cecilia Dinerstein (Basingstoke, UK: Palgrave Macmillan, 2016), 122.
25 Ibid., 123.
26 Janet Conway, *The Edges of Global Justice: The World Social Forum and Its Others* (London and New York: Routledge, 2012), 165–66.
27 See, for example, Michal Ostwerweil, "A Cultural-Political Approach to Reinventing the Political," *International Social Science Journal* 56, no.182 (2004): 495–506; Teivo Teivainen, "The Political and Its Absence in the World Social Forum," in *Handbook on World Social Forum Activism*, ed. Jackie Smith, Scott Byrd, Ellen Reese, and Elizabeth Smythe (London: Routledge, 2012); Emily Brissette, "The Prefigurative Is Political: On Politics Beyond 'The State,'" in *Social Sciences for an Other Politics*, ed. Dinerstein, 109–19; and Marina Sitrin, "Rethinking Social Movements with Societies in Movement," in *Social Sciences for an Other Politics*, ed. Dinerstein, 143.
28 Roberto Mangabeira Unger, *Social Theory: Its Situation and Its Task* (New York: Verso, 2004), 145. See Teivainen for a discussion of Unger's definition of the political in relation to the World Social Forum ("The Political and its Absence in the World Social Forum," 74).
29 Félix Guattari, *The Three Ecologies*, trans. Ian Pindar and Paul Sutton, Bloomsbury Revelations edition (London and New York: Bloomsbury Academic, 2014), 33.
30 ibid,, 33.
31 Michal Osterweil, "A Cultural-Political Approach to Reinventing the Political," *International Social Science Journal* 56, no. 182 (2004): 498.
32 Michal Osterweil, "Place-based Globalism: Locating Women in the Alternative Globalization Movement," in *Women and the Politics of Place*, eds. Harcourt and Escobar, 180–81.
33 See, for example, Taj James, "From Protest to Power: Why Movements Matter & How They Work," February 26, 2016, YouTube video,14:19, accessed November 16, 2018,

www.youtube.com/watch?time_continue=11&v=Ye00UGYF5QI; and Chris Dixon, "Building 'Another Politics': The Contemporary Anti-Authoritarian Current in the US and Canada," *Anarchist Studies* 20, no. 2 (2012): 32–60.
34 Some exceptions include Amory Starr and Jason Adams, "Anti-globalization: The Global Fight for Local Autonomy," *New Political Science* 25, no.1 (2003): 19–42; and Arturo Escobar, *Designs for the Pluriverse: Radical Interdependence, Autonomy and the Making of Worlds* (Durham, NC: Duke University Press, 2018), 165–201.
35 Rob Hopkins, *The Power of Just Doing Stuff: How Local Action Can Change the World* (Cambridge, UK: UIT/Green Books, 2013), 107.
36 Cameron Tonkinwise, "Design for Transitions – From and to What?" *Critical Design/Critical Futures Articles* Paper 5 (2015), http://digitalcommons.risd.edu/critical_futures_symposium_articles/5.
37 Tonkinwise, "Design for Transitions."
38 Arturo Escobar, "*Transiciones*: A Space for Research and Design for Transitions to the Pluriverse," *Design Philosophy Papers* 13, no. 1 (2015): 21.
39 Ezio Manzini, *Design, When Everybody Designs: An Introduction to Design for Social Innovation*, trans. Rachel Coad (Cambridge, MA: The MIT Press, 2015), 35.
40 Manzini, *Design, When Everybody Designs*, 35.
41 Escobar, *Designs for the Pluriverse*, 15.
42 Escobar, 4.
43 Anne-Marie Willis, "Ontological Designing," *Design Philosophy Papers* 4, no. 2 (April 2006): 69–92.
44 "Official Transition Initiatives," TransitionUS.org, accessed August 13, 2018, http://transitionus.org/initiatives-map.
45 Anneleen Kenis and Matthias Lievens, "Searching for 'The Political' in Environmental Politics," *Environmental Politics* 23, no. 4 (2014): 11.
46 Esther Alloun and Samuel Alexander, "The Transition Movement: Questions of Diversity, Power and Affluence," *Simplicity Institute Report* 14g (2014): 15. See also Paul Chatterton and Alice Cutler, *The Rocky Road to a Real Transition: The Transition Towns Movement and What It Means for Social Change* (April 2008). http://trapese.clearerchannel.org/resources/rocky-road-a5-web.pdf; Ted Trainer, "The Transition Movement: Its Huge Significance, and a Friendly Criticism" published at CultureChange.org (2009).
47 Marina Sitrin, "Rethinking Social Movements with Societies in Movement," in *Social Sciences for an Other Politics*, ed. Dinerstein, 143.
48 Arturo Escobar, "Response: Design for/by [and from] the 'Global South,'" *Design Philosophy Papers* 15, no. 1 (2017): 43.
49 Hopkins, *The Transition Companion*, 74.
50 Ibid., 141.
51 "10 Stories of Transition in the US: Transition Sarasota's Suncoast Gleaning Project," TransitionUS.org, accessed August 24, 2018, www.transitionus.org/stories/10-stories-transition-us-transition-sarasotas-suncoast-gleaning-project.
52 Sari Steuber, quoted in Rob Hopkins, *21 Stories of Transition* (Totnes, Devon: Transition Network, 2015), 56.
53 Ibid., 56.
54 Escobar, *Designs for the Pluriverse*, 165.
55 Ibid., 167, following on Francisco Varela's definition of autonomy.
56 Hopkins, *The Power of Just Doing Stuff*, 41.
57 Starr and Adams, "Antiglobalization," 42.
58 As Janet Conway writes, "'the cultural' and 'the material' and the relations between them [are] mutually constituting," and the meanings and practices are inseparable. Conway, *Praxis and Politics*, 12.
59 Escobar, *Designs for the Pluriverse*, 4.
60 Sonia Alvarez, Evelina Dagnino, and Arturo Escobar, *Cultures of Politics/Politics of Cultures: Re-visioning Latin American Social Movements* (Boulder, CO: Westview Press, 1998), 22.
61 Griffiths, "The Transition Initiative."

62 Wendy Harcourt and Arturo Escobar Harcourt, "Women and the Politics of Place," *Development* 45, no.1 (March 2002): 11.
63 Charles Tilly, *Contentious Performances* (Cambridge: Cambridge University Press, 2008), 5; Doug McAdam, Sidney Tarrow, and Charles Tilly, *Dynamics of Contention* (Cambridge: Cambridge University Press, 2001), 22.
64 Manzini, *Design, When Everybody Designs*, 23.
65 Glen David Kuecker, "Enchanting Transition: A Post Colonial Perspective," in *Resilience, Community Action and Societal Transformation: People, Place, Practice, Power, Politics and Possibility in Transition*, ed. Thomas Henfrey, Gesa Maschkowski, and Gil Penha-Lopes (White River Junction, VT: Chelsea Green Publishers, 2017), 193.
66 This is true of the broader relocalization movement in the US as well. As David Hess writes, "Localism is not a poor people's movement. Rather, it articulates a middle-class radicalism in the global field of antiglobalization movements." David Hess, *Localist Movements in a Global Economy: Sustainability, Justice and Urban Development in the United States* (Cambridge, MA and London: The MIT Press, 2010), 17.
67 Esther Alloun and Samuel Alexander, "The Transition Movement: Questions of Diversity, Power and Affluence," *Simplicity Institute Report* 14 (2014): 11.
68 Charis Boke, "Resilience's Problem of the Present: Reconciling Social Justice and Future-oriented Resilience Planning in the Transition Town Movement," *Resilience* 3, no. 3 (2015): 207–20.
69 Fred Brown, "Urban Transition Cities Movement," Transition United States, September 19, 2016, http://transitionus.org/blog/urban-transition-cities-movement.
70 Tony Fry, *Design as Politics* (Oxford and New York: Berg, 2011), 11.
71 Escobar, *Designs for the Pluriverse*, 138.

18 Occupied Theater Embros

Designing and Maintaining the Commons in Athens under Crisis—An Interview with Eleni Tzirtzilaki[1]

Ursula (Orsalia) Dimitriou

Introduction

The Free Self-Managed Theater Embros[2] is one of several urban commons[3] that emerged in Athens in the context of the Greek financial and social crisis that started around 2010.[4] Since that period, discussions about urban commons have become widespread among city dwellers, as it was increasingly evident that the city's public spaces and property were being treated by the state as assets ready for exploitation and threatened with enclosure.

The commons, although an old word, is a contested concept. It is at the center of political discussions in social movements but, as Silvia Federici notes, it is also trendy among mainstream economists and capitalist planners, and has been appropriated by the World Bank, which puts it at the service of privatization.[5] Commons are considered to be the wealth of assets and resources collectively owned or shared between or among populations, with special regard for equitable access, use, and sustainability.[6] The shared resources can be both material, such as fisheries, water sources, and public land, or immaterial, such as the human genome, the airwaves, the Internet, etc. In this interview, we will follow De Angelis's and Stavrides's understanding of the term, according to whom the commons involve simultaneously: a common pool of resources (understood as non-commodified means of fulfilling people's needs), a community to sustain them, and "commoning" as a verb, which is the social process that creates and reproduces the commons.[7]

As a space of commons, Embros Theater differs from other commons in Athens, such as the activist spaces that formed in Parko Navarinou or the park in Kyprou and Patission Street, in that the latter are outdoor spaces, while Embros is taking shape inside a building. Thus Embros poses a number of dilemmas regarding the boundaries or specificities of the commoning practice, related to its spatial realization and the way it embodies the notion of the commons.

The building housing Embros was originally an interwar printing house. It was listed as a historical building under the preservation law in 1989, and adapted to become a theater space during the same year, named Embros Theater, in order to host the fringe theater company *Morphes* (1988–99) founded by Tasos Bantis, Dimitris Katalifos, and Rania Ikonomidou. Embros Theater closed in 2007, and when the state proposed the de-classification of the building and sale to private investors in 2011,[8] a group of artists and local residents decided to intervene by occupying the building.[9]

Here, I interview Eleni Tzirtzilaki,[10] an architect, community artist, and founder of Nomadic Architecture,[11] about her participation in the occupation of the space of the Embros Theater building, and its subsequent use as a space of commons. My conversation with Eleni[12] brought us to our shared interest in commoning practices, the indeterminate distinction between commons and squats, between sharing spaces and sharing feelings, and the potential role of the architect in designing and practicing the commons.

The Activation of Embros

URSULA: Talk to us about the Occupied Theater Embros and your participation in the project.

ELENI: I was one of the initial participants of the occupation in 2011. It is actually better to use the term "activation" rather than "occupation," as this is the term that we have used at the project since the beginning. Embros Theater was a building that remained unused for several years in the neighborhood of Psiri in downtown Athens. The idea of reusing this building has been the subject of frequent discussions both among the Psiri residents and Nomadic Architecture. Later as a member of the Mavili Initiative,[13] joined by inhabitants of the area, we proceeded to the activation of the theater, an act that was both artistic and political.

URSULA: How did the project start and why do you use the word "activate"? It seems to me that the term implies more than merely unlocking the building and entering the space.

ELENI: We actually did have to break into the space as it was locked. But the building was activated through a series of happenings (Figure 18.1, Plate 15). It started with a 12-day artistic activity. The project had an artistic character since the beginning because of the Mavili Initiative, a collective mainly composed of theater artists. I also believe that the social climate and the urban conditions at the time were auspicious: the tension in Athens in the autumn of 2011, the earlier occupation of the National Opera building,[14] and a range of events that followed the assassination of Alexis Grigoropoulos in 2008 brought the artistic community of Athens together. A lot of the artists who were part of the National Opera Occupation joined Embros. Soon, Embros became a cultural space. The activation performed by the Mavili Initiative had a quite intense experimental nature and formed part of a quest for a political-artistic expression. In order for art to be political, it is not enough to discuss political matters, but also to offer another way of expression; a new methodology. This tendency continued and became more intense following the Mavili Initiative's withdrawal from Embros. The space opened up new opportunities for collective activities and new collaborations. It triggered constructive discussions, debates, and experimentation. New art forms were suggested by all participants, and at the same time people were engaged in a quest for a different way of living. A number of performances took place at Embros, which back then was a relatively new art form in Athens. Embros hosted many artistic activities, in which I participated, including poetry events with Syrian artists as well as activist and artistic activities performed by African women and immigrants from Afghanistan.[15] Embros has also hosted experimental cultural-political festivals, discussing issues of biopolitics. A series of discussions took place during the workshops I organized, "*Embros os kino agatho*" ("Embros as a common good") and "*Ergastirio gia to kentro tis polis*" ("Workshop for the city

Figure 18.1 First day of Occupied Theater Embros's activation, Athens, November 11, 2011. Photo: Nikos Kazeros.

center"), that addressed issues concerning the center of Athens, where people decided to actively oppose any form of crisis management aiming at the center's re-mapping.[16] The crisis, the insecurity, and the fear of police and state violence, and the economic and social instability all formed a new geography in Athens, and we initially pictured Embros as an open space for diversity in the city, as a shelter in a war zone. Vulnerable artists, undocumented immigrants, queer people, and vagabonds found their space here. 2012 and 2013 were years of creative juxtaposition, while the space served as a shelter for the nomads of Athens. A Christmas meal event that we organized in 2013 was a representative example of this atmosphere, with high attendance and dynamism, as people forming a potential community gathered at the stage around a big table (Figure 18.2, Plate 16). In this sense, Embros started as a place where art met vulnerability.

Embros Self-management

URSULA: Would you say that the artistic-political nature of the venture was also interlinked with the way the space was managed?
ELENI: Indeed it was. We strived to make Embros a common space. Our aim was to give it a commonality on a political and artistic level. To make it a common good. It is

Figure 18.2 A communal Christmas meal in 2013 taking place on the stage of the Embros Theater.
Photo: Eleni Tzirtzilaki.

important to mention that shortly after its activation, the police tried to close it down and this is when the occupation of the theater was decided (Figure 18.3). The number of participants increased drastically as more people joined. The place started to be managed by an open assembly. Thereafter, the assemblies of the theater were full of

Figure 18.3 The police threatened to evacuate the state-owned building of Embros several times. Symbolic wrapping of Embros in protest of its imminent closure on November 25, 2012.

Photo: Nikos Kazeros.

people and very important discussions took place. Unfortunately, I would say that there was a noted patriarchal approach right from the beginning of the assemblies, which is often the case in many assemblies in Athens. However, we would talk openly about it, and organized different feminist and queer activities, in order to avoid it.

URSULA: So, how was the space managed?

ELENI: In the beginning, the space was managed by the Mavili Initiative which was organizing artistic events in Embros and in the city. Following Mavili Initiative's withdrawal, it switched to being run by an open assembly on the basis of self-management rotation (Figure 18.4). This meant that the management changed hands, i.e., one group was responsible for management this week, another one next week, etc. Basically, all work within the space was shared. The assembly would take place once a week and was open. We also agreed that anyone could come to Embros to organize an event, i.e., to suggest a performance, an exhibition, etc., and there were no exceptions to this rule. There would be a calendar and the suggestion would be logged in the calendar. We wouldn't ask for a CV, nor would we be interested in finding out whether someone was a recognized artist. Unknown artists were also welcomed. In addition, Embros was not running any profit-making activities. Right from the beginning, we used a box to collect money for the maintenance of the space. Everyone was free to contribute to this box with the amount of their choice.

URSULA: What is the relation of Embros with the local community? Was it seen as resistance to gentrification?

Figure 18.4 Assembly in the main theater space of Embros.
Photo: Eleni Tzirzilaki.

ELENI: The inhabitants had already requested to the city council to reopen the space, and were in favor of activating Embros from the beginning. For most of them, activating Embros was an act of opposition to the gentrification taking place in the area that started in 1998, when the governmental decree of land use regulation in the area took effect. This implementation displaced artisanal enterprises, traditional workshops, and inhabitants in favor of nightclubs, bars, and cafes that were seen as a threat to the neighborhood. So initially, several events took place with the support of the inhabitants, many of whom participated in the activation and later on in the occupation. Even locals who were not involved were content that the space had finally re-opened and they supported the effort. They contributed by offering water, Internet, food, as well as by joining our events and discussions, signing petitions to keep the place open, etc. A communal meal that Nomadic Architecture organized at the square of Psiri during Embros's activation had a very high attendance of locals, artists, vagabonds, and artisans.

URSULA: The Embros website reads: "Embros, as a theater, differs from other squats or social-political oriented occupations towards which it remains in solidarity." In what sense does it differ?

ELENI: Up until Embros started, squats in Athens were different. Villa Amalias and numerous other squats were mainly used for habitation. Events and happenings were taking place in these squats, but these were mainly addressed to limited audiences which were somehow involved in the squats. Embros was open, and since it was located in the city center, it was accessible to many different communities. It was open both by being available for public access and both by encouraging all minorities (of diverse ethnicities, sexual preferences, etc.) to visit and participate in it. We made numerous public calls, and used posters and online posts. This is why we mainly tried

to find a way to implement the idea of a common space. And for this reason we did not name it a squat, but "Free Self-Managed Theater Embros."

URSULA: Was this common and open condition threatened at any point?

ELENI: Embros was not formed by a political group, but rather by politically minded artists and inhabitants. So right from the beginning, we tried to make Embros open to many different groups in the city. A positive aspect of Athens is that it hosts many different communities of incredible dynamics. Both the events and the assemblies were attended by an incredibly diverse audience. The situation changed with the organization of the Antifascist festival in Embros in 2015 and 2016. That organization was based on an approach used for big movement festivals, having a program of scheduled performances of high demand in terms of lighting, stage design, etc. Things also changed because such groups simply wanted to find a place to host their performances, but were not interested in any involvement with the rest of the Embros community. This created a clear distinction between the internal Embros community and the audience, the performances, and the rave parties that started taking place at Embros. High attendance at events started to be considered important and desirable. Gradually, Embros started to adopt this way of operation that inhibited the maintenance and further cultivation of an ecology where a new perception for art and life could be experienced, as was the case for a long time. Let me clarify that this way of operating described above did not happen via a clear assembly's decision but took place gradually. It might have been related to the fact that the venture had reached a point of exhaustion. Maybe indeed such a condition of inclusivity cannot last forever … it has its limits. After four years, the residents of the neighborhood also progressively withdrew. This withdrawal was linked to the changing condition in the city center, as the crisis was deepening. The crisis is masked by an apparent tranquility, and by the increase of tourism, including the so-called "alternative tourism" that paid visits to Embros following its listing in the Documenta 14 exhibition that took place in Athens, as well as to other artistic spaces in the city center. Based on the current situation, it seems that despite the diversity of the communities in the city center, there is no larger public that would support the social transformation and the volatile condition of the city center. I personally withdrew from Embros in 2015.

URSULA: Are you suggesting that Embros, like any other commons, has an ephemeral character?

ELENI: I would say it had its limits rather than being ephemeral. I agree with what an article in *e Blaumachen* magazine claimed, that the various forms of commons that are created today are not foreshadows of a "communist society," or "microcommunisms."[17] Furthermore, the space was interacting with everything that was happening in the city. The current SYRIZA government[18] and its politics had a negative indirect impact on the space.

URSULA: SYRIZA was initially a movement party that created hope for an alternative movement politics. When were these hopes dashed?

ELENI: Yes, SYRIZA's election in 2015, as the first government of the left in Greece, slowed down all actions of the movement without bringing the social transformation that was hoped for. However, this slowing down was also related to the way some groups perceive the city and the commons. I think that there is still a lot of work to be done on the subject of self-management, commons, and community.

URSULA: Are you suggesting that your sense of Embros now decaying is related to two different things: first, to the sociopolitical condition in the city and the feeling of

tiredness following the slowing down of movements that affected the entire city; and secondly, the fact that some of these explosive actions have an ephemeral character and as such cannot maintain this tempo for long?

ELENI: Yes. I believe that we came very close to the creation of a new language. We wanted to create a language, a new unprecedented vocabulary that we sometimes felt related to. A language that would entail new aspects on politics and new methodologies on art. Quite frequently though, we would end up entangled in an all-too-common political debate that has remained nearly unchanged in terms of language since the post-civil war era in Greece,[19] an artistic approach that is trapped in petit-bourgeois stereotypes, audience, and star actors. I think that an occupation with such a strong character has to accept its own limits. I personally suggested moving to other spaces. The rupture between us was further intensified by the fact that we stayed confined to the space of Embros, when we could have initiated further similar situations in the city. During the first assemblies we had talked about creating a network of artistic spaces-occupations-urban commons in Athens. But people's wishes were trapped in the specific space, and hegemonic trends emerged.

URSULA: So you wanted expansion.

ELENI: I wanted the venture to spread out. This happened later with the emergence of other spaces like the City Plaza,[20] the Immigrant's Community Center,[21] and Communitism.[22] However, it is very difficult to make such situations last. Moreover, there were certain groups that managed to prevail within Embros as they had more experience and were united, whereas we, the group that started Embros, were different from each other, and not necessarily sharing the same ideology.

Between "A Home and a Void"

URSULA: On June 7, 2015—your last day of your participation in Embros—during the workshop on the commons that you organized, you read a text that started with this phrase: "As every story in capitalism, in fact, in the state of exception, it [Embros] had its limits." In this text you explain the reasons you wanted to resign from Embros, and you mentioned that the space is used by some as their own home, but yet again you characterized it as a void.[23] Could there be an ideal intermediary situation between a home and a void?

ELENI: This ideal is a space of commons. When people use this space as their emotional or symbolic home—as was the case for many, including me—they run the risk of feeling that this is their private space (even though as explained before, Embros was not used as a space of inhabitation). However, this feeling of ownership creates conflicts arising from territorial tendencies. The fact that so many people felt at home in Embros created a lot of conflicts.

URSULA: There is a fine distinction between the notions of "feeling comfortable within a space" and "assuming it belongs to me." I imagine that the initial objective of Embros was to make different groups feel comfortable within it but not to be seen as a home.

ELENI: Embros was not a home, but a borderless space. The problem was that they—actually we—made the space our home failing to respect the occupation's nomadic character, and we were then trapped in this condition. Gloria Anzaldua speaks about a space that would serve as a bridge, adding that it is essential to leave home and its

illusory safety, if we want to try to create a community; however, there is a dual risk associated with this idea: integration and exclusion.[24]

URSULA: What is the difference between the commons and a familiar private space? How could the space acquire this sense of familiarity without creating an enclosure?

ELENI: A familiar private space does not entail a community, the commons does. A community is not merely a group of people. It emerges through interactions, assemblies, and sharing. I was just reading the book *Notes Toward a Performative Theory of Assembly* by Judith Butler, which suggests that this can be achieved via events and performances.[25] Our bodies created different assemblies, and many of the bodies that met and designed the activities were particularly vulnerable. The understanding of this encounter could perhaps have opened a way. But we had no experience to draw upon. We contacted Teatro Valle,[26] a common space in Rome, and similar spaces in Spain, as it was important to exchange ideas on the culture of a commons. The idea of self-management could be learned by people with relevant experience, such as the Zapatistas who have been putting self-management into practice for years. You can read, learn, and try to implement. But this is quite hard because we haven't learned how to share. We had also started conversations on how to convert the space into commons from a legal perspective. But we finally left. Some participants in the assembly argued that it was not possible to create a community in the city center. They might have been right.

URSULA: Is this related to the way the space is managed or also to some ephemeral qualities that define the way one feels and inhabits a space like this?

ELENI: This might sound awkward to those not involved in such a space, but all these spaces are closely linked to emotions and the management of emotions.

URSULA: How do we allow an emotion to be developed without restricting it somehow? I am just trying to understand how you can develop this sense of familiarity with a tangible space of strong character without creating an enclosure. Would you say that this is a matter of education on the way spaces and feelings are managed?

ELENI: By developing activities within a space and channeling these emotions towards the activities, and not towards competition. This is a key point for me. Furthermore, we should ensure that everyone is given enough space. What I also mentioned to you about rotation and the open space is important. There are processes that are known to people who are involved in squats and common spaces about learning how to participate in a cycle and share. In order for a space to be common, emotions need to be cultivated, so that the space can be neither a void, nor an enclosure.

The Architecture of Embros

URSULA: How did this sociopolitical character of Embros relates to its particular three-dimensional space? Who made the spatial/designing decisions? What was changed, knocked down, or created in relation to the initial space?

ELENI: There was a close relation between the sociopolitical character of the occupation and the three-dimensional space. The building was listed for conservation and is an urban monument with significant architectural value. We didn't want to change anything about the space. Any changes applied were temporary; we didn't knock down any walls nor did we touch the initial features of the building. Various situations, in

particular the parties that started later on, caused a lot of damage to the building that now feels like a "void."[27]

URSULA: What exactly do you mean when you mention that changes to the building were "temporary"?

ELENI: I mean work that was necessary for reasons of maintenance, as for example treating the stage with primer. Back then, when we first entered and activated the building, this space used to be a source of inspiration. Because it bore the aura of a significant, historic space; in keeping with the spirit of a Bauhaus building, a significant theater and an old printing house. The theater conversion was undertaken by two brilliant architects[28] who kept features like the old machines, the table in the middle of the background, as well as the spaces on the upper floor with the windows. The space had a quality that we tried to maintain as much as possible.

URSULA: You mentioned that there was an interaction between the space and the ephemeral nature of the events. How was this achieved from an architectural point of view?

ELENI: We tried to use the space for our events in an effort to bring out its very essence. An act that would take place around the table[29] could highlight the table itself, such as the act with the shoemaker, a resident in the area, in 2013 (Figure 18.5). Acts taking place on the upper floors could highlight the windows, for instance. The reason for having a minimal intervention was in order to preserve, enhance, and use the numerous capabilities of the spaces, i.e., the stage, the windows, the staircase, the

Figure 18.5 Performance by a resident of Psiri district using as stage the foyer of the theatre and featuring the table of Embros. Nomadic Architecture and the Stories of People, February 4, 2013.

Photo: Eleni Tzirtzilaki.

bar, and the top floor. There was also lighting put on the building's façade. In the early stage, this dialogue with elements of the building itself resulted in events that activated certain spaces of the building.

URSULA: So you adopted an approach which specified that each group or event could activate the space in different ways, as long as it can be reverted back to its initial form.

ELENI: Indeed. To give you an example, there was an international artist at some point, who wanted to paint the whole stage white. We could not allow this, even though the artist said she would repaint the stage black, because the wall would lose its texture acquired through time. We suggested using white papers to transform the space in a more temporary way, but she didn't accept it and withdrew her activity.

URSULA: Who decided on the changes applied to the space? Was it part of the assembly's conversation?

ELENI: Not exactly. Not everyone wants to be involved in design. Each working group had the capacity to decide what to do. We talked extensively about the aesthetics of the space and its significance. For the spatial changes we formed a team of three architects, three non-architects, and a photographer, and it was an open team—other people were free to join. We surveyed the building and had the building drawings produced by an interior design student. We loved and admired this building.

URSULA: What I have noticed is that in Greek we use two terms are used to translate the word "design": a Greek-based one, *shediasmos*, and a Latin-based one, "design." The word "design" often has negative connotations in Greek. In the context of a commons, one would say derogatorily "We don't do design here!" denoting a divide between design as a commercial activity on the one hand, and activism or anti-authoritarian intention, on the other. And as the role of the architect or any designer is deemed anywhere from unnecessary to a tool of capitalism, the spaces that are considered as anti-authoritarian and anti-establishments (e.g., squats, co-operatives, and so on), at least in the western European context, adopt very specific aesthetics. These might vary from hippie to punk aesthetics or more recently to patterns that connote indigenous Latin American cultures. Is it possible that by adopting this position the space becomes more of a home for specific groups rather than an open platform, a common?

ELENI: Yes, the groups that up until now have been involved in squats do have this mindset. But I believe it needs to change. We need to change. I think that suggestions about how to include architecture should be brought forward. In Embros, we created a team of architects who intended to implement different ideas over time. I can say that there were architectural and design ideas for the space right from the beginning. We worked hard on the space and its spatial features. Right from the beginning of the occupation, we highlighted the stage, the table in the foyer, and the building's façade through lighting, which constitutes a principle of design. Our perception at the time was that this would be a long and continuous process. This is contrary to the approaches you mentioned before, as I believe that there is a difference between maintaining and highlighting the features of a space, on one hand, and leaving it to decay, on the other. We thought that this is the preferable design approach as Embros was a listed historic building. Some extra work could have been done, such as a staircase that would lead to the terrace or a library.

URSULA: And why was this work not done?

ELENI: There was no time. We spent four years there doing thousands of maintenance chores on a daily basis. Also, all these projects required money that we didn't have.

The money collected in the box through donations was allocated to more collective activities and social assistance, rather than being invested in the space itself. Indeed, it might be that commoning actions have to be ephemeral, as architecture requires more time and money. What we did from an architectural point of view was to draw the floor plans, record which features were of architectural value and highlight these features, which is something very important in my opinion. The space had some original qualities and people who visited the space liked that. And maintenance comprises both design and functional decisions.

URSULA: So, would you say that by disdaining design, there is somehow no thinking of maintenance either?

ELENI: Yes, because in reality design is an integral part of maintenance, and vice versa, and they cannot be performed by everyone. And because the practitioner who coordinates the maintenance of a building is usually the architect. So, architects are needed along with others, especially when the commons is based on pre-existing spaces of particular architectural interest, like the City Plaza, Rosa Nera squat in Chania (Crete)[30] which is in an amazing building, or Alexandra Avenue Refugee Camps.[31]

URSULA: So architecture, in its wider definition, from taking care of urban space to designing, detailing, and maintaining, can play an important role to the commoning practices. What is needed so that the current mindset about the relationship between design and the commons changes, and a more conscious implementation of design is achieved?

ELENI: This could happen through initiatives. If we don't change our mindset, the current situation won't change either. First of all, we should see whether the Municipality could offer some financial support. I am not opposed to this, although it is sometimes seen as an impediment to the autonomy of the project.[32] Then, we would need some architects—ideally actively involved in the space—as well as an assembly, or a team involved in the space to put the project forward. There was a team from the Greek Association of Architects that wanted to help Embros, and I was in support of this idea, even after I had withdrawn from Embros. But this was not materialized in the end. Nevertheless, I do believe that architects' involvement in the commons is of paramount importance even if currently it is very difficult. Architects have to get involved with the commons, and must find the right way to do so.

URSULA: Do you think that commons can be designed?

ELENI: I think that they need to be designed collectively, from all the people involved in them. What happened in Embros was for me the beginning of an effort to design common space by the participants and not by an outsider.

URSULA: Why are improvisation and collective design methods considered compatible with self-management, but design undertaken by a single designer is not? Could the Zapatistas' principle of rotational office be applied in design? Would it be possible to have a rotating individual designer, instead of a designer who follows the decisions made by the community?

ELENI: No, this would not work. The goal in a common space or in an occupation/squat is to always have a collective process in place, in every venture. For me, collective designing is the way forward. An architect is allowed to talk about or present their individual drawings in the collective assembly. But when work is done to the space, this should be a result of collective work. Anything that happens in the space should

change hands. Back then, we said that we all need to try and acquire some knowledge, even on technical issues, so that we could have a rotational process in place.

URSULA: Would you consider it hegemonic if an individual was placed in charge of the design for a part of the whole space?

ELENI: Yes, it would be authoritarian and hegemonic and would bring unpleasant results. Because by following this design approach we would revert back to the self, and ignore the community. For a good result you would need to architects and space users sharing the design activity.

URSULA: It seems to me that in this approach aesthetics are not considered part of architectural expertise but a collective domain. Would this collective design process result in a dynamic aesthetic project or would it always end in compromise?

ELENI: It would not end in compromise. On the contrary, creating Embros was forward-thinking, in terms of both the actual design and the discussions that took place there about the city, the void, and the common spaces. All these are aspects of architecture. The joint activation and occupation of this space was a pioneering movement.

URSULA: What do you think will happen to Embros?

ELENI: I would like to believe that new communities will continue to emerge within Embros via relations of solidarity, such as those that happened on November 19, 2014, when Embros organized an event for Syrian refugees at Syntagma Square, where poems and texts in different languages were read. Anti-hierarchical forms were birthed by groups of immigrants, people of the queer community, feminists, actors/actresses, etc. I would like to end with a quote from the Zapatistas:

We are like birds, flying to all places, but we need trees to rest. Autonomy is the most important principle for the future. Let's fight from the bottom up with discipline, camaraderie and unity, let's learn how to see and be seen, let's do our own thing, let's take control of the fate of our struggle by building autonomy [33]

Postscript by Eleni Tzirtzilaki[34]

I came back to Embros on April 18, 2019, to defend the space in the current state of affairs and create in the foyer an event titled "*Gia tin epanastasi, gia na mirastoume ta onira, Antartisa Nitsa Eleni Papagiannaki, Ilektra*" ("For the Revolution, to Share the Dreams, Guerilla-fighter Nitsa Eleni Papagiannaki, Ilektra").[35] This included the screening of my documentary *Antartissa Nitsa Eleni Papagiannaki, Ilektra*, as well as the reading of texts and poems, and performances by different participants. Each of them spoke about the idea of the revolution or insurgence in today's world, and how this is connected with the notion of the commons. The event was co-produced by Nomadic Architecture and the collective Laboratory for the Urban Commons.

It is important to note that the current policy of the right-wing government Nea Dimokratia in collaboration with the new mayor of Athens (both elected in July 2019) has been to shut down occupied buildings in the city, especially in the area of Exarcheia, but also in Koukaki, most of which were spaces of hospitality for refugees. The police actions are violent, and include taking out to the street young children, and arresting citizens who are considered as defenders of the

occupation. At the same time, the new administration is promoting the gentrification of the city's center, facilitating the sales of buildings to foreign investors, and the spread of Airbnb and hotels.

The Occupied Theater Embros is one of the few occupied spaces that still exist in the city.

Notes

1. The interview was translated from the Greek by Mary Christou.
2. *Elefthero Aftodiaheirizomeno Theatro Embros* (Free Self-Managed Theater Embros), accessed November 11, 2019, www.embros.gr/.
3. Besides Embros, other common spaces of Athens in the same period are Navarino park, the park in Kyprou and Patission Street, and Green Park. See my writings about Athens' commons: Orsalia Dimitriou, "The Politics of Public Space and the Emergence of the Commons in Contemporary Athens," (Ph.D. diss., London: Goldsmiths College, University of London, Department of Visual Cultures, 2016) and Orsalia Dimitriou, "Whose Commons? Challenges of Commoning Practices in an Athenian Public Space," *TRANSLOCAL. Culturas Contemporâneas Locais e Urbanas*, no. 1 (2018).
4. A wave of social insurgence in Greece begun in December 2008 after the murder of 15-year old Alexis Grigoropoulos by the police in Athens' Exarcheia area. On May 25, 2011, peaceful demonstrations spread across Greece opposing the imposed austerity measures, and the movement of *Aganaktismenoi* (the Indignant) occupied Syntagma Square in front of the Greek Parliament for three months.
5. Silvia Federici, "Feminism and the Politics of the Commons," *The Wealth of the Commons*, accessed August 10, 2019, http://wealthofthecommons.org/essay/feminism-and-politics-commons.
6. David Bollier, "Imagining a New Politics of the Commons," *On the Commons*, October 9, 2010, accessed June 24, 2019, www.onthecommons.org/imagining-new-politics-commons#sthash.Z6pNqKCK.KQ180MPY.dpbs.
7. Massimo De Angelis and Stavros Stavrides, "On the Commons: A Public Interview with Massimo De Angelis and Stavros Stavrides," *E-Flux*, no. 17 (June 2010), accessed August 11, 2019, www.e-flux.com/journal/17/67351/on-the-commons-a-public-interview-with-massimo-de-angelis-and-stavros-stavrides/.
8. The building was part of the Hellenic Republic Asset Development Fund.
9. Hara Tzanavara, "*I ponemeni istoria tou Embros*" ("The Painful Story of Embros"), *Efimerida ton Sintakton*, March 6, 2016, accessed December 24, 2019, www.efsyn.gr/nisides/mnimeia-tis-polis/61226_i-ponemeni-istoria-toy-Embros; Iro Kouniadi, "*Embros: Ena Theatro gia Olous*" ("Embros: A Theater for All"), *In2life*, March 12, 2013, accessed December 24, 2019, www.in2life.gr/culture/theatre/article/269029/Embros-ena-theatro-gia-oloys.html; Yannis Moshos, "*I drastiriotita tou theatrikou organismou 'Morfes' sto theatro Embros (1988–89)*" ("The Activities of the Theatrical Organization 'Morfes' in Embros Theater (1988–89))," *Skini*, April 7, 2015 http://ejournals.lib.auth.gr/skene/article/view/4931.
10. Eleni Tzirtzilaki is an architect, activist, and community artist. She was member of the group *Astiko Keno* (Urban Void) from 1998 to 2005, and founded the Nomadic Architecture Network in 2005. She organizes actions that integrate a variety of art expressions, including walking, performance, poetry, painting, and writing. Her work focuses on nomadic subjects; their actions, relations, and materiality as they traverse borders, their involvement with each other and with residents, and with the creation of ephemeral communities.
11. See Nomadic Architecture, *Walking through Fragile Landscapes* (Athens: Futura, 2018), and Nomadic Architecture Network, accessed August 11, 2019, http://nomadikiarxitektoniki.net/en/.
12. Eleni Tzirtzilaki was interviewed in June 2018.
13. See *Kinisi Mavili* (Mavili Initiative), accessed August 11, 2019, http://kinisimavili.blogspot.com/.

14 On January 30, 2009 the building of the National Opera was occupied for nine days in solidarity to the rest of the protests in Athens. During the occupation, the participants run a cultural program in opposition to the institutionalized culture.
15 "With Nails and Teeth Workshops," 2013–14, "Eyes See Sky: Journey to Prison," and "The Unrealized Journey" were titles of events realized in Embros by Eleni Tzirtzilaki and Nomadic Architecture in collaboration with artists Christina Thomopoulou, Christos Chandelis, Lia Giannakou, Omar Samir, and others. "*Me nichia kai me dontia*" ("With Nails and Teeth"), accessed January 8, 2020, https://menychiakaimedontia.wordpress.com/.
16 Such programs were *Xenios Zeus*, an anti-immigration operation of the Greek police—using paradoxically the name of the ancient Greek god of hospitality, and Rethink Athens, a 2014 European Architectural Competition for the creation of a new city center in Athens organized and funded by the Onassis Foundation (a private institution).
17 *Blaumachen* was the magazine of an anarchist collective (blaumachen.gr). For *Blaumachen*, commons today "are alternative forms of managing the social reproduction of the proletariat within capitalism, and as such they are integrated with the rationale of capitalism, as a positive elaboration of its own categories, even when they expressively question and are directed against it." Blaumachen, "Peri koinon" ("Concerning the Commons"), *Blaumachen* 06, Spring 2013, Athens, republished in *Indymedia*, accessed August 10, 2019, https://athens.indymedia.org/media/upload/2018/07/31/Περί_Κοινών.pdf.
18 When the interview took place SYRIZA was still in power. On July 2019, the conservative party *Nea Dimokratia* was elected.
19 The Greek Civil War (1946–49) took place between the Greek government army and the Democratic Army of Greece (the Communist Party of Greece's military branch). Political commentators see this polarization returning in today's politics.
20 City Plaza, Refugee Accommodation, and Solidarity Space was an occupation of an empty hotel in the center of Athens that began in April 2016 and ended in July 2019. See: City Plaza, Refugee Accommodation, and Solidarity Space, accessed August 11, 2019, http://solidarity2refugees.gr/.
21 *Steki Metanaston* (Immigrants' Community Center) is a self-managed space in the area of Exarcheia in Athens that is hosting activities for and with immigrants. It has been the target of many racist attacks. See: *Steki Metanaston – Kinoniko Kentro* (Immigration Hang Out – Community Center), accessed August 11, 2019, https://tsamadou13-15.espivblogs.net/about/.
22 www.facebook.com/pg/communitism/about/?ref=page_internal.
23 Eleni Tzirtzilaki, "About the Free Self-Managed Embros Theater," Nomadic Architecture Network, accessed February 16, 2020, https://nomadikiarxitektoniki.net/en/texts-en/about-the-free-self-managed-embros-theatre/.
24 Gloria Anzaldua and Ana Louise Keating, *This Bridge We Call Home: Radical Visions for Transformation* (New York and London: Routledge, 2002).
25 Judith Butler, *Notes toward a Performative Theory of Assembly* (Cambridge, MA: Harvard University Press, 2018).
26 *Teatro Valle Occupato* is a state theater in Rome that was occupied in 2011 by a group of actors, musicians, directors, technicians, and creative staff in opposition to its closure and planned sale to private investors. *Teatro Valle Occupato*, accessed August 11, 2019, www.teatrovalleoccupato.it/.
27 The Greek word *keno* (void) is contrasted here with the word *koino* (common).
28 Architects Takis Frangoulis and Antonis Daglidis undertook the conversion of the printing factory to a theater in 1989.
29 Eleni refers here to the original large table made of wood and iron that features in the theater's foyer.
30 See: Rosa Nera see Rosa Nera Squat, accessed August 11, 2019, https://rosanera.squat.gr/.
31 For Alexandra Avenue Refugee Housing Units see: *Archeologia tis polis ton Athinon* (Archaeology of the city of Athens), "Προσφυγικές Πολυκατοικίες (Refugee Multihousing Units)," *Archeologia tis polis ton Athinon*, accessed August 11, 2019, www.eie.gr/archaeologia/gr/arxeio_more.aspx?id=1.

32 This is a recurrent debate in commoning projects, as typically anarchist groups reject external funding and prefer total autonomy even if this renders a project's survival problematic.
33 Guillaume Daravanche, ed., *Aftodiacheirisi mia idea panta epikairi* (*Self-Management: An Always New Idea*, original title: *L'Autogestion: une idée toujours neuve*), trans. Theodoris Ditsas and Kostas Spatharakis (Athens: Ekdosis ton Sinadelfon, 2015).
34 Email communication, January 2020.
35 Event listed under "Ekdiloseis tou Embros" ("Events at Embros)," assessed January 16, 2020, www.embros.gr/18-4-16-00-gia-thn-epanastash-gia-na-moirastoyme-ta-oneira.html.

Response to Section 2

Dissenting through Material Engagement

19 Designing While Dissenting While Dissenting While Designing

A Response in Counterpoint

Zoy Anastassakis

When we use the term "design," often we are referring to a professional field that specializes in materializing and enabling new and better means for human life on earth. Certain narratives link the emergence of design as a professional practice to the consolidation of the means of production in capitalism. This view directly ties the origins of design as a professional practice to services provided in an industrial context. Yet we can expand this definition by designating as "design" a field of action that is associated with any activity of imagination and materialization related to the human domain—not necessarily restricted to capitalist means of production.

It is possible to go still further and employ the term "design" to account for the myriad actions of dwelling and building carried out not only by humans, but also by all other living beings. Or, in yet another approach, we can argue that everything in existence, including all the phenomena we find on earth and beyond—the very idea of creation—is the result of acts of designing.

The field of design studies has kept this debate alive. It feeds the production of books and academic articles, and typically it is associated with a need for describing and defining the contours of what the community of professionals and researchers identify with design as an area of knowledge and what they consensually recognize as a legitimate process or product of the design field. This discussion is not without tension. What largely informs it, however, is a quest for answers and definitions.

This is true even for actors who advocate for the value of a certain expansion befitting the design field. Even when asserting that design can be considered all of the above and more, these actors remain concerned with broadening the spectrum of what is deemed inherent in the field of design, without foregoing the need for a definition. Considering alternative definitions of "design" raises problems that seem to serve, then, as a necessary means to an end—the definition of the contours of the field—which, consequently, would lead us to also demarcate the limits of its professional characterization.

When we encounter the cases of dissent through designing presented in the chapters of the second part of this book, we find diverse manifestations of design, such as those in a conflict kitchen, a new type of restaurant in Pittsburgh; an occupied theater in Athens; DIY urbanism and design activism events in São Paulo; the Transition Movement across the United States; support for a design school in Rio de Janeiro; unseaworthy boats used by migrants to cross the Mediterranean; a hologram protest in Madrid; drones for indigenous mapping in Indonesia, and

design activist practices in Copenhagen. In these situations, the actors are concerned with the real circumstances in which processes of design and acts of political dissent intermingle and emerge as situated and indissoluble aspects of a specific political event.

If we are interested in ways of producing dissent through design, we will have to suspend our obsession with the debate over what characterizes the domain of design: is it this *or* that *or* that over there? Instead we must observe what happens *in the midst* of situations where design manifests as dissent, and where dissent actualizes as design. These chapters invite us to pay attention to the space that opens up when we replace the conjunction "or" with "and." The authors ask us to emphasize what emerges with "and" in lieu of focusing on the terms that this conjunction articulates and distinguishes: It is this *and* that *and* that over there.

In the experience of this interval—between what we identify as the possible alternatives to considering the relationships between processes of design and acts of political dissent—lies the space of indetermination and openness. In this in-between zone, we encounter the different possibilities in play in a given situation. If, alongside the authors of these chapters, we are interested in considering the interplay of processes of designing and acts of political dissent, it is to this interval, then, that we must turn in answering their call.

British anthropologist Tim Ingold characterizes this experience of the interval where processes of differentiation are produced as "midstream" or "interstitial differentiation"[1]—"the way in which difference continually arises from within the midst of joining *with*."[2] By paying attention to the overtures that continually burst through the midstream, we can perceive, amid acts of political dissent, the processes wherein dissent is manifest as the continuous production of differentiation. Thus, in order to perceive the circumstances in which the dissensus emerges, we must observe the fissures, cracks, edges, and borderlines that insinuate themselves between what we define or delimit as one thing *or* another. We must therefore focus on the intervals or the borderlands between what we identify as this *and* that; from the perspective of these zones, we may be able to designate the circumstances in which dissent arises as a space of political openings and continuous production of differentiation.

The chapters of this book that are immersed in these borderlands—these open, transitory, liminal, interstitial zones—communicate not only how the political is revealed in acts of design, but also how, in counterpoint, acts of political contestation are actualized as they are effected, enacted, materialized: designed. Counterpoint, a mode of composition used in music when two or more distinct melodies are harmoniously combined while they are executed in unison by various instruments, is a modality that is also pertinent in the acts of conjunction between design and dissent.

From this contrapuntal composition of dissensus (a space for a political opening realized as a continuous process of differentiation) and processes of designing (the materialization of this space), we might begin to pay attention to the multiple threads introduced by the aforementioned chapters. With Ingold's proposal in mind,[3] we might follow these multiple threads toward an open, ongoing, interdisciplinary understanding of the relationship between processes of designing and acts of political dissent. There is more to it, however, than merely asking what is

inherent in design that leads us to acts of political dissent and, on the flip side, what elements of political dissent can be characterized as design.

The cases presented to us in these chapters examine the circumstances and matters of concern surrounding dissensus and design processes, so that we may further explore the potential of these intertwined threads. Staying on the line charted by Ingold, we may also consider what happens when we exchange the conjunction "and," whose logic articulates, for the preposition "with," which differentiates—much like the acts of dissent described here. After all, the importance of the texts gathered here is not limited to their scrutiny of what happens when dissensus is inserted into processes of design or, conversely, when design is introduced into acts of political dissent. Indeed, these chapters yield a detailed examination of the circumstances and issues that encourage a mishmash of design and dissent to "carry on alongside one another,"[4] in counterpoint.

Thus, when evaluating the concept of dissent in the cases presented here, we should not expect analytical lists or toolkits for producing design projects that make space for political dissent. If we characterize dissent as an opening toward continuous differentiation, there is no purpose in freezing time at any particular moment of these acts that we perceive as an example of process, movement, openings. Through these cases, we encounter a diverse repertoire of contention, in which dissensus is materialized in a great variety of ways. In the course of this materialization, the hegemonic processes of design are examined, challenged, put to the test.

In examining these cases and following the clues they provide, therefore, we do make space for speculation on other potential intersections of design and dissensus. In this way, we will come to think no longer in terms of *design with dissensus*, nor in terms of *dissenting with design*. Rather, we will contemplate the various situations that give rise to the continuous production of differentiation—and speak instead of *designing while dissenting while dissenting while designing*. We will thereby remain in counterpoint, in indeterminacy, foregoing our obsession with solving problems to linger with them instead, as the US biologist Donna Haraway proposes.[5] After all, what use is an established list of supposed solutions and procedures when we are challenged with the need for continuous production of differentiation?

If what happens next is always something else, our ability to respond must be anchored not in a predetermined formula, but instead in cultivating our capacity to be attentive to the present and to the possibilities for responding together—as appropriate at each moment in time—to the challenges posed by each unique event. In "The Agonistic Design of Conflict Kitchen," Veronica Uribe investigates how, in a process of social engagement that "borrows" the form of a restaurant, design processes and the materials they generate inform the constitution of a public space that by its very nature instigates political debate. In commenting on two episodes of materialized dissent, Uribe invites us to discern the borderlands wherein political engagement as it takes an unexpected turn, placing in doubt the coherence and the very viability of the project. We are asked to turn our attention to how acts of political dissent can expand beyond what was intended for the project, erupting into a political moment when dissidence becomes present and threatens the original plan for dissent.

In "Occupied Theater Embros," Ursula Dimitriou in an interview with Eleni Tzirtzilaki, brings to our attention processes of designing and maintaining the

commons in Athens under crisis. Proposing that "Embros poses a number of dilemmas regarding the boundaries or specificities of the commoning practice," Dimitriou and Tzirtzilaki observe the limits that activist groups face as they engage in the production of common spaces. Uncovering these moments of impasse that seem like dead ends, they return to the dilemmas of the theater's occupants in situations that triggered political moments of dissensus. Underscoring what was learned, and what could have been achieved (but was not) while the space was activated, Dimitriou and Tzirtzilaki construct a conversation around the unfolding of that experience and the continuous process of opening into the spaces of uncertainty and vulnerability. In the course of this debate, they also point to how, by disdaining design, those involved in activating the theater tested the possible meanings of the specialized practice of design in collective processes of political dissent.

In "Events and Ecologies of Design and Urban Activism," Kristine Samson explores ecologies of design and urban activism in São Paulo, Brazil, by examining the outburst of such activist events in the city in 2012–13, and by revisiting, in 2018, the ecology that gave rise to and emerged out of those events. Comparing several cases that occurred during these two time periods, Samson reveals how, despite their investment in the liberation of spaces for political engagement, the actors nevertheless reproduced existing power relations between urban activists situated close to the city center and those on the periphery. Samson thus highlights the limits of activism's ability to break with the procedures of segregation that determine who can lay claim to the city, and she invites us to probe further the problem raised by the authors of the previous chapters: the liminal zones wherein dissensus emerges amid processes of designing.

What matters here, they argue, is that these borderlands—although configured as impasses—are in fact the proper locus in which dissensus arises. We should not, then, treat them as obstacles or saturation points, preventing us from taking further action or requiring us to reach a solution. Instead, these thresholds are simply the fissures and loopholes where processes of design cease to have meaning; they offer an avenue for the transformation that this book compels us to consider: the circumstances and methods that allow design processes to materialize spaces for openness, experimentation, and the emergence of difference.

In "Designing Post-carbon Futures: The Prefigurative Politics of the Transition Movement," Emily Hardt observes how the Transition Movement—a grassroots movement that seeks to end dependence on fossil fuels, and build resilience in response to climate and economic uncertainty—faces the challenges of redesigning life on the local level within the North American context, and how the dilemmas and limitations posited by this confrontation unearth fundamental questions about its actualization. By transforming processes of design into political acts, those involved in the movement make space for continuous investment in and openness to moments of dissensus.

In "Temporarily Open: A Brazilian Design School's Experimental Approaches against the Dismantling of Public Education," Marcos Martins, Lucas Nonno, Juliana Paolucci, Jilly Traganou, and I delve into the experimental approaches adopted by the Advanced School of Industrial Design (ESDI) in Rio de Janeiro, Brazil, to contest the increasingly precarious status of its parent university, the State University of Rio de Janeiro (UERJ). We discuss how, by occupying the school, the "*ESDI Aberta* movement diverted a state of political disorder into a condition of

disobedience to the government's narrative of crisis and made it possible to launch experimental, student-run design and educational initiatives and bottom-up management processes." As the academic community strove to keep ESDI functioning, moments of dissensus contributed to the transformation of spaces reserved for students, teachers, and staff to performing an opening. They thus ultimately destabilized the normative understanding of what the teaching of design could be in such a situation. By sharing the experiences of *ESDI Aberta* (Open ESDI), we present a process in which the political moment cut across an educational institution, leading the scholarly community to stop and ponder the impasses that threatened academic activities, thus reflecting on the inseparability of education and politics.

In "Vulnerable Critical Makings: Migrant Smuggling by Boats and Border Transgression," Mahmoud Keshavarz discusses the limits of designed artifacts and "the technical, geographical and material practices which shape contemporary European border politics," which compel forced migrants, refugees, and asylum seekers—whom he calls travelers without the "right" papers—to take lethal routes across the Mediterranean Sea in "unseaworthy boats." Both the production and the use of these boats raise a series of political questions that are also design questions. Addressing the processes by which such boats are built, Keshavarz leads us to question why the community of design "activists," simultaneously concerned with their own engagement in the political issues that affect refugees and inspired by do-it-yourself design, fail to recognize the effective manifestation of a critical making that is involved in the material practices of the boats' production and use. He goes on to discuss how the wave of "democratizing design" ends up merely echoing the hegemonic discourses that link design with elitist, segregationist output, remaining "unwilling to recognize certain illicit practices as critical, or indeed political." Consequently, material acts of dissent performed by travelers without the right papers "go unnoticed."

In "The Madrid Hologram Protest and the Democratic Potential of Visuality," Ksenija Berk analyzes how "digital technologies and social networks played a crucial role in the organization, dissemination, and propagation" of a recent protest and in the participatory experience that they enabled. Berk suggests that in the spring 2015 Hologram Protest on the streets of Madrid, Spain, we glimpse "an alternative aesthetic model for civil disobedience." She observes how the material substitutions adopted by the protest's organizers produce differentiations that unlock space for new modes of political action, in which digital technologies and social networks mingle in the streets. Remarking on the diverse aspects of material production involved in this manifestation, Berk identifies a "new language of dissent amid the reality of the street," which establishes itself "by building heterogeneous connections between disparate historical events, urban movements, nonviolent protests, digital technologies, and human rights claims."

In "Data Acquisition, Data Analytics, and Data Articulations: DIY Accountability Tools and Resistance in Indonesia," Alessandra Renzi interviews Irendira Radjawali member of the Drone Academy, which produces high-precision maps to delineate the boundaries of indigenous communities, among other services. "Inspired by the DIY ethics of citizen science as much as by a longstanding tradition of participatory mapping, [both of] which have made Indonesia a global reference point for this kind of activism," activist groups are using data mapping to achieve data sovereignty. Renzi and Radjawali reflect on "the ongoing struggle

against forces of cooption through which corporations and institutional actors appropriate the tools, discourses, and practices that social movements and some NGOs develop."

In "Politics of Design Activism: From Impure Politics to Parapolitics," Thomas Markussen looks at the contradictions that emerge when design activism projects include acts of political dissent that provoke the design establishment. Through a study of the work of Bureau Detours in Denmark, he discusses the various politics of design activism. Taking politics as "the idea of design's capacity to resist and contest existing paradigms of power and control," Markussen draws attention to an important point:

> to fully understand the politics of design activism, it is necessary to make a nuanced analysis of how dissent can be enacted through design activism in opposition to the ruling neoliberal system, and at the same time allow for varying outcomes.

He thus reminds us that any act of political dissent must be "understood in the moment and the setting in which it occurs."

Dissensus emerges in concrete situations, and is thereby related to the continuous production of difference. If we take this point seriously, then in order to practice design as an ongoing process of opening toward this continuous production of differentiation, we must cease to think of design as providing solutions. In this way, revealed here as in the chapters in the first part of this book, we will be designing while dissenting while dissenting while designing.

Notes

1 Tim Ingold, "On Human Correspondence," *Journal of the Royal Anthropological Institute* (N.S.), 23 (2017): 9–27.
2 Ibid., 10.
3 Tim Ingold, *Being Alive: Essays on Movement, Knowledge and Description* (London: Routledge, 2011).
4 Ibid., 14.
5 Donna Haraway, *Staying with the Trouble: Making Kin in the Chthulucene (Experimental Futures)* (Durham, NC: Duke University Press, 2016).

Bibliography

Abbott, Jason P. "Of Grass Mud Horses and Rice Bunnies: Chinese Internet Users Challenge Beijing's Censorship and Internet Controls." *Asian Politics & Policy* 11 (2019): 162–168.

Abujbara, Juman, Andrew Boyd, Dave Mitchell, and Marcel Taminato, eds. *Beautiful Rising: Creative Resistance from the Global South*. New York and London: OR Books, 2018.

Action Aid in Denmark. "Action Aid Denmark Intro." Accessed December 2019. www.ms.dk/.

"A Documentary Project." Art of the March. Accessed February 24, 2019. http://artofthemarch.boston/page/about.

Ahmed, Sarah. "Affective Economies." *Social Text* 22, no. 2 (79) (Summer 2004): 117–139.

Ahmed, Sarah. *The Cultural Politics of Emotion*. Edinburgh: Edinburgh University Press, 2014.

Akrich, Madeleine. "The De-Scription of Technical Objects." In *Shaping Technology/Building Society: Studies in Sociotechnical Change*, edited by Wieber E. Bijke, and John Law, 206–224. Cambridge, MA: The MIT Press, 1992.

Akrich, Madeleine, and Bruno Latour. "A Summary of a Convenient Vocabulary for the Semiotics of Human and Nonhuman Assemblies." In *Shaping Technology/Building Society: Studies in Sociotechnical Change*, edited by Wieber E. Bijke, and John Law, 259–262. Cambridge: The MIT Press, 1992.

Albers, Joseph. *Interaction of Color*. New Haven, CT: Yale University Press, 2006/1963.

Alexander, Christopher, Sara Ishikawa, and Murray Silverstein. *A Pattern Language: Towns, Buildings, Construction*. Oxford: Oxford University Press, 1977.

Aliansi Masyarakat Adat Nusantara. Accessed December 25, 2018. www.aman.or.id/.

Alloun, Esther, and Samuel Alexander. "The Transition Movement: Questions of Diversity, Power and Affluence." *Simplicity Institute Report* no. 14 (2014): 1–24. http://simplicityinstitute.org/wp-content/uploads/2011/04/TransitionMovement.pdf.

Althusser, Louis. *On Ideology*. London: Verso, 2008.

Alvarez, Sonia, Evelina Dagnino, and Arturo Escobar. *Cultures of Politics/Politics of Cultures: Re-visioning Latin American Social Movements*. Boulder, CO: Westview Press, 1998.

Amin, Ash, and Nigel Thrift. *Cities Reimagining the Urban*. London: Polity Press, 2002.

Amnesty.Org. "Taiwan: Restraint Urged in Protests over China Trade Deal." March 19, 2014. www.amnesty.org/en/press-releases/2014/03/taiwan-restraint-urged-protests-over-china-trade-deal/.

Amoore, Louise. "On the Line: Writing the Geography of the Virtual Border." *Political Geography* 30, no. 2 (2011): 61–69.

Andersson, Ruben. "Hardwiring the Frontier? The Politics of Security Technology in Europe's 'Fight against Illegal Migration'." *Security Dialogue* 47, no. 1 (2016): 22–39.

Anonymous. "Million Mask March." Millionmaskmarch.com. Accessed November 11, 2016. www.millionmaskmarch.com/.

Anzaldua, Gloria, and Ana Louise Keating. *This Bridge We Call Home: Radical Visions for Transformation*. New York and London: Routledge, 2002.

"A People's Archive of Police Violence in Cleveland." People's Archive of Police Violence. Accessed March 15, 2019. www.archivingpoliceviolence.org/.

Appadurai, Arjun, ed. *The Social Life of Things: Commodities in Cultural Perspective*. New York: Cambridge University Press, 1986.

Archeologia tis polis ton Athinon. "Prosfigikes polikatoikies." Archeologia tis polis ton Athinon. Accessed August 11, 2019. www.eie.gr/archaeologia/gr/arxeio_more.aspx?id=1.

Archer, Bruce. "The Three Rs." *Design Studies* 1, no. 1 (July 1979): 17–20.

Archer, Carol, and Christopher Kelen. "Macao Monuments: In Art, in Poetry, and in Your Face." *Space and Culture* 14, no. 2 (2011): 140–164.

Arditi, Benjamin. "Post-Hegemony: Politics outside the Usual Post-Marxist Paradigm." *Contemporary Politics* 13, no. 3 (2007): 205–226.

Arruzza, Cinzia, Tithi Bhattacharya, and Nancy Fraser. *Feminism for the 99%*. London and New York: Verso, 2019.

Atta-Mills, John, Jackie Alder, and Ussif Rashid Sumaila. "The Decline of a Regional Fishing Nation: The Case of Ghana and West Africa." *Natural Resources Forum* 28, no. 1 (2004): 13–21.

Attfield, Judith. *Wild Things: The Material Culture of Everyday Life*. Oxford: Berg Publishrs, 2000.

"Auditing Algorithms: Adding Accountability to Automated Authority." Auditing Algorithms. Accessed March 15, 2019. http://auditingalgorithms.science/?page_id=82.

Awan, Nishat, Tatjana Schneider, and Jeremy Till. *Spatial Agency: Other Ways of Doing Architecture*. New York: Routledge, 2011.

Bahng, Aimee. *Migrant Futures: Decolonizing Speculation in Financial Times*. Durham, NC: Duke University Press, 2017.

Balibar, Etienne. *Politics and the Other Scene*. London: Verso, 2002.

Bargu, Banu. "The Politics of Commensality." In *The Anarchist Turn*, edited by Jacob Blumenfeld, Chiara Bottici, and Simon Critchley, 35–58. London: Pluto Press, 2013.

Barish, Jonas A., and Jonas Alexander Barish. *The Antitheatrical Prejudice*. Berkeley: University of California Press, 1981.

Barney, Darine, Gabriela Coleman, Christine Ross, Jonathan Sterne, and Tamar Tembeck, eds. *The Participatory Condition in the Digital Age*. Minneapolis, MN: University of Minnesota Press, 2016.

Barros, Carina. "Glicério tem protesto contra retirada dos objetos de moradores de rua." Folha de S.Paulo. April 10, 2017. Accessed January 2, 2019. https://mural.blogfolha.uol.com.br/2017/04/10/glicerio-tem-protesto-contra-retirada-dos-objetos-de-moradores-de-rua/.

Barthes, Roland. *Camera Lucida: Reflections on Photography*. New York: Hill and Wang, 1980.

Bazzichelli, Tatiana. *Networking. The Net as Artwork*. Aarhus: Digital Aesthetics Research Center, 2008.

Beaugé, Gilbert, and Jean-François Clément, eds. *L'image dans le Monde Arabe*. Paris: Editions CNRS, 1995.

Beautiful Rising. "Beautiful Rising." Accessed May 29, 2019. www.beautifulrising.org.

Beautiful Trouble. "Beautiful Trouble: A Toolbox for Revolution." Accessed May 29, 2019. www.beautifultrouble.org.

Beck, Eevi E. "P for Political: Participation Is Not Enough." *Scandinavian Journal of Information Systems* 14, no. 1 (2002): 1.

Belting, Hans. *Art History After Modernism*. Chicago, IL: University of Chicago Press, 2003.

Bendix, Regina, and Donald Brenneis, eds. "The Senses." *Etnofoor* 18, no. 1 (2005): 3–14.

Benjamin, Walter. *The Work of Art in the Age of Mechanical Reproduction*. London: Penguin Books, 2008.

Bennet, W. Lance, and Alexandra Segerberg. *The Logic of Connective Action: Digital Media and the Personalization of Contentious Politics*. Cambridge: Cambridge University Press, 2013.

Bennett, Jane. *Vibrant Matter: A Political Ecology of Things*. Durham, NC: Duke University Press, 2010.
Berk, Gerald, Dennis Galvan, and Victoria Hattam, eds. *Political Creativity*. Philadelphia: University of Pennsylvania Press, 2014.
Berk, Ksenija. "Die slowenischen Proteste 2012/13 im Lichte von Protestgrafiken." *Religion & Gesellschaft in Ost und West* 4–5 (2015): 34–37.
Berk, Ksenija. "At the Crossroads of Cultural and Ideological Exchange – Behind the Visual Communications of 2012–2013 Slovene Protests." In *Social Movements in the Balkans: Rebellion and Protest from Maribor to Taxim*, edited by Florian Bieber, and Dario Brentin, 48–66. London: Routledge, 2018.
Berube, Michael. *Foreword to Claiming Disability: Knowledge and Identity*, by Simi Linton. New York: New York University Press, 1998.
Besançon, Alain. *L'image Interdite: Une Histoire Intellectuelle de l'Iconoclasme*. Paris: Arthème Fayard, 1994.
Bieber, Florian, and Dario Brentin, eds. *Social Movements in the Balkans. Rebellion and Protest from Maribor to Taxim*. London: Routledge, 2018.
Bishop, Claire. "Introduction: Viewers as Producers." In *Participation*, edited by Claire Bishop. London and New York: White Chapel Gallery and MIT Press, 2006.
Bishop, Claire. *Artificial Hells: Participatory Art and the Politics of Spectatorship*. London and New York: Verso, 2012.
Blaumachen. "Peri koinon" ("Concerning the Commons"). *Blaumachen*. 06, Spring 2013, Athens, republished in *Indymedia*. Accessed August 10, 2019. https://athens.indymedia.org/media/upload/2018/07/31/Περί_Κοινών.pdf.
Blesser, Barry, and Linda-Ruth Salter. *Spaces Speak, Are You Listening?* Cambridge, MA: The MIT Press, 2007.
Blitzer, Jonathan. "Protest by Hologram." *The New Yorker*. April 20, 2015. www.newyorker.com/news/news-desk/protest-by-hologram.
Boehnert, Joanna. "Design & Transition: What Designers Can Learn from the Transition Movement." Paper presented at "Changing the Change" Conference, Turin, Italy, July 2008. www.eco-labs.org/resources/papers-on-line/97-designers-a-the-transition-movement.
Boehnert, Joanna. *Design, Ecology, Politics: Towards the Ecocene*. New York and London: Bloomsbury, 2018.
Boggs, Carl. "Marxism, Prefigurative Communism and the Problem of Workers' Control." *Radical America* 6 (Winter 1977): 99–122.
Böhm, Steffen, Ana Dinerstein, and André Spicer. "(Im)possibilities of Autonomy: Social Movements in and beyond Capital, the State and Development." *Social Movement Studies* 9, no. 1 (2010): 17–32.
Boke, Charis. "Resilience's Problem of the Present: Reconciling Social Justice and Future-oriented Resilience Planning in the Transition Town Movement." *Resilience* 3, no. 3 (2015): 207–220.
Bollas, Christopher. *The Shadow of the Object: Psychoanalysis of the Unthought Known*. New York: Columbia University Press, 1989.
Bollas, Christopher. *The Freudian Moment*. London: Karnac, 2007.
Bollas, Christopher. *The Evocative Object World*. New York: Routledge, 2009.
Bollier, David. "Imagining a New Politics of the Commons." *On the Commons*. Accessed June 24, 2019. www.onthecommons.org/imagining-new-politics-commons#sthash.Z6pNqKCK.KQ180MPY.dpbs.
Borasi, Giovanna, and Mirko Zardini, eds. *Actions: What You Can Do with the City*. Montréal: Canadian Centre for Architecture, 2008.
Boren Davies, Zachary. "Spain's Hologram Protest: Thousands Join Virtual March in Madrid against New Gag Law." *Independent*. April 12, 2015. www.independent.co.uk/news/world/europe/spains-hologram-protest-thousands-join-virtual-march-in-madrid-against-new-gag-law-10170650.html.

Bottici, Chiara. *Imaginal Politics: Images beyond Imagination and the Imaginary*. New York: Columbia University Press, 2014.

Bottici, Chiara, and Rob Ritzen, "Imaginal Interventions: An Interview with Chiara Bottici." *Krisis* no. 2 (2017): 41–49. https://krisis.eu/wp-content/uploads/2017/11/Krisis-2017-02-Rob-Ritzen-Imaginal-Interventions.pdf.

Bourdieu, Pierre. "The Politics of Protest: An Interview with K. Ovenden." *Socialist Review* 242 (June 2000): 2–12.

Bourriaud, Nicolas, Simon Pleasance, Fronza Woods, and Mathieu Copeland. *Relational Aesthetics*. Dijon: Les presses du réel, 2002.

Boyd, Andrew. *Activist Cookbook: Creative Actions for a Fair Economy*. Boston, MA: United for a Fair Economy, 1997.

Boyd, Andrew, and Dave Oswald Mitchell, eds. *Beautiful Trouble: A Toolbox for Revolution*. New York and London: OR Books, 2012.

Breidbach, Olaf. "Imaging Science: The Pictorial Turn in Bio- and Neurosciences." In *Imagery in the 21st Century*, edited by Oliver Grau, 111–127. Cambridge, MA: The MIT Press, 2011.

Breines, Wini. "Community and Organization: The New Left and Michels' 'Iron Law'." *Social Problems* 27, no. 4 (1980): 419–429.

Breines, Wini. *Community and Organization in the New Left, 1962–1968: The Great Refusal*. New Brunswick, NJ: Rutgers University Press, 1981.

Brenner, Neil, Peter Marcuse, and Margit Mayer. "Cities for People, Not for Profit." *City* 13, no. 2–3 (2009): 176–184.

Brenner, Neil, Peter Marcuse, and Margit Mayer. *Cities for People, Not for Profit: Critical Urban Theory and the Right to the City*. London and New York: Routledge, 2012.

Brooke, Heather. *The Revolution Will Be Digitized: Dispatches from the Information War*. London: William Heinemann, 2011.

Brown, Fred. "Urban Transition Cities Movement." *Transition United States*. September 19, 2016. http://transitionus.org/blog/urban-transition-cities-movement.

Brown, Gavin, Anna Feigenbaum, Fabian Frenzel, and Patrick McCurdy, eds. *Protest Camps in International Context. Spaces, Infrastructures and Media of Resistance*. Bristol: Policy Press, 2017.

Brown, Steven E. "Zona and Ed Roberts: Twentieth Century Pioneers." *Studies Quarterly* 20, no. 1 (Winter 2000): 26–42.

Brown, Wendy. *Walled States, Waning Sovereignty*. Cambridge, MA: The MIT Press, 2010.

Bryson, Norman, Michael Ann Holly, and Keith Moxey, eds. *Visual Culture: Images and Interpretations*. Hanover, NH: University Press of New England, 1994.

Buchanan, Richard. "Wicked Problems in Design Thinking." *Design Issues* 8, no. 2 (1992): 5–21.

Buckner, Randy. "Remembering the Past to Imagine the Future: The Prospective Brain." *Nature Reviews/Neuroscience* 8 (September 2007): 657–661.

Bureau Detour. Accessed January 7, 2020. https://detours.biz/bureau-detours/.

Butler, Judith. *Notes toward a Performative Theory of Assembly*. Cambridge, MA: Harvard University Press, 2018.

Butler, Judith, Zeynep Gambetti, and Leticia Sabsay. *Vulnerability in Resistance*. Durham, NC: Duke University Press, 2016.

Byrne, Janet, and Robin Wells. *Occupy Handbook*. New York: Back Bay Books, 2012.

Caffentzis, George, and Silvia Federici. "Commons Against and Beyond Capitalism." *Community Development Journal* 49, suppl. 1 (2014): i92–i105.

Campbell, Fiona. *Contours of Ableism: The Production of Disability and Abledness*. New York: Palgrave Macmillan, 2009.

Canguillhem, George. *The Normal and the Pathological*. New York: Zone Books, 1991.

Canguillhem, George, and Therese Jaeger. "Monstrosity and the Monstrous." *Diogenes* 10, no. 40 (1962): 27–42.

Carroll, William. *Critical Strategies for Social Research*. Toronto: Canadian Scholars' Press, 2004.

Castells, Manuel. *Networks of Outrage and Hope: Social Movements in the Internet Age*. Cambridge: Polity Press, 2012.

Chambers, Samuel A. *The Lessons of Rancière*. Oxford and New York: Oxford University Press, 2013.

Chan, Holmes. "Hong Kong's Leading Umbrella Movement Activists Handed Jail Sentences." *Hong Kong Free Press*. April 24, 2019. www.hongkongfp.com/2019/04/24/breaking-hong-kongs-leading-umbrella-movement-activists-handed-jail-sentences/.

Chao, Jason. "貪貪」、污污」勝出熊貓民間花名投票" ("Tam Tam and Wu Wu Won the Folk Naming Competition"). *Medium*. September 12, 2016. https://medium.com/庭-思-問/貪貪-污污-勝出熊貓民間花名投票-b46a76ccedaf.

Chatterton, Paul, and Alice Cutler. *The Rocky Road to a Real Transition: The Transition Towns Movement and What It Means for Social Change*. Trapese Popular Education Collective. April 2008. http://trapese.clearerchannel.org/resources/rocky-road-a5-web.pdf.

Chen, Fang-Yu, and Wei-Ting Yen. "Who Supports the Sunflower Movement? An Examination of Nationalist Sentiments." *Journal of Asian and African Studies* 52, no. 8 (2017): 1193–1212.

China Digital Times, ed. *Decoding the Chinese Internet: A Glossary of Political Slang*. Berkeley, CA: China Digital Times, 2015.

Cidade Democrática. "Coletivo planta árvores no Largo da Batata sem autorização da prefeitura." January 19, 2015. Accessed January 2, 2019. http://blog.cidadedemocratica.org.br/2015/01/19/coletivo-planta-arvores-no-largo-da-batata-sem-autorizacao-da-prefeitura/.

Cipolla, Carlo M. *Guns, Sails and Empires: Technological Innovation and the Early Phases of European Expansion, 1400–1700*. New York: Pantheon Books, 1966.

City Plaza. "Refugee Accommodation and Solidarity Space." Accessed August 11, 2019. http://solidarity2refugees.gr/.

Clarke, Jackie. "Rancière, Politics and the Social Question." In *Rancière Now – Current Perspectives on Jacques Rancière*, edited by Oliver Davis, 13–27. Cambridge: Polity Press, 2013.

Cocco, Giuseppe, and Gerardo Silva. *Territórios produtivos rooportunidades e desafios para o desenvolvimento local*. Rio de Janeiro: DP&A, 2006.

Conduru, Roberto. *Arte Afro-Brasileira*. Belo Horizonte: Editora C/ Arte, 2007.

Conflict Kitchen. "Conflict Kitchen." Accessed December 23, 2018. www.conflictkitchen.org/.

Connolly, William. *Neuropolitics: Thinking, Culture, Speed*. Minneapolis: University of Minnesota Press, 2007.

Conservation Drones. Accessed January 6, 2019. https://conservationdrones.org/.

Conway, Janet. "Civil Resistance and the Diversity of Tactics in the Anti-Globalization Movement: Problems of Violence, Silence, and Solidarity in Activist Politics." *Osgoode Hall Law Journal* 41, no. 2/3 (2003): 505–530.

Conway, Janet M. *Praxis and Politics: Knowledge Production in Social Movements*. New York: Routledge, 2006.

Conway, Janet M. *The Edges of Global Justice: The World Social Forum and Its Others*. London and New York: Routledge, 2012.

Corbin, Alain. *The Foul and Fragrant: Odor and the French Social Imagination*. Cambridge, MA: Harvard University Press, 1988.

Crawford, Kate. "Can an Algorithm be Agonistic? Ten Scenes from Life in Calculated Publics." *Science, Technology, & Human Values* 41, no. 1 (2016): 77–92.

Crawford, Margaret. "Rethinking 'Rights,'Rethinking 'Cities': A Response to David Harvey's 'The Right to the City'." In *The Right to the City*, edited by Zanny Begg, and Lee Stickells, 33–38. Sydney: Tin Sheds Gallery, 2011.

Crinion, Jonathan, and Rob Hopkins. "Adapting to Peak Oil and Climate Change: Lessons from the Transition Movement." Unpublished, Stockholm University, 2011.

Critical Art Ensemble. *The Electronic Disturbance*. New York: Autonomedia, 1994.

Critical Art Ensemble. *Digital Resistance: Explorations in Tactical Media*. New York: Autonomedia, 2001.

Critical Legal Thinking. "Slovenians Demand Radical Change." *Critical Legal Thinking–Law and the Political*. January 15, 2013. Accessed February 2, 2020. http://criticallegalthinking.com/2013/01/15/slovenians-demand-radical-change/.

Cross, Nigel. "Designerly Ways of Knowing." *Design Issues* 3, no. 4 (1982): 49–55.

Crossley, Nick. "Repertoires of Contention and Tactical Diversity in the UK Psychiatric Survivors Movement: The Question of Appropriation." *Social Movement Studies: Journal of Social, Cultural and Political Protest* 1, no. 1 (2002): 47–71.

Cuttitta, Paolo. "'Borderizing' the Island Setting and Narratives of the Lampedusa 'Border Play'." *ACME: An International E-Journal for Critical Geographies* 13, no. 2 (2014): 196–219.

Cvetkovich, Ann. "Public Feelings." *South Atlantic Quarterly* 106, no. 3 (Summer 2007): 459–468.

Daravanche, Guillaume, ed. *Aftodiacheirisi mia idea panta epikairi*. Translated by Theodoris Ditsas and Kostas Spatharakis. Athens: Ekdosis ton Sinadelfon, 2015.

Dawkins, Nicole. "Do-it-yourself: The Precarious Work and Postfeminist Politics of Handmaking (in) Detroit." *Utopian Studies* 22, no. 2 (2011): 261–284.

Day, Richard J. F, *Gramsci Is Dead: Anarchist Currents in the Newest Social Movements*. London and Ann Arbor, MI: Pluto Press, 2005.

Daybreak Project. "Attempts at International Outreach during the Movement—Daybreak Project." July 20, 2017. Accessed March 17, 2020. https://daybreak.newbloommag.net/2017/07/20/international-outreach/.

DDED HK. "The TriForce of Occupy Hongkong." YouTube. October 7, 2014. www.youtube.com/watch?v=dHwWPXdtII4&feature=youtu.be.

De Angelis, Massimo, and Stavros Stavrides. "On the Commons: A Public Interview with Massimo De Angelis and Stavros Stavrides." *E-Flux* no. 17 (June 2010). Accessed August 11, 2019. www.e-flux.com/journal/17/67351/on-the-commons-a-public-interview-with-massimo-de-angelis-and-stavros-stavrides/.

de Berg, Henk. *Freud's Theory and Its Use in Literary and Cultural Studies: An Introduction*. Columbia, MD: Camden House Inc, 2004.

de Certeau, Michel. *The Practice of Everyday Life*. Translated by Steven Rendall. Berkeley: University of California Press, 1984.

De Genova, Nicholas. "Migrant 'Illegality' and Deportability in Everyday Life." *Annual Review of Anthropology* 31 (2002): 419–447.

De Genova, Nicholas. "Spectacles of Migrant 'Illegality': The Scene of Exclusion, the Obscene of Inclusion." *Ethnic and Racial Studies* 36, no. 7 (2013): 1180–1198.

Debord, Guy. *The Society of Spectacle*. Detroit, MI: Black and Red Press, 1977.

Delaure, Marilyn, Moritz Fink, and Mark Dery, eds. *Culture Jamming: Activism and the Art of Cultural Resistance*. New York: New York University Press, 2017.

"Democracy at 4am: What Unprecedented Protest Means for Taiwan." 2014. 4am.tw. Accessed December 3, 2019. 4am.tw.

"DENNIS Design Center." Bureau Detour. Accessed January 7, 2020. www.in-situ.info/en/artists/bureau-detours/works/en/dennis-design-center-39.

Dery, Mark. *Flame Wars. The Discourse of Cyberculture*. Durham, NC and London: Duke University Press, 1994.

Deseriis, Marco. "The People's Mic as a Medium in Its Own Right: A Pharmacological Reading." *Communication and Critical/Cultural Studies* 11, no. 1 (2014): 42–51.

"Design Justice." Design Justice. Accessed March 15, 2019. http://designjusticenetwork.org.

Deutche, Rosalyn. "Art and Public Space: Questions of Democracy." *Social Text* 33 (1992): 34–53.

Dilnot, Clive. "The Critical in Design (Part One)." *Journal of Writing in Creative Practice* 1, no. 2 (2008): 177–189.

Dimitriou, Orsalia. "The Politics of Public Space and the Emergence of the Commons in Contemporary Athens." PhD diss., Goldsmiths University of London, Department of Visual Cultures, 2016.

Dimitriou, Orsalia. "Whose Commons? Challenges of Commoning Practices in an Athenian Public Space." *TRANSLOCAL*. Culturas Contemporâneas Locais e Urbanas 1 (2018): 66–76.

DiSalvo, Carl. "Design and the Construction of Publics." *Design Issues* 25, no. 1 (2009): 48–63.

DiSalvo, Carl. "Design, Democracy and Agonistic Pluralism." Design Research Society Montreal. 2010.

DiSalvo, Carl. *Adversarial Design*. Cambridge, MA and London: The MIT Press, 2012.

Dixon, Chris. "Building 'Another Politics': The Contemporary Anti-Authoritarian Current in the US and Canada." *Anarchist Studies* 20, no. 2 (2012): 32–60.

DIY Drones. Accessed December 25, 2018. https://diydrones.com/.

"Documenting the Now." DocNow. Accessed March 15, 2019. www.docnow.io.

Dominguez, Ricardo. "Electronic Civil Disobedience: Inventing the Future of Online Agitprop Theater." *PMLA* 124, no. 5 (2009): 1806–1812.

Dunne, Anthony, and Fiona Raby. *Speculative Everything: Design, Fiction, and Social Dreaming*, 366–371. Cambridge: The MIT Press, 2013.

Earle, Lucy. *Transgressive Citizenship and the Struggle for Social Justice: The Right to the City in São Paulo*. London: Palgrave McMillian, 2017.

Elbaor, Caroline. "A Horde of Zombies Overtook Hamburg Ahead of the G20 Summit, for Art's Sake. The City Sees a Host of Artistic Interventions Calling for Political Action." *Artnetnews*. July 6, 2017. https://news.artnet.com/art-world/g20-summit-hamburg-zombie-performers-1014083.

Elderfield, John. *Manet and the Execution of Maximilian*. Italy: MOMA, 2006.

Elefthero Aftodiaheirizomeno Theatro Embros. Accessed November 11, 2019. www.embros.gr/.

Elefthero Aftodiaheirizomeno Theatro Embros. "Gia tin epanastasi, gia na moirastoume ta oneira." Event listed under "Ekdiloseis tou Embros" April 18, 2019. Assessed January 16, 2020. www.embros.gr/18-4-16-00-gia-thn-epanastash-gia-na-moirastoyme-ta-oneira.html.

Escaño, Carlos, and Michou Hélène. "United against Spain's Gag Laws: Change Bottom-up." *OpenDemocracy*. September 14, 2016. www.opendemocracy.net/can-europe-make-it/carlos-esca-o-h-l-ne-michou/united-against-spain-s-gag-laws-change-bottom-up.

Escobar, Arturo. "Sustainability, Design for the Pluriverse." *Development* 54 (2011): 137–140.

Escobar, Arturo. *Autonomia y diseño. La realización de lo communal*. Popayán: Universidad del Cauca sello editorial, 2016.

Escobar, Arturo. "Response: Design for/by [and from] the 'Global South'." *Design Philosophy Papers* 15, no. 1 (2017): 39–49.

Escobar, Arturo. *Designs for the Pluriverse: Radical Interdependence, Autonomy and the Making of Worlds*. Durham, NC: Duke University Press, 2018.

Escola sem Muros. www.semmuros.com/escolasemmuros. Accessed January 2, 2019.

ESDI Aberta 2017. Accessed March 7, 2020. https://ESDIaberta2017.wixsite.com/linhadotempo.

EZLN. *Ejército Zapatista de Liberación Nacional Communiqué (Zapatista Army of National Liberation Communiqué)*. Accessed March 10, 2020. www.elkilombo.org/communique-indigenous-revolutionary-clandestine-committee/.

Fahlenbrach, Katrin, Erling Sivertsen, and Rolf Werenksjord, eds. *Media and Revolt. Strategies and Performances from the 1960s to the Present*. Oxford: Berghann Books, 2014.

Farber, Yael. "Erwin Piscator—In Spite of Everything." *Threebathspa*. February 29, 2016. https://threebathspa.wordpress.com/2016/02/29/erwin-piscator-in-spite-of-everything/.

Federici, Silvia. *Caliban and the Witch: Women, the Body and Primitive Accumulation*. New York: Autonomedia, 2003.

Federici, Silvia. "Feminism and the Politics of the Commons." *Wealth of the Commons*. Accessed August 10, 2019. http://wealthofthecommons.org/essay/feminism-and-politics-commons.

Feigenbaum, Anna. "Written in the Mud." *Feminist Media Studies* 13, no. 1 (2013): 1–13.

Feigenbaum, Anna, Fabian Frenzel, and Patrick McCurdy. *Protest Camp*. London and New York: Zed Books, 2013.

Feldman, Michael, and Elizabeth Bott Spillius, eds. *Psychic Equilibrium and Psychic Change: Selected Papers of Betty Joseph*. New York: Routledge, 1989.

Ferguson, Rafter Sass, and Sarah Taylor Lovell, "Permaculture for Agroecology: Design, Movement, Practice and Worldview. A Review." *Agronomy for Sustainable Development* 34, no. 2 (2014): 251–274.

Figueiras, Rita, and Paola Espírito Santo, eds. *Beyond the Internet: Unplugging the Protest Movement Wave*. London: Taylor and Francis, 2015.

Finkelpearl, Tom. *What We Made: Conversations on Art and Social Cooperation*. Durham, NC: Duke University Press, 2012.

Fishman, Robert M. "Rethinking State and Regime: Southern Europe's Transition to Democracy." *World Politics* 42, no. 3 (April 1990): 422–440.

Flesher Fominaya, Cristina. *Social Movements and Globalization: How Protests, Occupations and Uprisings are Changing the World*. London: Palgrave Macmillan, 2014.

Flesher Fominaya, Cristina. "Debunking Spontaneity: Spain's 15-M/Indignados as Autonomous Movement." *Social Movement Studies* 14, no. 2 (2015a): 142–163.

Flesher Fominaya, Cristina. "Redefining the Crisis/Redefining Democracy: Mobilising for the Right to Housing in Spain's PAH Movement." *South European Society and Politics* 20, no. 4 (2015b): 465–485.

Flesher Fominaya, Cristina. "World's First Hologram Protest in Spain." *Interface: A Journal for and about Social Movements* 7, no. 1, Movement Practice(s) (2015c): 144–149. www.interfacejournal.net/2015/06/interface-volume-7-issue-1-movement-practices/.

Flood, Catherine, and Gavin Grindon, eds. *Disobedient Objects*. London: V&A Publishing, 2014.

Florida, Richard. *The Rise of the Creative Class. And How It's Transforming Work, Leisure, Community and Everyday Life*. New York: Basic Books, 2000.

Foucault, Michel. *Abnormal. Lectures at the Collège de France 1974–1975*. New York: Picador, 1999.

Foucault, Michel. *Naissance de la biopolotique – Cours au Collège de France*. Paris: Gallimard/Seuil, 2004.

Foucault, Michel, and Jay Miskowiec. "Of Other Spaces." *Diacritics* 16, no. 1 (1986): 22–27.

Frantz, Fanon. *The Wretched of the Earth*. Harmondsworth, Middlesex: Penguin Books, 1971 [1961].

Fraser, Niall. "Macau Journalists are Concerned about Press Freedom and Access to Official Information, Survey Shows." *South China Morning Post*. September 29, 2017. www.scmp.com/news/hong-kong/politics/article/2113462/macau-journalists-are-concerned-about-press-freedom-and.

Freedom HK (@Freedomhkg). Twitter. Accessed July 10, 2019. https://twitter.com/FreedomHKG?lang=en.

Freedom Hong Kong. Hong Kong's Today; The World's Tomorrow? Accessed December 10, 2019. https://freedomhongkong.org/en/aboutus.

Freud, Sigmund. *The Psychopathology of Everyday Life*. New York: WW Norton & Co, 1990.
Fry, Tony. *Design Futuring: Sustainability, Ethics and New Practice*. Oxford and New York: Berg Publishers, 2009.
Fry, Tony. *Design as Politics*. Oxford and New York: Berg Publishers, 2011.
Fuad-Luke, Alastair. *Design Activism: Beautiful Strangeness for a Sustainable World*. Abingdon: Routledge, 2013.
Galison, Peter. *Image and Logic: A Material Culture of Microphysics*. Chicago, IL: University of Chicago Press, 1997.
Gan, Wendy. "Puckish Protesting in the Umbrella Movement." *International Journal of Cultural Studies* 20, no. 2 (2017): 162–176.
Garrett, Dan. "Superheroes in Hong Kong's Political Resistance: Icons, Images, and Opposition." *PS: Political Science and Politics* 47, no. 1 (2014): 112–119.
Gathercole, Miranda. "VIDEO: B.C. First Nation Joins 'Hologram' Protest vs Kinder Morgan Pipeline." *The Columbia Valley Pioneer*. November 24, 2017. Accessed July 17, 2018. www.columbiavalleypioneer.com/news/video-b-c-first-nation-joins-hologram-protest-vs-kinder-morgan-pipeline/.
Gerbaudo, Paolo. *Tweets and Streets*. London: Pluto Press, 2012.
Gerbaudo, Paolo. "The Persistence of Collectivity in Digital Protest." *Information, Communication & Society* 17, no. 2 (2014): 264–268.
Ghazzal, Amer. "A Group of Animal Rights Protesters Stage a Protest against Skin Trade outside London Fashion Week." *Alamy*. February 18, 2017. www.alamy.com/stock-photo-london-uk-18th-february-2017-a-group-of-animal-rights-protesters-stage-134116965.html.
Gielen, Phillip, and Pascal Dietachmair, eds. *The Art of Civil Actions: Political Space and Cultural Dissent*. Amsterdam: Valiz, 2017.
GIL Goteborg Assistans. "CP-trucken – Parkeringskonverteraren." February 23, 2016. YouTube video, 4:38 minutes. www.youtube.com/watch?v=mc5qm1KW7TU.
Glissant, Éduoard. *Poetics of Relation*. Ann Arbor: University of Michigan Press, 1997.
Gómez Cruz, Edgar, and Asko Lehmuskallio, eds. *Digital Photography and Everyday Life: Empirical Studies on Material Visual Practices*. London: Taylor and Francis, 2016.
Graeber, David. "The New Anarchists." *New Left Review* 13, no. 6 (2002): 61–73.
Grau, Oliver. *Virtual Art: From Illusion to Immersion*. Cambridge, MA: The MIT Press, 2003.
Griffiths, Jay. "The Transition Initiative: Changing the Scale of Change." *Orion Magazine*. July/August 2009. www.orionmagazine.org/index.php/articles/article/4792.
Grosz, Elizabeth. *Becoming Undone: Darwinian Reflections on Life, Politics, and Art*. Durham: Duke University Press, 2011.
Guattari, Félix. *The Three Ecologies*, Translated by Ian Pindar and Paul Sutton, Bloomsbury Revelations edition. London and New York: Bloomsbury Academic, 2014.
Gudme, Peter Nicola. "Designcenter vil beskytte sig mod DENNIS Design." *Politiken*. September 3, 2011. https://politiken.dk/kultur/art5024452/Designcenter-vil-beskytte-sig-mod-Dennis-Design.
Guffey, Elizabeth. *Designing Disability: Symbols, Space, and Society*. London: Bloomsbury, 2018.
Haack, Sophie, Ulla Aude, and Alexander Muchenberger, eds. *DENNIS Design Center – W.I.P.* Copenhagen: Bureau Detours, 2012.
Habermas, Jürgen. *The Structural Transformation of the Public Sphere: An Inquiry into a Category of Bourgeois Society*. Cambridge, MA: The MIT Press, 2001.
Hadjimichalis, Costis. *Crisis Spaces: Structures, Struggles and Solidarity in Southern Europe*. London: Routledge, 2018.
Hagen, Jamie J. "And Then Judith Butler Showed up at Occupy Wall Street." *Autostraddle*. October 25, 2011. Accessed November 12, 2011. www.autostraddle.com/and-then-judith-butler-showed-up-at-occupy-wall-street-in-solidarity-117911/.

Halse, Joaquim. "Ethnographies of the Possible." In *Design Anthropology – Theory and Practice*, edited by Wendy Gunn, Ton Otto, and Rachel Charlotte Smith, 180–197. London and New York: Bloomsbury, 2013.

Hamraie, Aimi. "Universal Design and the Problem of 'Post-Disability' Ideology." *Design and Culture* 8, no. 3 (2016): 285–309.

Hamraie, Aimi. *Building Access: Universal Design and the Politics of Disability*. Minneapolis: University of Minnesota Press, 2017.

Haraway, Donna. *Staying with the Trouble: Making Kin in the Chthulucene (Experimental Futures)*. Durham, NC: Duke University Press, 2016.

Harcourt, Wendy, and Arturo Escobar. "Women and the Politics of Place." *Development* 45, no. 1 (March 2002): 7–13.

Harcourt, Wendy, and Arturo Escobar. *Women and the Politics of Place*. Bloomfield, CT: Kumarian Press, 2005.

Harkin, James. "Cyber-Con." *London Review of Books* 32, no. 2 (December 2010): 19–21.

Hart, Anna. "Steve Wintercroft's Fox Masks Stole the Show at This Week's Anti-Hunting Demonstrations." *The Independent*. July 15, 2015. www.independent.co.uk/life-style/fashion/features/steve-wintercrofts-fox-masks-stole-the-show-at-this-weeks-anti-hunting-demonstrations-10391614.html.

Harvey, David. "The Political Economy of Public Space." In *The Politics of Public Space*, edited by Setha Low, and Neil Smith, 23–188. New York: Routledge, 2006.

Harvey, David. "The Right to the City." *New Left Review* 53 (2008): 23–40.

Harvey, David. *Rebel Cities: From the Right to the City to the Urban Revolution*. New York and London: Verso, 2012.

Hashemi, Nader, and Danny Postel, eds. *The People Reloaded: The Green Movement and Struggle for Iran's Future*. Brooklyn, NY: Melville House, 2010.

Hattam, Victoria. *In the Shadow of Race*. Chicago, IL: University of Chicago Press, 2007.

Hattam, Victoria, and Joseph Lowndes. "From Birmingham to Baghdad: The Micropolitics of Partisan Change." In *Political Creativity*, edited by Gerald Berk, Dennis Galvan, and Victoria Hattam, 211–235. Philadelphia: University of Pennsylvania Press, 2014.

Hawkins, Simon. "Teargas, Flags and the Harlem Shake: Images of and for Revolution in Tunisia and the Dialectics of the Local in the Global." In *The Political Aesthetics of Global Protests: The Arab Spring and Beyond*, edited by Pnina Werbner, Martin Webb, and Kathryn Spelman-Poots, 31–52. Edinburgh: Edinburgh University Press, 2014.

Hemenway, Toby. *Gaia's Garden: A Guide to Home-Scale Permaculture*, 2nd edition. White River Junction, VT: Chelsea Green Publishers, 2009.

Herrera, Linda. *Revolution in the Age of Social Media. The Egyptian Popular Insurrection and the Internet*. London: Verso, 2014.

Hertz, Garnet. *Critical Making*. Hollywood, CA: Telharmonium Press, 2012.

Heylighen, Ann. "About the Nature of Design in Universal Design." *Disability and Rehabilitation* 36, no. 16 (2014): 1–9.

Hill, Simon. *Digital Revolutions: Activism in the Internet Age*. Oxford: New Internationalist Publications Ltd, 2013.

Hillier, Jean. *Stretching beyond the Horizon—A Multiplanar Theory of Spatial Planning and Governance*. New York and Oxford: Routledge, 2007.

Hoffman, Abbie. *Revolution for the Hell of It*. New York: Thunder's Mouth Press, 1968.

Holmgren, David. "Permaculture Design Principles." *Permaculture Principles*. Accessed August 20, 2018. https://permacultureprinciples.com/principles/.

Holston, James. "Spaces of Insurgent Citizenship." In *Making the Invisible Visible: A Multicultural Planning History*, edited by Leonie Sandercock, 37–56. Berkeley: University of California Press, 1998.

Holston, James, and Arjun Apparadurai. "Cities and Citizenship." *Public Culture* 8 (1996): 187–204.

"Homepage of the Transition Network." *TransitionNetwork.org*. Accessed May 25, 2018. https://transitionnetwork.org.

Hopkins, Rob. *The Transition Handbook: From Oil Dependency to Local Resilience*. Devon, UK: Green Books Ltd., 2008.

Hopkins, Rob. *The Transition Companion: Making Your Community More Resilient in Uncertain Times*. White River Junction, VT: Chelsea Green Publishing, 2011.

Hopkins, Rob. *The Power of Just Doing Stuff: How Local Action Can Change the World*. Cambridge, UK: UIT/Green Books, 2013.

Hopkins, Rob. *21 Stories of Transition*. Totnes, Devon: Transition Network, 2015.

Hopkins, Rob. "10 Years of Transition Network: The Early Days …" Transition Network. org. March 1, 2017. https://transitionnetwork.org/news-and-blog/10years/.

Hopkins, Rob, and Peter Lipman. *Who We Are and What We Do*. Version 1.0 Totnes, UK: Transition Network. February 1, 2009. www.transitionnetwork.org/sites/www.transitionnetwork.org/files/WhoWeAreAndWhatWeDo-lowres.pdf.

Howes, David. "Scent, Sound, and Synaesthesia: Intersensoriality and Material Culture Theory." In *Handbook of Material Culture*, edited by Christopher Tilley, Webb Keane, Susanne Küchler, Michael Rowlands, and Patricia Spyer, 161–172. Los Angeles, CA: Sage Publications, 2013.

Hsiao, Hsin-Huang Michael, and Po-San Wan. "The Student-Led Movements of 2014 and Public Opinion: A Comparison of Taiwan and Hong Kong." *Asian Journal of Comparative Politics* 3, no. 1 (2018): 61–80.

Hughes, James J. "Posthumans and Democracy in Popular Culture." In *The Palgrave Handbook of Posthumanism in Film and Television*, edited by Michael Hauskeller, Thomas D. Philbeck, and Curtis D. Carbonell, 235–245. London: Palgrave MacMillan, 2015.

Hustvedt, Siri. "Freud's Playground: Some Thoughts on the Art and Science of Subjectivity and Intersubjectivity." *Salmagundi* no. 174/175 (Spring 2012): 59–78.

Hustvedt, Siri. *A Woman Looking at Men Looking at Women: Essays on Art, Sex, and the Mind*. New York: Simon and Schuster Paperbacks, 2016.

Huszka, Beáta. *Secessionist Movements and Ethnic Conflict: Debate-Framing and Rhetoric in Independence Campaigns*. London: Routledge, 2014.

Huysmans, Jef. "The European Union and the Securitization of Migration." *JCMS: Journal of Common Market Studies* 38, no. 5, (2000): 751–777.

Hyndman, Jennifer, and Alison Mountz. "Refuge or Refusal." In *Violent Geographies: Fear, Terror, and Political Violence*, edited by Derek Gregory, and Allan Pred, 77–92. New York and London: Routledge, 2007.

Indymedia Montreal 2016 Convergence Working Group. "Holding Out for Un-alienated Communication." *Briarpatch Magazine*. January 2017. https://briarpatchmagazine.com/articles/view/holding-out-for-un-alienated-communication.

Ingold, Tim. *Being Alive: Essays on Movement, Knowledge and Description*. London: Routledge, 2011.

Ingold, Tim. "On Human Correspondence." *Journal of the Royal Anthropological Institute* 23, no. 1 (2017): 9–27.

"Interference Archive." Interference Archive. Accessed March 15, 2019. https://interferencearchive.org.

IPHAN. "Sítio Arqueológico Cais do Valongo: Proposta de Inscrição na Lista do Patrimônio Mundial." IPHAN website, Accessed December 30, 2018. http://portal.iphan.gov.br/uploads/ckfinder/arquivos/Dossie_Cais_do_Valongo_versao_Portugues.pdf.

Irani, Lilly. "Hackathons and the Making of Entrepreneurial Citizenship." *Science, Technology, & Human Values* 40, no. 5 (2015): 799–824.

Jasper, James M. *The Art of Moral Protest: Culture, Biography, and Creativity in Social Movements*. Chicago, IL: University of Chicago Press, 1997.

Jasper, James M. "Cultural Approaches in the Sociology of Social Movements." In *Handbook of Social Movements across Disciplines*, edited by Bert Klandermans and Conny Roggerband, 59–109. New York: Springer, 2010.

Jasper, James M. "Emotions and Social Movements: Twenty Years of Theory and Research." *Annual Review of Sociology* 37 (2011): 285–303.

Jasper, James M. "Introduction" to *Players and Arenas*, edited by James M. Jasper and Jan Willem Duyvendak. Amsterdam: Amsterdam University Press, 2015.

Jasper, James M. "The Doors that Culture Opened: Parallels between Social Movement Studies and Social Psychology." *Group Processes & Intergroup Relations* 20, no. 3 (2017): 285–302.

Jasper, James M. *The Emotions of Protest*. Chicago, IL: University of Chicago Press, 2018.

Jasper, James M. "Linking Arenas: Structuring Concepts in the Study of Politics and Protest." *Social Movement Studies*, published online October 28, 2019.

Jay, Martin. *Downcast Eyes: The Denigration of Vision in Twentieth-century French Thought*. Berkeley: University of California Press, 1993.

Jeffries, Ian. *The Former Yugoslavia at the Turn of the Twenty-first Century. A Guide to the Economies in Transition*. London and New York: Routledge, 2002.

Jenkins, Henry. "Youth Voice, Media, and Political Engagement: Introducing the Core Concepts." In *By Any Media Necessary: The New Youth Activism*, edited by Henry Jenkins, Sangita Shresthova, Liana Gamber-Thompson, Neta Kliger-Vilenchik, and Arely Zimmerman, 1–61. New York: New York University Press, 2016.

Johnson, Corey, et al. "Interventions on Rethinking 'the Border' in Border Studies." *Political Geography* 30, no. 2 (2011): 61–69.

Jones, Elizabeth. "What Brecht Did for the Theatre Was to Heighten the Spectator's Participation, but in an Intellectual Way, Whereas Artaud Had Specifically Rejected Intellectual Approaches in Favour of Theatre as 'a Means of Inducing Trances.' Discuss." *Innervate; Leading Undergraduate Work in English Studies* 2 (2009–2010): 247–253.

Julier, Guy. "Political Economies of Design Activism and the Public Sector." *Nordic Design Research Conference 2011*, Helsinki. www.nordes.org.

Julier, Guy. "From Design Culture to Design Activism." Special Issue "Design Activism." *Design and Culture* 5, no. 2 (2013a): 215–236.

Julier, Guy. "Introduction: Material Preference and Design Activism." Special Issue "Design Activism." *Design and Culture* 5, no. 2 (2013b): 145–150.

Kaika, Maria, and Lazaros Karaliotas. "Spatialising Politics: Antagonistic Imaginaries of Indignant Squares." In *The Post-Political and Its Discontents: Spaces of Depoliticisation, Spectres of Radical Politics*, edited by Japhy Wilson, and Erik Swyngedouw, 244–260. Edinburg: Edinburgh University Press, 2014.

Kanwisher, Nancy. "The Brain Basis of Human Vision." MIT World Special Events and Lectures. Filmed April 26, 2006 in Cambridge, MA. Video, 1:12:47. https://techtv.mit.edu/videos/16456-the-brain-basis-of-human-vision.

Karyotis, Georgios, and Wolfgang Rüdig. "The Three Waves of Anti-Austerity Protests in Greece, 2010–2015." *Political Studies Review* 16, no. 2 (2017): 158–169.

Keeling, Kara, and Josh Kun, eds. "Special Issue: Sound Clash: Listening in American Studies." *American Quarterly* 63, no. 3 (September 2011): Special Issue.

Kenis, Anneleen, and Matthias Lievens. "Searching for 'The Political' in Environmental Politics." *Environmental Politics* 23, no. 4 (2014): 531–548.

Kerr, Dylan. "The Future Is Here, and It's a Little Scary: Watch Spain's Hologram Protests." *Art Bytes, ArtSpace*. April 24, 2015. www.artspace.com/magazine/news_events/art-bytes/spanish-hologram-protest-52768.

Keshavarz, Mahmoud. "The Violence of Humanitarian Design." In *Design Philosophy Reader*, edited by Anne Marie Willis, 120–126. London: Bloomsbury, 2018.

Keshavarz, Mahmoud. *The Design Politics of the Passport: Materiality, Immobility and Dissent*. London: Bloomsbury, 2019.
Keshavarz, Mahmoud, and Eric Snodgrass. "Orientations of Europe: Boast, the Mediterranean Sea and the Materialities of Contemporary Mobility Regime." *Borderlands e-journal* 17, no. 2 (2018): 1–17.
Khatib, Kate, and Margaret Killjoy, eds. *We Are Many*. Oakland, CA: AK Press, 2012.
Khosravi, Shahram. "Is a World without Borders Utopian?" In *The Silent University Reader*, edited by Emily Fahlen, 6–11. Stockholm: Tensya Konsthall, 2013.
Killip, Christopher. *Seacoal*. Gottingen, Germany: Steidl, 2011.
Kioupkiolis, Alexandros. "Counter-hegemony, the Commons and New City Politics." *Transform Europe*. Accessed February 24, 2020. www.transform-network.net/en/publications/yearbook/overview/article/yearbook-2019/counter-hegemony-the-commons-and-new-city-politics1/.
Kirn, Gal. "Maribor's Social Uprising in the European Crisis: From Antipolitics of People to Politicisation of Periphery's Surplus Population." In *Social Movements in the Balkans. Rebellion and Protest from Maribor to Taxim*, edited by Florian Bieber, and Dario Brentin, 30–48. London: Routledge, 2019.
Kjær, Birgitte. "Dennis Design Center er åbnet på Amager." *Politiken*. August 11, 2011. https://politiken.dk/kultur/art5439146/Dennis-Design-Center-er-%C3%A5bnet-p%C3%A5-Amager.
Knoppers Lunger, Laura, and Johan B. Landes, eds. *Monstrous Bodies/Political Monstrosities in Early Modern Europe*. Ithaca, NY and London: Cornell University Press, 2004.
Kounadi, Iro. "Embros: Ena theatro gia olous." *In2life*. March 12, 2013. www.in2life.gr/culture/theatre/article/269029/empros-ena-theatro-gia-oloys.html.
Kress, Gunther, and Theo van Leeuwen. *Reading Images: The Grammar of Visual Design*. London: Routledge, 1996.
Kristeva, Julia. *Powers of Horror: An Essay on Abjection*. New York: Columbia University Press, 1982.
Kuecker, Glen David. "Enchanting Transition: A Post Colonial Perspective." In *Resilience, Community Action and Societal Transformation: People, Place, Practice, Power, Politics and Possibility in Transition*, edited by Thomas Henfrey, Gesa Maschkowski, and Gil Penha-Lopes, 193–210. White River Junction, VT: Chelsea Green Publishers, 2017.
Kwon, Miwon. *One Place after Another: Site-Specific Art and Locational Identity*. Cambridge, MA: The MIT Press, 2004.
Labelle, Brandon. *Acoustic Territories: Sound Culture and Everyday Life*. New York: Continuum, 2010.
Laclau, Ernesto. *New Reflections on the Revolution of Our Time*. London: Verso, 1990.
Laclau, Ernesto, and Chantal Mouffe. *Hegemony and Socialist Strategy: Towards a Radical Democratic Politics*. London: Verso Trade, 2014.
Latour, Bruno. "Where are the Missing Masses? the Sociology of a Few Mundane Artifacts." In *Shaping Technology/Building Society: Studies in Sociotechnical Change*, edited by Wieber E. Bijke, and John Law, 225–258. Cambridge, MA: The MIT Press, 1992.
Latour, Bruno. "Why Has Critique Run Out of Steam? From Matters of Fact to Matters of Concern." *Critical Inquiry* 30, no. 2 (2002): 225–248.
Latour, Bruno. *Making Things Public: Atmospheres of Democracy*. Cambridge, MA: The MIT Press, 2005.
Latour, Bruno, and Peter Weibel. *Making Things Public: Atmospheres of Democracy*. Exhibition from March 10–20, 2005. Karlsruhe: ZKM/Center for Art and Media in Karlsruhe, 2005.
Lauro, Juliet, ed. *Zombie Theory: A Reader*. Minneapolis: University of Minnesota Press, 2017.

Law, John. "On the Methods of Long-distance Control: Vessels, Navigation and the Portuguese Route to India." *The Sociological Review* 32, no. 1 (1984): 234–263.

Law, Wing-sang. "Decolonisation Deferred: Hong Kong Identity in Historical Perspective." In *Citizenship, Identity and Social Movements in the New Hong Kong: Localism after the Umbrella Movement*, edited by Wai-man Lam, and Luke Cooper, 13–33. Abingdon: Routledge, 2018.

Lazzarato, Maurizio. *As revoluções do capitalism*. Rio de Janeiro: Civilização Brasileira, 2006.

Lee, Siu-yau. "Surviving Online Censorship in China: Three Satirical Tactics and Their Impact." *The China Quarterly* 228 (2016): 1061–1080.

Lee, Yimou. "Taiwan President Defiant after China Calls for Reunification." *Reuters World News*. January 2, 2019. www.reuters.com/article/us-china-taiwan-president/taiwan-president-defiant-after-china-calls-for-reunification-idUSKCN1OW0FN.

Lefebvre, Henri. *Le droit à la ville*. Paris: Anthropos, 1968.

Lefebvre, Henri. "La production de l'espace – L'homme et la société." *Sociologie de la connaissance: marxisme et anthropologie* no. 31–32 (1974).

Lefebvre, Henri. *The Production of Space*. Translated by D. Nicholson Smith. Oxford: Blackwell, 1991.

Lefebvre, Henri. *Writings on Cities*, 7. Oxford: Basil Blackwell, 1996a.

Lefebvre, Henri. "The Right to the City." In *Writings on Cities*, edited by E. Lebas and E. Kofman, 63–181. New York: Blackwell, 1996b.

Leónidas, Martín. "#sinmordaza: Una intervención fotográfica contra la ley de protección ciudadana." *LEODECERCA, Vida, obra y milagros de Leónidas Martín*. March 20, 2015. http://leodecerca.net/sinmordaza-una-intervencion-fotografica-contra-la-ley-de-proteccion-ciudadana/.

Lesy, Michael. "Visual Literacy." *Journal of American History* 94, no. 1 (June 2007): 143–153.

Li, Hongmei. "Parody and Resistance on the Chinese Internet." In *Online Society in China: Creating, Celebrating, and Instrumentalising the Online Carnival*, edited by David Kurt Herold, and Peter Marolt, 71–88. New York: Routledge, 2011.

Link, Perry, and Xiao Qiang. "Introduction: China at the Tipping Point." In *Decoding the Chinese Internet: A Glossary of Political Slang*, edited by China Digital Times, 4–9. Berkeley, CA: China Digital Times, 2015.

Liu, Frank C. S., and Francis L. F. Lee, "Country, National, and Pan-national Identification in Taiwan and Hong Kong Standing Together as Chinese?" *Asian Survey* 53, no. 6 (2013): 1112–1134.

Llach, Daniel Cardoso. "Software Comes to Matter: Toward a Material History of Computational Design." *Design Issues* 31, no. 3 (2015): 41–54.

Lo, Sonny Shiu-Hing. "One Formula, Two Experiences: Political Divergence of Hong Kong and Macao since Retrocession." *Journal of Contemporary China* 16, no. 52 (2007): 359–387.

Loizidou, Elena, ed. *Disobedience: Concept and Practice*. London: Routledge, 2013.

Luckman, Susan. *Craft and the Creative Economy*. Basingstoke: Palgrave Macmillan, 2015.

Lucy, John A., and Richard Shweder. "Whorf and His Critics: Linguistic and Nonlinguistic Influences on Color Memory." *American Anthropologist* 81, no. 3 (September 1979): 581–615.

Luiqiu, Luwei Rose. "The Cost of Humour: Political Satire on Social Media and Censorship in China." *Global Media and Communication* 13, no. 2 (2017): 123–138.

Lukić, Reneo, and Allen Lynch. *Europe from the Balkans to the Urals: The Disintegration of Yugoslavia and the Soviet Union*. Oxford: Oxford University Press, 1996.

Luxemburg, Rosa. *The Mass Strike, the Political Party and the Trade Unions*. Detroit, MI: Marxist Educational Society of Detroit, 1925. Online version Rosa Luxemburg Internet archive (marxists.org), 1999.

M.R. "Janševa stranka ne vidi protestnikov temveč zombije" ("Janša's Party Does Not See Protesters, but Zombies"). *24ur.com*. December 21, 2012. Accessed June 17, 2017. www.24ur.com/novice/slovenija/janseva-stranka-ne-vidi-protestnikov-temvec-zombije.html.

Mace, Ronald. *Accessible Environments: Toward Universal Design*. Raliegh, NC: Center for Accessible Housing: North Carolina State University, 1990.

Mack, Arien, and Irvin Roc. *Inattentional Blindness*. Cambridge, MA: The MIT Press, 1998.

Maeckelbergh, Marianne. "The Prefigurative Turn: The Time and Place of Social Movement Practice." In *Social Sciences for an Other Politics, Women Theorizing without Parachutes*, edited by Ana Cecilia Dinerstein, 121–134. Basingstoke: Palgrave Macmillan, 2016.

Malpass, Matt. *Critical Design in Context: History, Theory and Practices*. London: Bloomsbury, 2017.

Manzini, Ezio. *Design, When Everybody Designs: An Introduction to Design for Social Innovation*. Translated by Rachel Coad. Cambridge, MA: The MIT Press, 2015.

Markussen, Thomas. "The Disruptive Aesthetics of Design Activism. Enacting Design between Aesthetics and Politics." *Nordes*. Helsinki: Nordic Design Research Conference, 2011.

Markussen, Thomas. "The Disruptive Aesthetics of Design Activism: Enacting Design between Art and Politics." *Design Issues* 29, no. 1 (Winter 2013): 38–50.

Marx, Karl. *Economic & Philosophic Manuscripts of 1844*. New York: Dover Publications, 2007.

Massey, Doreen. *For Space*. London, Thousand Oaks, CA, and New Delhi: Sage Publications, 2005.

Mattern, Mark. *Anarchism and Art: Democracy in the Cracks and on the Margins*. Albany: State University of New York, 2016.

Mavili, Kinisi. Accessed August 11, 2019. http://kinisimavili.blogspot.com/.

Mayer, Margit. "The 'Right to the City' in the Context of Shifting Mottos of Urban Social Movements." *City* 13, no. 2–3 (2009): 362–374.

Mayer, Margit. *Social Movements in the (Post-)Neoliberal City*. London: Bedford Press, 2010.

Mayer, Margit. "The 'Right to the City' in Urban Social Movements." In *Cities for People, Not for Profits: Critical Urban Theory and the Right to the City*, edited by Neil Brenner, Peter Marcuse, and Margit Mayer, London and New York: Routledge, 2012.

Mayer, Margit. "First World Urban Activism: Beyond Austerity Urbanism and Creative City Politics." *City* 17, no. 1 (2013): 5–19.

Maynard, Patrick. *The Engine of Visualisation. Thinking through Photography*. Ithaca, NY and London: Cornell University Press, 1997.

McAdam, Doug. *Political Process and the Development of Black Insurgency, 1930–1970*. Chicago, IL: University of Chicago Press, 2010.

McAllister, Steve. "10 Stories of Transition in the US: Transition Sarasota's Suncoast Gleaning Project." *Transition US*. Accessed August 24, 2018. www.transitionus.org/stories/10-stories-transition-us-transition-sarasotas-suncoast-gleaning-project.

McCart, Melissa. "Conflict Kitchen's Palestinian Focus Criticized as One-Sided." *Pittsburgh Post-Gazette*. October 6, 2014. www.post-gazette.com/local/city/2014/10/07/Conflict-Kitchen-s-Palestinian-dishes-leave-bitter-taste/stories/201410070088.

McCarthy, John D., and Mayer N. Zald. "Resource Mobilization and Social Movements: A Partial Theory." *American Journal of Sociology* 82, no. 6 (1977): 1212–1241.

McKee, Yates. *Strike Art: Contemporary Art and the Post-Occupy Condition*. London: Verso, 2016.

McQuiston, Liz. *Visual Impact: Creative Dissent in the 21st Century*. London: Phaidon Press Limited, 2015.

"Me nichia kai me dontia." Accessed January 8, 2020. https://menychiakaimedontia.wordpress.com/.

Mehta, Uday Singh. *Liberalism and Empire: A Study of Nineteenth-Century British Liberal Thought*. Chicago, IL: University of Chicago Press, 1999.

Melucci, Alberto. *Challenging Codes: Collective Action in the Information Age*. Cambridge and New York: Cambridge University Press, 1996.

Meng, Bingchun. "From Steamed Bun to Grass Mud Horse: E Gao as Alternative Political Discourse on the Chinese Internet." *Global Media and Communication* 7, no. 1 (2011): 33–51.

Milohnić, Aldo. "Artivistic Interventions as Humorous Re-appropriations." *The European Journal of Humour Research* 3, no. 2/3 (2015): 35–49.

Mina, An Xiao. "Batman, Pandaman and the Blind Man: A Case Study in Social Change Memes and Internet Censorship in China." *Journal of Visual Culture* 13, no. 3 (2014): 359–375.

Minder, Raphael. "Workers across Europe Synchronize Protests." *The New York Times*. November 11, 2015. www.nytimes.com/2012/11/15/world/europe/workers-in-southern-europe-synchronize-anti-austerity-strikes.html.

Mitchell, W. J. T. *What Do Pictures Want? The Lives and Loves of Images*. Chicago, IL: University of Chicago Press, 2005.

Mitchell, W. J. T. *Image Science: Iconology, Visual Culture, and Media Aesthetics*. Chicago, IL: University of Chicago Press, 2015.

Moshos, Yannis. "I drastiriotita tou theatrikou organismou 'Morfes' sto theatro Embros (1988–89)." *Skini*. April 7, 2015. Accessed January 16, 2020. http://ejournals.lib.auth.gr/skene/article/view/4931.

Mouffe, Chantal. "Politics and Passions: The Stakes of Democracy." *Ethical Perspectives* 7, no. 2–3 (2000a): 146–150.

Mouffe, Chantal. *The Democratic Paradox*. London: Verso, 2000b.

Mouffe, Chantal. *The Return of the Political*. London: Verso, 2005.

Mouffe, Chantal. *On the Political*. Abingdon: Routledge, 2011.

Mouffe, Chantal. *Democratic Politics and Agonistic Public Spaces*. Harvard Graduate School of Design (Harvard GSD), 2012. www.youtube.com/watch?v=4Wpwwc25JRU.

Mouffe, Chantal. *Agonistics: Thinking the World Politically*. London: Verso, 2013.

Mouffe, Chantal. "Democratic Politics in the Age of Post-Fordism." In *Thinking—Resisting—Reading the Political*, edited by Anneka Esch-van Kan, Stephan Packard, and Philipp Schulte. Accessed August 21, 2018. www.diaphanes.com/titel/democratic-politics-in-the-age-of-post-fordism-2216.

Mouffe, Chantal. "The Affects of Democracy." *Eurozine*. November 23, 2018. www.eurozine.com/the-affects-of-democracy/.

Mountz, Alison. "Specters at the Port of Entry: Understanding State Mobilities through an Ontology of Exclusion." *Mobilities* 6, no. 3 (2011): 317–334.

Mountz, Alison, and Jenna M. Loyd. "Constructing the Mediterranean Region: Obscuring Violence in the Bordering of Europe's Migration 'Crises'." *ACME: An International E-Journal for Critical Geographies* 13, no. 2 (2014): 173–195.

Mumford, Lewis. "Authoritarian and Democratic Technics." *Technology and Culture* 5 (1964): 1–8.

National Unification Council. "The National Unification Council's Definition of 'One China'." (August 1, 1992). *Chinese Law and Government* 35, no. 3 (2002): 60–61.

New Macau Association. "Macau Concealers, New Macau, Issue #45." *Issuu*. September 9, 2010. https://issuu.com/newmacau/docs/newmacau45_idaily.

Nomadic Architecture. *Walking through Fragile Landscapes*. Athens: Futura, 2018.

Nomadic Architecture Network. Accessed August 11, 2019. http://nomadikiarxitektoniki.net/en/.

Novak, Marjeta. "Slovenia Rises in Artful 'Protestivals'." *Waging Nonviolence*. March 21, 2013. http://wagingnonviolence.org/author/marjetanovak/2013.

Nunley, John W., and Cara McCarty. "Introduction." In *Masks: Faces of Culture*, edited by John W. Nunley, Cara McCarty, John Emigh, and Lesley K. Ferries. St Louis, MO: St Louis City Art Museum, 1999.
"Official Transition Initiatives." *Transition US*. Accessed August 13, 2018. http://transitionus.org/initiatives-map.
Oiticica, Filho César, ed. *Hélio Oiticica—Museu é o mundo*. Rio de Janeiro: Azougue, 2011.
Oliver, Michael. *The Politics of Disablement: A Sociological Approach*. New York: St. Martin's Press, 1990.
Ortiz, Isabel, Sara Burke, Mohamed Berrada, and Hernán Cortés. "World Protests 2006–2013." *Initiative for Policy Dialogue and Friedrich-Erbert-Stiftung New York Working Paper 2013*. September 2013. http://policydialogue.org/files/publications/papers/World_Protests_2006-2013-Complete_and_Final_4282014.pdf.
Orwell, George. "George Orwell: Funny, but Not Vulgar." Accessed April 24, 2019. http://orwell.ru/library/articles/funny/english/e_funny.
Osterweil, Michal. "A Cultural-political Approach to Reinventing the Political." *International Social Science Journal* 56, no. 182 (2004): 495–506.
Osterweil, Michal. "Place-based Globalism: Locating Women in the Alternative Globalization Movement." In *Women and the Politics of Place*, edited by Wendy Harcourt and Arturo Escobar, 174–187. Bloomfield, CT: Kumarian Press, 2005.
Oswalt, Phillipp, Klaus Overmeyer, and Philipp Misselwitz. *Urban Catalyst. The Power of Temporary Use*. Berlin: Dom Publishers, 2013.
Papadopoulos, Dimitris, Niamh Stephenson, and Vassilis Tsianos. *Escape Routes: Control and Subversion in the Twenty-First Century*. London: Pluto Press, 2008.
Parla, Ayse. "Protest and the Limits of the Body." *Cultural Anthropology*. October 31, 2013. https://culanth.org/fieldsights/403-protest-and-the-limits-of-the-body.
Patsiaouras, Georgios, Anastasia Veneti, and William Green. "Marketing, Art and Voices of Dissent: Promotional Methods of Protest Art by the 2014 Hong Kong's Umbrella Movement." *Marketing Theory* 18, no. 1 (2018): 75–100.
"Performance and Art in Public Space." *Metropolis*. Accessed March 6, 2018. www.metropolis.dk/en/.
Polletta, Francesca. *Freedom Is an Endless Meeting: Democracy in American Social Movements*. Chicago, IL: University of Chicago Press, 2002.
Polletta, Francesca. *It Was like a Fever: Storytelling in Protest and Politics*. Chicago, IL: University of Chicago Press, 2009.
Porta, Donatella della. *Can Democracy Be Saved: Participation, Deliberation and Social Movements*. Cambridge: Polity Press, 2013.
Porta, Donatella della, and Sidney Tarrow, eds. *Transnational Protest and Global Activism*. London: Rowman & Littlefield Publishers, 2004.
Pridham, Geoffrey. *The Dynamics of Democratization: A Comparative Approach*. London and New York: Continuum, 2000.
Public Lab. Accessed January 6, 2019. https://publiclab.org.
Puig de la Bellacasa, María. *Matters of Care: Speculative Ethics in More than Human Worlds*. Minneapolis: University of Minnesota Press, 2017.
Pullin, Graham. *Design Meets Disability*. Cambridge, MA: The MIT Press, 2011.
Purcell, Mark. "Excavating Lefebvre: The Right to the City and Its Urban Politics of the Inhabitant." *GeoJournal* 58 (2002): 99–108.
Purcell, Mark. *Recapturing Democracy: Neoliberalization and the Struggle for Alternative Urban Futures*. New York: Routledge, 2008.
Rancière, Jacques. *Disagreement: Politics and Philosophy*. Minneapolis and London: University of Minnesota Press, 1999.
Rancière, Jacques. *The Emancipated Spectator*. London and New York: Verso, 2009.

Rancière, Jacques. *Dissensus: On Politics and Aesthetics*. Edited by Steven Corcoran. London and New York: Continuum International Publishing Group, 2010.

Rancière, Jacques. "The Thinking of Dissensus: Politics and Aesthetics." In *Reading Rancière*, edited by Paul Bowman, and Richard Stamp, 1–17. London and New York: Continuum International Publishing Group, 2011a.

Rancière, Jacques. "Democracies against Democracy." In *Democracy in What State?* edited by Giorgio Agamben, Daniel Bensaïd, and Giorgio Agamben 76–81. New York: Columbia University Press, 2011b.

Rancière, Jacques. *The Politics of Aesthetics: The Distribution of the Sensible*. London and New York: Continuum, 2013.

Redfield, Peter. "Fluid Technologies: The Bush Pump, the LifeStraw and Microworlds of Humanitarian Design." *Social Studies of Science* 46, no. 2 (April 2016): 159–183.

Rediker, Markus. *The Slave Ship: A Human History*. London: Penguin Books, 2007.

Reed, Darren, and Andrew Monk. "Inclusive Design: Beyond Capabilities towards Context of Use." *Universal Access in the Information Society* 10, no. 3 (2011): 295–305.

Rheinhardt, Mark. "The Art of Racial Profiling." In *Kara Walker: Narratives of a Negress*, edited by Ian Berry, Vivian Patterson, and Mark Reinhardt, 109–129. Cambridge, MA: The MIT Press, 2003.

Ribot, Jesse C., and Nancy Lee Peluso. "A Theory of Access." *Rural Sociology* 68 (October 2003): 153–181.

Roberts, John Michael. *New Media and Public Activism: Neoliberalism, the State and Radical Protest in the Public Sphere*. Bristol: Policy Press, 2014.

Rogoff, Irit. "Looking Away: Participations in Visual Culture." In *After Criticism—New Responses to Art and Performance*, edited by Gavin Butt, 117–134. London: Blackwell, 2005.

Romanos, Eduardo. "Collective Learning Processes within Social Movements: Some Insights into the Spanish 15M/Indignados Movement." In *Understanding European Movements: New Social Movements, Global Justice Struggles, Anti-austerity Protests*, edited by Christina Flesher Fominaya, and Laurence Cox, 203–219. London: Routledge, 2013.

Rosa Nera Squat. Accessed August 11, 2019. https://rosanera.squat.gr/.

Rosière, Stéphane, and Reece Jones. "Technopolitics: Re-considering Globalisation through the Role of Walls and Fences." *Geopolitics* 17, no. 1 (2012): 217–234.

Routledge, Paul. *Space Invaders: Radical Geographies of Protest*. London: Pluto Press, 2017.

Rovisco, Maria, and Jonathan Corpus Ongs eds. *Taking the Square: Mediated Dissent and Occupation of Public Spaces*. London: Rowman & Littlefield Publishers, 2016.

Rubin, Jon. "Jon Rubin." Accessed September 22, 2018. www.jonrubin.net/.

Russel, Peter A. "BC'S 1944 'Zombie' Protests Against Overseas Conscription." *BC Studies, The British Columbian Quarterly* 122 (Summer 1999): 49–67.

Sahlins, Marshal. "Colors and Cultures." *Semiotica* 16, no. 1 (1976): 1–22.

Samson, Kristine. "The Becoming of Urban Space: From Design Object to Design Process." In *Design Research: Synergies from Interdisciplinary Perspectives*, edited by Jesper Simonsen, Jørgen. O. Bærenholdt, Monica Büscher, and Jan Damm Scheuer, 172–186. London and Oxford: Routledge, 2010.

Sanhermelando, Juan. "Estrasburgo pide a España que reforme la Ley Mordaza porque no protege la libertad de expresión." *El Español*. November 23, 2018. www.elespanol.com/espana/politica/20181123/estrasburgo-espana-ley-mordaza-no-libertad-expresion/355464773_0.html.

Sanjines, Javier. "Visceral Cholos: Desublimation and the Critique of Mestizaje in the Bolivian Andes." In *Impossible Presence: Surface and Screen in the Photographic Era*, edited by Terry Smith, 223–236. Chicago, IL: University of Chicago Press, 2001.

Sassen, Saskia. *The Global City: New York, London, Tokyo*. Princeton, NJ: Princeton University Press, 1991.

Sataline, Suzanne. "'Umbrella Nine' Hong Kong Pro-Democracy Leaders Sentenced to Jail." *The Guardian.* April 24, 2019. www.theguardian.com/world/2019/apr/24/umbrella-nine-hong-kong-pro-democracy-leaders-sentenced-to-jail.

Schedel, Margaret, and Andrew V. Uroskie, eds. "Special Issue: Sonic Arts and Audio Cultures." *Journal of Visual Culture* 10, no. 2 (August 2011).

Schrijver, Lara. "Utopia and/or Spectacle? Rethinking Urban Interventions through the Legacy of Modernism and the Situationist City." *Architectural Theory Review* 16, no. 3 (2011): 245–258.

Schultz, Tristan, Danah Abdulla, Ahmed Ansari, Ece Canlı, Mahmoud Keshavarz, Matthew Kiem, Luiza Prado de O. Martins, and Pedro J. S. Vieira de Oliveira. "What Is at Stake with Decolonizing Design? A Roundtable." *Design and Culture* 10, no. 1 (2018): 81–101.

Sennett, Richard. *The Fall of Public Man.* Cambridge: Cambridge University Press, 1977.

Serafini, Paula. "Subversion through Performance: Performance Activism in London." In *The Political Aesthetics of Global Protest. The Arab Spring and Beyond*, edited by Pnina Werbner, Martin Webb, and Kathryn Spellman-Poots, 320–340. Edinburgh: Edinburgh University Press, 2014.

Siegert, Bernhard. *Cultural Techniques: Grids, Filters, Doors, and Other Articulations of the Real.* New York: Fordham University Press, 2015.

Silva, Gerardo, and Szaniecki Barbara. "Rio: dois projetos para uma cidade do conhecimento." *Outras palavras.* September 28, 2010. https://outraspalavras.net/posts/rio-dois-projetos-para-uma-metropole-conhecimento/.

Simon, Herbert. *The Science of the Artificial.* Cambridge, MA: The MIT Press, 1969.

Sitrin, Marina. "Rethinking Social Movements with Societies in Movement." In *Social Sciences for an Other Politics, Women Theorizing without Parachutes*, edited by Ana Cecilia Dinerstein, 135–149. Basingstoke: Palgrave Macmillan, 2016.

Skocpol, Theda. *States and Social Revolutions: A Comparative Analysis of France, Russia and China.* Cambridge and New York: Cambridge University Press, 1979.

Smith, Terry. "Enervation, Viscerality: The Fate of the Image in Modernity." In *Impossible Presence: Surface and Screen in the Photographic Era*, edited by Terry Smith, 1–28. Chicago, IL: University of Chicago Press, 2001.

Snow, David A., E. Burke Rochford, Jr, Steven K. Worden, and Robert D. Benford. "Frame Alignment Processes, Micromobilization, and Movement Participation." *American Sociological Review* 51, no. 4 (1986): 464–481.

Solce, Brane. "How to Make PAPER ZOMBIE MASK." *YouTube.* Accessed March 09, 2013. www.youtube.com/watch?v=WkpmnuvyCqo.

Springer, Anna-Sophie, and Etienne Turpin, eds. *Reverse Hallucinations in the Archipelago.* Intercalations 3. Berlin: K Verlag & Haus der Kulturen der Welt, 2017.

Squire, Vicky, et al. "Crossing the Mediterranean Sea by Boat: Mapping and Documenting Migratory Journeys and Experiences." University of Warwick: Coventry, UK. 2017. https://warwick.ac.uk/fac/soc/pais/research/researchcentres/irs/crossingthemed/ctm_final_report_4may2017.pdf.

Starr, Amory, and Jason Adams. "Anti-globalization: The Global Fight for Local Autonomy." *New Political Science* 25, no. 1 (2003): 19–42.

Stavrakakis, Yannis. "Post-Hegemonic Challenges: Discourse, Representation and the Revenge(s) of the Real." *Network of Analysis of Political Discourse, Working Papers* no. 2, 2013. www.democritics.net/discourse-analysis/wp-content/uploads/2013/06/stavrakakis.pdf.

Steinberg, Philip E. *The Social Construction of the Ocean.* Cambridge: Cambridge University Press, 2001.

Steki Metanaston – Koinoniko Kentro. "Deka hronia istorias." Accessed August 11, 2019. https://tsamadou13-15.espivblogs.net/about/.

Stengers, Isabelle. "Introductory Notes on an Ecology of Practices." *Cultural Studies Review* 11, no. 1 (2005): 183–196.

Stengers, Isabelle. *Cosmopolitics*. Minneapolis: University of Minnesota Press, 2010.

Stern, Daniel N. *The Present Moment in Psychotherapy and Everyday Life*. New York: W.W. Norton, 2004.

Stevens, Quentin, and Kim Dovey. "Pop-ups and Public Interests: Agile Public Space in the Neoliberal City." In *The Palgrave Handbook of Bottom-up Urbanism*, edited by Mahyar Arefi, and Conrad Kickert, 323–337. Cham, Switzerland: Palgrave Macmillan, 2019.

Steyerl, Hito. "Documentarism as Politics of Truth." *Transversal – eipcp multilingual webjournal*. May 2003. Accessed March 15, 2016. http://eipcp.net/transversal/1003/steyerl2/en.

Stickells, Lee. "The Right to the City: Rethinking Architecture's Social Significance." *Architectural Theory Review* 16, no. 3 (2011): 213–227.

Strathern, Marilyn. "Cutting the Network." *The Journal of the Royal Anthropological Institute* 2, no. 3 (1996): 517–535. doi:10.2307/3034901.

Sturken, Marita. "Absent Images of Memory: Remembering and Reenacting the Japanese Internment." *Positions* 5, no. 3 (1997): 687–707.

Suchman, Lucy. *Human-Machine Reconfigurations: Plans and Situated Actions*. Cambridge: Cambridge University Press, 2007.

Suri, Jane Fulton, and IDEO. *Thoughtless Acts? Observations on Intuitive Design*. San Francisco, CA: Chronicle Books, 2005.

Swennerfelt, Ruah. *Rising to the Challenge: The Transition Movement and People of Faith*. Caye Caulker, Belize: Producciones de la Hamaca, 2016.

Swyngedouw, Erik. "Post-Democratic Cities: For Whom and for What?" Paper Presented in Concluding Session Regional Studies Association Annual Conference, Pecs, Budapest, May 26, 2010. www.variant.org.uk/events/pubdiscus/Swyngedouw.pdf.

Swyngedouw, Erik. *Designing the Post-Political City and the Insurgent Polis*. London: Bedford Press, 2011.

Szaniecki, Barbara. *Disforme contemporâneo e design encarnado: outros monstros possíveis*. São Paulo: Annablume, 2014.

Tabachnick, Toby. "University Honors College Co-Sponsors One-Sided Talk on Middle East." *Pittsburgh Jewish Chronicle*. Accessed February 7, 2019. http://jewishchronicle.timesofisrael.com/university-honors-college-co-sponsors-one-sided-talk-on-middle-east/.

Tagg, John. "The Discontinuous City." In *Visual Culture: Images and Interpretations*, edited by Norman Bryson, Michael Ann Holly, and Keith Moxey, 83–104. Hanover, NH and London: Wesleyan University Press, 1994.

Tampio, Nicholas. "Assemblages and the Multitude. Deleuze, Hardt, Negri, and the Postmodern Left." *European Journal of Political Theory* 8, no. 3 (2009): 383–400.

Tanenbaum, Joshua G., Amanda M. Williams, Audrey Desjardins, and Karen Tanenbaum. "Democratizing Technology: Pleasure, Utility and Expressiveness in DIY and Maker Practice." Paper Presented at Proceedings of the SIGCHI Conference on Human Factors in Computing Systems, 2013.

Taylor, Sunaura. *Beasts of Burden*. New York: New Press, 2017.

Tazzioli, Martina. "Which Europe? Migrants' Uneven Geographies and Counter-mapping at the Limits of Representation." *Movements. Journal for Critical Migration and Border Regime Studies* 1, no. 2 (2015).

Teatro Valle Occupato. Accessed August 11, 2019. www.teatrovalleoccupato.it/.

Teivainen, Teivo. "The Political and Its Absence in the World Social Forum." In *Handbook on World Social Forum Activism*, edited by Jackie Smith, Scott Byrd, Ellen Reese, and Elizabeth Smythe, 50–63. London: Routledge, 2012.

"The Performance of July 5th: That's How Our Day Went." *1000 Gestalten*. Accessed January 22, 2018. https://1000gestalten.de/en/the-performance/.

Thoreau, Henry David. "Walking." In *The Making of the American Essay*, edited by John D'Agata, 167–195. Minneapolis, MN: Graywolf Press, 2016.
Thorpe, Ann. "Applying Protest Event Analysis to Architecture and Design." *Social Movement Studies* 13, no. 2 (2014): 275–295.
Tilly, Charles. "Contentious Repertoires in Great Britain, 1758–1834." In *Repertoires and Cycles of Collective Action*, edited by Mark Traugott, 15–42. London and Durham, NC: Duke University Press, 1995.
Tilly, Charles. *From Mobilization to Revolution*. New York and London: McGraw-Hill, 1998.
Tilly, Charles. "Spaces of Contention." *Mobilization: An International Quarterly* 5, no. 2 (September 2000): 135–159.
Timpanaro, Sebastiano. *Freudian Slip: Psychoanalysis and Textual Criticism*. London: Verso, 2011.
Tomanič Trivundža, Ilija. "And the Word Was Made Flesh, and Dwelt among Us: On Zombies, Political Protests and the Transmodality of political Metaphors/*Beseda je meso postala in se naselila med nami: O zombijih, političnih protestih in transmodalnosti političnih metaphor*." *Družboslovne razprave* 31, no. 80 (2015): 29–46.
Tomlinson, Simon. "The World's First HOLOGRAM Protest: Thousands Join Virtual March against Law Banning Demonstrations outside Government Buildings in Spain." *Daily Mail*. April 14, 2015. www.dailymail.co.uk/news/article-3038317/The-world-s-HOLOGRAM-protest-Thousands-join-virtual-march-Spain-against-law-banning-demonstrations-outside-government-buildings.html.
Tonkinwise, Cameron. "Design for Transitions—From and to What?" *Critical Design/Critical Futures Articles Paper*, no. 5 (2015). http://digitalcommons.risd.edu/critical_futures_symposium_articles/5.
Traganou, Jilly. *Designing the Olympics: Representation, Participation, Contestation*. New York: Routledge, 2016.
Tzanavara, Hara. "I ponemeni istoria tou Emrpos." *Efimerida ton Sintakton*. March 6, 2016. Accessed December 24, 2019. www.efsyn.gr/nisides/mnimeia-tis-polis/61226_i-ponemeni-istoria-toy-empros.
Tzirtzilaki, Eleni. "About the Free Self-Managed Embros Theater." *Nomadic Architecture Network*. Accessed August 11, 2019. https://nomadikiarxitektoniki.net/en/texts-en/about-the-free-self-managed-embros-theatre/.
Unger, Roberto Mangabeira. *Social Theory: Its Situation and Its Task*. New York: Verso, 2004.
United for a Fair Economy. "United for a Fair Economy Introduction." Accessed December, 2019. www.faireconomy.org/.
Vallet Córdoba, Carlos. "Hologramas contra la 'ley mordaza'." *El País*. April 11, 2015. http://ccaa.elpais.com/ccaa/2015/04/10/madrid/1428698276_149818.html.
van der Ryn, Sim, and Stuart Cowan. *Ecological Design*. Washington, DC: Island Press, 2007.
Vaughan-Williams, Nick. "Borderwork beyond Inside/Outside? Frontex, the Citizen–Detective and the War on Terror." *Space and Polity* 12, no. 1 (2008): 63–79.
Verbeek, Peter-Paul. *What Things Do: Philosophical Reflections on Technology, Agency, and Design*. Philadelphia: Pennsylvania State University Press, 2005.
Verbeek, Peter-Paul. "Materializing Morality: Design Ethics and Technological Mediation." *Science, Technology, & Human Values* 31, no. 3 (2006): 361–380.
Verbeek, Peter-Paul. *Moralizing Technology: Understanding and Designing the Morality of Things*. Chicago, IL: University of Chicago Press, 2011.
Vergara, Camilo Jose. *How the Other Half Worships*. New Brunswick, NJ: Rutgers University Press, 2005.
"VIKUS Viewer: Explore Cultural Collections along Time, Texture, and Themes." *VIKUS Viewer*. Accessed February 5, 2019. https://vikusviewer.fh-potsdam.de/.

Wang, Chih-ming. "'The Future that Belongs to Us': Affective Politics, Neoliberalism and the Sunflower Movement." *International Journal of Cultural Studies* 20, no. 2 (2017): 177–192.

Wang, Fei-Ling. *The China Order: Centralia, World Empire, and the Nature of Chinese Power*. Albany: State University of New York Press, 2017.

Weibel, Pete, ed. *Global Activism: Art and Conflict in the 21st Century*. Cambridge, MA: The MIT Press, 2015.

Wendling, Amy E. *Karl Marx on Technology and Alienation*. Basingstoke: Palgrave MacMillan, 2009.

Werbner, Pnina, Martin Webb, and Kathryn Spellman-Poots, eds. *The Political Aesthetics of Global Protest: The Arab Spring and Beyond*. Edinburgh: Edinburgh University Press, 2014.

"Who are We?" *Nosomosdelito*. Accessed August, 2016. http://nosomosdelito.net/page/2014/09/11/who-are-we.

Willis, Anne-Marie. "Ontological Designing." *Design Philosophy Papers* 4, no. 2 (2006): 69–92.

Winner, Langdon. "Do Artifacts Have Politics?" *Daedalus* 109, no. 1 (Winter 1980): 121–136.

Winograd, Terry and Fernando Flores. *Understanding Computers and Cognition*. Norwood, NJ: Ablex, 1986.

Wodiczko, Krzystof. *Critical Vehicles: Writings, Projects, Interviews*. Cambridge, MA: The MIT Press, 1999.

Worldometers. "Macao Population (2019)—Worldometers." *Worldometers.Info*. Accessed April 29, 2019. www.worldometers.info/world-population/china-macao-sar-population/.

Wright, Alexa. *Monstrosity: The Human Monster in Visual Culture*. London and New York: IB Tauris, 2013.

Yaneva, Albena. "Making the Social Hold: Towards an Actor-Network Theory of Design." *Design and Culture* 1, no. 3 (2009): 273–288.

Yaneva, Albena, and Alejandro Zaera-Polo. *What Is Cosmopolitical Design? Design, Nature and the Built Environment*. Farnham: Ashgate Publishing, 2015.

Yasko, Brett. "Brett Yasko." Accessed September 22, 2018. https://brettyasko.com/.

Young, Diana. "The Smell of Greenness: Cultural Synaesthesia in the Western Desert." *Etnofoor* XV111, no. 1 (2005): 61–77.

Young, Iris Marion. *Inclusion and Democracy*. Oxford: Oxford University Press, 2000.

Young, Stella. "I'm Not Your Inspiration, Thank You Very Much." Filmed April 2014 in Sydney, Australia. TEDxSydney video, 9:13 min www.ted.com/talks/stella_young_i_m_not_your_inspiration_thank_you_very_much/.

Zeki, Semir. "Art and the Brain." *Daedalus* 127, no. 2 (March 1998): 71–104.

Zhang, Hong, and Brian Hok-Shing Chan. "Translanguaging in Multimodal Macao Posters: Flexible versus Separate Multilingualism." *International Journal of Bilingualism* 21, no. 1 (2017): 34–56.

Zhang, Yahong, and Cecilia Lavena. *Government Anti-Corruption Strategies: A Cross-Cultural Perspective*. Boca Raton, FL: CRC Press, 2015.

Index

15-M/Indignados 7, 55, 147, 149, 204
1000 GESTALTEN 54

Aaron Yung-Chen Nieh 46, 47
abjection 53, 59–60
access-ability 66, 68–70
accountability tools 161–170
Action of Citizenship against Hunger and Misery and for Life (*Ação da Cidadania contra a Fome, a Miséiia e pela Vida*) 99
ActionAid 117
activation of Embros theater 242–254
"Activist Cookbook" 111
activist-artists 110
actor-network theory (ANT) 124–125
advenience 28
adversarial design 4
advertising 46, 47, 48, 49, 150
advocacy 16, 65
aesthetics: aesthetic disruption 4; disability activism 66; dissensus 175, 178, 179, 180; as distribution of the sensible 66; Embros Theater 251, 253; Madrid Hologram Protest 147, 148, 152, 154; participatory aesthetics 61; and politics 29; urban activism 173; Women's March 81
affect and emotion: Embros Theater 249; ESDI Aberta 220; Green Stripe 33–34; and identification 13, 16, 189–190; imagery 28–29, 32–33; and objects 124–125; political identification 189–190; and politics 34–35; social science/political philosophy discourse 5–6
affective 3, 8, 16, 27–29, 32–35, 123, 189, 194, 220
affinity groups 13–14
affirmative design efforts 205, 212
affordance 6, 16, 193
Afoxé Filhos de Gandhi 97
afrofuturism 104–106
afterlife of artefacts 2, 8, 15, 90, 79–130
Agamben, Giorgio 7

Aganaktismeni 55
agitprop performance 153
agonism 4, 187, 188–190, 195–198, 199
Ahmadinejad, Mahmoud 27
Ahmed, Sarah 16
Aiman Ribao 愛瞞日報 (Macau Concealers) 42–43
Akrich, Madeleine 190
aletheia (manifestation) 155
algorithms 77, 93, 168
Alla Ska Fram 71
Alliance of Indigenous Peoples of the Archipelago 164
All-Slovenian People's Uprisings 52–64, 126
Almedalen Week 72–73
alternation 7
Althusser, L. 155
American Youth International Party (Yippies) 152
Amin, Ash 203
Amnesty International 157
An Xiao Mina 44
Anastassakis, Philippe 105–106
Anastassakis, Zoy 3, interview with 217–225
Anderson, Chris 164–165
animation 105
anonymity 57
Anonymous 56, 126
"Another World is Possible" 106
Ansari, Ahmed 214
anthropology, design 105
anti-austerity protest 4, 13, 54–55, 174, 180, 181
anti-authoritarianism 251
anti-capitalist protest 153, 231; see also Occupy movements
anti-corruption protest 54–55
Antifacist 247
anti-gag law protests 147–160
anti-growth movements 4
anti-hunting protests 56

anti-neoliberalism 4, 12–13, 54, 153, 171–181, 235
anti-Olympics activism 1, 5, 95
Anzaldua, Gloria 248
Appadurai, Arjun 204
Arab Spring 2, 147, 204
architecture 2–4, 173, 188, 208, 211–212, 242, 246, 249–251, 252–253
archives 81–94, 128
Arco de la Victoria 153
arena 11–12, 124–125, 127–128
Arruda, Marcella 211
art historian 52
Art of the March 81–94, 128, Plate 5, Plate 6
artificial intelligence 90
artistic activism 110
assemblage 15, 32. 89, 153, 199, 212–213
assembly 7, 147, 157, 173, 239, 244, 245, *246*, 247, 249, 251, 252
asylum seekers 135–146
Athens 8, 241–256, Plate 15, Plate 16
audio materials 151–152
austerity activism 4, 13, 54–55, 174, 180, 181
authorship 15
autonomous design 102–103
autonomy 5, 54, 227, 229, 231, 232–234, 252
awareness-raising 76, 210

Bahng, Aimee 192, 194
Balibar, Etienne 136
Balkans 54, 139, 147
banner 9, 52, 124, 152, 154, *218*, 228
Barcelona 97, 101
"bare life" 7
Bargu, Banu 195
Barthes, Roland 28
Basurama Brasil 206–207, 210
Batiste, João 207–208, 209
"Battle of Seattle" 3
Bauman, Zygmunt 172
Beautiful Rising (Abujbara et al., eds.) 112, 117
Beautiful Trouble 110–120
beer 70, 72–73, 75–76
begging 171
Bennett, Jane 213
Berk, Ksenija 126
Berube, Michael 69
Big Data 84, 90, 93, 162
binaries 106–107, 127
bio-politics 108n17
Bishop, Claire 60, 152, 156
black clothing 57
Black Lives Matter 229, 236
black movements 107

Black Panthers 128
"Blanket Game" *115*, Plate 8
Bloch, Nadine, interview with 110–124
boats, migrant 135–146, 263
bodies, role of 123–129, 143, 147, 155
body paintings 55
Boehnert, Joanna 226
Boggs, Carl 10
Boke, Charis 235
Bolha Imobiliária (The Real Estate Bubble) *207*, Plate 11
Bollas, Christopher 32–33
Borasi, Giovanna 172, 173, 174, 176
border crossings 263
border transgression 135–146
borderlands/liminal areas 260–262
Borneo 161–162
Boston Women's March 81–94, 128
Botticci, Chiara 8
Bourdieu, Pierre 15
"box ESDI Aberta" 220, 221, 222
box (money collection) at Embros Theater 245, 252
Boyd, Andrew 111–112
Brazil: ESDI Aberta 8, 12, 217–225, 262–263, Plate 12, Plate 13; Rio de Janeiro 8, 12, 95–109, 125, 126, 217–225, 262–263, Plate 7; São Paulo 202–216, 262, Plate 11
Brecht, Bertolt 152
Breidbach, Olaf 155
Breines, Wini 10, 16
Brenner, Neil 5
Brown, Wendy 138
Budapest *111*, cover image
buen vivir 102
buildings: architecture 212, 249–250; as background to protest 154; climbing 57; occupying 217–225, 241–256; projections onto 152–153
Bureau Detours 12, 176, *177*, *178*, 180, 264
Butler, Judith 249

Caffentzis, George 15
Campbell, Fiona 67
Canguilhem, Georges 59
capitalism: and architects 251; and innovation 163; and the commons 241; and Conflict Kitchen 187, 188; and dehumanization 156; design as means of production 259; deterritorialization 229; and feminism 8; global justice movement (GJM) 6–7; and place making 102; "right to the city" movements 5; Transition movement 231, 234; urban activism 172, 174, 202; and urbanization 172; and zombies 54; see also neoliberalism

Cardoso Llach, Daniel 142
carnival 96–97
Carroll, William 76
censorship 44
Chambers, Samuel 176
change theories 114
Change Collective (*Muda Coletivo*) 206–207, 210, 212, Plate 11
character construction work 127–128
Chile 54
China 38–51
China Order 38
Chock, Sasha-Constanza 93
Chow, Alex 41
Chthulucene 105
circular thinking 105
citizen science 161
citizenship: new forms of 4; post-citizenship movements 6, 13; sites of insurgent citizenship 12; urban activism 203–204, 212, 213, 214
civil disobedience 6, 9, 39, 45–48, 147, 152, 156, 217
civil society 11, 12, 15, 42, 48, 54–55, 59, 81, 118
claim strategies 210
Clarke, Jackie 175
climate change 226–240
climate justice 229
co-design practices 102, 103, 106, 126, 190
Colaboratório (ESDI, Rio) 222–224, *223*
collaborative design 102–103, 107
collaborative knowledge 162
collective consumption 12
collective identification 32, 33, 67, 187
collective memory 101
collective political struggle 11
collective practices 3–4, 6–7
collective production 89–90
collective space 156
collective street cooking events 176, 178
colonialism 38, 42, 43, 140
color identification 27–37
commensality 187, 190–195, 199
common table 195, *196*, 197
commoning 7–8, 15, 204, 241–256
commons 210, 241–256, 262
communal land ownership 100
communities of praxis 115–117
community redesign 102–103
community resilience 227, 235–236
community-led design processes 227, 229, 230–231, 236–237
Condaque, Júlio César 103–104, 105
configurations 190, 198
Conflict Kitchen 11, 187–201, 261; Conflict Kitchen Iran *178*, 192, Plate 10; Conflict Kitchen Afghanistan 191, *193*; Conflict Kitchen Venezuela 192, *196*; Conflict Kitchen Palestine 195–198, *198*
Confucianism 38
"Conservation Drones" 164
Conway, Janet 228–229
Cooper Glicério (*Cooperative Glicério*) 207–208, *209*, *210*, 213, 214
Cop15 173
Copenhagen 171, 173, 176–180, 264
corporations 11, 54, 59, 102, 113–114, 162–163, 166, 264
corruption 54–55
cosmopolitanism 102
Council of Europe 157
counterfeit goods 143
counterhegemony 13, 14, 16
counterpoint 260
CP doll 70, *71*, 72, 76, Plate 4
CP truck 73, *74*, 76–77
Crawford, Margaret 173, 174, 176, 180
creative dissent strategies 38–51
creative resistance 110–120
crisis of representation 54
Critical Art Ensemble 153
critical design discourse 136
critical disability studies 66
critical makings 136, 143
critical urbanism 5, 12, 203, 213
Cross, Nigel 2
Crossley, Nick 15
crowdfunding 48
crowdsourcing 150, 168
culture: cultural resistance 96, 98, 124; cultural revolution 173; cultural workers 110; culture cities 174; fluid notions of 194–195; social science/political philosophy discourse 6

Dadaists 152
data analytics 161–170, 263
data compression 168
data sovereignty 162–163, 169, 263
data visualization 85–87, 89, 91, 92–94, 161–170, 263
Dawkins, Nicole 146n44
Day, Richard 13
DDB advertising agency 150, 156
DDED HK 39, *40*, Plate 3, 41
De Angelis, Massimo 241
De Certeau, Michel 34
De Genova, Nicholas 139
Debord, Guy 156
decolonization 5, 205, 214
de-escalation 114
defective consumers 172
de-identification 189, 192, 195

de-individualization 189
de-industrialization 103
Deleuze, Gilles 29, 106, 212
Della Porta, Donatella 6
democracy: agonistic pluralism 189; "democratizing design" 142, 143, 263; disability activism 75; and dissensus 13; ESDI Aberta 217; Madrid Hologram Protest 147–160; prefigurative politics 10; protest as a fundamental part of 61; and public spaces 188; in south-eastern Europe 60; Transition Towns 229; Umbrella Movement, Hong Kong 41; Valongo Wharf, Rio 99, 103; zombie protests in Slovenia 56, *58*, 59
"Democracy at 4 a.m." 46, *47*, 48
Denmark 171, 176–180, 264, Plate 9
DENNIS design project 12, 14, 176–180, 181, Plate 9
Dery, Mark 105
design, definition of 2–3
design for all 65–66
Design Justice 93
design scholarship 4, 259
Detroit 146n44
Deutche, Rosalyn 155
Di Salvo, Carl 188, 189
Dias, Marcelo 107
Dickinson, Emily 46
differential space 15
differentiation processes 260–261
digital technologies 147–160; see also Internet; social media; websites
disability activism 65–78, 128
disability rights 65, 68–70, 73, 75
DiSalvo, Carl 4
discourse analysis methods 53
"disobedient objects" 2, 52–64, 126
Disobedient Objects (V&A, 2014) 5
disorientation 34
dissensus 13, 172, 174–176, 178–179, 180, 260–264
distributed leadership 156
distribution of abilities 66–68
DIY 142, 179, 207–208; accountability tools 161–170; furniture 178–179; paper masks 56; tutorials 56
"DIY Drones" 164–165, *166–168*
DIY urbanism 5, 172, 202–216; see also tactical urbanism, urban activism
Doc Now 88
documentation of events 153–155; see also archives
dolls 70, *71*, 72, Plate 4
Dominguez, Ricardo 153
dramaturgy 153
Drone Academy, Indonesia 161–170, 263

Dunne, Anthony 192
dystopia 105

Eames, Charles 152
Earle, Lucy 204
ecological design 226, 228
ecologies of practices 203, 214
economic justice 114
ecosystems 228, 235
education in activism 110–120
egao (恶搞) (slang term for parody) 43–45
EITI, Extractive Industries Transparency Initiative 167
electronic civil disobedience 152, 153
Electronic Disturbance Theatre (EDT) 153
Electronic System for Travel Authorization (ESTA) agreement 54
embodied processes 123–129, 143, 147, 155
Embros Theater, Athens 8, 10–11, 13–14, 241–256, 261–262, Plate 15, Plate 16
emotion 6, 9, 16, 61, 89, 124–128, 249; also see affect
energy descent 227
engineering 87
environmental justice 89, 161
environmentalism 227
ephemerality 152, 208, 247, 249, 250, 252
Escaño, Carlos 157
escape 141
Escobar, Arturo 5, 93, 102, 213, 230, 232, 237
Escola sem Muros (School Without Walls) 212
ESDI Aberta 8, 12, 217–225, 262–263, Plate 12, Plate 13
ethnographic research 53, 156
ethnographies of the possible 105
Eubanks, Virginia 93
European borders 136–138
European Commission 54
European Union (EU) 137, 140, 142, 171
evocative objects 194, 199

Facebook 70, 72, 219
faces, hidden 56–57
failure, learning from 113
fake products 143
Fawkes, Guy 56, 126
Federici, Silvia 15, 241
feeling voyages 28–29
feeling-thinking processes 123–129
Feigenbaum, Anna 7, 16
feminism 8, 84, 206, 245
fiction, design 105, 127
film/movies 53, 152
first world activism 174, 181
fishbowl method 7

flags 30
flash mobs 54
Flesher Fominaya, Cristina 7, 149, 150
Flickr 155
floating elements, reconfiguration of 14
FloodNet 153
Flores, Fernando 230
folk kitchen 179, *178*, Plate 9
font design 125
food, shared 176, 178, 187–201, 208, 219, 231, 243, 244, 261
food sovereignty 166
food wrappers 193–195, 197, 199, Plate 10
forgeries 5, 135, 136, 143
Foucault, Michel 60, 108n17
foxy-boxy masks 56
Free Self-Managed Theater Embros 8, 10, 11, 13, 14, 241–256, 261–262, Plate 15, Plate 16
freedom to 8
Freud, Sigmund 32–33
Frontex 137, 139
Fry, Tony 236
funding 116, 124, 165, 168, 221, 222, 245, 251–252
Futurists 152

G20 48, 49, 54, 173
Gambia 137–138, 140
Gan, Wendy 41
garden 211, 222, 226, 231, 223, 232, Plate 13, Plate 14
gardening 14
Garrett, Dan 41
gender inequality 169
gentrification 4, 101, 172, 202, 206–208, 214, 245–246, 254
Gerbaudo, Paolo 156
Germany 54, 173, 207
"Ghost Protest," Gwanghwamun Square, Seoul 157
Giangrande, Naresh 227, 228, 234–235
global cities 103
Global Justice Movement 6–7, 53, 54, 59
Global South 15, 112, 117, 143
Goethe-Institut 206, 211
Gothenburg Cooperative for Independent Living 65, 68–77, Plate 4
Graeber, David 6
Grau, Oliver 152, 154
Greece 55, 135, 143, 147, 241–256, Plate 15, Plate 16
Green Movement / Green Revolution (Iran) 27–37, 28, 30, 31, plates 1–3
Green Space (ESDI, Rio) 223, 224, Plate 13
Green Stripe 27–37

Greenpeace 157
Grigoropoulos, Alexis 242
Grosz, Elizabeth 8
Guattari, Félix 212, 229
guerrilla activism 5, 152, 205
Guran, Milton 98–99, 100, 104
Gwanghwamun Square, Seoul 157

Habermas, Jürgen 15
habits of exclusion 67
habitus 15
hacking 142, 143, 221, 224
Haddad, Fernando 211
Halse, Joachim 105
Hamburg G20 protests 54, 173
Hamraie, Aimi 66
Haraway, Donna 102, 105, 261
Harvey, David 4, 5, 172, 173, 174, 176, 202
hash tags 156
Hattam, Victoria 127
Haudenosaunee Confederacy 192
heterotopia 192
hexie shehui 和諧社會 (Harmonious Society) 43
hierarchies 7, 175, 195, 199
historical reparation 103–104
Hoffman, Abbie 152
Holmgren, David 228
Hologram Protest, Madrid 147–160, 263
Holston, James 12, 204
Hong Kong 2, 38–41, 45–48
Hopkins, Rob 226–227, 228, 229–230, 233
horizontalism 7, 14, 193, 195, 224
Hughes, James J. 53
human rights 157
humanitarianism 136, 138–139, 200n28
humor 38–51, 77, 126, 180
Hungary *111*, cover image
hunting 56

identity 45, 135, 136–137, 156, 175, 189
IEEE Visualization Conference (VIS) 93
illegal migration 135–146, 263
Illuminator art collective 153
illusion 155
image games 106
image journeys 32–33, 34
imaginal into action 8
immateriality 155
impure politics 176, 179–181, 213, 264
independent living movement 68–70
indigenous land rights 162, 164, 166
Indignados/15-M 7, 55, 147, 149, 204
Indonesia 161–170
Indymedia 163
Ingold, Tim 15, 260, 261
Ing-wen, Tsai 39

inscriptions and scripts 190, 191, 199
insu^tv 92
interdisciplinary lens 2–3, 16, 83, 128, 260
Interference Archive 88
Internationale, The 52
Internet: access 168; censorship 44; memes 44, 156; online archives 81–94; online campaigns 77; see also social media; websites
intersubjectivity 28, 29, 33
Iran 27–37
Irani, Lilly 146n44
Irwin, Terry 230
Islamist-extremism-inspired terrorist attacks 173
Italy 92
iterative design processes 86

Jakarta 92
jam sessions 112, 115, 117
Janša, Janez 52, 55
Jasper, James 3, 6, 7
Jensen, Frank 171
Jornadas de Junho (June Journeys) 204–205, 208, 213, 214
Julier, Guy 4, 12

Kainós 105
Kant, Emmanuel 29
Kassab, Gilberto 205
Keshavarz, Mahmoud 5
Khosravi, Shahram 137
Killip, Chris 29
Kinder Morgan Pipeline protests 157
King Jr., Martin Luther 128
Kioupkiolis, Alexandros 14
Kitchen Monument, Germany 207
knowledge: collaborative knowledge 162; different forms of 101; local knowledge 162, 167, 169; plant knowledge 166, 224; and power structures 76
Kossoff, Gideon 230
Kress, Gunther R. 53
Kristeva, Julia 53
Kwon, Miwon 190

Laboratory for the Urban Commons 253
Laclau, Ernesto 157
Lanchonete (Snack Bar) 106
land occupation activism 204
language change 248
language play 42–43, 125–126, 179, 206–207
Laterna Magika 152
Latour, Bruno 15, 124, 190
Lauro, Sarah Juliet 53
Law, Nathan 41
Law, Wing-sang 38, 41

Lazzarato, Maurizio 106
leadership of movements 156, 224, 245, 252–253
Lee, Siu-yau 44
Lefebvre, Henri 15, 99, 100–101, 173, 202–203
left-wing politics 54–55, 111, 211, 247
legislation, anti-protest 55
Li, Hongmei 44
liberalism 13, 176, 188–189; see also neoliberalism
libertarian Marxism 152
libraries 81–82
Link, Perry 44, 45
living environments 66
living museums 99, 103–106, 107
Ljubljana 52, 55–59
local economies 235
local knowledge 162, 167, 169
localism 102
Luckman, Susan 143
Luxembourg, Rosa 60

Macao 38–39, 41–43
Macau Concealers 愛瞞日報 (Aiman Ribao) 42–43
machine learning 90
Madrid Hologram Protest 147–160, 263
Maeckelbergh, Marianne 229
maker culture 136
maker spaces 142, 143
Malpass, Matt 105
Mangabeira Unger, Roberto 229
Manzini, Ezio 102, 230
manifesto 8, 105, 219, *221*
Maribor, Slovenia 55
Markussen, Thomas 4–5
Martins, Marcos 217–225
Marx, Karl 156, 173, 203
Marxist geography 4, 101, 202
masks, zombie 55–57
Massey, Doreen 203
material reuse 207, 208, 211, 213
Mattress Performance 17n1
Mavili Initiative 242, 245
Mayer, Margit 5, 12, 172, 173–174, 176, 180, 181, 202, 213
McAdam, Doug 7, 124
McCart, Melissa 197
McCarthy, John 124
meal (communal, collective) *219*, *244*, 246, Plate 16
Means, Pearl 236
media: disability activism 70; Drone Academy, Indonesia 162, 163; global justice movement (GJM) 6; Green Stripe 27; literacy 93; Madrid Hologram Protest

148, 153, 157; *ngok gaau* (惡攪) (parodic protest strategy) in Macao 42; parodies of 39–41; Umbrella Movement, Hong Kong 39–41; urban activism 173; use of imagery 28; zombie protests in Slovenia 55, 56; see also social media
Mehri, Behrouz 27, 28, 29, 30–32, 33
Mehta, Uday 32
memorialization 104
memory, design of 95, 99, 103–106, 107, 128
Meng, Bingchun 44
meshwork 15
Metropolis Festival 176, 179, 180
Michou, Hélène 157
micro-politics of change 33, 212
micro-utopias 14
migrant smuggling 135–146, 263
Mijatović, Dunja 157
Million Mask March 57
Minhocão 10, 206, 207, 208, 210, 211, 214, 207, Plate 11
Mir Hossein Mousavi 28, 30, Plate 1, Plate 3
Mitchell, Dave 111–112
Mitchell, W.J.T. 154
modalities 15
Mohammad Kheirkhah 30
Mollison, Bill 228
Monstrous 59–60
morality 15, 123, 128
Morphes 241
motion graphics 39, 40, Plate 3
Mouffe, Chantal 4, 13, 188, 189, 195
Movement for Black Lives 88
"Movement of the Squares" 7–8
Muda Coletivo (Change Collective) 206–207, 210, 212, Plate 11
Mumford, Lewis 16
municipalism 7–8, 14
Museum of Slavery, Rio de Janeiro 12, 95–109, 125
Museum of Tomorrow 96, 101, 107, 96

naming of movements 156
Negri, Antonio 212
neoliberalism: and decolonialism 214; design activism 4, 12; and dissensus 176; *Jornadas de Junho* (June Journeys) 205; neoliberalization 171–172, 174, 180; and politics 171; prefigurative politics 229; "right to the city" movements 5; Transition movement 231, 235; urban activism 173–174, 180, 181
net art 153
networks: of activists 15; actor-network theory (ANT) 124–125; Beautiful Trouble 110, 112, 116–119; Conflict Kitchen 195, 199; Drone Academy, Indonesia 163, 167; Madrid Hologram Protest 149, 157
ngok gaau (惡攪) (parodic protest strategy) 39–41
NGOs 111, 163, 165, 167, 170, 206, 208, 210
Nieh, Aaron Yung-chen 46
Noble, Safiya 93
Nogueira, Nilcemar 100
Nomadic Architecture 242, 246, 250, 253, Plate 16
non-human categories 59–60, 199
Nonno, Lucas 217–225
non-professional designers 5, 11, 102, 226
nonviolent resistance 110, 116, 119
NoSomosDelito (WeAreNotACrime) 149, 151, 152, 153, 155–156

Occupied Theater Embros 8, 10, 11, 13, 14, 241–256, 261–262, Plate 15, Plate 16
Occupy movements: contagious spirit of protest 147; emergence of concept of "the 99%" 14; encampments 2; ESDI Aberta 217–225, 262–263, 218, 219, 220, 221, 222, 223, 224, Plate 12, Plate 13; Occupy Gezi 204, 205, 213; Occupy Hongkong 39, 40, Plate 3; Occupy Wall Street 53, 153, 202, 204, 205; and the Transition movement 236; urban activism 204; visual technologies 152; zombies 53–54
OcUPA Esdi 218, 219–221
Offenhuber, Dietmar 82, 85, 86, 89, 90, 91
Oiticica, Hélio 99
Olympics 1, 95, 96, 97, 101
One China Policy 38–51
online archives 81–94
online campaigns 77
ontological design 230
ontologies of designing 16
open source material 86, 110, 112, 162, 163, 164
open teams 251
openDemocracy 157
open-ended design 3, 29, 32, 34, 198, 226
oppositional inquiry 76, 77
oral history 100
Orange Revolution, Ukraine 30
Orwell, George 43
Oswalt, Phillipp 210
other, the 102–103, 106, 143
other worlds 229

palm oil 161, 163, 166
panda cubs 42, 43
panoramas 154
Paolucci, Juliana 217–225

parapolitics 176, 180, 264
parking 73, 74
Parks, Rosa 74
Parodic Protest Strategy *Ngok Gaau* (惡攪) 39–41
parody 38–51, 59, 61, 125–126
participatory art 156, 188, 190, 191, 199
participatory mapping 161, 164, 166, 263
participatory research 53, 89
passports 5, 135, 136, 143
Patsiaouras, Georgios 41
pattern language 110–120
pedestrian areas 206
People's Archive of Police Violence, Cleveland 88
people's mic 7–8
People's Republic of China (PRC) 38–51
perfomativity: border crossings 141; Madrid Hologram Protest 152; São Paulo 206–207; of sovereignty 138; zombie protests in Slovenia 57–58; zombies 54, 56, 58
peripheries/margins of cities 206, 212
permaculture 226, 227–228
philosophy 29, 101, 106, 174–176
photographs 127, 147–148, 153–155
Pietsch, Christopher 82, 86
pillow protests 1
Pin Koh, Lian 164
Piscator, Erwin 152
Pittsburgh 187–201, Plate 10
placards/signs 81–94, 152
place making 102–103
placebo-politicalness 202–203
plant knowledge 166, 224
pluralism 189, 229
pluriverse 205, 230
poetry 46, 91, 222
police: and disability 73; geography of 6; and the Madrid protests 148; police interpretations 60; police order 13, 175–176, 181; Rancière's notion of 175–176; use of force 46; violence 253; zero-tolerance 171
political identification 27–37, 189–190
political philosophy 5–6
political process model 7
politics of demand 12–14
politics of design activism 171–183, 264
politics of the act 13–14
politics of truth 154
Polletta, Francesca 7
Polyecran 152
polyphonic content 194–195
Porto Maravilha, Rio de Janeiro 95, 96–99, 100, 101
post-carbon futures 226, 262
post-citizenship movements 6, 13
Poster House museum 93

posters ; Madrid Hologram Protest 152; São Paulo 205; zombie protests in Slovenia 55, 57–58
post-industrial movements 6
post-materialism 4, 6
post-political issues 231
power structures: critical disability studies 66; decolonization of 214; dissensus 174–175; ecologies of practice 203; ESDI Aberta 224; hierarchies 7, 175, 195, 199; horizontal 195; and knowledge 76; power to design 126; production of space 101; and protest 60; spatial geometries of 203, 205, 206, 211, 213, 262; Transition movement 235; urban activism 202, 205
praxeology 15
prefigurative politics 10, 228–229, 231, 235
Preliminares 205–211
production modalities and techniques 15
production of space 5, 100–102, 213
professionalization 12
projection art 152–153
propaganda 147
props, objects as 126–127
protest camps 7–8; see also ESDI Aberta; Occupy movements
Protestivals 56, 58
prototypes 105
provisional encounters 32
psychoanalysis 32–33
public art 190, 199
public characters 127
public interest design 12
Public Lab 166
Public Society, The 114
public space 7, 9, 14, 16, n70, 61, 66, 154, 157, 231, 241; Conflict Kitchen 187–189, 192, 195, 261; definition of 11–12; Hong Kong protests 48; Madrid Hologram Protest 147–160; São Paulo 202, 202–206, 208, 210-12Hologram Protest 147–160; São Paulo 205–206
public sphere 15
puppets 55, 57
Purcell, Mark 171, 172, 174, 180
PWYP, Publish What You Pay 167

Qiang, Xiao 44, 45
QR codes 114
queer theory 245
Queirós, Adirley 105
Quilombo das Guerreiras or Zumbi dos Palmares (Quilombo Warriors or Zumbi of Palmares) 103

Raby, Fiona 192
race 104, 143, 146n44, 226, 235–236

radical inquiry 76, 77
Radjawali, Irendra, interview with 161–170, 263
Radok, Alfréd 152
Rajoy, Mariano 157
Rancière, Jacques 4, 13, 66, 172, 174–176, 179, 180, 213
Rebouças, André 99
reclaiming 4, 10, 14–15, 173, 181, 203–204, 219
reconfigured boats 136, 141
"refugee crisis" 139, 142
regeneration movements 228
re-identification 189, 190, 192
re-inscriptions 189, 191, 199
relationship building 231, 234
relocations 137
Renzi, Alessandra; interview with 81–94
repair 96, 136, 141, 142, repair cafés 231
repertoires of action 4, 6
repertoires of contention 2, 5–6
repurposed everyday objects 5
resource mobilization theory 124
restaurants and bars 71–72
retrospection 128
reuse of materials 207, 208, 211, 213
revolution: colour revolutions 30; as disturbance/disorder 60; urban activism 173–174
right to protest 149
right to the city 5, 12, 99, 100–101, 103, 172–173, 202, 204, 208–209
Rights International 149
right-wing politics 55, 111, 192, 205, 253
Rio de Janeiro 8, 12, 95–109, 125, 126, 217–225, 262–263, Plate 7
Roberts, Ed 68
Rogoff, Irit 29
Romanos, Eduardo 7
Romero, George 53
Rousseff, Dilma 211
Rubin, Jon 187, 191, 195, 197
Russel, Peter A. 53

safe spaces 6
São Paulo 202–216, 262, Plate 11
satire 44, 59
School Without Walls *(Escola sem Muros)* 212
Schrijver, Lara 172, 173, 174, 176, 180
science fiction 105
scripts 190, 191–192, 196, 197
Seattle 106
self-determination 227, 229, 231, 232–234
self-management 4, 156, 243–248, 249, 252–253

Seoul 157
shelter 243
Shui-bian, Chen 45
signs: 82, 83, Plate 5, Plate 6 ESDI Aberta 218, 221; handwritten signs 7; Women's March 81–94
Simon, Herbert 2, 230
Singh, Navarjun 82, 87
singing 52
site-specific art 190
sit-ins 39, 70, 217
slavery 95–109, 140
Slavery Museum, Rio 95–109, 125
SLOC (small, local, open, connected) 102
slogans: disability activism 73; global movements 106; São Paulo 205
Slovenia 52–64, 126; zombie uprising in 52–64
Smith, Neil 202
social class 143, 175, 206, 208, 235–236
social justice 41, 73, 92, 161, 213, 236
social media: archives 88; disability activism 70; Drone Academy, Indonesia 162; *egao* (恶搞) (slang term for parody) in Taiwan 44; ESDI Aberta 219; Facebook 70, 72, 219; Green Stripe 27; Hong Kong protests 48; Indymedia 163; Madrid Hologram Protest 147, 263; for organization of protests 156; as a public space 11; public space occupations post 2011 8; Twitter 48, 92; Umbrella Movement, Hong Kong 39–41; YouTube 40, 56, 151, 155; zombie protests in Slovenia 55
social movements theory, classic 124
social science/political philosophy discourse 5–6
Socialist International (SI) 152
socially engaged art (SEA) 190
Solce, Mitja 56, 58
South Korea 157
Spain 55, 147–160, 249
Spanish Parliament 148, 150, 154, 157, *149, 151*
spatial citizenship 204
spatial inequality 208
spatial justice 213
spatial rights 208
spatialities 15
spectacle, sites of 138
speculative design 105, 192
squatting 180, 217, 218–219, 246
"Stand with Hong Kong at G20" 48, 47
Standing Rock 236
Stavrides, Stavros 241
Stengers, Isabelle 16, 203
Stern, Daniel 28, 29, 33, 34
sticker posting 57

stigma 67–68, 128
storytelling 5, 90, 92–93, 99, 105, 112–113, 115, 127
Strategy Card Decks 110, 112, *113*, 114
Strathern, Marilyn 201n51
street art 205
street protest 3, 5, 9, 13, *28*, *30*, *31*; Iranian election protest 2009 27–37; Madrid Hologram Protest 149–160; urban activism 173; zombie uprising in Slovenia 52–64
strikes 7, 8, 12, 60, 65, 218
student protests: ESDI Aberta 217–225; Hong Kong 39; Taiwan 46
subversive inquiry 76, 77
Sunflower Movement 46–47, 48
Suri, Jane Fulton 29
sustainability movements 4, 226, 228
Svoboda, Jozef 152
sweatshops 143
Sweden 65, 68–77
Swyngedouw, Erik 5, 202–203, 213
symbolic capital 156
Syntagma Square 147
SYRIZA 247
Szymborska, Wisława 46

table, as common social space 195
tactical urbanism 172, 202, 206, 208, 211; see DIY urbanism, urban activism
Taiwan 38–39, 43–48
Taksim Square 147
Tampio, Nicholas 213
Tanjung Puting National Park 161–162
Tarrow, Sidney 4, 6, 7
Taylor, Sunaura 67, 68
Teatro Valle 249
technologies of exclusion 67
Tehran 27, *28*, *30*, *31*, 32–33
temporalities 16, 104–106
territorial ecologies 102
territory, design of 95, 99–103, 107
terrorism 173
Theater Embros, Athens 8, 10, 11, 13, 14, 241–256, 261–262, Plate 15, Plate 16
theatrical interventions 152
therapeutic encounter 32–33
thick present 105
Thorpe, Ann 4, 12
Thrift, Nigel 203
Tilly, Charles 4, 5–6, 7, 11, 124
Tonkinwise, Cameron 230
Toronto 157
tourism 104, 174
trading zones 190, 192, 199
training for activists 110–120
transdisciplinary work 16

transference 33
transgressive contentious politics 11
Transition movement 8, 226–240, 262; Transition Pasadena 231, *232*, Plate 14; Transition Media Free Store, Media, PA, 231–32, *233*; Village Building Convergence, Brookfield, VT, 233, 234
translation 117–118, 190, 251
transnational movements 6–7
transnational organizations 4
trees 166–167
Trivundža, Iija Tomažić 56
tropes 15
Trump, Donald 81, 126
Turkle, Sherry 194
Twitter 48, 92
Tzirtzilaki, Eleni, interview with 241–256

UERJ 217, 220, 262, *218*, *221*
UK 56, 226, 228
Ukraine 30
Umbrella Movement, Hong Kong 39–41, 46–47
UNESCO World Heritage 95, 97–98, 99, 104
Unified Black Movement (*Movimento Negro Unificado*) 98, 107
United for a Fair Economy 111
universal design (UD) 65–66
"unseaworthy boats" 135–146, 263
unspoken political 33
unthought knowns 33
Uprising of the Zombies 52–64
urban activism 4, 5, 172–183, 202–216; see also DIY urbanism; tactical urbanism
urban commons 241–256
urban planning 100, 176, 204
Urban Poor Consortium 92
urban revitalization works 96–99, 101, 102, 107
urban survival 207
urbanism 3, 4, 96, 103, 171–183, 202–216; see tactical urbanism; DIY urbanism; urban activism
urbanization 95, 107, 172, 173
USA: Transition Towns 226, 230–235; Women's March 81–94
us/them narratives 195–196
Utopia 73
utopian design 105

Vainer, Carlos 98, 99, 103
Valongo Wharf, Rio 95–109, 126
value-oriented factors 10
Vergara, Camilo Jose 29
vibrant materiality 213
Victoria and Albert Museum 5, 126

videos 39, 40, 147–160
Vikus Viewer 86–87
Vilas Boas, Thelma 106
virtual protest 147–160; see hologram protest
visual disagreements 33–35
visual politics 27–37
voids 248, 249, 250

Waffle Shop 201n45
Wang, Fei-ling 38
wearethe99percent.tumblr.com 8
websites: Art of the March 81–94; asylum seekers 142; Beautiful Trouble 112, 114; disability activism 71–72; Drone Academy, Indonesia 164; ESDI Aberta 219, 220; Madrid Hologram Protest 150; Porto Maravilha, Rio de Janeiro 97
"Welcome to Hell" 54
Weleski, Dawn 187, 188, 191, 192, 193, 195, 197, 198
welfare states 69
well-being 102
Westgerd, Anders 68–69, 70–72, 75–77
"what if" questions 107
"What Place is This?" 106, Plate 7
White Leaves, Black Stays 105
white paper masks 56–57
Wich, Serge 164
Wild Lilies Movement 46
Wild Strawberries Movement 46
Willis, Anne-Marie 16, 230

Winner, Langdon 2, 16, 67
Winograd, Terry 230
Wintercroft, Steve 56
Wodiczko, Krzysztof 152–153
women 7, 97, 100, 166, 169, 193, 242
Women's March 81–94, 128, Plate 5, Plate 6
Wong, Joshua 41
World Bank 241
World Cup 95
World Heritage sites 95, 97–98, 104
World Institute on Disability 68
World Social Forum 4
World Trade Organization protests 2, 3
Wright, Alexa 59

Xi Jinping 39

Yaneva, Albena 15, 125
Yasko, Brett 192
Young, Iris Marion 15, 16
Young, Phyllis 236
Young, Stella 67, 72
YouTube 40, 56, 151, 155
Yugoslavia, former 54, 60

Zald, Mayer 124
Zapatistas 4, 153, 229, 249, 252, 253
Zardini, Mirko 172, 173, 174, 176
Zavrtanik, Rok 58
Zhu, Siqi 82, 86, 89, 90, 91
zombie masks 9, 13, 55, 56
zombie uprising 52–64, 126